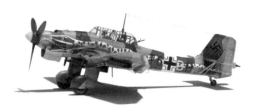

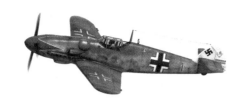

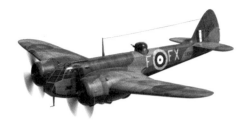

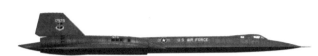

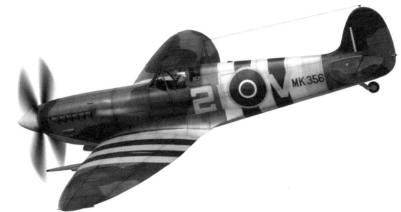

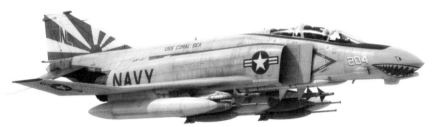

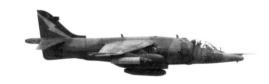

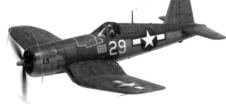

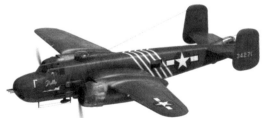

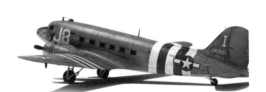

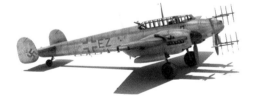

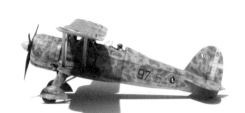

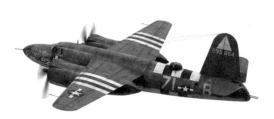

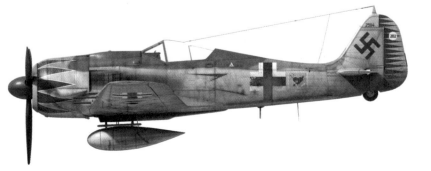

WARBIRDS

THE AVIATION ART OF ADAM TOOBY

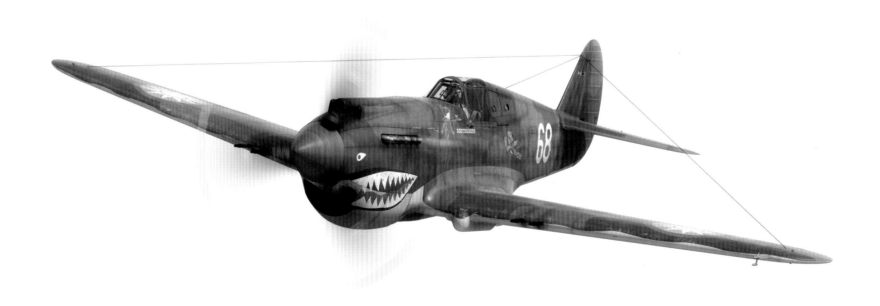

Warbirds: The Aviation Art of Adam Tooby
ISBN 9781781168486

Published by Titan Books
A division of Titan Publishing Group Ltd
144 Southwark St, London SE1 0UP

First edition: October 2014
10 9 8 7 6 5 4 3 2 1

Images on pages 32-33, 87, 180 are the property of Airfix. Used with permission.
Images on pages 19, 20-21, 51 top, 168, 175 are the property of Osprey Publishing (Air Vanguard). Used with permission.
All other artwork is copyright © 2014 Adam Tooby.

Titan Books would like to thank Airfix and Osprey Publishing for their permission to reproduce select works. Clive Rowley for supplying the Foreword and other commentary for the book. Steve White for his tireless work on another passion project. Most importantly, Adam Tooby for supplying us with so many stunning pieces of artwork, especially those he produced exclusively for this book.

Big thank yous from Steve White to the debonair Richard Sullivan at Osprey for smoothing the path to artwork re-use; to designer Natalie Clay for her wonderful work on this mighty tome; to Jo Boylett, my ever-loving line editor at Titan Books; to Adam for not thinking my introductory email was from some random fanboy and for fully embracing the idea of *Warbirds*; and to the Royal Guardsmen for giving the title…

Did you enjoy this book? We love to hear from our readers. Please e-mail us at: readerfeedback@titanemail.com or write to Reader Feedback at the above address.

To receive advance information, news, competitions, and exclusive offers online, please sign up for the Titan newsletter on our website: www.titanbooks.com

A CIP catalogue record for this title is available from the British Library.

Printed and bound in China.

CASE FRONT: **Jolly Roger Nose View.** A Fighter Squadron 84 'Jolly Rogers' F-4N, USS *Franklin D. Roosevelt.*
CASE BACK: **Jolly Roger Tail View**
PAGE 1: **Flying Tiger.** A Curtiss P-40B with 'Flying Tigers' markings.
THIS SPREAD: **Liberators.** Consolidated B-24 Liberators.

This book is dedicated to my family Nicky, Lucas and Leia.

Acknowledgments
The production of a book of this sort is a milestone in any artist's career and it's been a privilege to have been asked to produce it. This also gives me the chance to thank and acknowledge the people how have helped me along the way on this journey. In no particular order I would like to thank the following people who have given their support in making this book possible. This is a big thank you to all of you for all your continuing support and help:
Nicola You
Darrell Burge
Martin Ridge
Karen Redwood
Jonathan Mock
Philip Smith
Paul Crickmore
Gareth Hector
Peter Davies
Clive Rowley MBE RAF
Simon Owen
All the Airfix designers new and old!

WARBIRDS

THE AVIATION ART OF ADAM TOOBY

EDITED BY STEVE WHITE

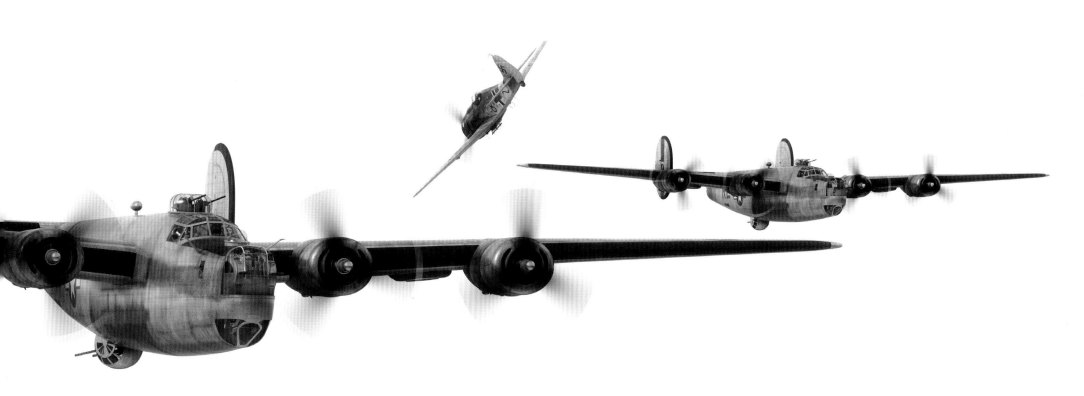

TITAN BOOKS

CONTENTS

Minsi III. Capt. David McCampbell's Grumman F6F-5 Hellcat.

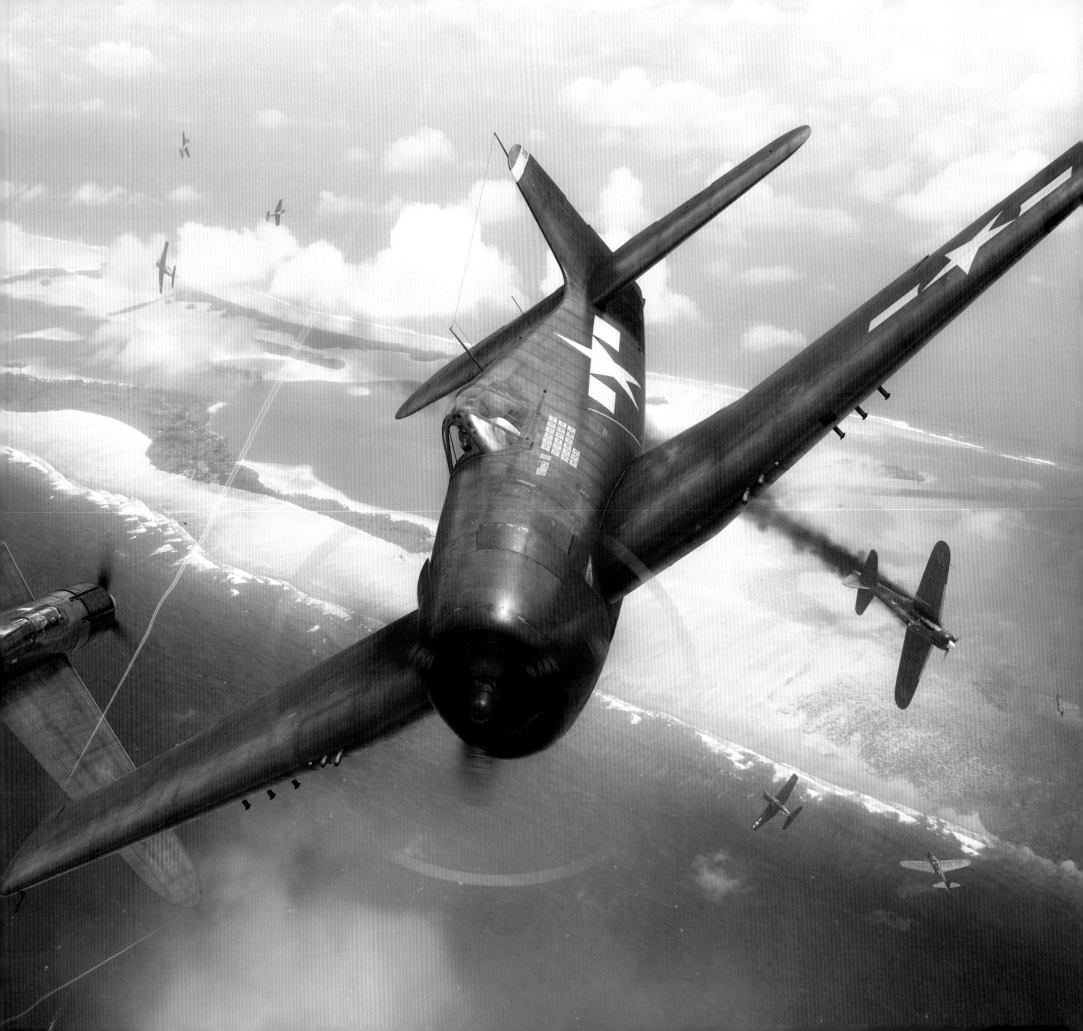

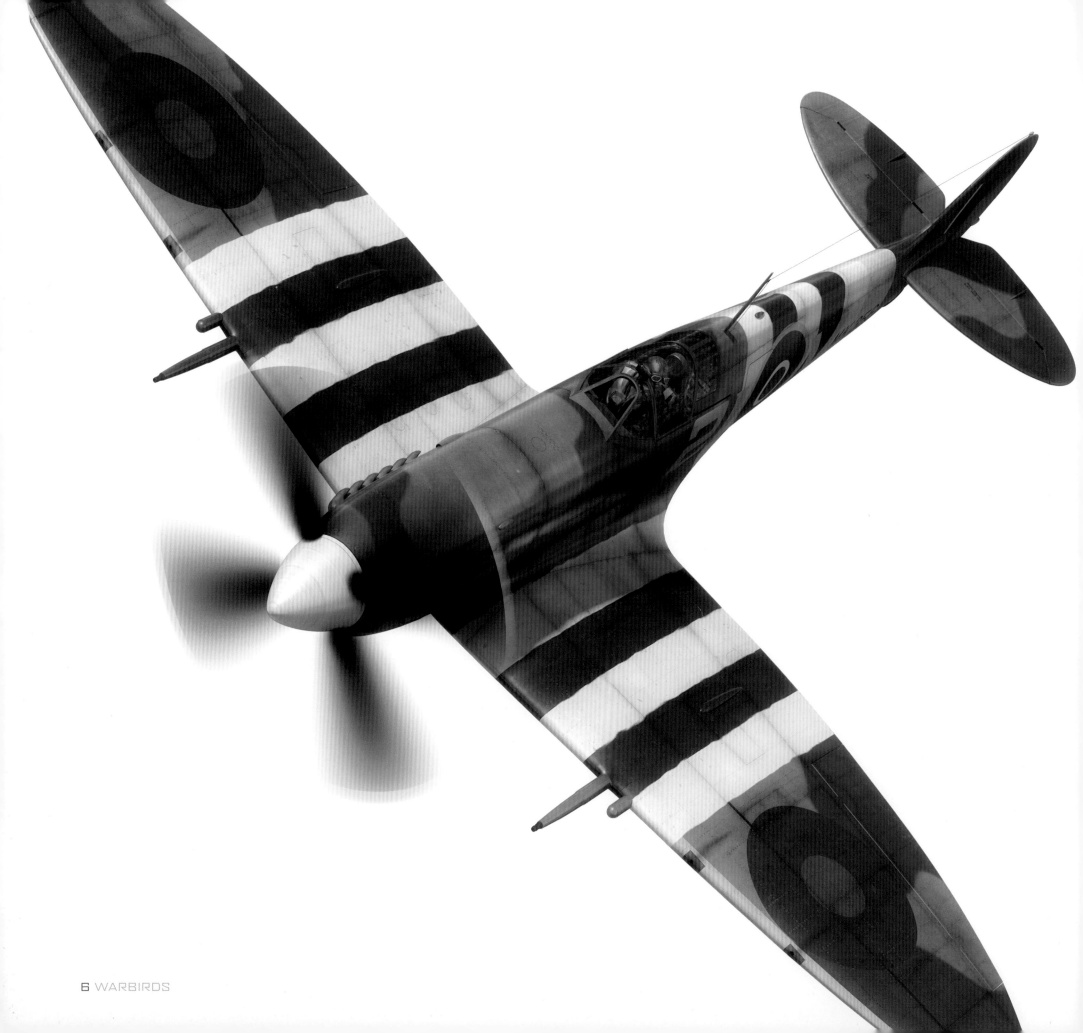

FOREWORD

I spent thirty-six years flying with the Royal Air Force, mostly as a jet fighter pilot, and during those decades hardly a day went by without me observing aircraft of many types, in many circumstances, sometimes with a privileged view not available to most people. I have always been fascinated by how aircraft can look completely different from various angles and in altering light conditions.

For each of us there are eras of aviation that were before our time, or places that we could not be (perhaps, in some cases, we would not actually want to be), when aircraft, their pilots and crews were earning a place in history or even shaping it. Some of those 'snapshots' in aviation history are what Adam Tooby brings to life with his amazing digital aviation artwork, showing the drama of those moments in great detail.

Having worked with Adam on a number of his illustrations, especially those for my own publications, I can vouch for the meticulous research that goes into each and every one to produce astonishing technical and historical accuracy. Not only can you see practically every rivet in the aircraft, but also the scenarios are as accurate as the available information allows. Adam's pictures are always dynamic, with a great sense of movement and speed. They tell, in a way that other media cannot approach, of the genius of the aircraft designers, the skill and prowess of the pilots and sometimes of inspirational courage.

This, Adam's first book, gives us the chance to revel in over 200 of his works in their full glory, covering 100 years of aviation from the First World War to modern jets. He also lets us into the secrets behind how his digital, computer-generated imagery – or perhaps that should be wizardry – is produced. I trust that you will enjoy Adam's work as much as I do and join me in hoping that this will be the first of many such books from this brilliant artist.

Squadron Leader Clive Rowley MBE RAF (Retd)
Former Officer Commanding the RAF Battle of Britain Memorial Flight and now an aviation historian and author.

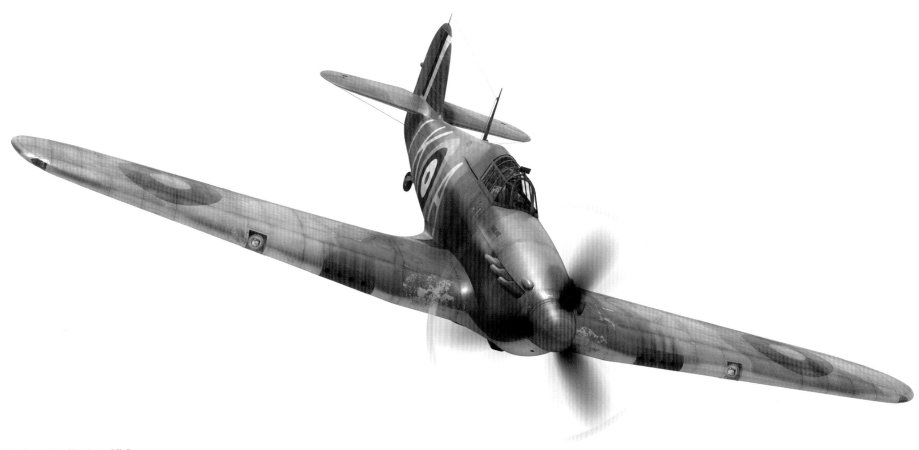

ABOVE: Hawker Hurricane Mk I
OPPOSITE: Supermarine Spitfire Mk XI

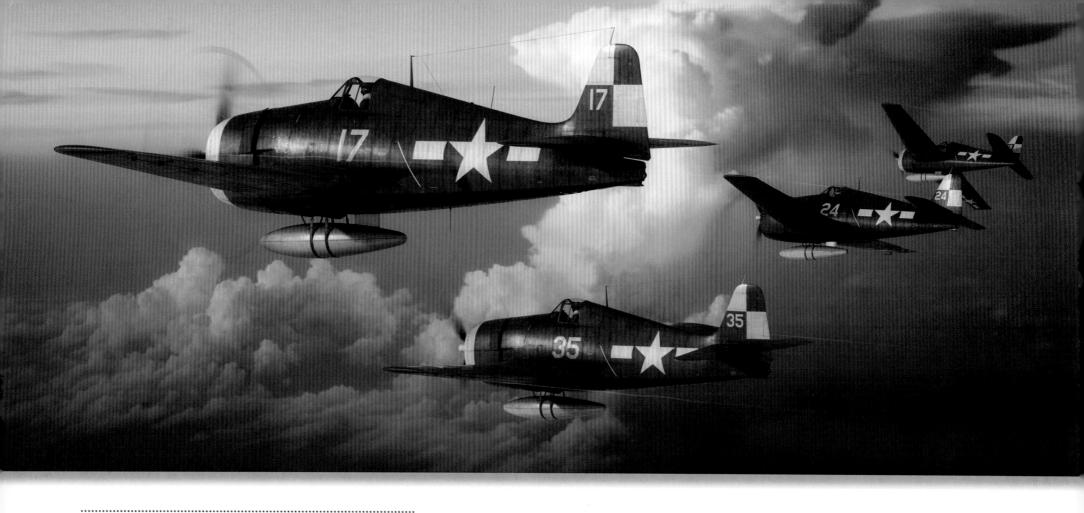

IN CONVERSATION

Have you always drawn aircraft? What attracted you to that subject?

The honest answer is no, I haven't always drawn aircraft – I really only got into aviation art about six years ago, so its been a very fast learning curve in this field. Though I always admired aviation art and the wonderful artwork that's been created, especially the model kit box covers; those I always found exciting and full of energy and drama. The golden age of Airfix box tops are a constant reminder of how impactful illustration should be. My first job illustrating was for Daimler-Benz Aerospace in Germany, so aviation played a huge part in my early career – although the work I did there wasn't too creative and dynamic!

I've always had a passion for aviation and most things that go fast. I think it's in all of us – the enjoyment of going fast or the thrill of being seduced by raw power that aircraft can deliver, whether it's the wonderful growl of a V-12 Merlin or the ear-shattering sounds of a modern jet fighter with full afterburners lit that resonate through your body at a display. There's something about it that puts a massive smile on my face and thoughts go through my mind of what it must be like to be doing that. I guess it draws the little boy out in all of us for a few moments and we feel like we're five again, seeing it for the first time.

This passion drew me towards illustrating aircraft from an early point in my professional career. However, as an illustrator you develop your skills to be able to tackle most projects you're commissioned to do, so in my time as a professional illustrator, my career has included designing children's toys, and full concept art and development for the entertainment industry. I've been fortunate enough to have a career that so far has been varied almost on a daily basis.

I also have a keen interest in military history, which I think helps in regards to creating the artwork – reading pilots' stories and visually re-creating their exploits. I like to think it keeps their memories alive and also gives our generation a glimpse at the bravery of every pilot, no matter which cause they fought for. I've been fortunate enough to meet some of these men (and women) and they truly are inspirational people who should never be overlooked for what they did during the wars they fought. This culmination of keen interests in military history and aviation drew me to the artwork I now produce.

Did you make aircraft models as a child?

Honest answer – not many, as I was always more interested in the box art!

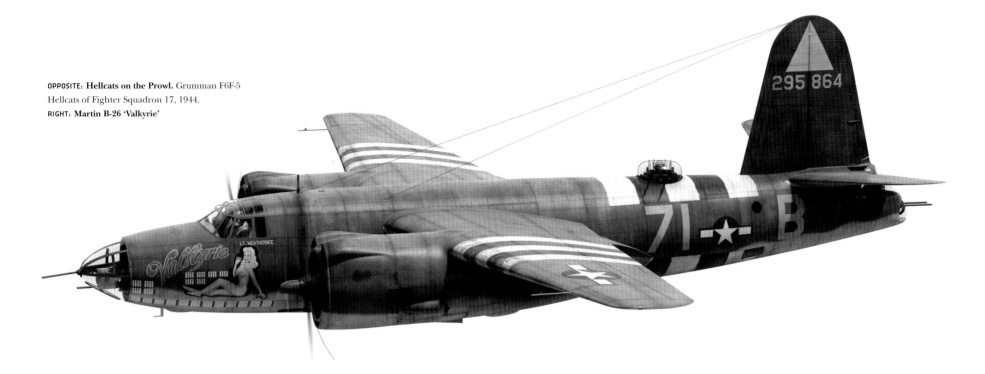

At what point in your life did you want to draw for a living?

I guess art and illustration was always on the cards from a very early age. I can remember drawing on almost anything I could get my hands on. It was very prominent from my first years in primary school as it was something that I seemed to be able to do naturally. As time progressed through my formative years I always wanted to become an artist of some form, but at the age of seven or eight I wasn't too fixed in my subject matter – just as long as I could draw something! I was always inspired by the 1980s technical cutaway illustrations and high-end, very detailed work, along with the fantastic airbrush artwork that was king during that era. I was always blown away by the technical and realistic finishes you could achieve and I wanted to be part of that in some form.

As the years went past and I reached high school, I selected all my subjects and choices to be in the creative arena – from normal art classes to technical and mathematic subjects. I always had it in the back of my mind that I wanted to do technical work, but at school there was no such outlet to follow this route, it was more about exploring different styles and forms. Whilst going through those processes it just focused me more into the areas I wanted to develop – I was never going to produce modern art! My career decisions were all decided in one fortunate afternoon on a school visit to our nearest major art college. We were visiting the end-of-year exhibitions of all the courses when I literally stumbled on the technical and informational illustration course. This was it – everything I had ever wanted to do was here and that's where I started my professional journey to becoming an illustrator. Once at the college I was fortunate to be taught by two very skilled and wonderful teachers who pushed me to my limits. They had an infectious enthusiasm, which I always keep in my mind when I approach a job today.

At what point did you experience the digital revolution?

At college. In the first two years of my course, the 'computer' was just about capable of doing text – slowly replacing the Letraset catalogue! I think the best thing about the computers then was that they were only a small add-on tool while we were learning to become illustrators. Everything we did was all by hand with pencil, Rotring pens and ellipse guides. All our classes were about freehand drawing and painting without a hint of a computer anywhere. We had to construct everything in the tried-and-tested methods that had been done for decades before us. From tri-metric grids to airbrush artwork, we learned the hard way – there was no 'undo' button! I was taught by some fantastic artist and illustrators whose work was truly inspiring. Everything was done by hand and we were very lucky to be the last few who were educated in the 'older techniques' before computers became more powerful and started to take over the modern-day practice and work-flow of creating artwork. By the last year of university, the first Apple Macs had appeared and the first editions of Photoshop and Illustrator were becoming part of our education. I can remember our tutors literally learning the software as we were, so it was all very fresh and raw to everyone. At that point I don't think I appreciated how the computer would revolutionise the whole industry and I always tended to shy away from them to hone my traditional skill-set.

Once the 3D aspect of computer artwork creation became commercially available it really did change the way, as a technical artist, I went about my day-to-day work. It was a huge advance in producing art. It would literally take weeks off producing a technical illustration and, more importantly, it gave you a better, more controlled finish. The biggest challenge about 3D was learning a host of new processes to get the results you'd learned by hand – it was almost like starting college again! I still firmly believe if I had not been taught the traditional methods I would not have reached the level I am at today. The digital revolution has been an amazing tool and it continues

to amaze me what computers can do, and also what other artists can do with them. In terms of aviation art I think the new processes give the artist a new perspective on how to go about producing scenes and compositions.

As to producing a piece of art that's been limited only to your imagination, well, the tools of the digital era have really given us the freedom to explore any possibility.

Illustrating aircraft is as much a technical exercise as it is a fine art one. Did that influence your art training?

The technical exercise and fine art work hand-in-hand together – neither would work without the other – the art would suffer dramatically if that were the case.

The technical aspect naturally influenced my training as I was studying technical illustration; everything had to be very accurate from a constructive point of view. The fine art aspect comes in to play more when you're producing the composition and choosing aesthetically pleasing views of the subject matter. Lighting is also a key area, as it can really bring out the shape of any subject you're illustrating. The next major area would be the detail – once you start to study the surfaces and materials it really can bring the subject matter to life. Whilst training, both these approaches were studied, as one improves so does the other, as it will show if it doesn't. I think the key

to any successful artwork is striking the right balance between both of these key aspects – technically accurate in form and beautifully detailed artistically so it draws you into the scene.

Has the computer simplified things for you or is it simply a change of tools?

It has simplified some areas, that's for sure, in particular the composing of a piece. You can freely move things until you're happy with them. It speeds up the workflow massively and has given me a limitless way to explore the artwork I'm trying to create. It gives you the confidence to really push and try new things that you may not have done before, as it would take a long time to do traditionally. So, yes, it has simplified the ways I approach my artwork. It also enables me to be more focused on the detailing of the subject matter as well – you can really push the boundaries in terms of detail that you wouldn't be able to do by hand very easily. You have better tools to explore lighting and perspective, which isn't quite as flexible when doing the same artwork by hand.

However, it is just another tool for the artist, although one that is constantly developing, giving you the freedom to create almost anything you can think of. It is the major part of any of today's processes, but for me, before I even go to the computer, it still starts with pen and paper, quickly scribbling down ideas and compositions. The computer just helps you refine them.

How do you construct an illustration? How do you construct your backgrounds?

To start illustrations I tend to look at the subject aircraft first and read about the history we're trying to put across as artwork. Once all that has been digested I usually start with the roughest of scribbles just to get my ideas down as fast as possible. The next thing I tend to do is build the aircraft in 3D; it gives me time to study the aircraft and to think about which views I'd like to do of it.

Constructing the actual illustration usual starts by studying the subject quite closely – looking at what makes it look great; you look at how the light bounces from the surfaces and what view shows the aircraft off at its best. Whilst doing this, it's good to always keep an eye on the subject's colours and markings, but be careful to never let this dictate the final angle of the scene, as it can become convoluted. Keeping the form is always key to a strong piece of artwork. The next thing to consider is the balance and focal points of any scene – never make them too cluttered, or lose the flow of the story you're telling in the image. This may take a few goes to get right, but it's the most important of stages to get right from the start.

This also has to work in tandem with the historical aspect. I have to consider all aspects from the pilot's testimony or the description of a particular scene. Those two key areas have to be considered from the start. Following very closely after this is the

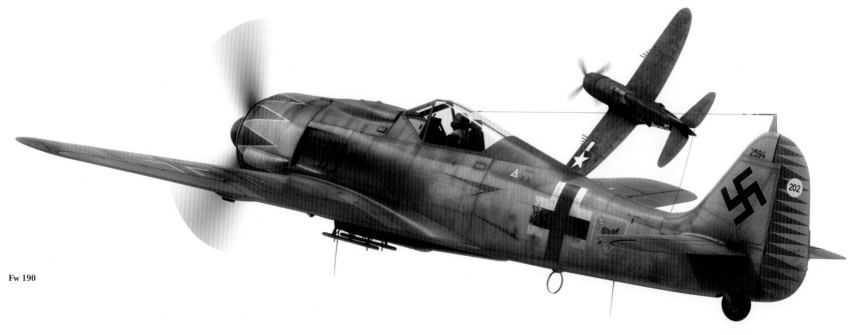

Fw 190

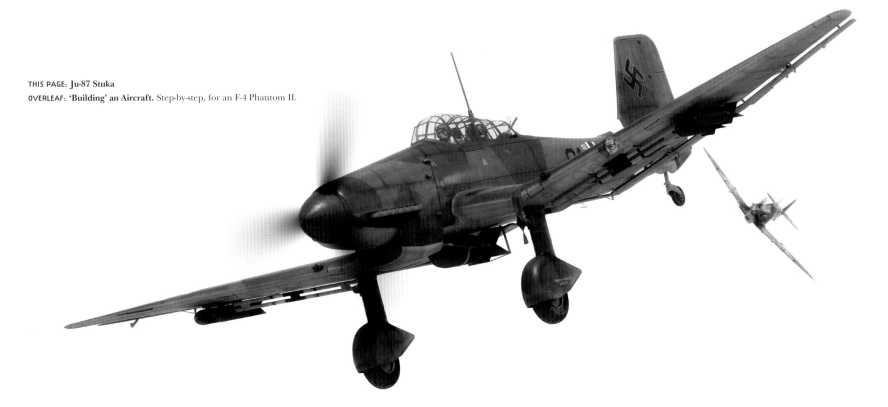

background and how it will integrate with the main subject matter, whether it's at ground level or 25,000ft in the air. Once you're happy with everything then the rest should fall into place.

As for constructing the backgrounds, this can be a mixture of 3D-created worlds, matte painting and some photographic aspects to get form and colours. The backgrounds tend to help contrast against the aircraft, very much in the same way a traditional artist would paint, albeit digitally. For clouds I tend to make all my own custom brushes. This gives you total control over the final background scene rather than just using a photograph.

How do you 'build' an aircraft and what software do you use?

I use Autodesk's 3D Studio Max. It's one of the industry's best software for creating 3D artwork. I use it in tandem with Adobe Photoshop and Adobe Illustrator.

Building aircraft usually starts with a simple approach:
1. Where possible get to a museum housing the actual aircraft. This is the best way of understanding the subject. You can get up close and see and feel the detail. I normally take around 100 to 200 detailed photos of the subject I'm illustrating.
2. The next stage is getting some accurate and well-drawn general assembly drawings (GAs) of the subject aircraft, including as many elevations as possible – top, side, belly etc. These are key in getting the construction right. Cross-sections are also very helpful, but not always available. With the GAs and the reference photos, you're ready to start the construction process.
3. My starting point is normally the nose area of the aircraft – it's as good as anywhere! It's really up to the artist to begin where they feel most comfortable.

These early stages are some of the most important. They form the airframe structure before the detailing – get these stages wrong and it will always show. It's always a good feeling for me starting the geometry and the 'sculpt' of the aircraft.
4. After constructing the nose area I tend to block in the canopy. For me, they are the 'eyes' of any aircraft and have to be very accurate.
5. Blocking out the fuselage tends to come next. Doing this, I'm always mindful of all the wing root areas. It's always good practice to make sure you gave enough thought to the geometry there so that you can build effectively and accurately.
6. Start forming the tail section and rudder. These areas complete the main body of the blocked-out sculpted aircraft framework. The next phase here will be to cut into the block and refine the detail on the tail, rudder and blended tail surfaces.

7. Detail the tail.
8. Block out and then refine and detail the tail planes.
9. Construct the wings.
10. Refine the wings. For me, this takes time, and care must be taken in making sure all flaps, brakes and all other parts are modelled correctly.
11. Cockpit detail.
12. Adding all the aerials and smaller details and weapons. Just adding the smaller details really makes the aircraft come together at this point.
13. Add the final smoothing detailing. The result is the final wireframe mesh that can be divided up into areas that can be unwrapped ready for the texturing.

Unwrapping the aircraft:
14. Divide up the aircraft into parts for mapping. These are then put in the UV editor to flatten out and stitch together. UV mapping is the process of projecting a texture map onto a 3D object.
15. Place a small chequered pattern on the aircraft parts to make sure that all the UV co-ordinates line up.
16. Create the detail for the maps.
17. Place the textures on the model. I usually start with a quick test with the aircraft's lines and rivets on.
18. Add the colours and map details.
19. Add the colour maps now to make sure all is looking fine.
20. Final aircraft now ready for artwork.

1

2

3

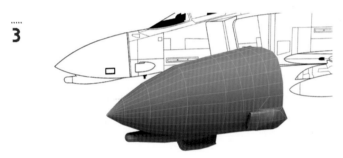

4

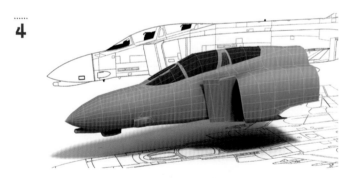

5

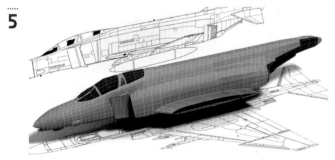

6

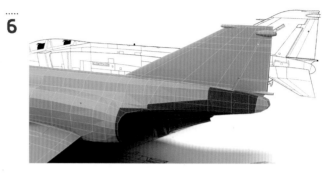

7

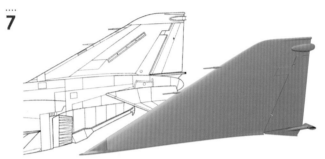

8

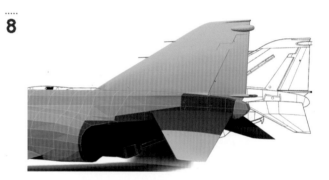

9

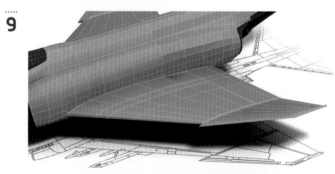

10

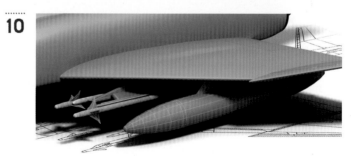

11

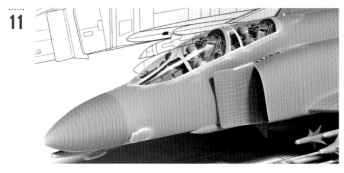

12

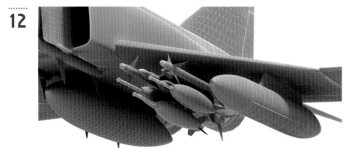

13

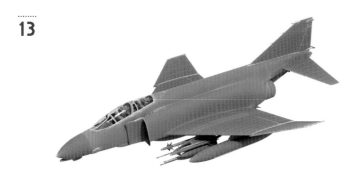

14

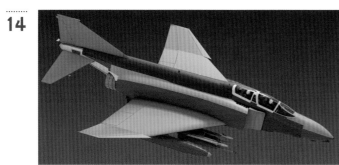

15

16

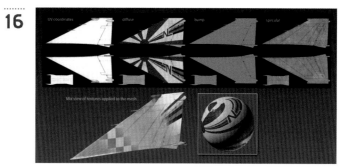

17

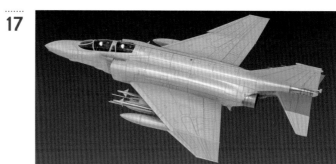

18

19

20

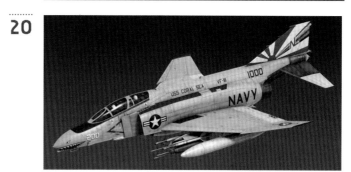

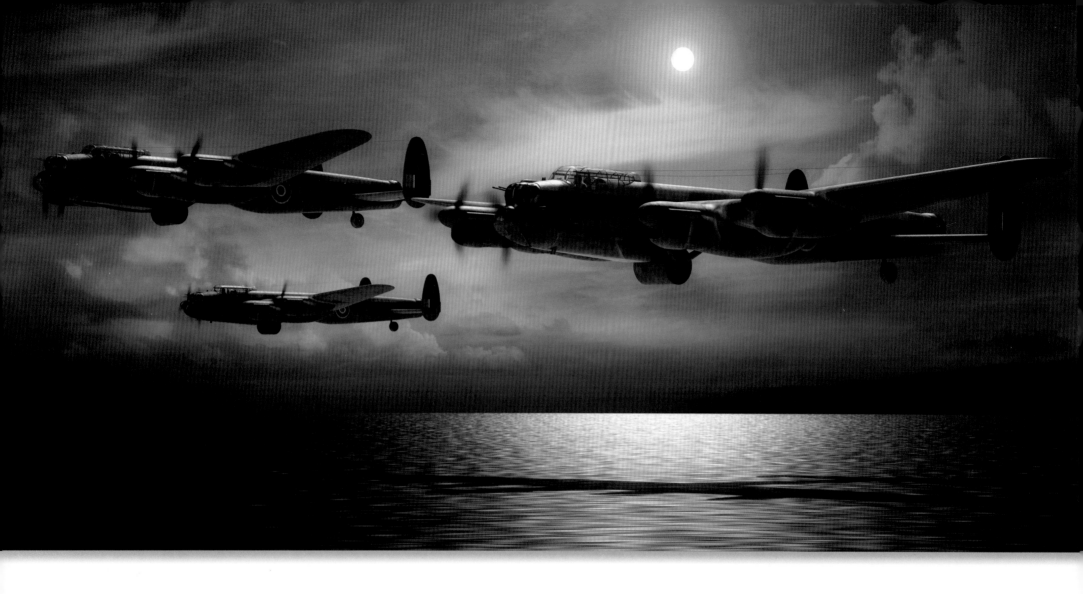

Aviation art is one of those areas that requires extreme accuracy from the artist. What's the type and level of research you do?

I tend to research the aircraft by usually visiting it at a museum or airshow and taking photos of all its details and finishes. I look at all the forms and compound curves, making notes of how they flow and also utilise how natural light falls upon the airframe. It's important to look at how the paint or natural metal finishes react with their environment, so that the textures can be reproduced accurately. Another aspect I always look for is how it's weathered. This is important to get the feel for the aircraft's natural wearing when it's been used.

I also tend to surround myself with lots of books on the subject matter I'm modelling. These usually contain photos of the aircraft in combat, so the detail you can find there is invaluable.

A good model kit also goes a long way in studying the form from angles you may not have been able to obtain reference shots of whilst visiting the aircraft. Naturally, the internet is a very good source of material as there are many specialist sites which display 'walkaround' photos of aircraft from all over the world.

Do you think attempting photorealism actually defeats the point of an artwork? In certain quarters, digital art is seen as 'lazy', that the computer takes the 'art' out of the image. Can you achieve things that a 'traditional' aviation artist can't?

I honestly wouldn't say the artwork is photorealistic – more in the bracket of hyperrealism akin to the airbrush artwork I was influenced by growing up in the '80s and through university. The art of these artists was sometimes close to being completely photorealistic, but the top artists would cleverly illustrate the subject so it gave you the impression it was a photo with the viewer's mind filling in the detail subconsciously. When producing artwork I try and keep those values in mind and pass them into digital form. I try and keep it dynamic, but still with the sense that it's been 'painted', albeit on a computer. There are no photos used for the textures on the aircraft; they have all been painted from scratch, which I believe helps separate them from being photorealistic. I also employ the same simple yet effective tricks a traditional aviation artist would use. Again, by using these it helps distance it from being photoreal and keeps 'digital' more in the art bracket. Using these techniques I think doesn't defeat the point of aviation art, but helps move it into a new dimension.

I've come across quite a few people who believe that digital art is 'lazy'. They have this notion that you just press a button and it does it all for you. Oh, how sometimes I wish that was the case! As I've explained, being a digital aviation artist means you have to have a very technical eye as you sculpt the aircraft from scratch. We then become a technical artist/draughtsman when it comes to the panel lines and rivet detailing. Then on to becoming a fine artist for the textures as well as the matte backgrounds we paint for the scene. As such, it's a real mixture of skills to produce our type of artwork. We're a sculptor, technical artist and fine artist all rolled into one!

I wouldn't say the computer takes the art out of the image. I think it adds a heightened level of detail. As with all aspects of the art world, it's the eye of the viewer that determines what's art and what's not, and I believe that digital aviation art is a new platform where aviation can be explored to new levels. I think there's more than enough room for traditional art as well as digital, as they both have their very distinctive and unique styles.

Is there any particular time period and type of aircraft you really enjoy illustrating? Any you dread being asked to do?

A favourite era in aviation art is of course 1939 to 1945. There's so much history and variety it's enough to keep you inspired for a lifetime. I really enjoy this era as the aircraft were given their own identity and when America entered the war they had some amazing colour schemes in their Bomber and Fighter Groups. I particularly like all the different nose art that was painted. I find them fascinating and I like the varying styles that adorned the fighters and bombers. This goes for the Luftwaffe and RAF planes too; they also look fantastic in their squadron markings. Another reason I like to illustrate this era is because you can make the aircraft all weathered and gritty. It gives you a wonderful chance to show them in their combative state.

Another era I enjoy illustrating is the Cold War, specifically the jet aircraft. These are such elegant aircraft and they also carried over high-vis markings similar to those from the WW2 era. As you can

probably tell, the F-4B is a particular favourite when it comes to that period!

I don't really dread being asked to do any aircraft, but helicopters are not always high on my list of 'to do' machines. That's just because they're quite tough to get right in the building processes, especially the rotor heads.

Who are your artistic inspirations?

My inspirations come from a wide variety of sources; they don't just have to be aviation based. I think if an image grasps your attention and you're drawn towards it, this will inspire you in whatever form. I'm particularly drawn to artwork that has atmosphere and depth, and that tells a story when you look at it. I'm inspired, I guess, by the storytelling an image gives you. It lets my mind wander off and be part of the action that's caught in the scene in front of me. As for certain artists that have inspired me, that's a long, diverse list as it has come from all areas of the artistic world, from the Japanese airbrush artists of the '80s to the classic box-top artists such as Roy Cross. Brian Knight has had a big influence certainly when it comes to the Airfix artwork. I always love what the Disney/Pixar guys produce as you can see the wonderful use of light and subject composition in their works.

As for aviation artists, personally for me the American artists just have that edge when it comes to traditional artwork. There's no one particular artist who's been my major influence, just more a collective of different styles and approaches which have helped shape what I do and the way I approach subjects.

If you could get behind the controls of one particular aircraft what would it be?

I'd love to get behind the controls of a few; the P-51, the Eurofighter Typhoon, but I guess like most of us it would have to be a Spitfire! I think with its beautiful design and distinguished history there's really not many finer aircraft to fly.

Are there any other fields of art you've contemplated trying your hand at, just for a change of pace?

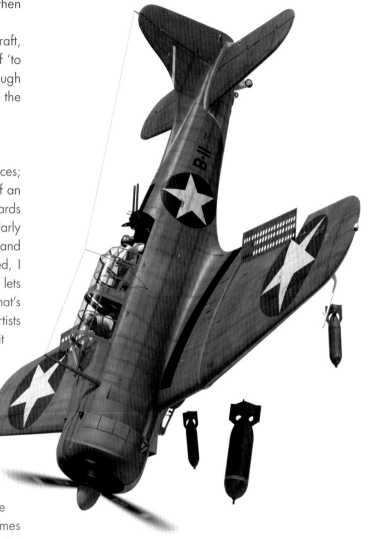

ABOVE: **Dauntless.** A Douglas SBD Dauntless.
OPPOSITE: **Outbound.** Avro Lancasters.

I'd love to do more conceptual work. My imagination works overtime and there's not enough time to do everything. I've worked with some parts of the entertainment industry and enjoyed it a lot, so I'd like to do more of that type of work, alongside all the aviation artwork of course!

What's been the high point of your career?

This book! I honestly never thought anything like this would ever happen, so this stands out more than any.

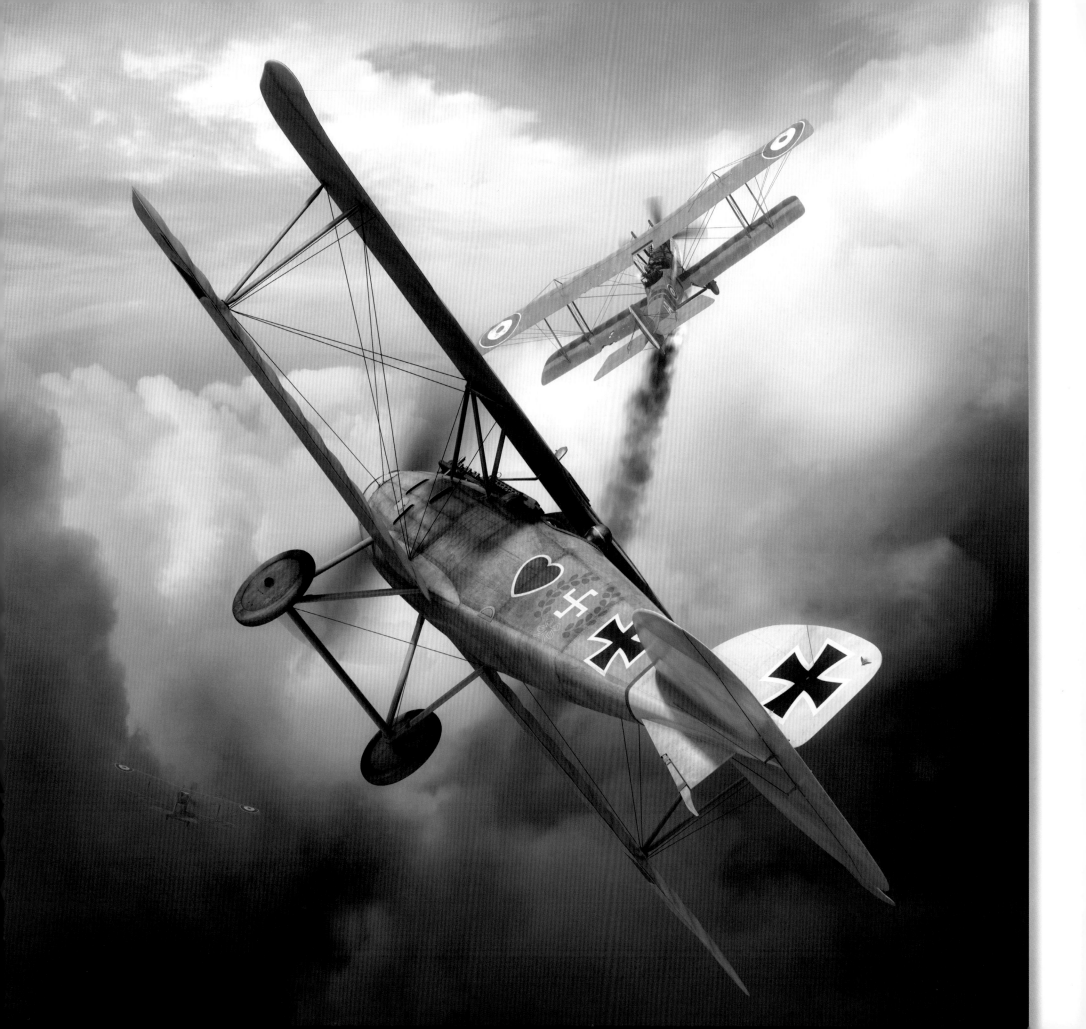

D.III

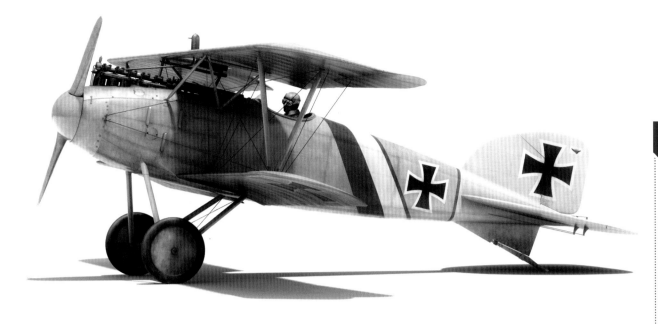

SPECIFICATIONS

TYPE: single-seat fighter

MANUFACTURER: Albatros-Flugzeugwerke

OPERATORS: Germany; Poland; Austria-Hungary

CREW: pilot

LENGTH: 24ft (7.33m)

WINGSPAN: 29.8ft (9.08m)

WEIGHT: 1,457lb (661kg) [empty]-1,953lb (886kg) [max. take-off weight]

MAX. SPEED: 107mph (180km/h)

SERVICE CEILING: 18,045ft (5,500m)

RANGE: 217 miles (350km)

POWERPLANT: Mercedes D.IIIa

ARMAMENT: Maxim 7.92mm LMG 08/15 machine gun x 2

MAIDEN FLIGHT: August 1916

IN SERVICE: December 1916-November 1918

NUMBER BUILT: 1,866

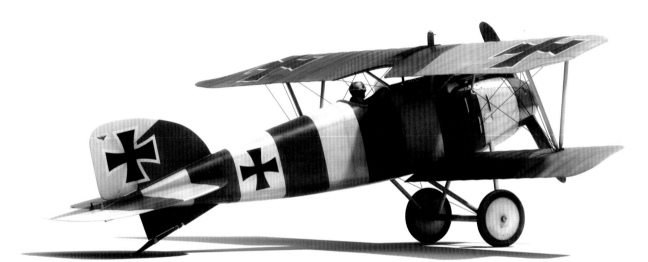

Following the introduction of new Allied fighters such as the Nieuport 11 Bébé, Germany lost aerial superiority over the Western Front in 1916. This prompted the development of the Albatros D.I. The result was a beautifully streamlined and powerful fighter boasting an aerodynamic cowling for the engine and cone of the spinner of the two-bladed propeller, and a pair of forward-firing, fixed, synchronised machine guns – all firsts in fighter design.

The Albatros quickly made its mark against British and French fighters when it entered service in December 1916, but there was still room for improvement. The result was the D.III. Manoeuverability was improved by using an unstaggered pair of redesigned low-

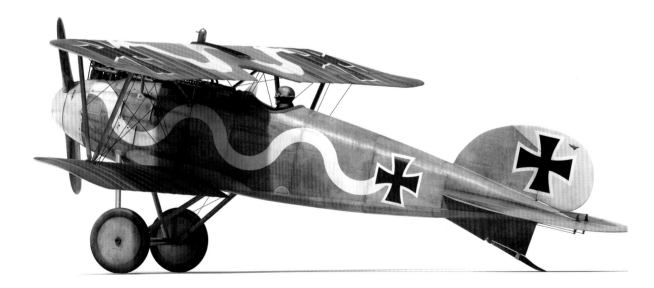

CLOCKWISE FROM OPPOSITE: Werner Voss in Action. Both the swastika and heart markings were for good luck. **Hermann Frommherz's 'Blaue Maus'. Bruno Loertzer's D.III.** Erich Löwenhardt's D.III

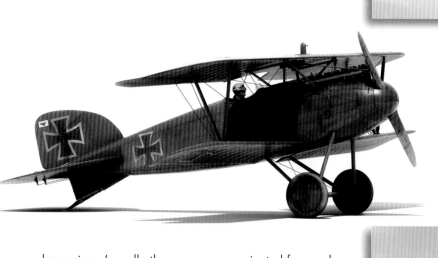

drag wings (usually the upper one projected forward of the one below) with a V-shaped strut between them – unlike the parallel struts used by most fighters. This improved upper-wing rigidity and consequently the manoeuverability of the Albatros. The upper-wing assembly had also been lowered to improve the pilot's vision above – a feature much appreciated by those who flew it in combat.

Early into its operational career, a number of D.IIIs suffered serious lower wing failures as a result of cracking in the leading edge and wing ribs. This was caused by torsioning of the wing during hard turns or dives. As a result, the fleet was grounded until February 1917, when it re-entered service with a strengthened lower wing.

With its improved manoeuverability, rate of climb, and pilot visibility and protection, the D.III was much loved by its pilots and equipped thirty-seven squadrons in the *Deutsche Luftstreitkräfte* (Imperial German Air Service). It remained in action until the end of WW1, even after new Allied types rendered it obsolete. It was also built under license by Germany's ally Austria-Hungary. After the end of the war, sixty Austrian-built models ended up in the Polish Air Force and were flown by American volunteers in combat against new Soviet Russian forces during the Polish-Soviet War of 1919-1921.

ABOVE: **Manfred von Richthofen's D.III.** Von Richthofen was known as the 'Red Baron' because of the colour of his aircraft and the fact that he was a member of the German nobility.

RIGHT: **Aces.** The only confirmed time German aces Voss, the Red Baron and his brother, Lothar von Richthofen, flew together during WW1, just as they spot an enemy squadron of Sopwith Strutters. *Courtesy of Osprey Publishing.*

OVERLEAF: **Balloon Bust.** Löwenhardt's fourth balloon victory. *Courtesy of Osprey Publishing.*

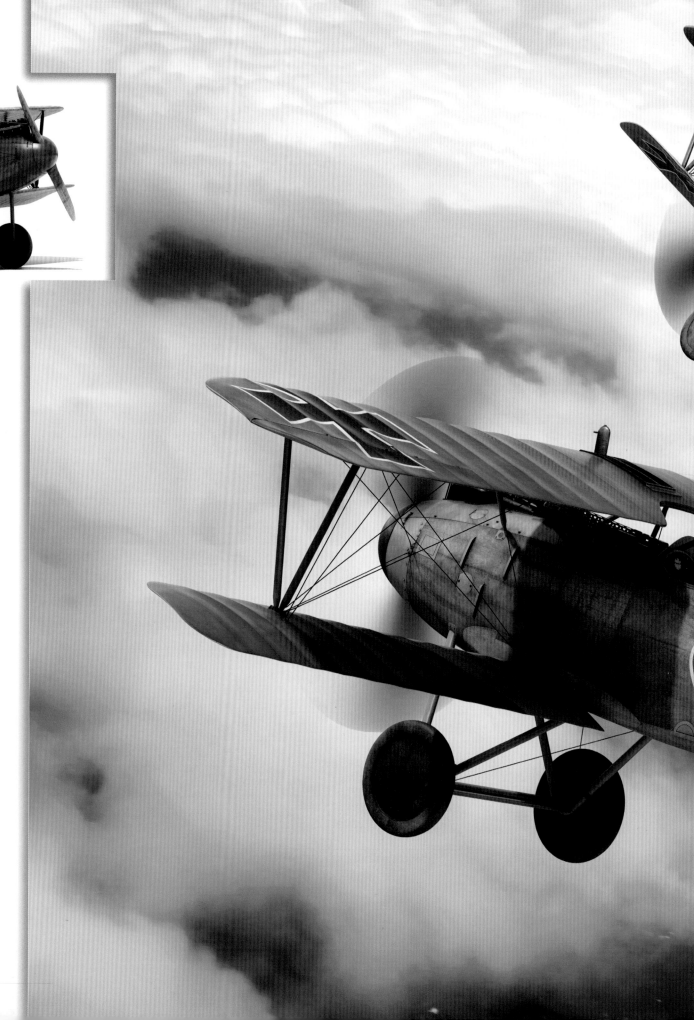

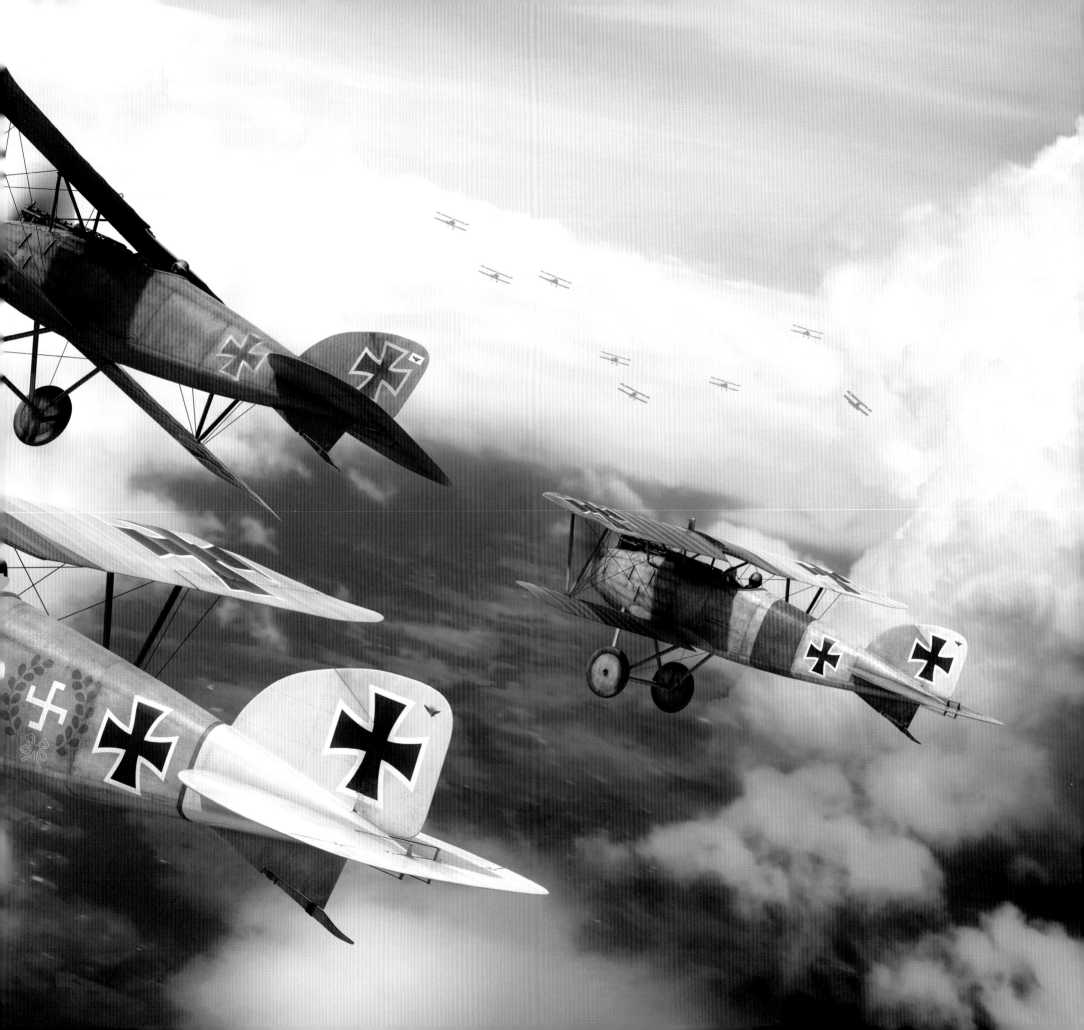

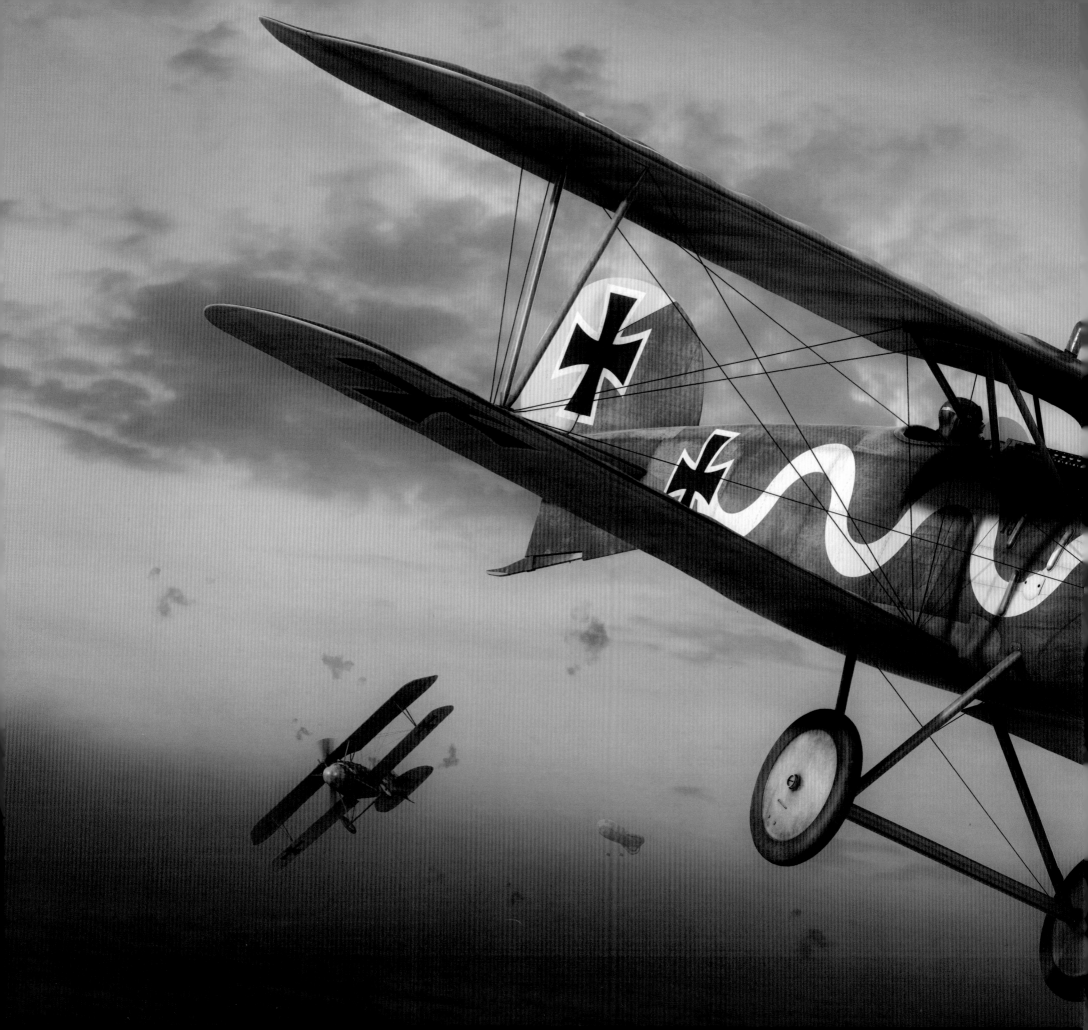

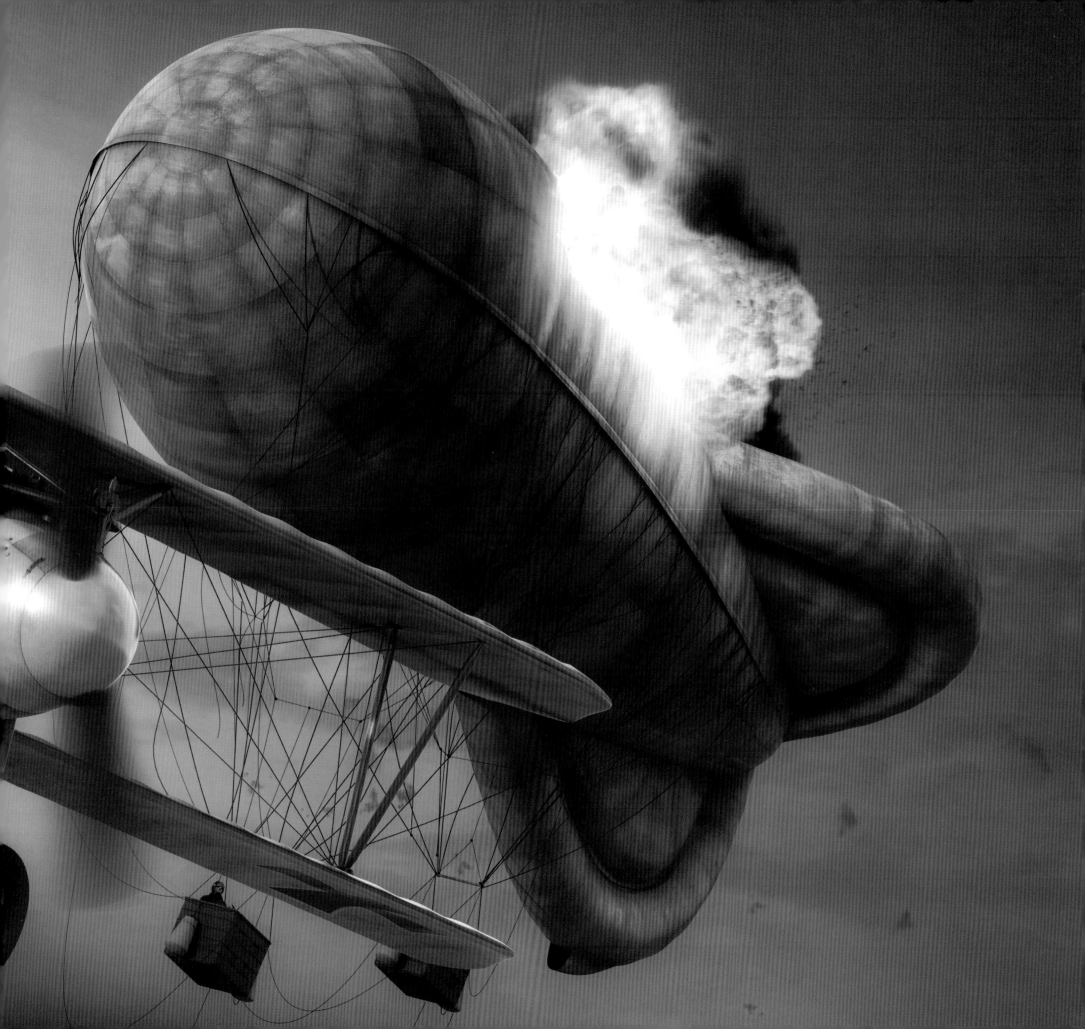

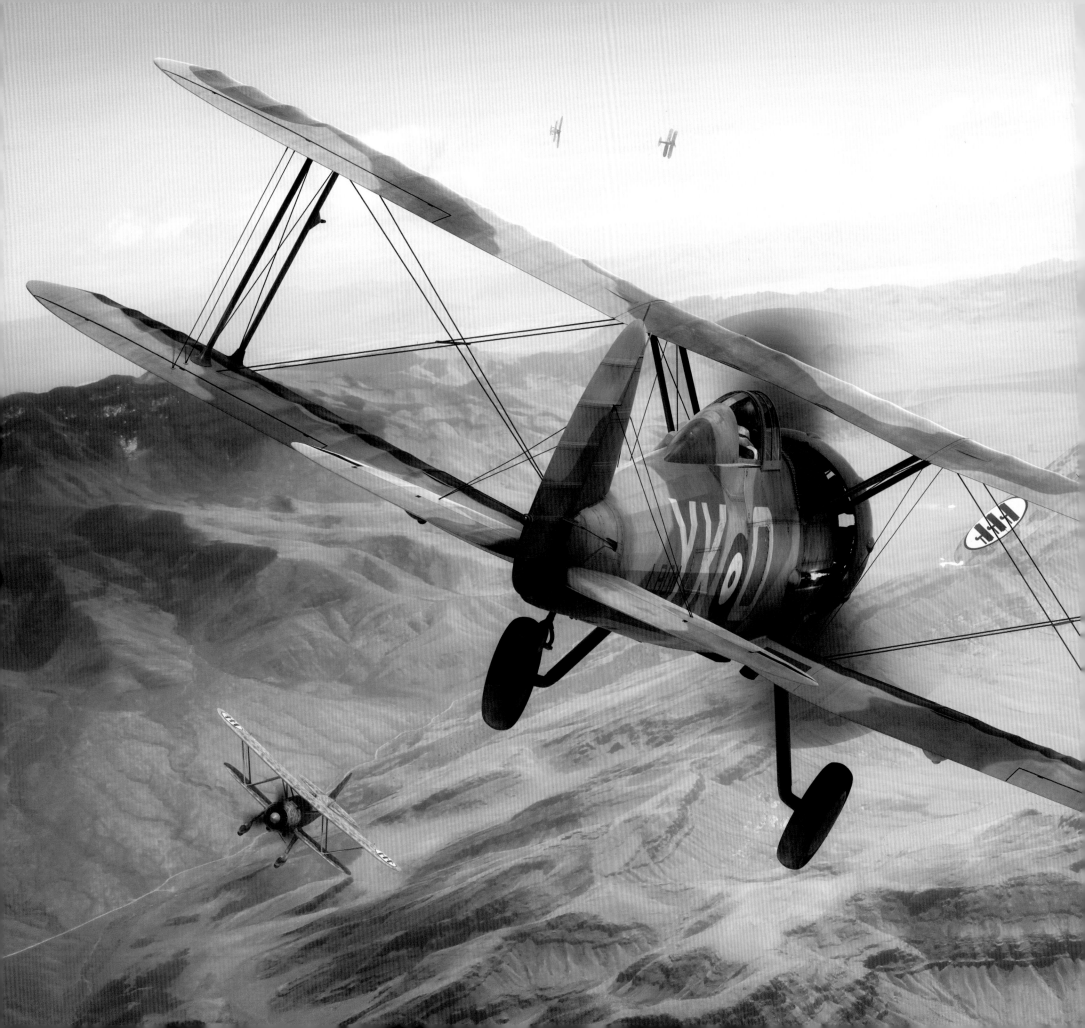

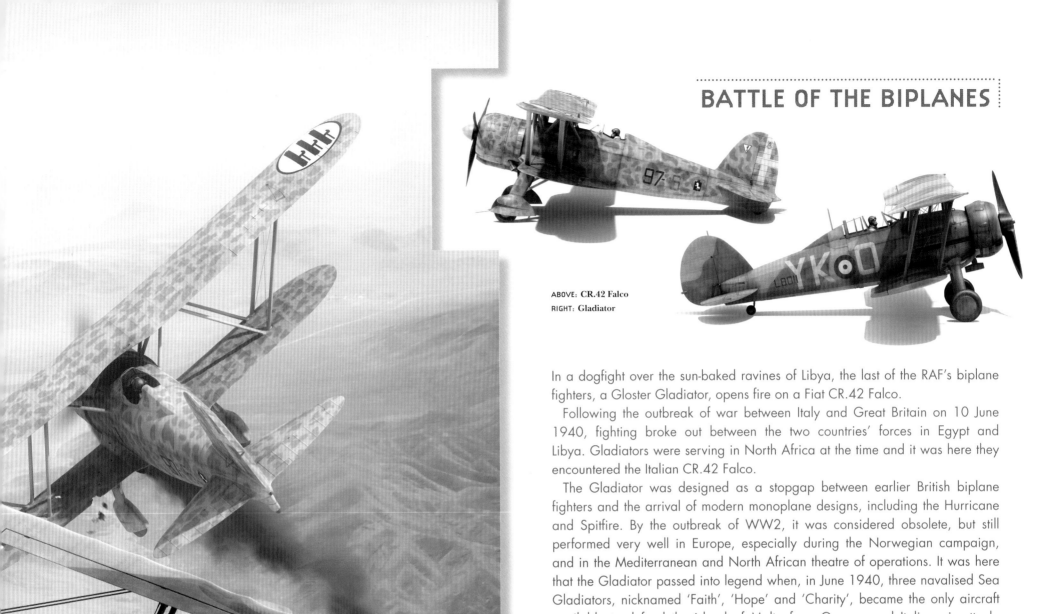

BATTLE OF THE BIPLANES

ABOVE: **CR.42 Falco**
RIGHT: **Gladiator**

In a dogfight over the sun-baked ravines of Libya, the last of the RAF's biplane fighters, a Gloster Gladiator, opens fire on a Fiat CR.42 Falco.

Following the outbreak of war between Italy and Great Britain on 10 June 1940, fighting broke out between the two countries' forces in Egypt and Libya. Gladiators were serving in North Africa at the time and it was here they encountered the Italian CR.42 Falco.

The Gladiator was designed as a stopgap between earlier British biplane fighters and the arrival of modern monoplane designs, including the Hurricane and Spitfire. By the outbreak of WW2, it was considered obsolete, but still performed very well in Europe, especially during the Norwegian campaign, and in the Mediterranean and North African theatre of operations. It was here that the Gladiator passed into legend when, in June 1940, three navalised Sea Gladiators, nicknamed 'Faith', 'Hope' and 'Charity', became the only aircraft available to defend the island of Malta from German and Italian air attack. (This wasn't entirely true; other aircraft were available, but often unfit for flight due to maintenance problems, while others were being stripped for spare parts. However, it made for great propaganda.)

The Falco had first flown in 1938 and was the last biplane fighter ever developed. Considered obsolete before it even entered service, it nevertheless saw plenty of action, proving a popular mount with pilots during the Spanish Civil War, but was found wanting when Italian aircraft joined the Luftwaffe during the Battle of Britain. The Falco did not live up to its name and proved easy prey for the more modern RAF monoplane designs.

The Falco had better luck closer to home, giving a good account of itself in the Mediterranean and over North Africa where, generally, their mainly British opponents were using more elderly aircraft types. However, the Falco and Gladiator were pretty evenly matched in the air, so in their encounters over the deserts of North Africa, the outcome was often down to the skill of the pilots.

BLENHEIM

Originally designed as a six-passenger airliner in answer to increasingly fast and excellent German commercial aircraft, the Bristol Type 142 first flew on 12 April 1935. One of the first British aircraft to feature an all-metal skin and retractable landing gear combined into an elegantly streamline frame, it shocked the RAF by being faster than any of their most modern fighters. The service's latest fighter was the Gloster Gauntlet, a biplane with a top speed of 230mph (370km/h) – some thirty miles slower than the Type 142. As such, it was only natural that a militarised version would be developed as the Type 142M (for Military).

The 142M lifted the wing from sitting low on the airframe to mid-level, making room for a bomb bay. The doors on the bay were forced open by the weight of the released bombs, but the aimer could not determine how fast the falling weapons would push them open, so could not guarantee that where he aimed was where the weapons would finally fall, making accuracy haphazard. To maintain its impressive speed the aircraft kept its faceted, all-glass nose in a very narrow fuselage – so narrow that the cockpit was cramped, the control yoke obstructed the pilot's view of the instrument panels, which in turn blocked the view of the ground when taking off and landing.

Still, the RAF was impressed enough to order 150 Blenheim Mark Is, as they became known, which entered service in March 1937. Despite its apparent modern design and the introduction of the more advanced Mark IV (with a modified nose, including new under-nose turret), by September 1939 it had been outclassed by the new generation of monoplane fighters, most worryingly those of the Luftwaffe. Bomber Command's principal light bomber, it had the distinction of being the first British aircraft to raid Germany, on 4 September 1939, three days after the outbreak of WW2. However, the Blenheim's lack of defensive armament and armour soon made the type vulnerable to German Messerschmitts.

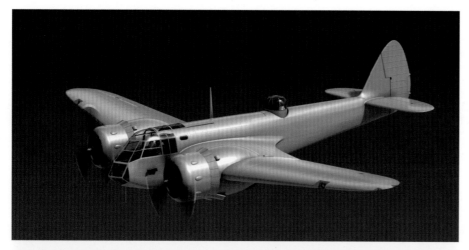

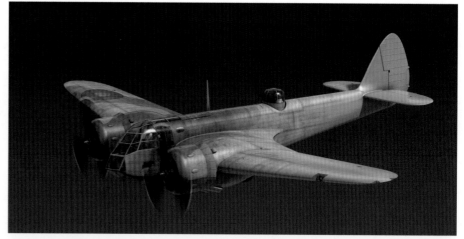

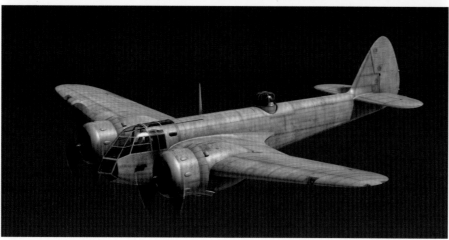

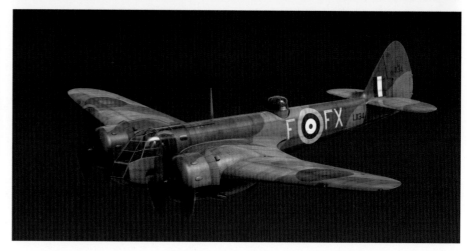

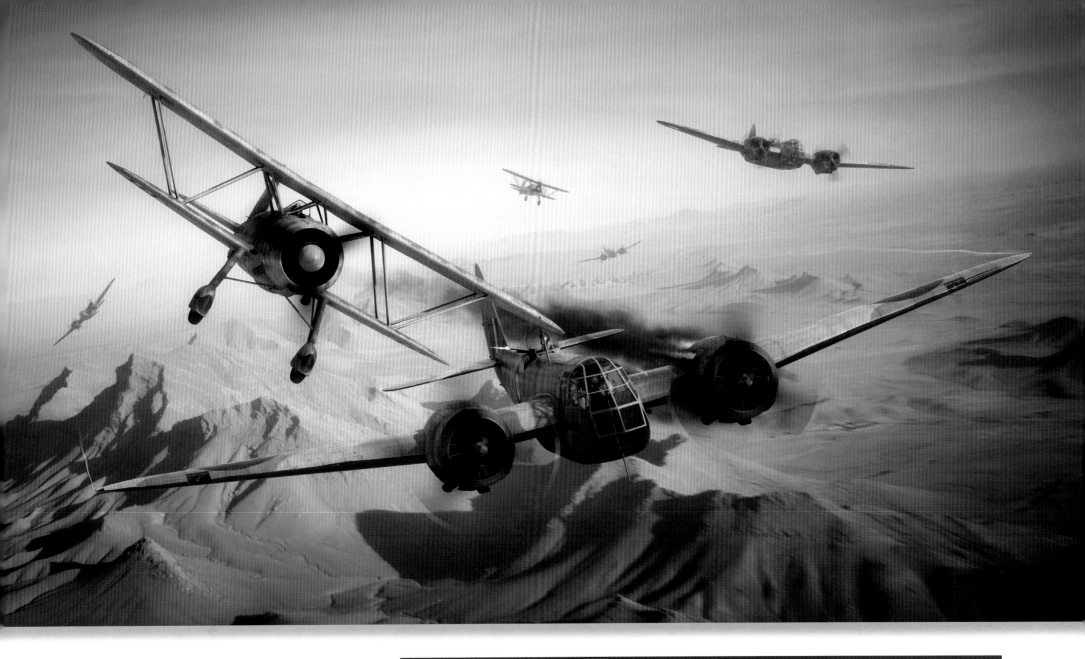

ABOVE: **Falcon Attack!** Blenheim Mk Is of the Desert Air Force being engaged by CR.42 Falcos.

OPPOSITE: **Blenheim Work in Progress**

SPECIFICATIONS

FOR MODEL: Mark IV

TYPE: light bomber/night fighter

MANUFACTURER: Bristol Aeroplane Co.

OPERATORS: UK; Canada; Finland; Greece; India; Turkey; Yugoslavia

CREW: pilot, navigator/bomb-aimer, turret gunner

LENGTH: 42.7ft (12.98m)

WINGSPAN: 56.4ft (17.17m)

WEIGHT: 9,790lb (4,441kg) [empty]-14,400lb (6,532kg) [max. take-off weight]

MAX. SPEED: 266mph (428km/h)

SERVICE CEILING: 27,260ft (8,310m)

RANGE: 1,460 miles (2,350km)

POWERPLANT: Bristol Mercury XV x 2

ARMAMENT: Browning .303in machine gun in port wing; Browning .303in machine gun x 1 or 2 in dorsal turret; Browning .303in machine gun x 1 or 2 in Nash & Thomson FN.54 nose turret; bomb payload of up to 1,320lbs (600kgs)

MAIDEN FLIGHT: 12 April 1935

IN SERVICE: 1937-1956 (Finland)

NUMBER BUILT: 4,422 (all versions)

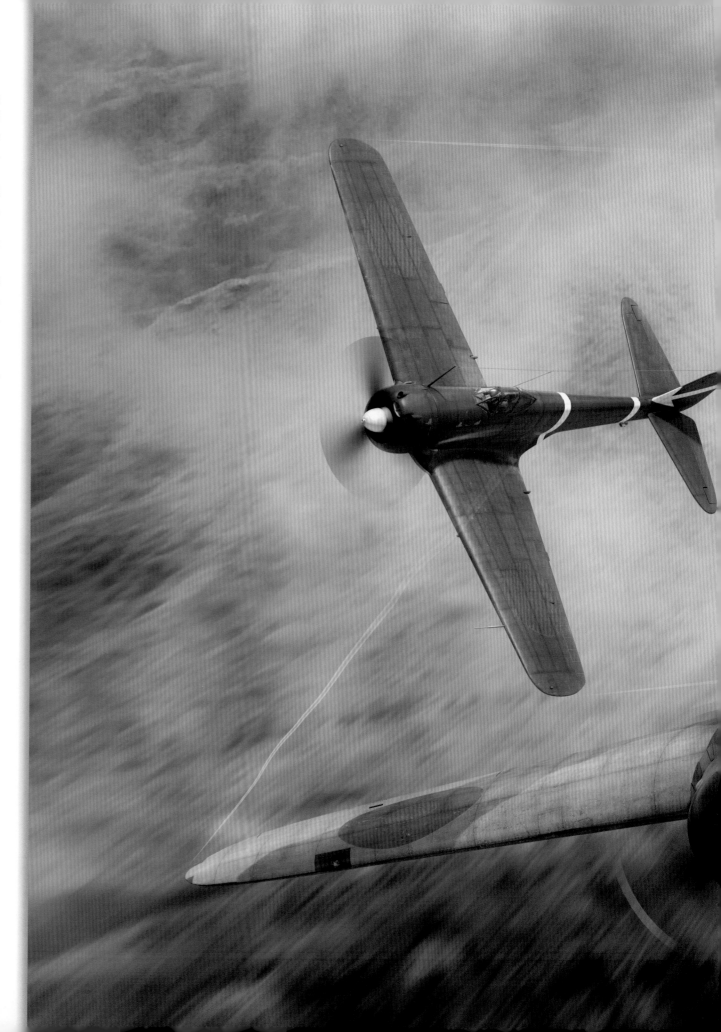

Flying low-level attacks against targets such as Luftwaffe airfields, these raids sometimes resulted in one hundred percent losses. The Blenheim fared no better in the other theatres it served in, squadrons in the Mediterranean and North Africa, and the Pacific, suffering serious losses. By the end of 1943 it had been more or less removed from frontline service.

Despite its failure as a light bomber, the RAF did see its potential as a stopgap night fighter. Some 200 Mark Is were fitted with a belly pack of four .303in machine guns and served with Fighter Command, designated Mark IF night fighters. They also made history as the first aircraft fitted with airborne radars, the AI Mark III. The Blenheims were soon scoring kills during the German night raids against London, the first radar-directed victories being scored on the night of 2-3 July 1940. Sixty Mark IVs were similarly upgraded, but by later that year, the Blenheims were being supplanted by the new and far more powerful Bristol Beaufighter.

Blenheims fought well in the Winter War between Finland and Russia. The German-backed Finns had bought eighteen Mark 1s and acquired another twenty-four during the fighting. By the time war broke out between Germany and Russia, Finland had ninety-seven Blenheims, including twenty-two Mark IVs, and they did sterling service against the Russians, flying some 3,500 missions until Germany's defeat in 1945. Seen as a Nazi ally, the Finns were banned from using the Blenheims in the light bomber role and required to place them in storage. Some were reactivated as target tugs until retired in May 1958.

RIGHT: **Peregrine Strike.** The 62 Squadron Blenheim Mk I flown by RAF Sqn Ldr Arthur Scarf under attack by Nakajima K-43 Hayabusas ('Hayabusa' is Japanese for peregrine) on 9 December 1941. A Japanese attack on his Malaya base had left Scarf's Blenheim to complete a planned bomb run against the Japanese forces in Thailand solo. Though he completed it successfully, his aircraft was damaged and Scarf seriously injured by Japanese fighters. He managed to crash land at Alor Setar in Malaysia, and his crew survived, though he died two hours later. Scarf was posthumously awarded the Victoria Cross.

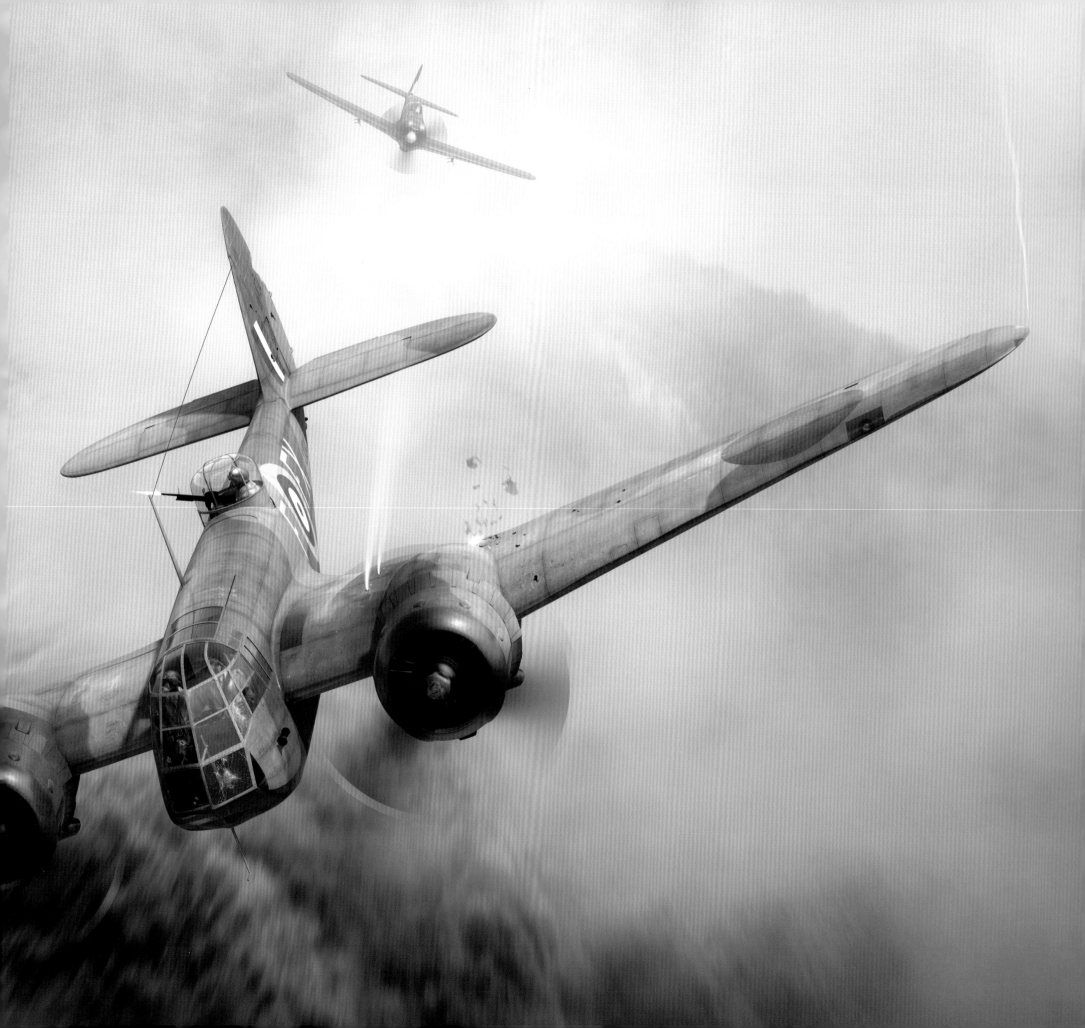

SPITFIRE

SPECIFICATIONS

FOR MODEL: IX

TYPE: fighter

MANUFACTURER: Supermarine

OPERATORS INCLUDE: UK; Australia; Belgium; Canada; Denmark; Egypt; France; Greece; India; Ireland; Israel; Italy; Netherlands; New Zealand; Norway; Pakistan; South Africa; Soviet Union; Sweden; USA

CREW: pilot

LENGTH: 31.1ft (9.47m)

WINGSPAN: 36.1ft (11.23m)

WEIGHT: 6,200lb (2,812kg) [empty]- 9,500lb (4,309kg) [max. take-off weight] max. speed: 408mph (657km/h)

SERVICE CEILING: 43,400ft (13,228m)

RANGE: 434 miles (698km)

POWERPLANT: Rolls-Royce Merlin 61

ARMAMENT: Hispano 20mm cannon x 2 and Browning 0.303in machine gun x 4 in wings; maximum payload of 1,000lbs (454kg) of bombs on underwing racks

MAIDEN FLIGHT: 5 March 1936

IN SERVICE: 1938-1948

NUMBER BUILT: 20,334 (all versions)

MK356

"On 7 June 1944, D-Day+1, the Spitfires of 443 Squadron, RCAF, were tasked with four beachhead cover patrols. On the third mission of the day, Spitfire Mk IX MK356, '2I-V' was flown by its regular pilot, Flying Officer Gordon Ockenden RCAF. The patrol was uneventful until nearing the time to leave, when the Spitfire pilots spotted four Luftwaffe Bf 109s east of Caen. Ockenden in MK356, accompanied by the Spitfire of Flight Lieutenant Hugh Russell, chased one of the Bf 109s out over the sea. The German fighter exploded in mid-air under the onslaught of their combined cannon and machine gun fire. Unsure which of them had delivered the coup de grace, they claimed half a kill each. This was the first of an eventual total of four combat kills plus one 'damaged' for Ockenden, who was awarded the Distinguished Flying Cross (DFC) in December 1944. Spitfire MK356 today flies with the RAF Battle of Britain Memorial Flight."

Squadron Leader Clive Rowley MBE RAF (Retd)

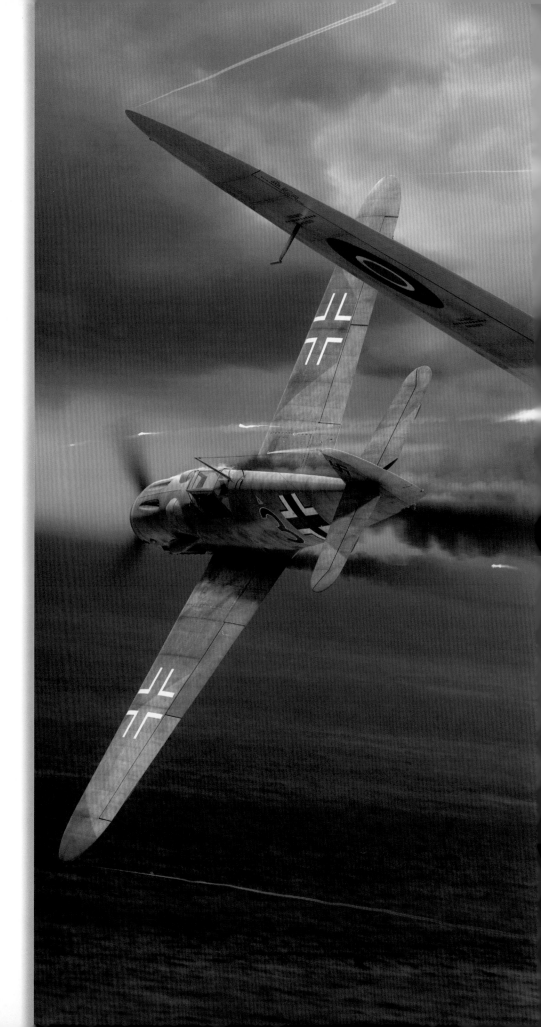

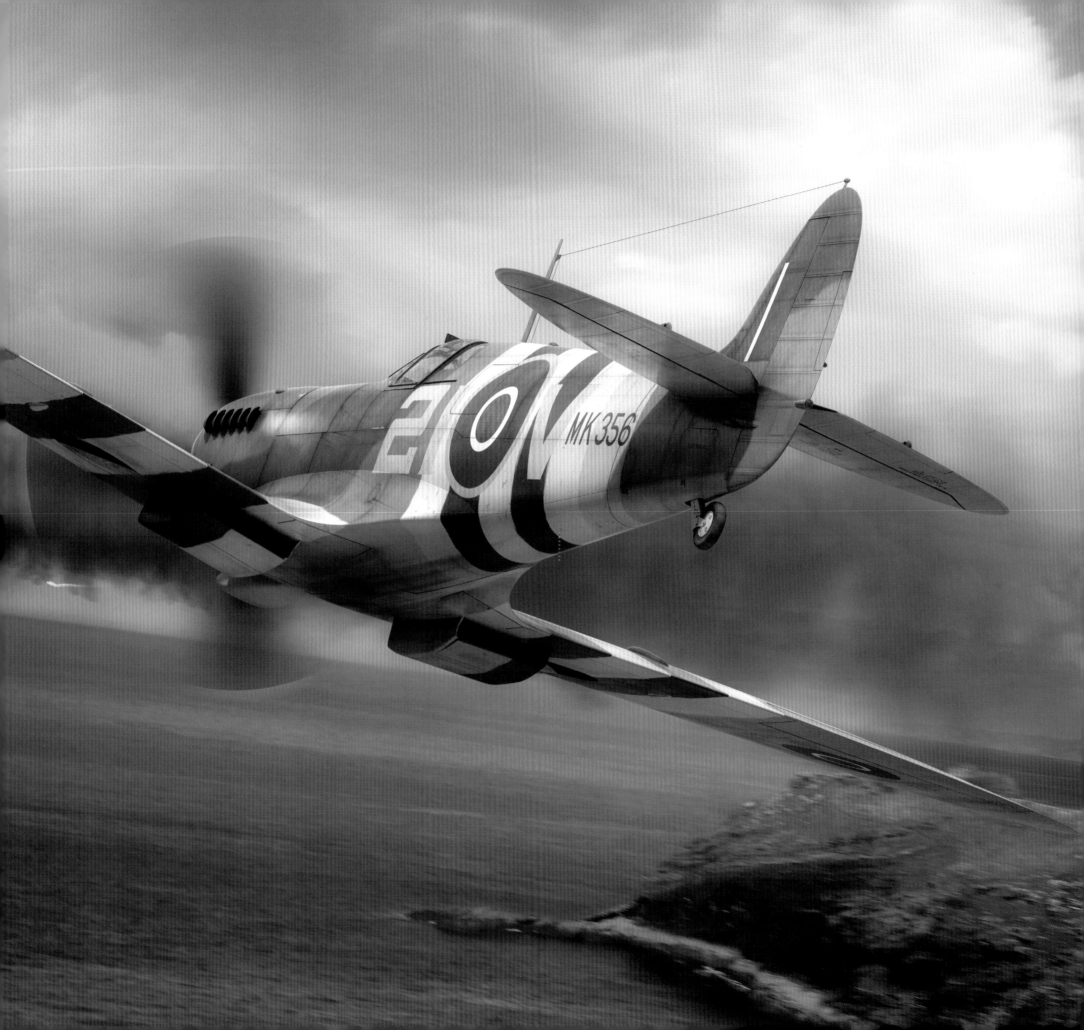

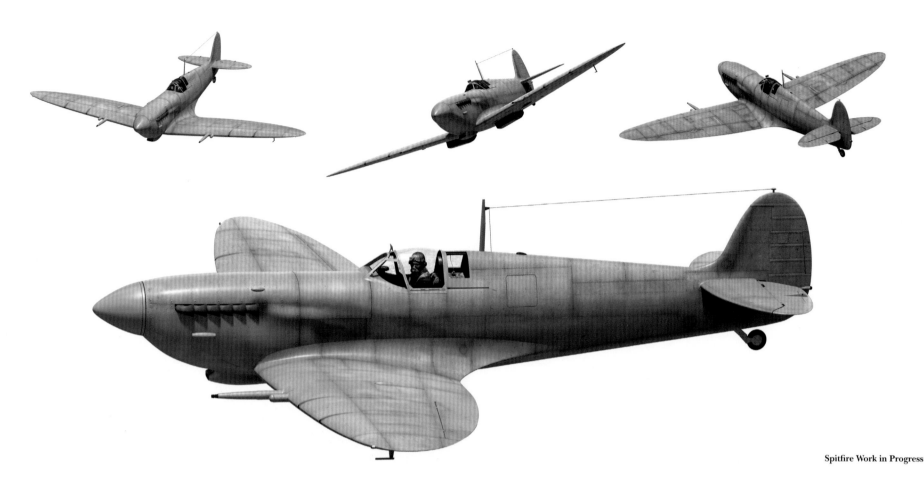

Spitfire Work in Progress

The Spitfire was the only British fighter to be built before, during and after WW2. Much of its development and subsequent career has been mythologised and it is one of those aircraft that has long been labelled 'legendary'.

Originally designed to fulfil the RAF's 1931 requirement for a modern fighter, the Spitfire design team, lead by R.J. Mitchell, extrapolated their experiences designing successful Supermarine racing seaplanes. The first prototype flew on 5 March 1936. Slightly faster than the RAF's newest (and first) monoplane fighter, the Hawker Hurricane, it impressed the RAF enough that they ordered 310 Spitfire Mark Is. However, its advanced stressed-skin construction and complex airframe meant the first production versions were not completed until mid-1938. By August that year, the aircraft were entering service with 19 Squadron at RAF Duxford, the first of 306 examples to be in service with the RAF in time for the outbreak of WW2 on 1 September 1939.

However, the Spitfire's war got off to a rather inauspicious start when, on 6 September, aircraft from 74 Squadron shot down two RAF Hurricanes, friendly fire resulting in the first British fatality of WW2. The type's first real kills were scored on 16 October, over Rosyth, Scotland, when Spitfires shot down two Junkers Ju-88s attacking shipping in the Firth of Forth.

By May 1940, 'Spits' were heavily engaged in the Battle of France. Encounters with German Bf 109s revealed some worrying weaknesses in the RAF fighter. Unlike the 109, with its fuel-injected engine, the Merlin used a carburettor, which may have added power to the engine, but when a Spitfire pilot dropped the nose into a dive, fuel was forced out of the carburettor, cutting off power. The 109's fuel injectors negated this problem and German pilots could escape a pursuing Spitfire by simply 'bunting' into a dive. The problem wasn't overcome until modifications were introduced in 1942.

Another issue was firepower. The Mark I's arsenal of eight .303in machine guns required a great deal more hits to bring down a target than the cannon armed 109s. One way of overcoming this was to move in closer to targets to ensure more hits. Consequently, pilots unofficially began synchronising their guns to converge on targets at 250 yards, rather than the officially proscribed 400 yards. Another solution was heavier weapons and by the summer of 1940, during the height of the Battle of Britain, the first variants armed with two 20mm cannons and four .303 machine guns were in service.

Following its legendary successes during the Britain of Britain, the Spitfire went on the offensive. A number of modifications had been made: new propellers and uprated Merlins were fitted, and the cannon armament was now standard. However, by summer 1942, and most infamously during the disastrous British raid on Dieppe on 19 August, the latest version, the Mark V, was suddenly up against a new opponent: the Focke-Wulf Fw 190. The new, better-armed German fighter was faster and could out-climb and out-dive the Spitfire Vs. Tactics for the RAF's premiere fighter were to ignominiously exit

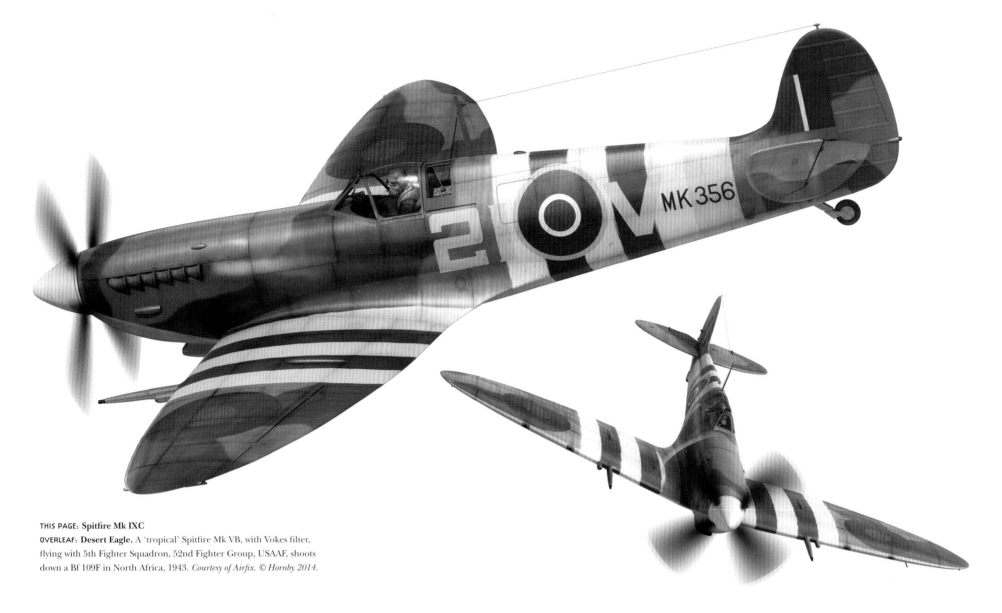

THIS PAGE: **Spitfire Mk IXC**
OVERLEAF: **Desert Eagle.** A 'tropical' Spitfire Mk VB, with Vokes filter,
flying with 5th Fighter Squadron, 52nd Fighter Group, USAAF, shoots
down a Bf 109F in North Africa, 1943. *Courtesy of Airfix. © Hornby 2014.*

the combat zone as fast as possible. It was a low point in the Spitfire's career.

However, Dieppe also saw the debut of the Spitfire Mark IX. It was initially intended as nothing more than a stopgap – essentially placing the engine of the Mark VIII in the airframe of the Mark V. But fitted with the new supercharged Merlin 61, the result was a fighter with excellent high-altitude performance that could now face the German fighters on more or less equal terms. It ended up being the most widely built version of the Spitfire and remained in service until the end of the war.

Spitfires had naturally been adapted for the high-altitude photo-reconnaissance role, but found another, more unconventional use on D-Day. Concerned that the usual spotter aircraft would prove too vulnerable to fighters, US naval gunfire

observers were trained to fly Spitfires and direct the shelling of a number of American battleships and heavy cruisers. They served in the role until the end of June 1944, by which time the Allied advance had moved beyond the range of naval fire.

While changing little externally, the Spitfire's performance was further enhanced by the fitting of the Roll-Royce Griffon engine in the Mark XII in August 1942. Now capable of 400mph (640km/h) and improved rates of climb and dive, it was a heavier aircraft and less beloved by its pilots as a result of poorer handling characteristics. Even so, it was still a worthy opponent of the Luftwaffe's finest in a turning fight.

Western Europe wasn't the only battlefront where the Spitfire saw action. It flew in all major theatres. In Southeast Asia, North Africa and the Mediterranean,

'tropical' Spitfires were fitted with a Vokes air filter under the nose (to filter out sand and grit that would clog and overheat the engines, though they also degraded performance). Some 1,300 also flew with the Soviet Union, initially older RAF Mark Vs replaced by new variants in the RAF, but later 1,183 Mark IXs. Not as popular with Soviet pilots, they did remain in frontline service with the Russian Air Force until the war's end.

Following the end of WW2, Spitfires were still available in enough numbers to take part in a number of post-war conflicts. The last British aircraft to see action were Mark XVIIIs during the Malayan Emergency. Here they were used primarily in the ground attack role, employing bombs and rockets against Communist insurgents. The last RAF machines were retired in the late 1950s.

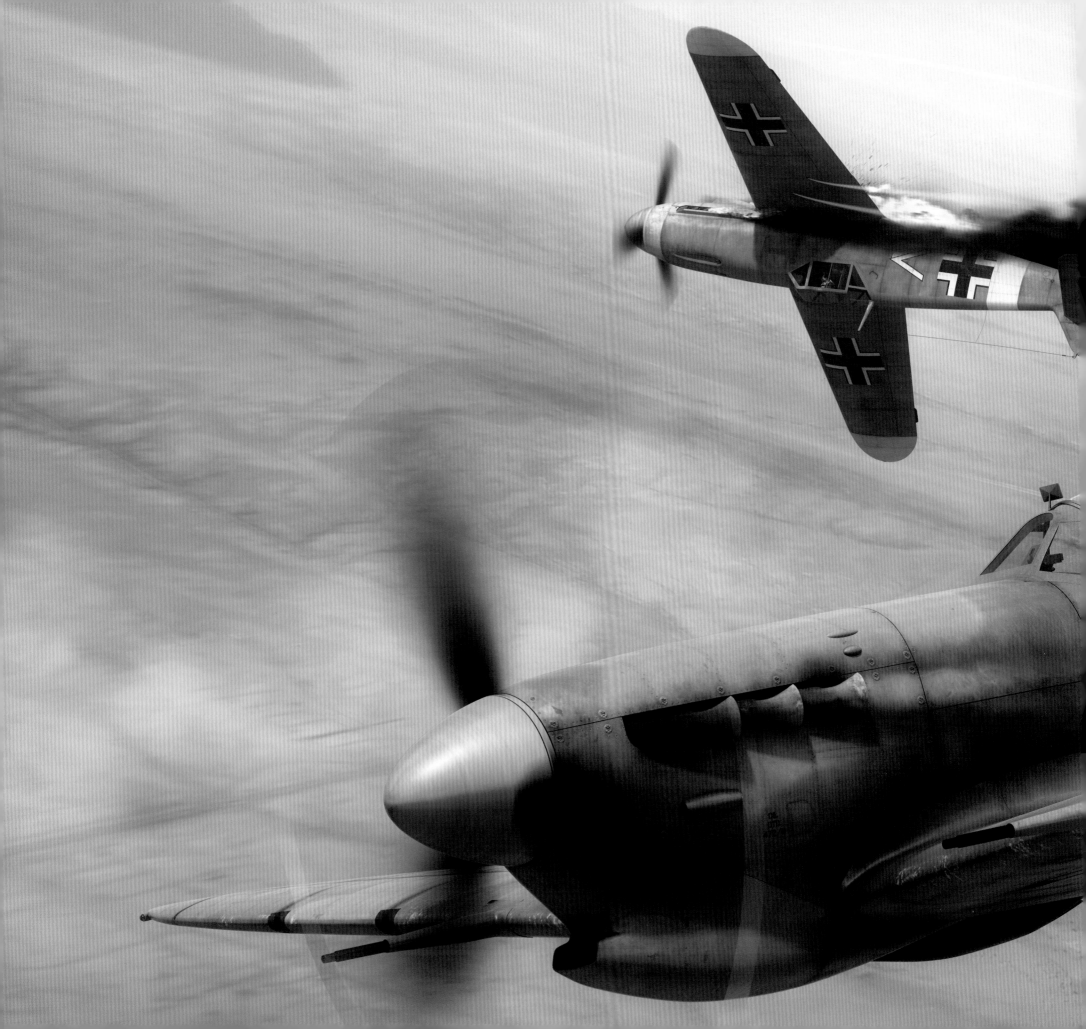

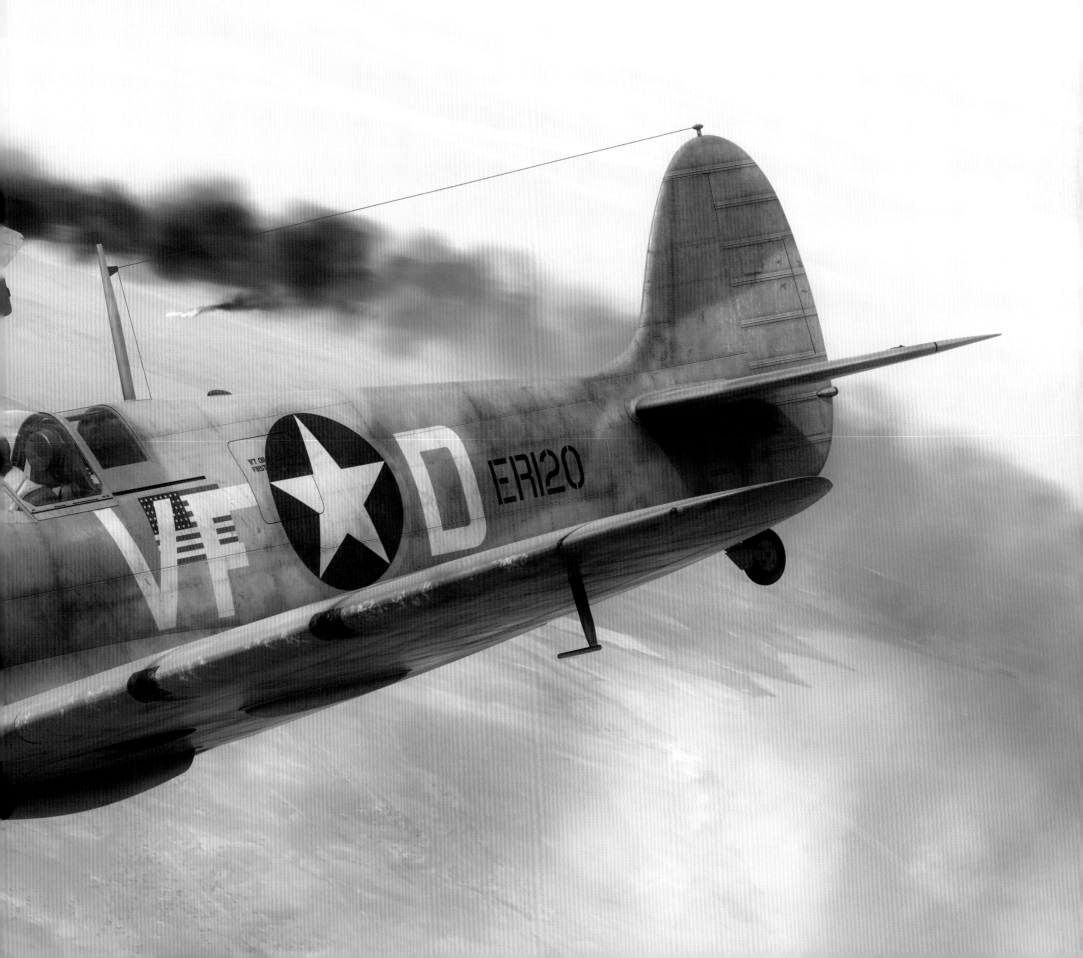

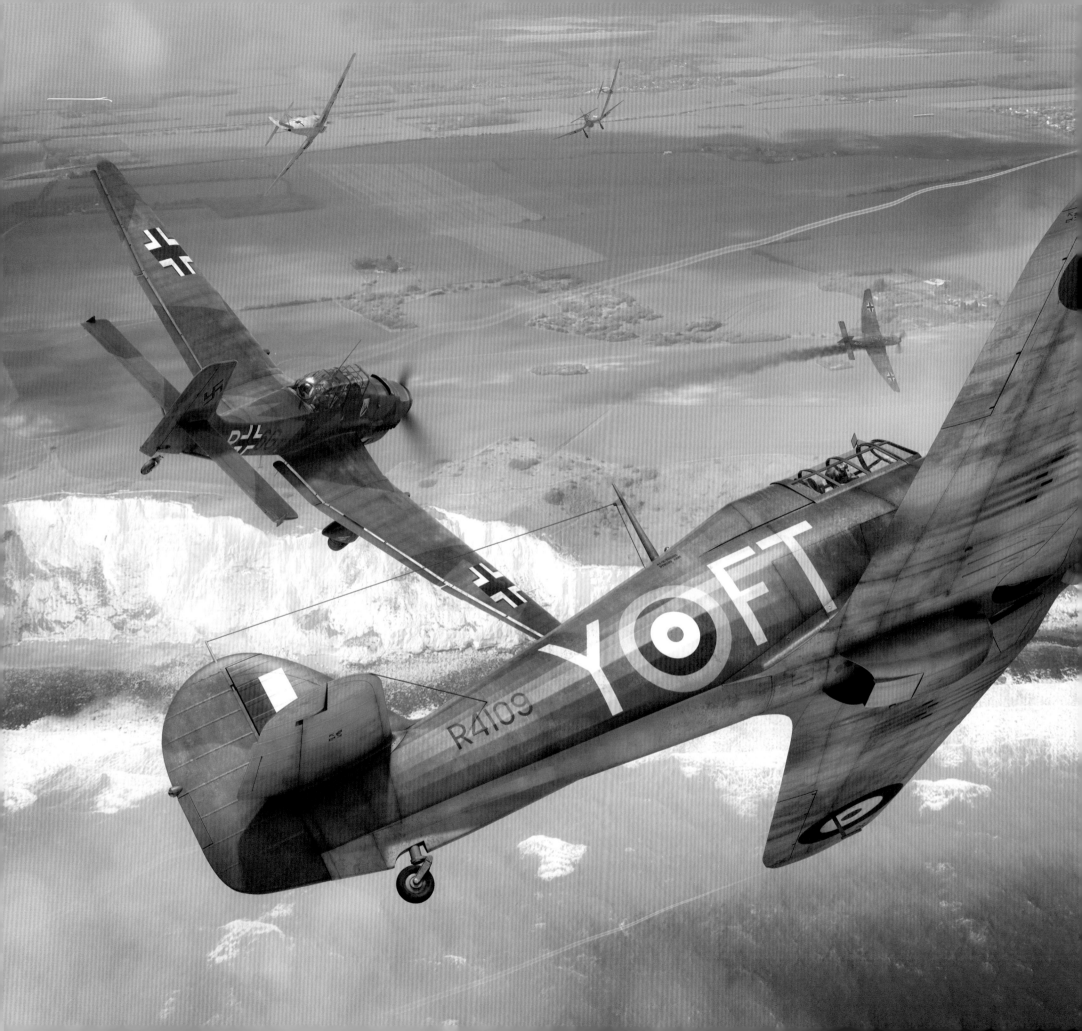

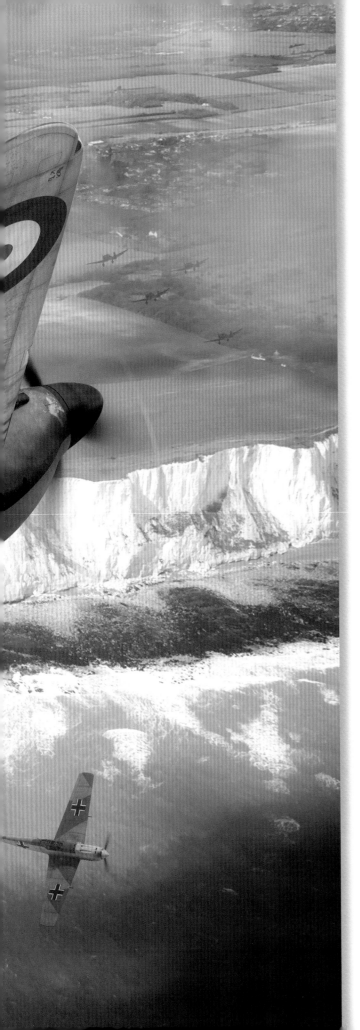

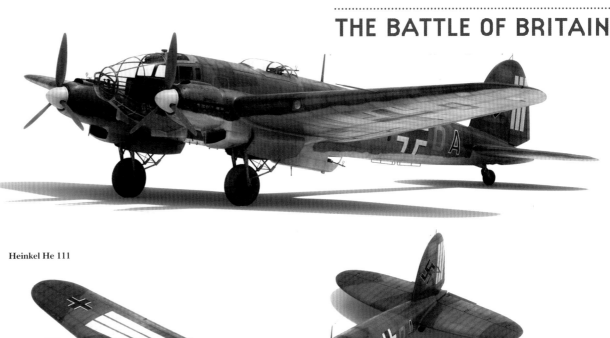

Heinkel He 111

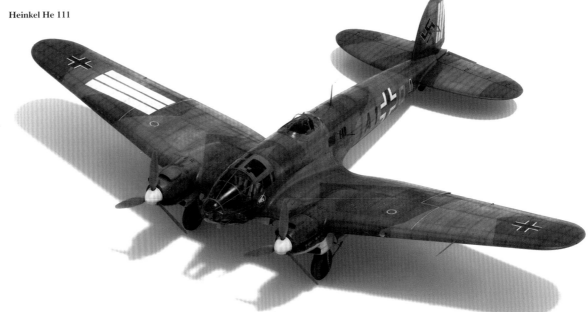

LEFT: **Hurricane Force.** On 16 August 1940, Frank Carey led 43 Squadron's 'A' Flight into "waves of Ju-87s", escorted by Bf 109s. Though hopelessly outnumbered, Carey accounted for four Ju-87s before running out of ammunition. Carey was generally considered to have been one of the RAF's most outstanding fighter pilots in WW2.

LOCK ON

Flying Spitfire Mk I N3162, 'EB+G', with a formation from 41 Squadron, Pilot Officer Eric Lock engages Heinkel He 111s and their escorts on 5 September 1940. The 5th is now recognised as Battle of Britain Day, and saw two huge bombing raids by the Luftwaffe against London, which the RAF were able to effectively counter, inflicting serious losses on German forces.

The Spitfires of 41 Squadron intercepted the German aircraft and in the ensuing dogfight Lock, known as 'Sawn-Off' because of his short height, shot down two He 111s. He was then wounded in the leg by a Bf 109 guarding the bombers, but when the German pilot stalled his aircraft, Lock was able to open fire on his attacker, which exploded in mid-air.

Lock went on to become the highest scoring RAF ace of the Battle. The markings of his Mk I are now carried by a Spitfire of the Battle of Britain Memorial Flight.

(OVERLEAF)

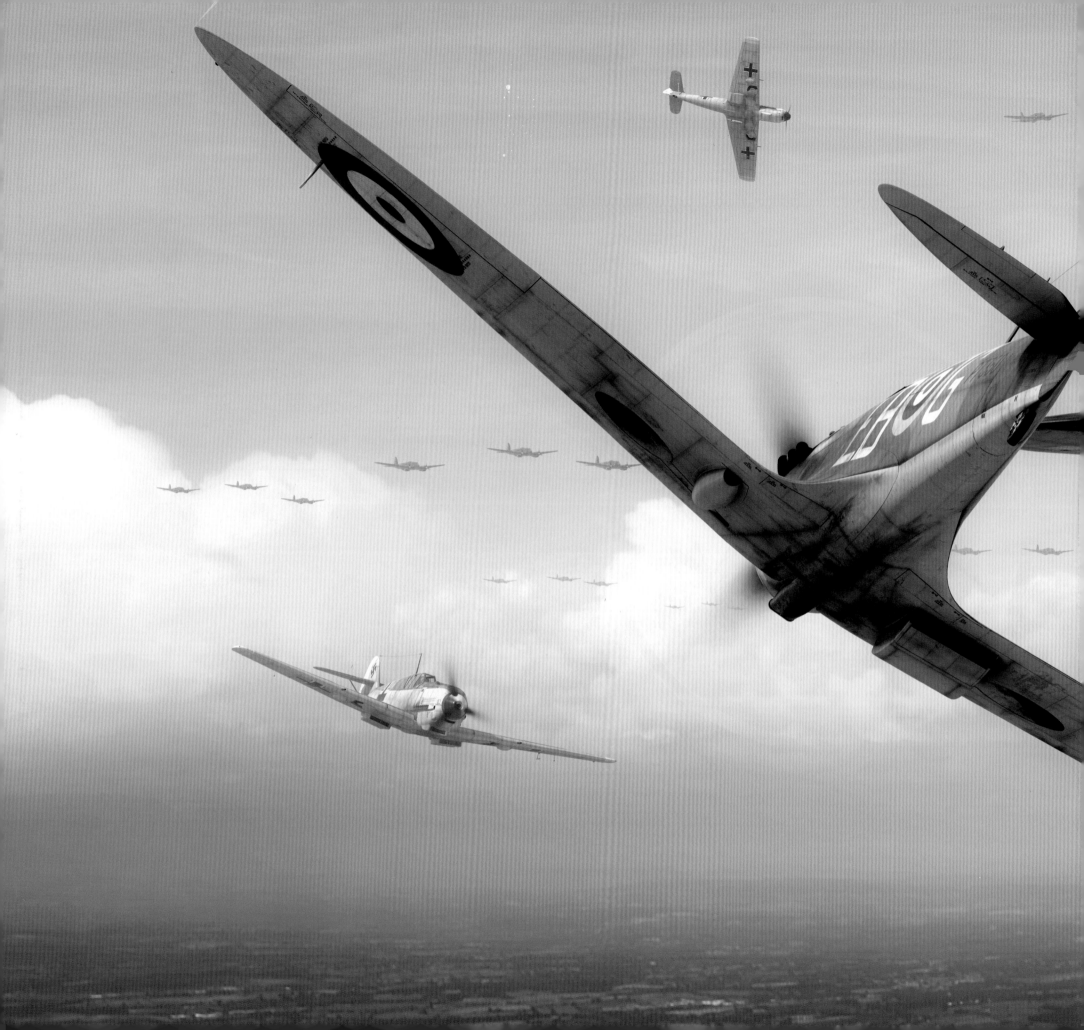

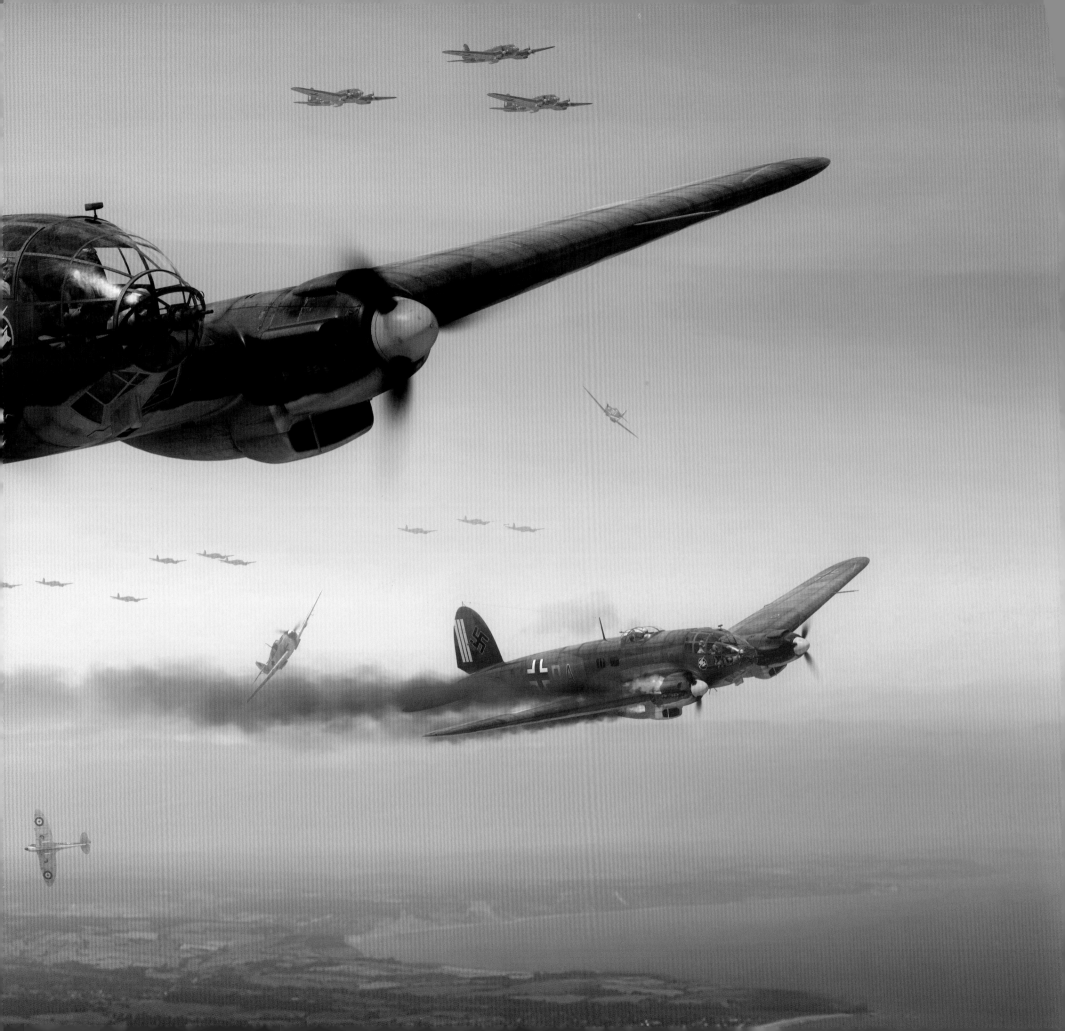

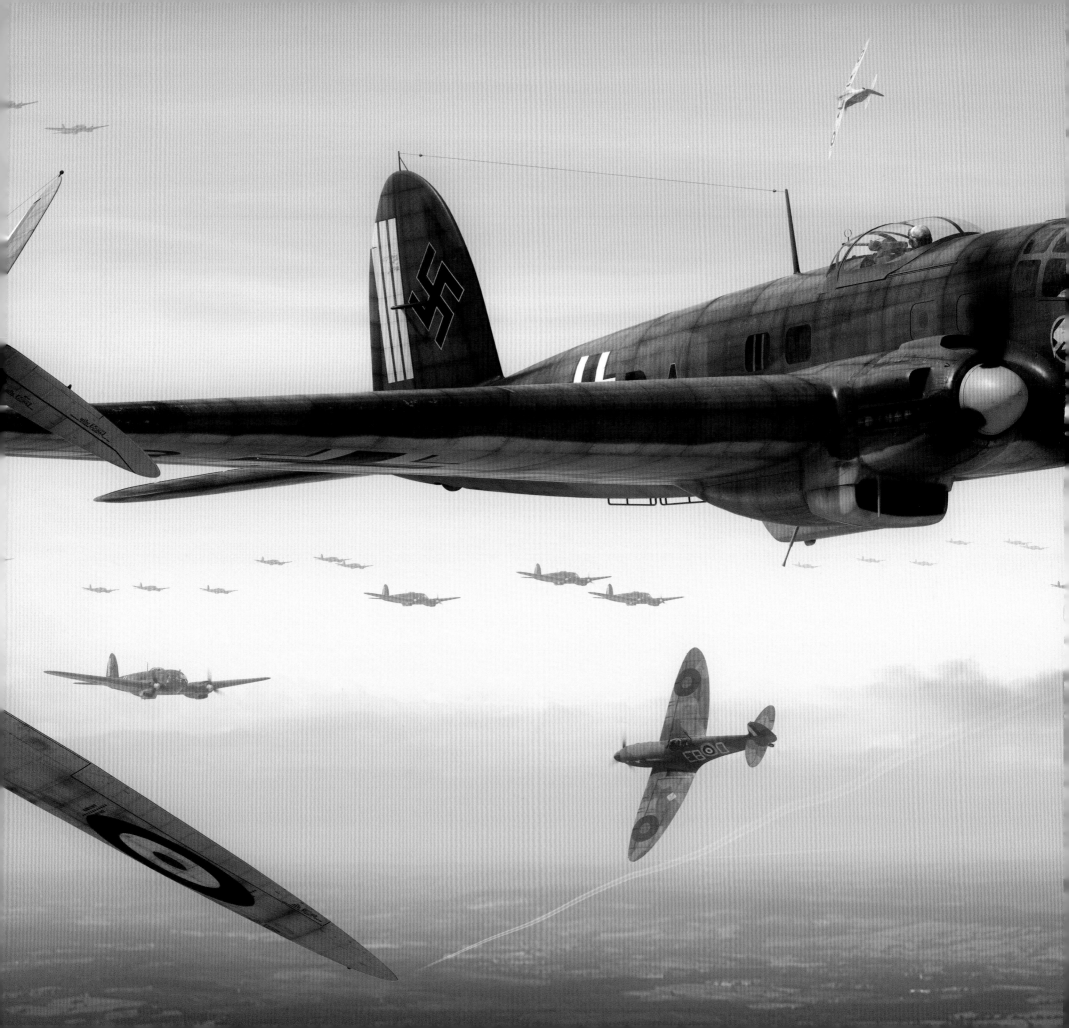

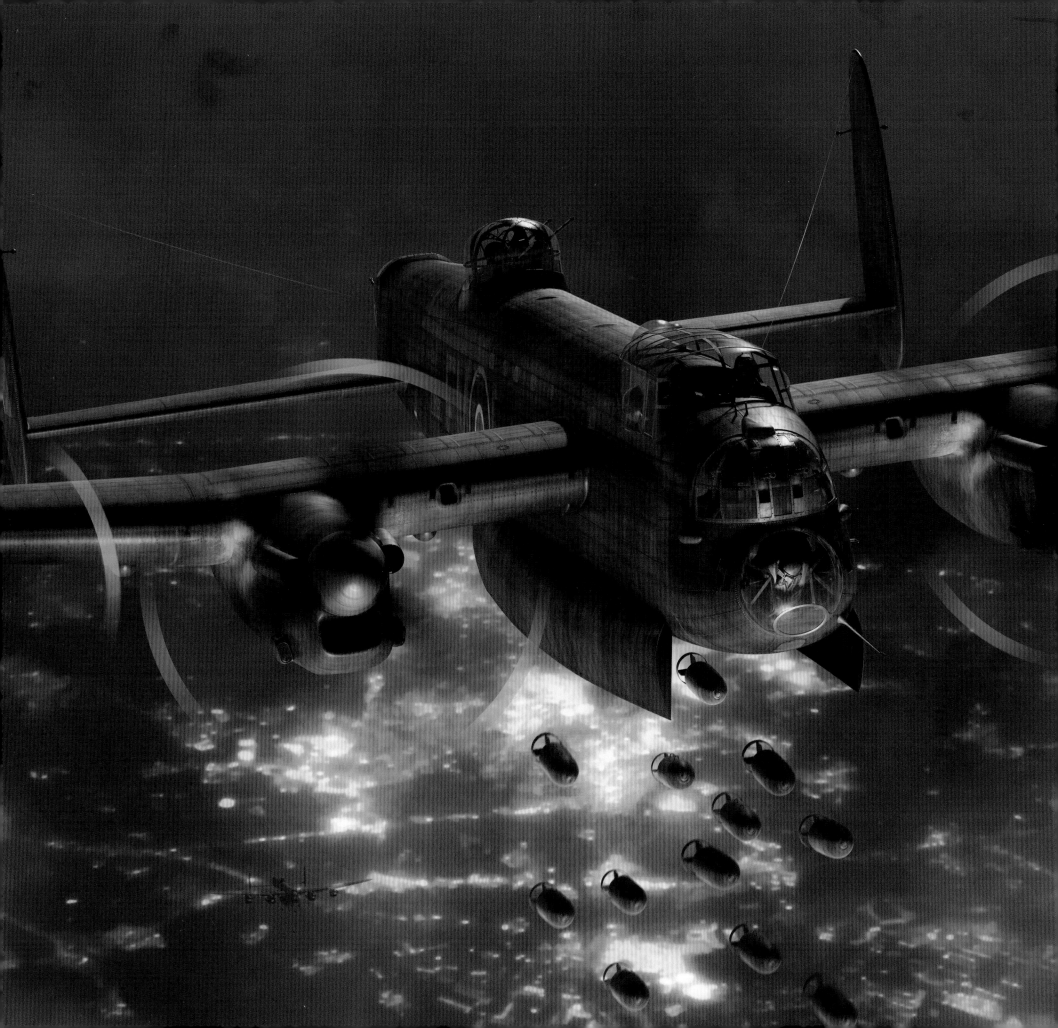

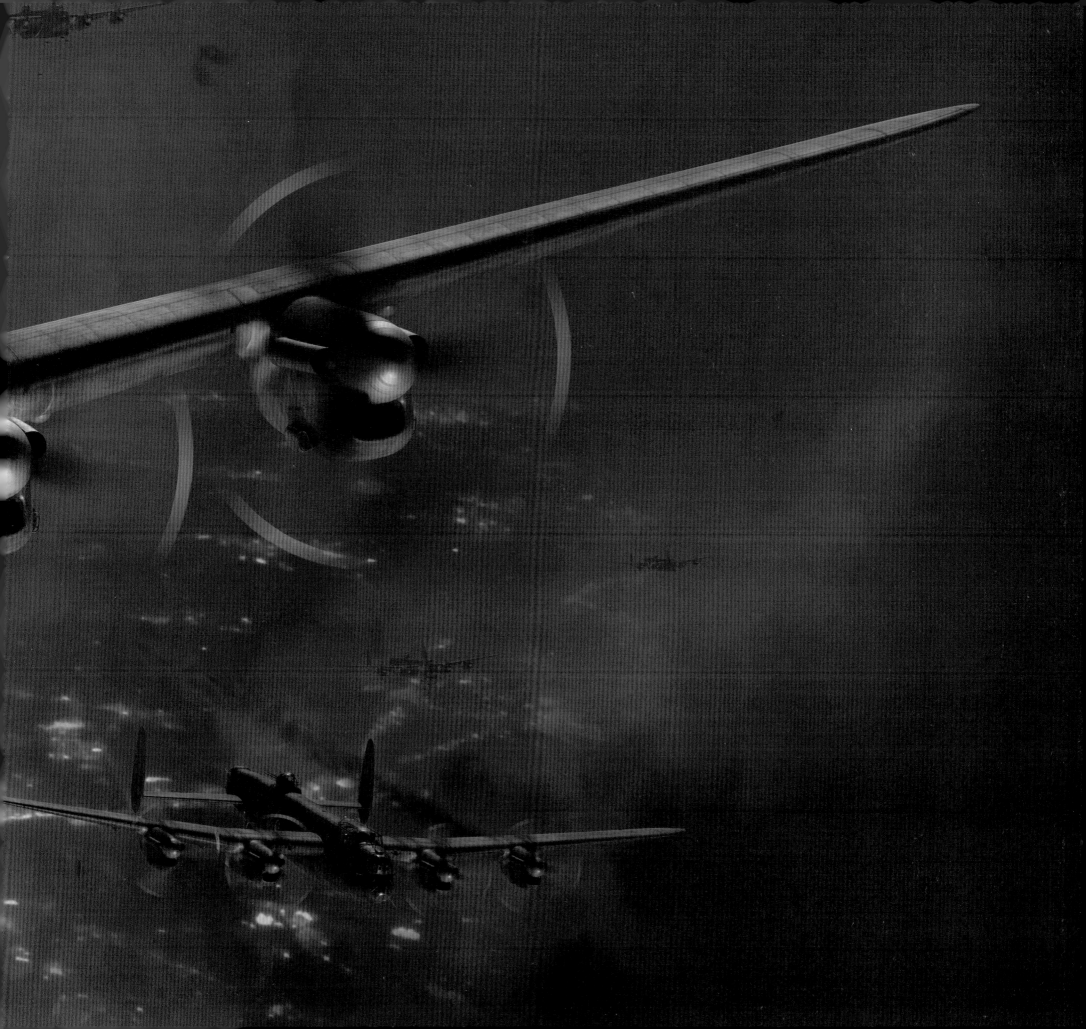

LANCASTER

SPECIFICATIONS

FOR MODEL: B I

TYPE: bomber

MANUFACTURER: Avro

OPERATORS: UK; Australia; Canada; France

CREW: pilot, flight engineer, navigator, bomb aimer/nose gunner, wireless operator, dorsal gunner, tail gunner

LENGTH: 69.6ft (21.18m)

WINGSPAN: 102ft (31.09m)

WEIGHT: 36,900lb (16,738kg) [empty]-70,000lb (31,751kg) [max. take-off weight]

MAX. SPEED: 287mph (462km/h)

SERVICE CEILING: 28,500ft (8,690m)

RANGE: 2,530 miles (4,072km)

POWERPLANT: Rolls-Royce Merlin 24 x 4

ARMAMENT: Browning .303in machine gun x 2 in nose and dorsal turrets; Browning .303 machine gun x 4 in tail turret; max. bomb load of 14,000lb (6,350kg)

MAIDEN FLIGHT: 9 January 1941

IN SERVICE: March 1942-October 1956

NUMBER BUILT: 7,377

By far the most successful bomber in RAF service, the Lancaster's genesis lay in the earlier, twin-engined Avro Manchester. With an almost identical airframe layout as the Lancaster, the Manchester was powered by two Rolls-Royce Vulture engines, but they proved miserably unreliable and underpowered. Avro re-winged the Manchester and powered the new aircraft with four Rolls-Royce Merlins. An aircraft designed during wartime, its wing length was not constrained by the need to fit in the RAF's regular peacetime hangars, so the Manchester's wing length of 80ft was increased to 102ft in the Lancaster, which, combined with the excellence of the Merlin engines, gave it vastly superior high-altitude performance.

Entering service in March 1942, it flew with some fifty-eight squadrons in Bomber Command as the service's principal warhorse during the bombing campaign against German cities, industry and infrastructure. It was a gruelling and bitter campaign, and one of major technical advances. Finding and hitting the target was of obvious importance, but at first crews had to rely on dead reckoning and celestial navigation. However, as the war progressed, new developments, including the pulsed radio transmissions of Gee and Oboe, and the H2S ground-mapping radar, helped improve bombing accuracy.

While flak was terrifying and indiscriminate, the war with the German night fighters was far more personal. Most attacks came from the rear and the position of 'tail-end Charlie' – the tail gunner – was not to be envied. The Lancaster's first rear turret was the Frazer-Nash FN 20 fitted with 600 rounds of .303 ammunition per gun laid in the turret, plus another 1,900 rounds each, held in the fuselage. The FN 20 had little room for the gunner, who wasn't even able to wear his parachute. To bail out, he had to climb back into the fuselage, put on his parachute, then wind the turret round and fall out through its back exit. Later versions of the turret were more spacious – enabling the gunner to evacuate over the guns – had better visibility and were fitted with a gun-laying radar to increase accuracy.

By the end of the war, Lancasters had flown 156,000 sorties and dropped 608,612 tons of high-explosive bombs and 51 million incendiaries. But the controversial bombing campaign was expensive in lives and aircraft; 55,000 RAF bomber crewmen lost their lives in WW2, many aboard the 3,249 Lancasters lost in action.

Following the war, many Lancasters were re-tasked as maritime patrol and transport aircraft, and were instrumental in the development of in-flight refuelling.

PREVIOUS SPREAD: **Night Bombing.** The Lancaster was the most successful WW2 night bomber.

THIS PAGE: **Lancaster Work in Progress**

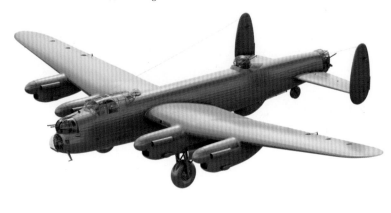

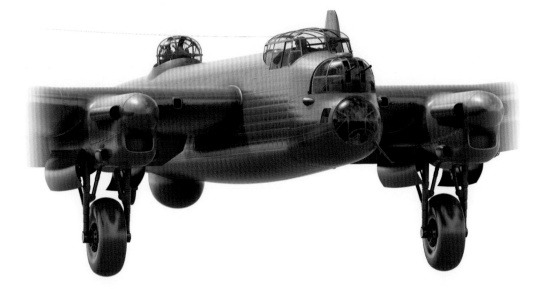

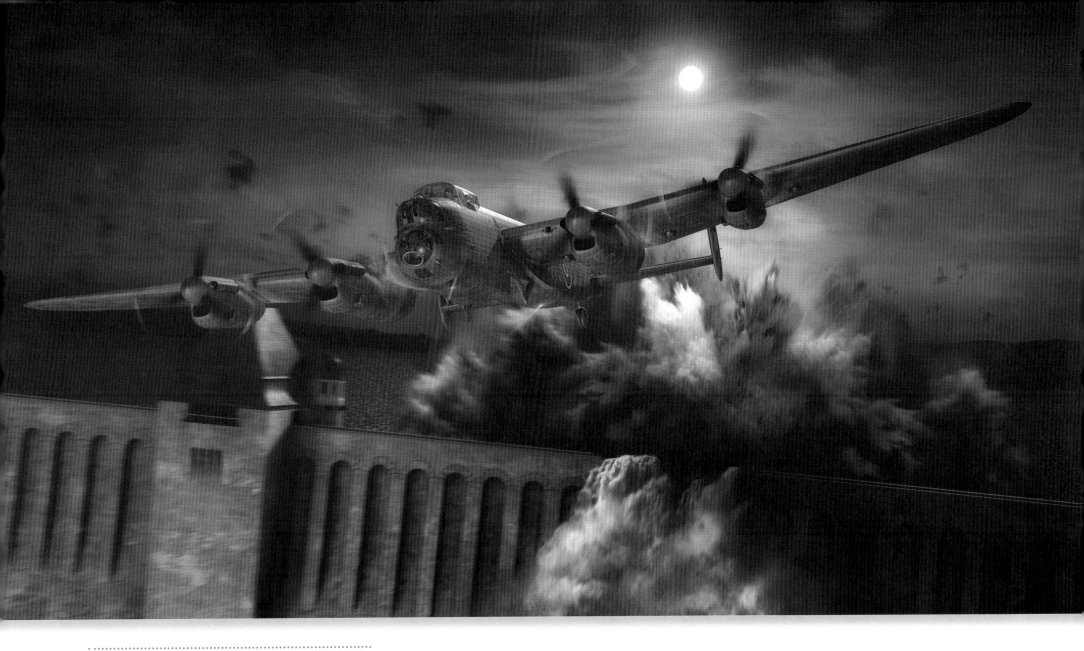

BREACHING THE MÖHNE

On the night of 16/17 May 1943, the RAF's 617 Squadron conducted Operation Chastise. Nineteen Lancasters were modified to drop 'bouncing bombs', codenamed 'Upkeep'. The bombers were stripped of much of their armour, and the bomb-bay doors and mid-upper turret was removed. A special mounting for the weapon (technically a mine) and the mechanism to spin it were fitted in the bomb bay, while two spotlights were fitted to the belly. The beams from the lights intersected at sixty feet – the optimum height for the dropping of the weapon.

The targets were a number of dams in Germany's industrial heartland, the Ruhr. The RAF hoped to reduce the availability of hydro-electric power and impact on Germany's steel-making capabilities. The bombs were to be spun up, then skipped across the water and over the torpedo nets protecting the dams by the low-flying Lancasters. On impact the bombs would sink and at a depth of 30ft (9m), 6,600lbs (2,994kg) of explosives would detonate, the shockwave cracking the thick concrete of the dams.

The first wave of nine aircraft attacked the Möhne and Eder dams. The former was breached after being hit by five Upkeeps and the remaining three destroyed the Eder. Over 330 million gallons of water were released from the dams, destroying three power stations and twenty-five bridges, and drowning 1,294 people. Water and electricity supplies were disrupted for a month in the surrounding area. One Lancaster was hit by flak en route to Germany, another during the attack on the Möhne, and two more were brought down on their way home.

The following two waves of bombers were less successful, failing to breach the Sorpse and Enepe dams, whose defences had been alerted by the initial attack.

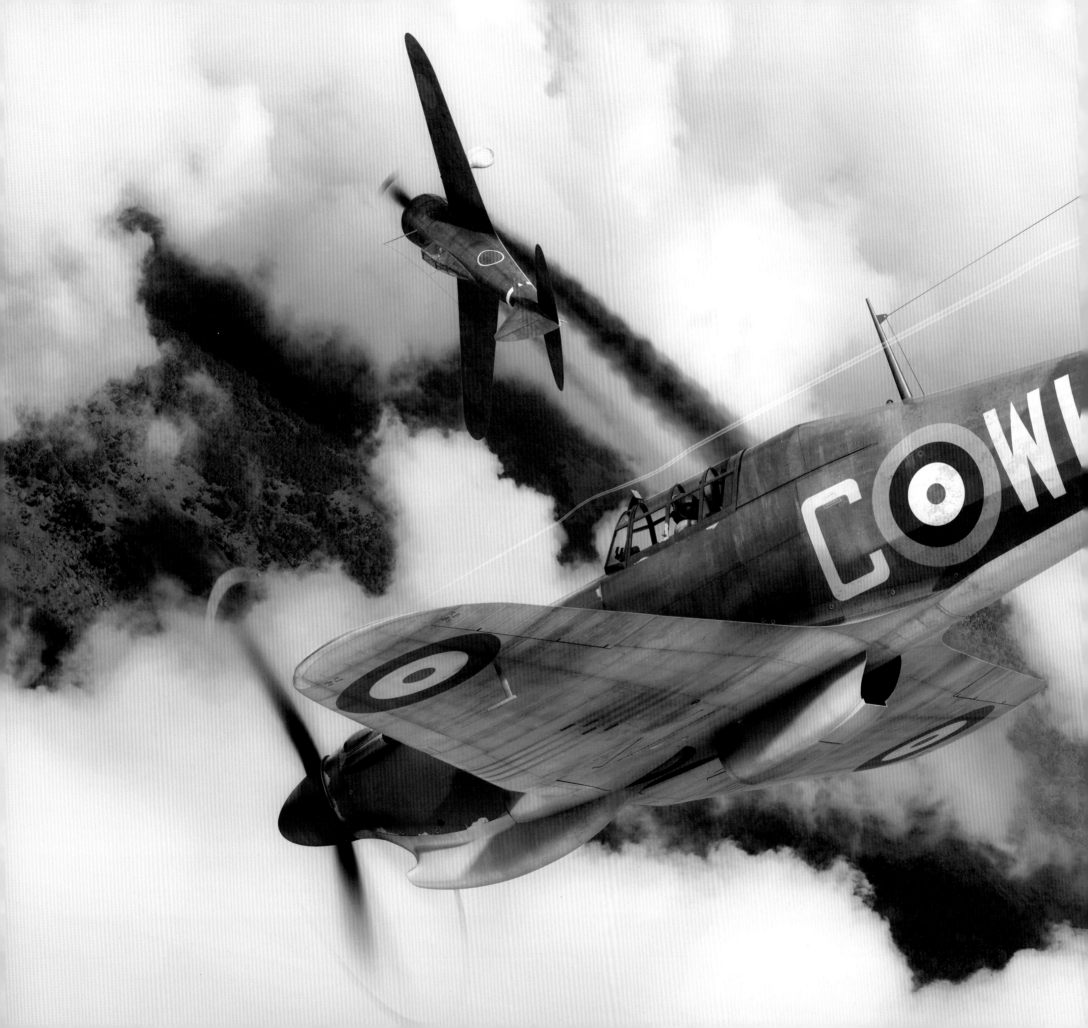

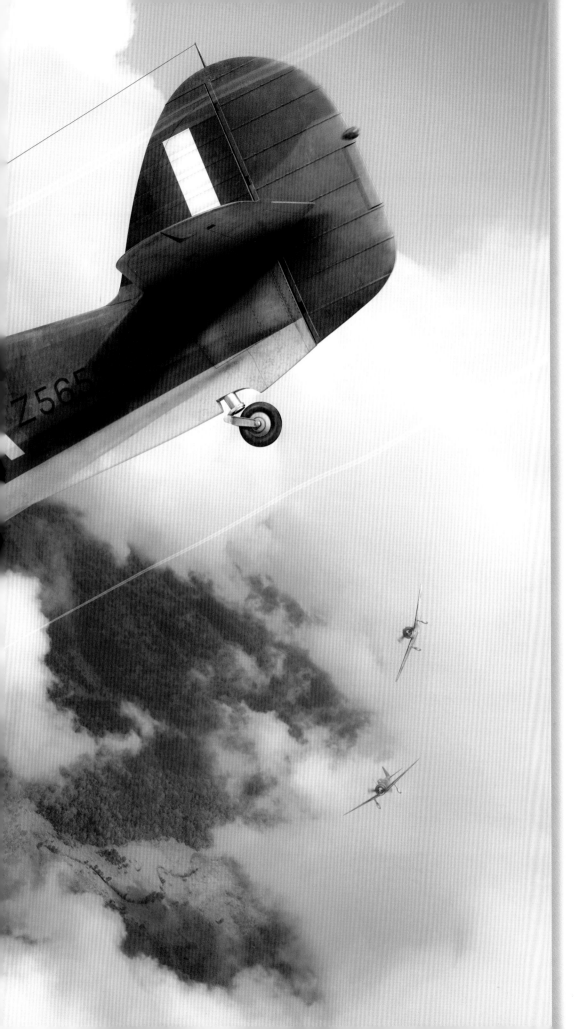

HURRICANE

SPECIFICATIONS

FOR MODEL: Mark I

TYPE: fighter

MANUFACTURER: Hawker Aircraft Ltd

OPERATORS INCLUDE: UK; Australia; Canada; Finland; France; Ireland; Netherlands; New Zealand; Norway; Poland; Portugal; South Africa; Soviet Union; Turkey; Yugoslavia

CREW: pilot

LENGTH: 31.5ft (9.58m)

WINGSPAN: 40ft (12.19m)

WEIGHT: 4,982b (2,260kg) [empty]-7,490b (3,397kg) [max. take-off weight]

MAX. SPEED: 324mph (521km/h)

SERVICE CEILING: 34,000ft (10,363m)

RANGE: 600 miles (965km)

POWERPLANT: Rolls-Royce Merlin II/III

ARMAMENT: Browning 0.303in machine gun x 8

MAIDEN FLIGHT: 6 November 1935

IN SERVICE: 1937-1944

NUMBER BUILT: 14,533 (all versions)

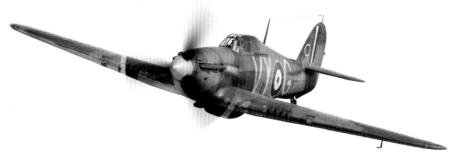

ABOVE: **Hurricane Mk I**
LEFT: **Burma Battler.** A 'tropical' Hurricane IIB, with Vokes filter, in combat with a Nakajima Ki-27 'Nate' fighter. The latter's fixed undercarriage made it easy prey for the Hurricane.

The RAF's first monoplane fighter aircraft began life as a single-winged development of Hawker's last biplane, the Fury. An initial 1934 requirement for a fighter armed with eight guns led to the building of a prototype that began air trails in November 1935, equipped with Rolls-Royce's new engine, the Merlin. The combination proved a winner. The Hurricane was capable of more than 300mph (482km/h). A raised canopy improved pilot visibility, but its structure was similar to the Fury's, with fabric laid over steel tubing. The latter would seem primitive compared to more advanced fighters such as the Spitfire, but it made the Hurricane easy to maintain in the field and in combat it had the surprising benefit of being flimsy enough to allow cannon shells to pass through without exploding.

The Hurricane entered service with 111 Squadron in December 1937. By the outbreak of WW2, almost 500 were operational with eighteen squadrons. Fighting over France revealed weaknesses against Luftwaffe Bf 109s, which had better acceleration and were faster, although the Hurricane could out-turn the 109 at lower altitudes. Hurricane Mark Is also bore the brunt of the Battle of Britain, equipping twenty-eight of the RAF's fifty-five fighter squadrons, and scoring 656 victories.

Some were converted to Sea Hurricanes and served aboard Royal Navy carriers in the North Atlantic and Mediterranean. Others were used aboard more unconventional carriers: the Catapult Aircraft Merchant (CAM) ships. A makeshift effort to see off Luftwaffe air attacks, a single Hurricane, nicknamed 'Hurricat' or 'Catafighter', would be fitted to a rocket-propelled catapult rail on a modified merchant ship. For the pilot it was a one-way trip; after launch and if he survived any subsequent combat, the pilot was required to ditch or parachute from the aircraft, then be recovered by the CAM or another conveniently located vessel. The CAM programme was abandoned in August 1942.

The Flying Can Openers. Hurricane IIDs of 6 Squadron take off from Sidi Haneish in Egypt on 20 June 1942. The Mk IID was a powerful anti-tank aircraft and its success in this role in the Western Desert campaign earned 6 Squadron its nickname.

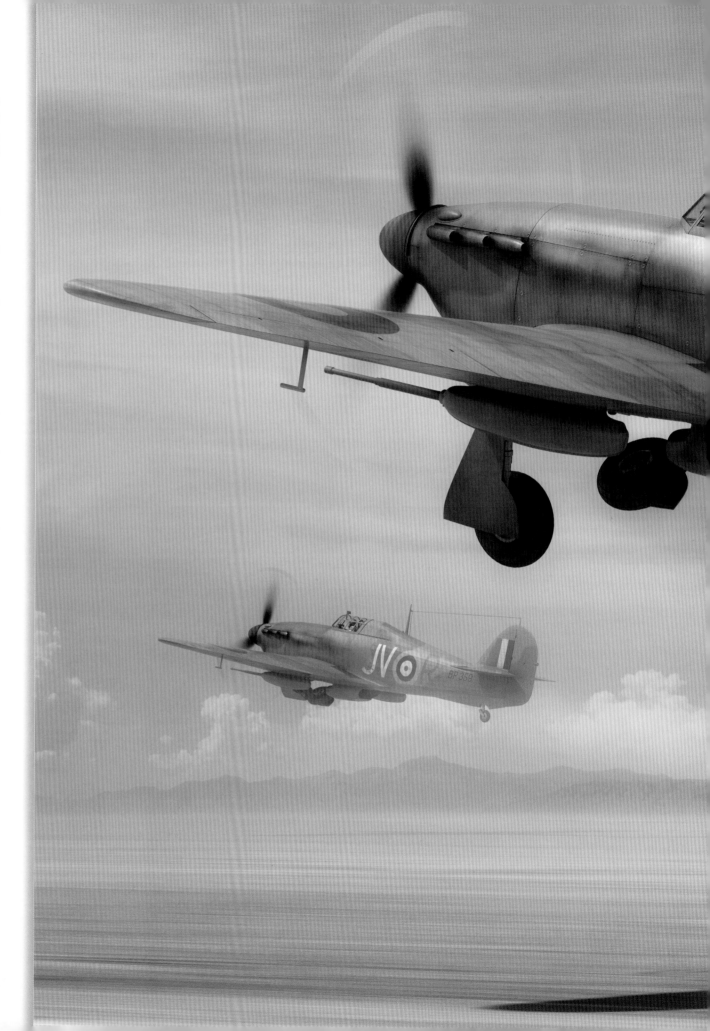

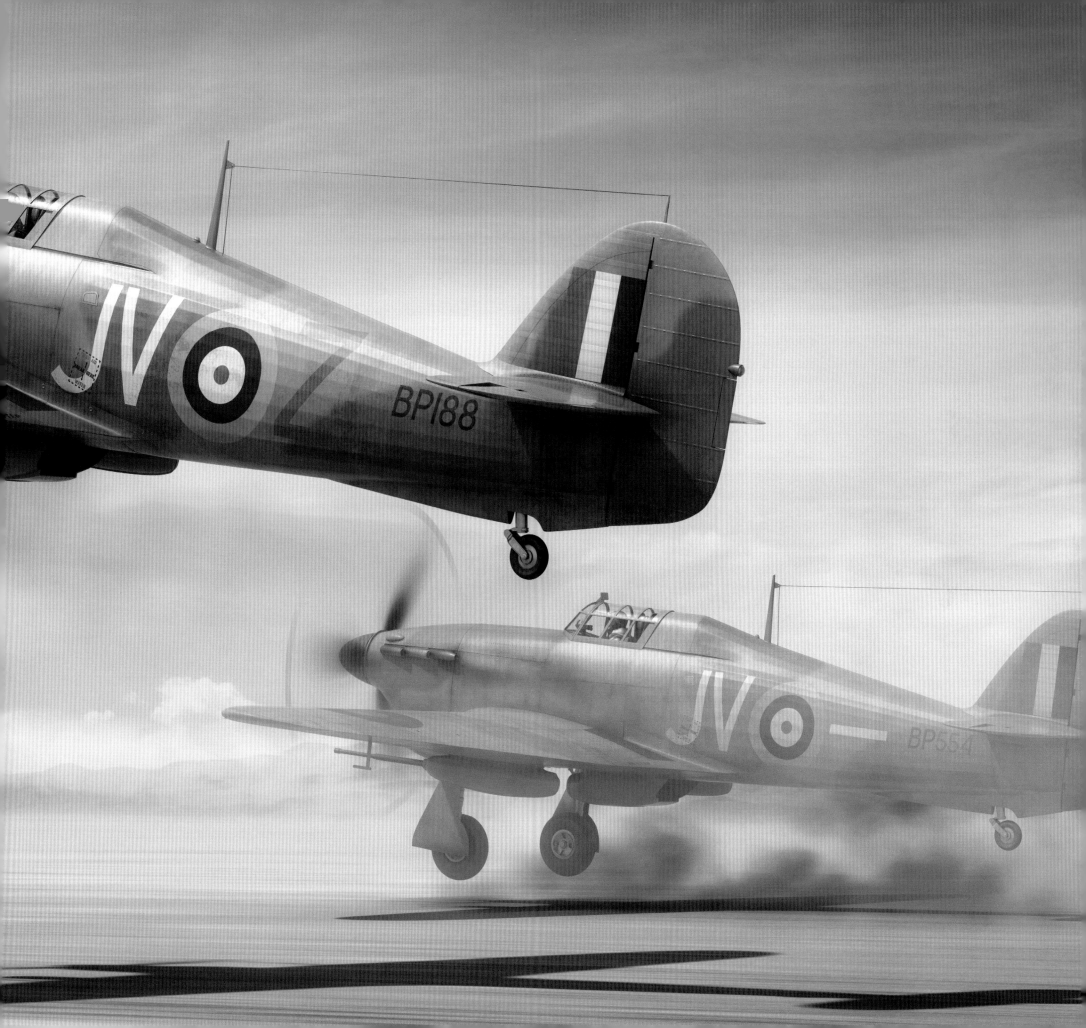

BF 110

Originally designed to be a long-range, twin-engine fighter-bomber, the Bf 110 entered service in 1937 mainly as an escort fighter for the Luftwaffe's bomber fleet. Messerschmitt stripped out the bomb bay originally required of the design so that they could increase the aircraft's armament and christened it the *Zerstörer* (Destroyer). It was presupposed that the aircraft would not need the agility of its counterpart, the Bf 109, relying instead on engine horsepower and firepower to live up to its name.

Too late to join the Condor Legion during the Spanish Civil War, the Bf 110 first saw action during the initial stages of Nazi Germany's invasion of Europe. It performed very well over the skies of Poland and France, but that was largely the result of facing inexperienced opponents in obsolete aircraft. By May 1940, as the Blitzkrieg thundered into France, the Bf 110 encountered the Spitfires and Hurricanes of the RAF for the first time and initial confidence in the heavy fighter concept began to wane as the British fighters exposed serious flaws in its design. At the start of the Battle of Britain, the type was escorting bombers, but its lack of manoeuvrability made it easy prey for the RAF fighters, who claimed over two hundred during the Battle. By the end of the campaign, the single-seat Bf 109s were required to escort the Bf 110s.

In the early years of the war, Bf 110s continued to provide sterling service in other theatres, including the Mediterranean and North Africa, and during the opening stages of the invasion of Russia. New variants fulfilled the type's potential as a fighter-bomber, like the E model, which was fitted with bomb racks on the wing and fuselage. The Bf 110 also found a niche it was eminently suitable for as a night fighter. As the RAF's night-bombing campaign gathered pace, the Luftwaffe was looking for types to counter the raids and the Bf 110's powerful engines and large size made it ideal to be modified as a night fighter that could reach the high altitudes flown by the bombers. Its size also provided space for the addition of a radar and extra armament.

The ultimate version was the Bf 110G, equipped with increasingly powerful radars, improved aerodynamics, a more easily accessible rear cockpit and more powerful engines. The G model also received a variety of weapons fits, including the *Schräge Musik* mount, which fired 20mm cannons upward. It ended up equipping sixty percent of the German night-fighter force, the *Nachtjagd*. It was beloved by its pilots and all the top-scoring night-fighter aces flew the type.

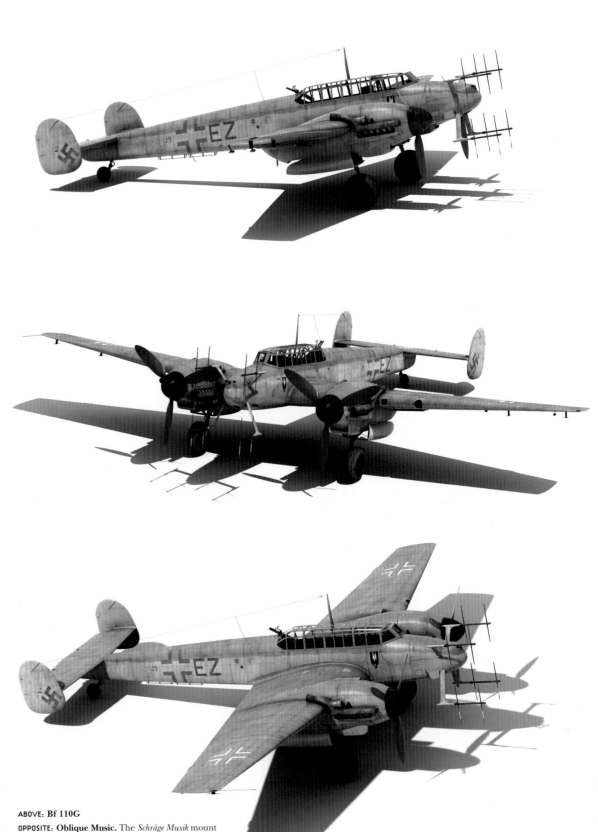

ABOVE: **Bf 110G**

OPPOSITE: **Oblique Music.** The *Schräge Musik* mount fires upward as the Bf 110 passes under the belly of the Lancaster, which has no turret, so the fighter remains unseen.

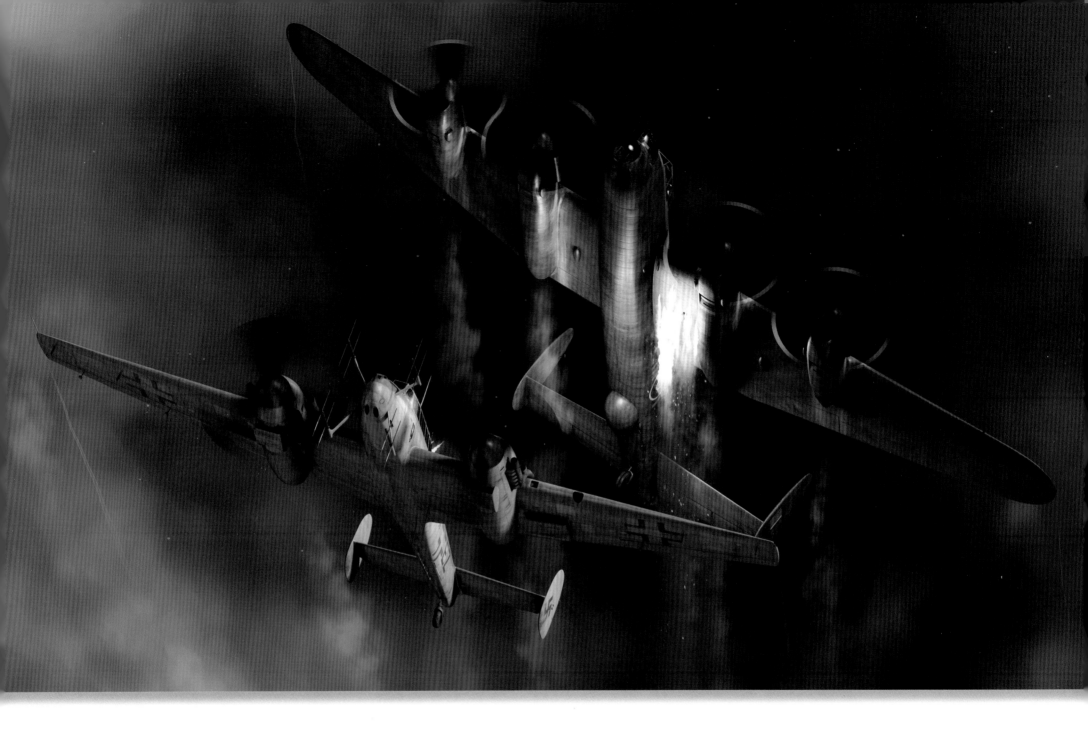

SPECIFICATIONS

FOR MODEL: Bf 110G-4

TYPE: heavy fighter-bomber

MANUFACTURER: Messerschmitt

OPERATORS: Germany; Hungary; Romania

CREW: pilot, radio operator/gunner; one additional for night fighter variants

LENGTH: 40.6ft (12.3m)

WINGSPAN: 53.4ft (16.27m)

WEIGHT: 9,920lb (4,500kg) [empty]-17,158lb (7,790kg) [max. take-off weight]

MAX. SPEED: 370mph (595km/h)

SERVICE CEILING: 36,000ft (11,000m)

RANGE: 558 miles (900km)

POWERPLANT: Daimler-Benz DB 601B-1 x 2

ARMAMENT: MG 151 20mm cannon x 2 and MG 17 7.92mm machine gun x 4 in nose; MG 81Z 7.92mm machine gun x 2 in rear cockpit

MAIDEN FLIGHT: 12 May 1936

IN SERVICE: 1937-1945

NUMBER BUILT (ALL TYPES): 6,050

P-40

SPECIFICATIONS

FOR MODEL: P-40B

TYPE: fighter

MANUFACTURER: Curtiss-Wright Corp.

OPERATORS: USA; UK; Australia; Canada; Finland; France; South Africa

CREW: pilot

LENGTH: 31.8ft (9.66m)

WINGSPAN: 37.5ft (11.37m)

WEIGHT: 5,812lb (2,636kg) [empty]-8,058lb (3,655kg) [max. take-off weight]

MAX. SPEED: 345mph (555km/h)

SERVICE CEILING: 29,000ft (8,800m)

RANGE: 800 miles (1,287km)

POWERPLANT: Allison V-1710-33

ARMAMENT: .50 calibre machine gun x 2 on nose; .30 calibre machine gun x 2 or 4

MAIDEN FLIGHT: 14 October 1938

IN SERVICE: June 1941-1945

NUMBER BUILT: 13,738 (all versions)

Never as successful as such famous fighters as the P-51 or P-47 and always out-performed by its German contemporaries the Bf 109 and Fw 190, the P-40 is nonetheless a legendary aircraft. Modified from the earlier Curtiss P-36 Hawk, the Warhawk, as it was known, was the American answer to the Spitfires and Messerschmitts then entering service in Europe. The US Army Air Corps ordered 524 of the sleek little fighters fitted with the new Allison V-1710-19 engine. However, the P-40's combat debut was not with the USAAC but Britain's RAF.

With the outbreak of war in Europe, the British were in dire need of aircraft to help battle the Luftwaffe. Cheap and quick to produce, they chose the P-40 to supplement their own homebuilt fighters. However, the Allison engine proved underpowered above 15,000ft

(4,600m) – while RAF Spitfires and Hurricanes regularly operated above 30,000ft (9,100m) – which made the P-40 vulnerable at high altitudes to the more powerful German fighters. Consequently, the aircraft was deemed unsuitable for operations over northern Europe. Instead, the P-40s, known as Tomahawks by the RAF, were dispatched to North Africa, where they flew with the Desert Air Force (DAF). Their excellent low-altitude performance giving the fighter a new role as a ground-attack aircraft.

The Tomahawk and the later models, called Kittyhawks, were generally superior to the Italian fighters they encountered and could still make a good account of themselves against the German Bf 109s below 15,000ft. P-40 pilots found their mounts nimble and rugged, and a solid gun platform. After

May 1942, the Kittyhawks were fitted out to carry small 250lb (113.4kg) bombs and these began flying ground attack and close air support missions. However, as the war progressed and more modern fighters became available to the DAF, the P-40s were gradually replaced by Hurricanes (especially in the ground attack role) and Spitfires modified to operate in the tropics.

Meanwhile, on the other side of the world, Warhawks were writing themselves into legend while flying with the famous 1st American Volunteer Group. Manned by volunteer American pilots, they operated alongside the Chinese Air Force from late 1941, following the Japanese invasion of China. Against their more agile Japanese opponents, the AVG utilised their high dive speed to make slashing

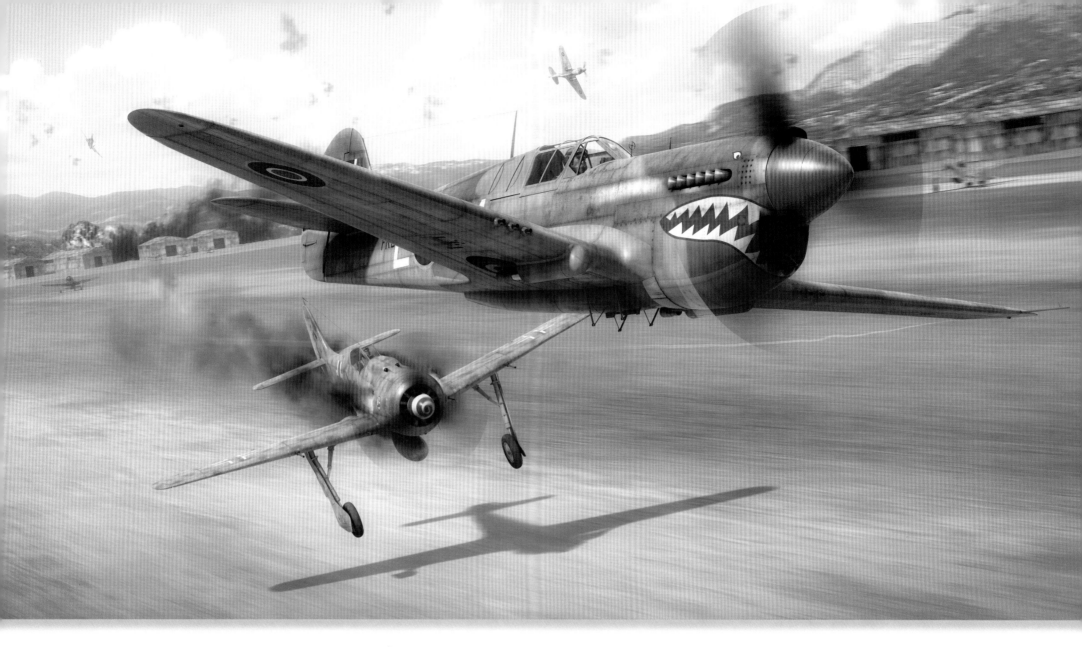

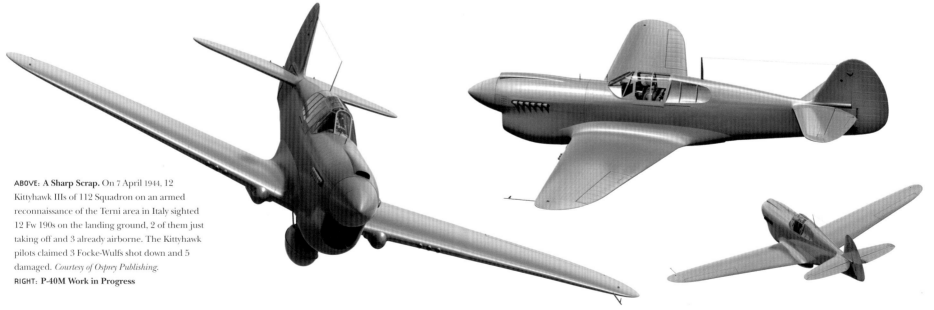

ABOVE: A Sharp Scrap. On 7 April 1944, 12 Kittyhawk IIIs of 112 Squadron on an armed reconnaissance of the Terni area in Italy sighted 12 Fw 190s on the landing ground, 2 of them just taking off and 3 already airborne. The Kittyhawk pilots claimed 3 Focke-Wulfs shot down and 5 damaged. *Courtesy of Osprey Publishing.*
RIGHT: P-40M Work in Progress

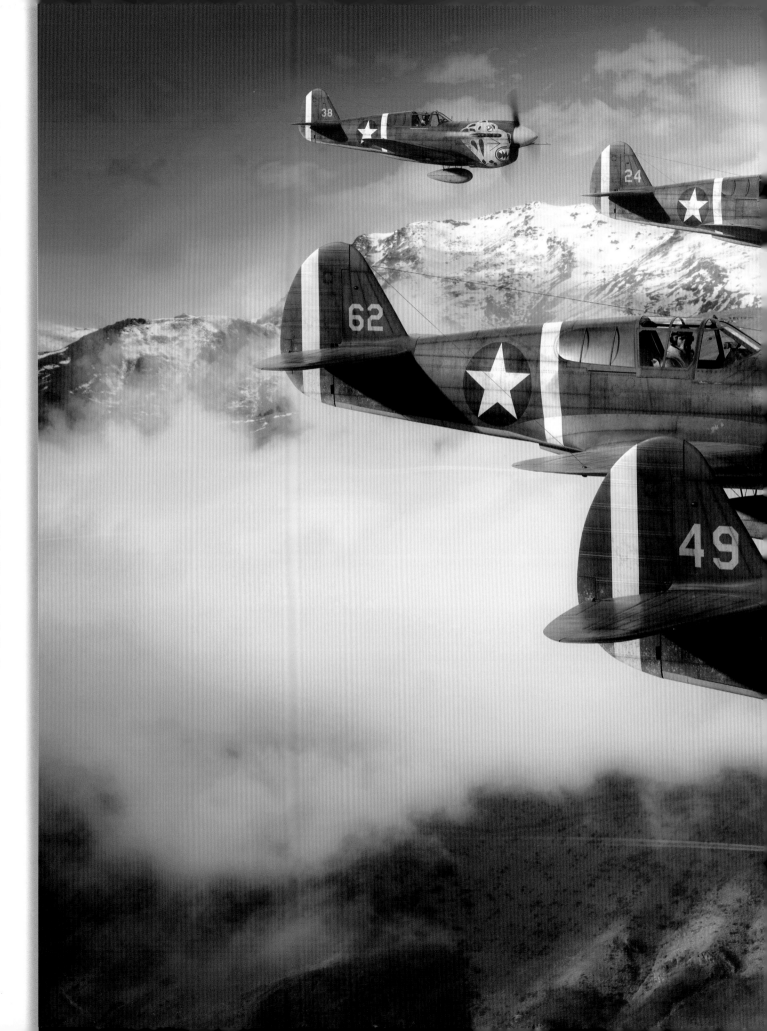

attacks into enemy formations – known as 'zoom and boom' tactics. These dive attacks proved highly successful.

The AVG were also known as the 'Flying Tigers' because of the shark mouths that adorned their P-40s, though DAF British pilots laid claim to being the first to decorate their Tomahawks in that way. Whatever the truth, a P-40 wasn't a P-40 without a shark's mouth.

USAAC Warhawk pilots were soon pressing their own P-40s into service following the attack on Pearl Harbor on 7 December 1941. As the Corps' most modern fighter, it fought many desperate actions against superior Japanese forces across the Pacific in such battles as Midway while US forces awaited the arrival of more advanced aircraft.

P-40s were similarly pressed into action by the Soviet Union, with Warhawks being the first fighters sent to the USSR by the US under the 1941 Lend-Lease Act. Eventually over 2,400 P-40s of all types operated with Russian fighter squadrons, many receiving a variety of field modifications at the hands of Russian pilots and ground crews. Despite being replaced in many frontline squadrons by superior Soviet aircraft, the P-40 continued to fly over the Eastern Front until the war's end.

Aleutian Tigers. P-40Ks of the 11th Pursuit [later Fighter] Squadron, the 'Aleutian Tigers', over Alaska in 1942.

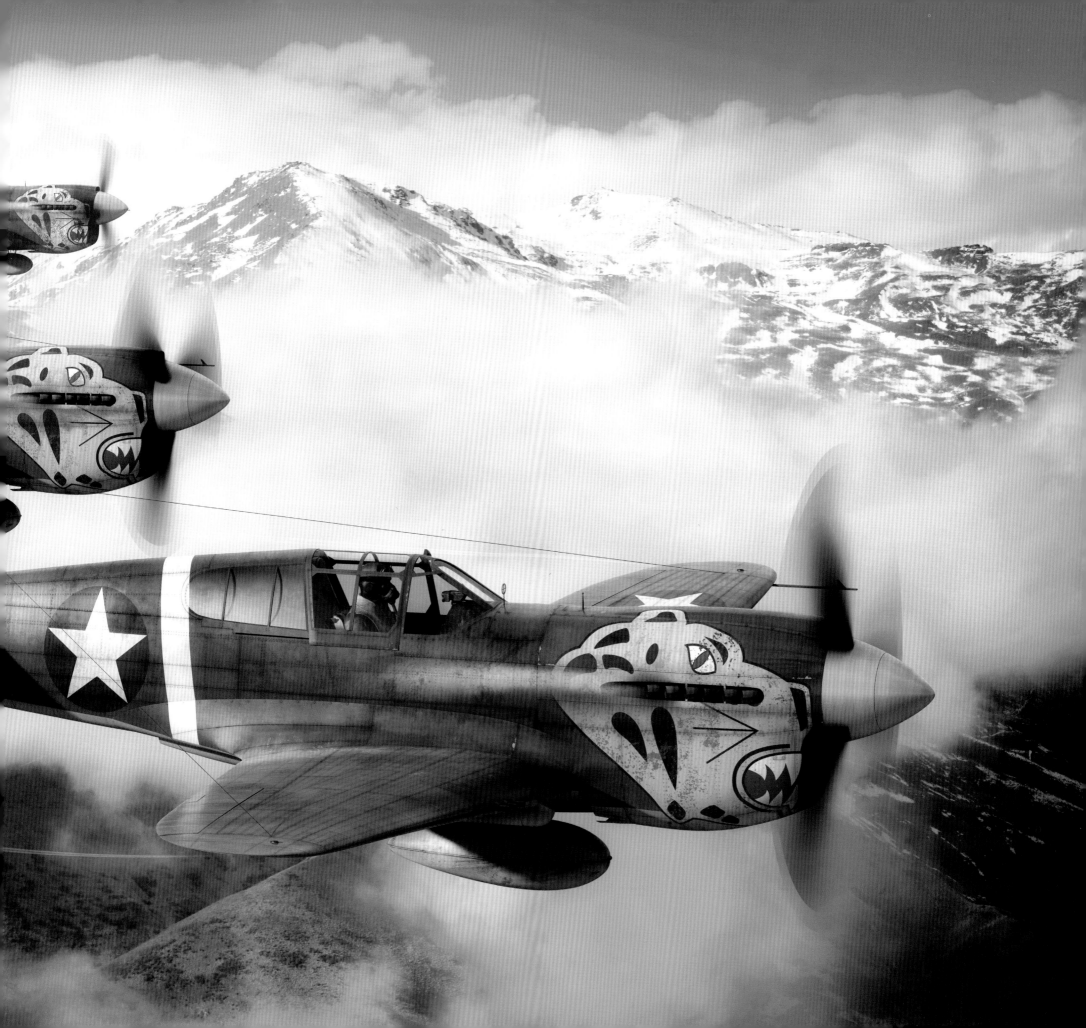

PALM SUNDAY MASSACRE

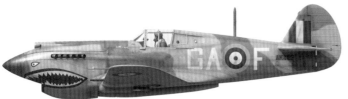

In April 1943, the Allies mounted Operation Flax, an air campaign to destroy the German air and sea routes that supplied the Afrika Korps in North Africa. On the afternoon of 18 April 1943, forty-seven USAAF P-40s, with RAF Spitfires flying top cover, intercepted a low-flying formation of sixty-five Junkers Ju-52s and their small fighter escort over Cape Bon, Tunisia. In the ensuing battle, twenty-four Ju-52s were downed and another thirty-five damaged, and ten German fighters were downed for the loss of six P-40s and a Spitfire.

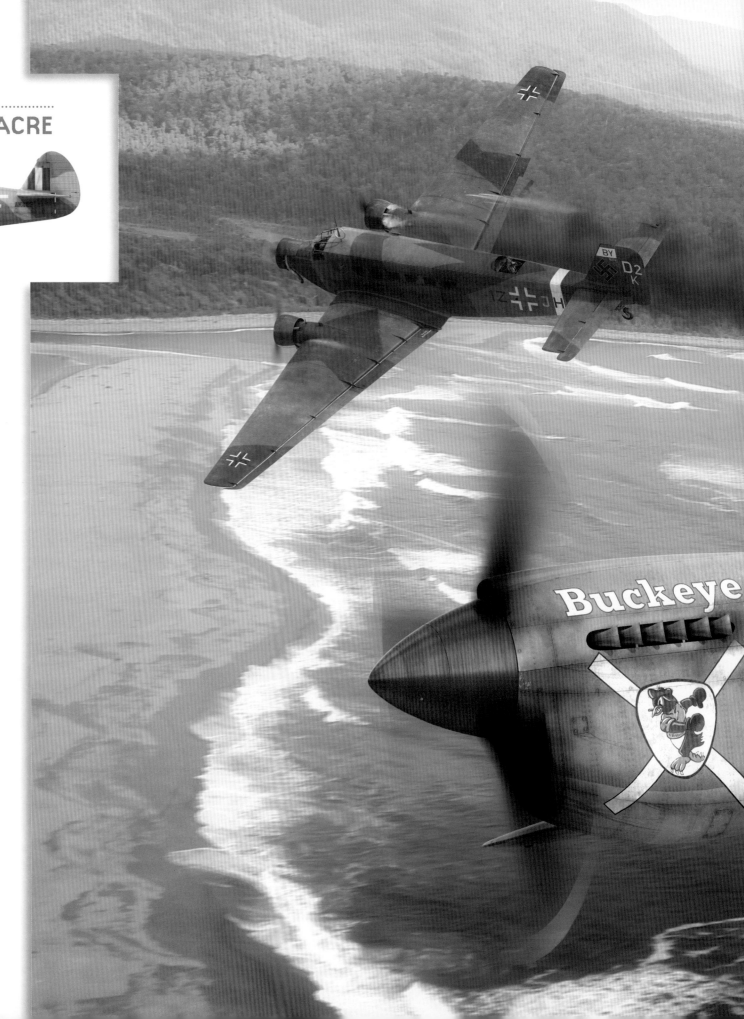

ABOVE: **P-40M**

FOLLOWING SPREAD: **Neville Duke in Action.** A famous British fighter ace who ended the war with 27 kills, Duke flew P-40s over North Africa. He was shot down twice during dogfights with German Bf 109s, but became the Mediterranean theatre's top fighter ace.

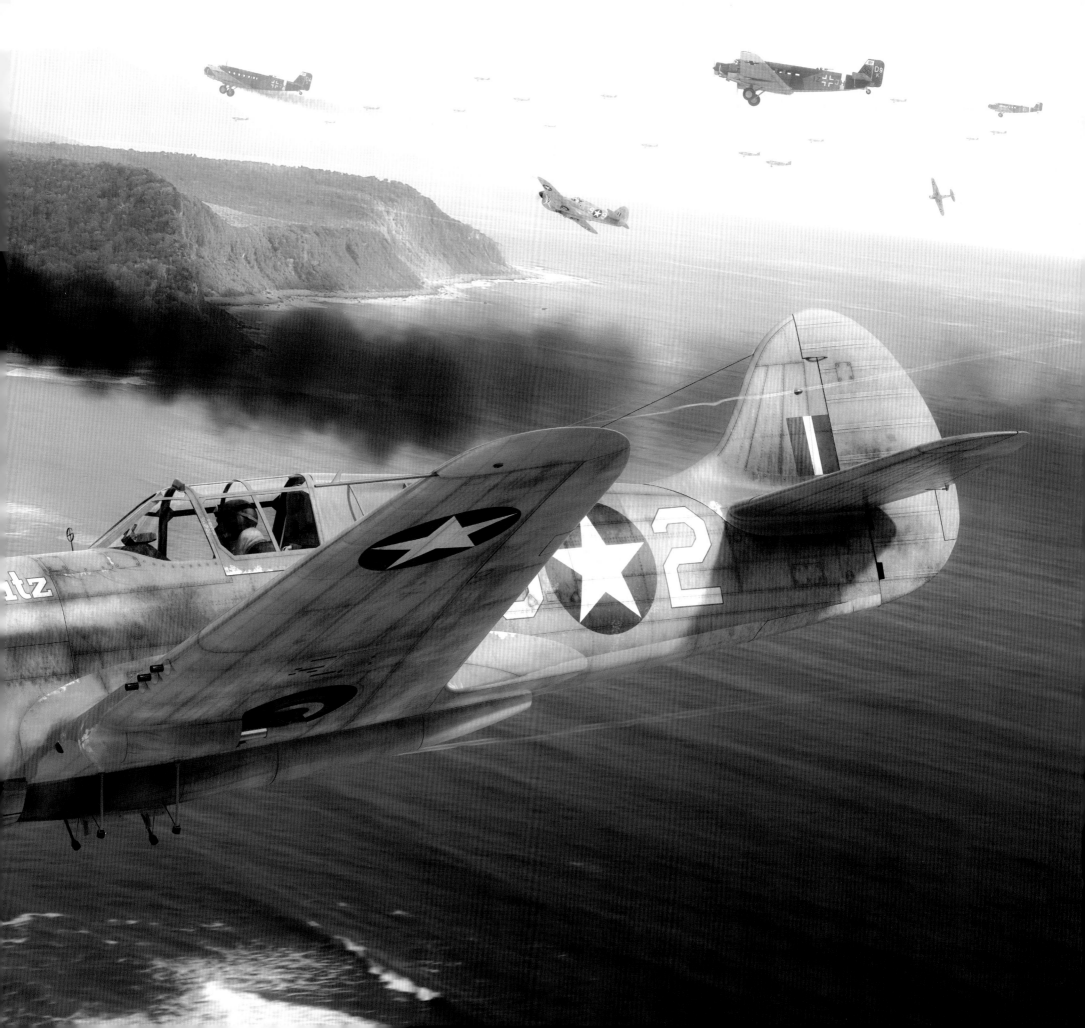

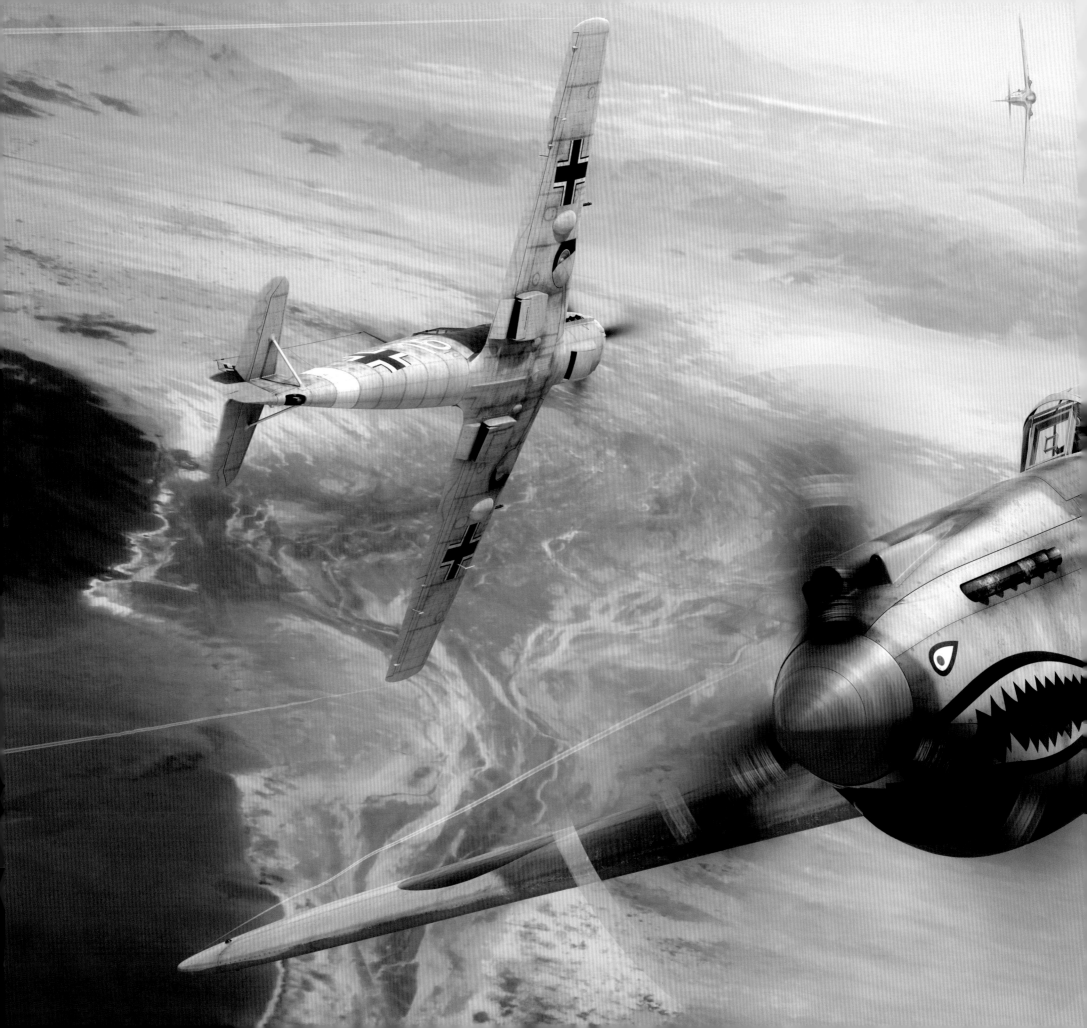

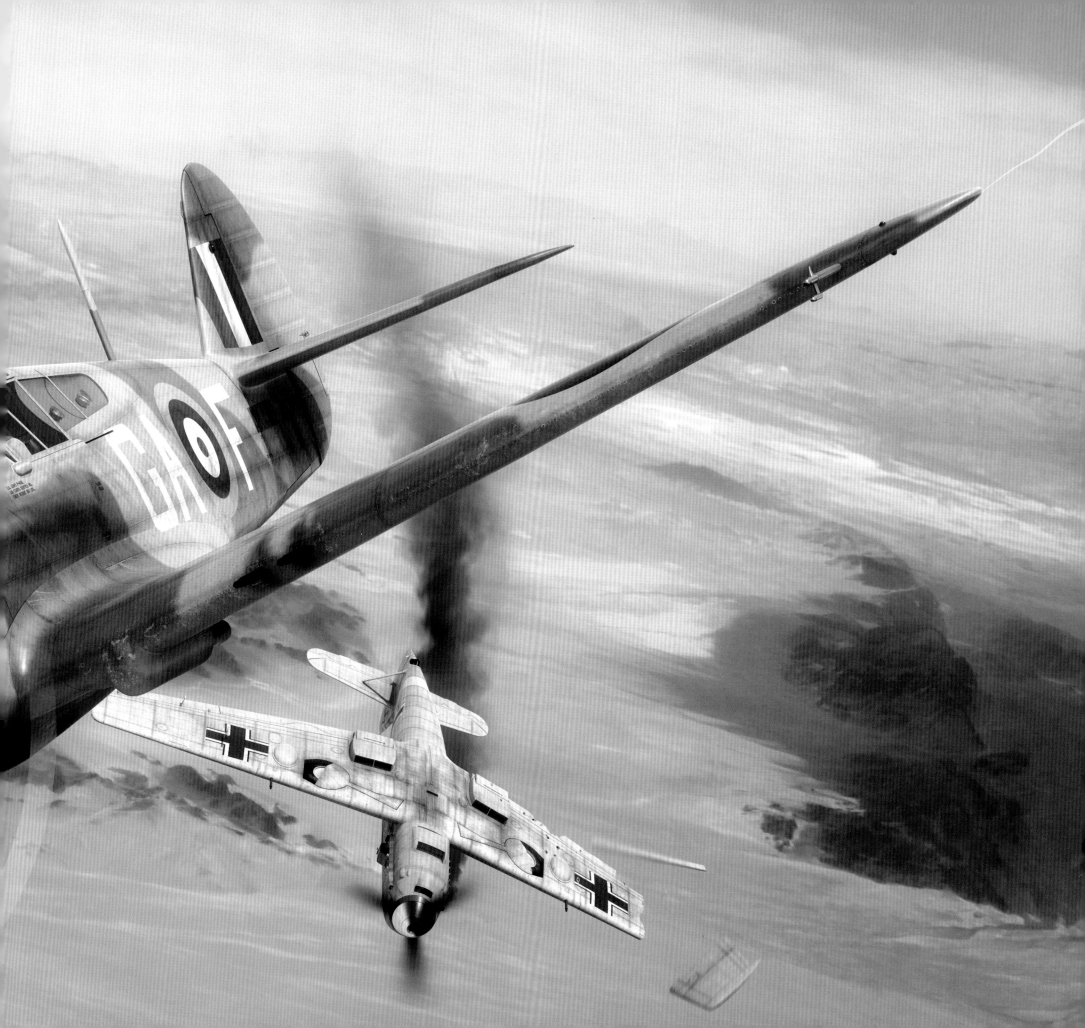

BF 109

FOR MODEL: Bf 109G-6

TYPE: fighter

MANUFACTURER: Messerschmitt

OPERATORS: Germany; Croatia; Finland; Hungary; Italy; Romania; Spain; Switzerland; Yugoslavia

CREW: pilot

LENGTH: 29.7ft (9.03m)

WINGSPAN: 32.6ft (9.92m)

WEIGHT: 5,893lb (2,673kg) [empty]-7,496lb (3,400kg) [max. take-off weight]

MAX. SPEED: 386mph (621km/h)

SERVICE CEILING: 39,370ft (12,000m)

RANGE: 620miles (998km) [with external tank]

POWERPLANT: Daimler-Benz DB 605A-11

ARMAMENT: MG 151 20mm cannon through propeller hub; MG 131 13mm machine gun x 2 on nose cowling;

underwing pod for 20mm cannon x 2 (optional); underwing stores per wing include 551lb (250kg) or 110lb (50kg) bomb x 4; 8in (21cm) rocket x 2

MAIDEN FLIGHT: 29 May 1935

IN SERVICE: 1937-1945 (although stayed in service with Spanish Air Force until 1965)

NUMBER BUILT: 34,826 (all versions)

Known by Allied flyers as the Me 109, the Bf 109 was produced in greater numbers than any other fighter, German or otherwise, during WW2. One of the first fighters to include an enclosed canopy and all-metal design, it entered service with the Luftwaffe in 1937, in time to see action with Germany's Condor Legion during the Spanish Civil War. It performed excellently against Republican types, mainly of Russian design and very much inferior to the German aircraft. Its first serious opponents came when the 109 encountered Spitfires and Hurricanes of the RAF early in WW2. The former was more agile than the Messerschmitt, even if the German aircraft could out-dive the Spitfire and was more powerfully armed.

By 1941, new models of the Spitfire were out-flying the Bf 109E (or 'Emil'), so Messerschmitt updated their fighter, refining the contours of the nose to make it more streamlined, uprating the engines, and pressurising

Hermann Graf's Bf 109G-6 Work in Progress

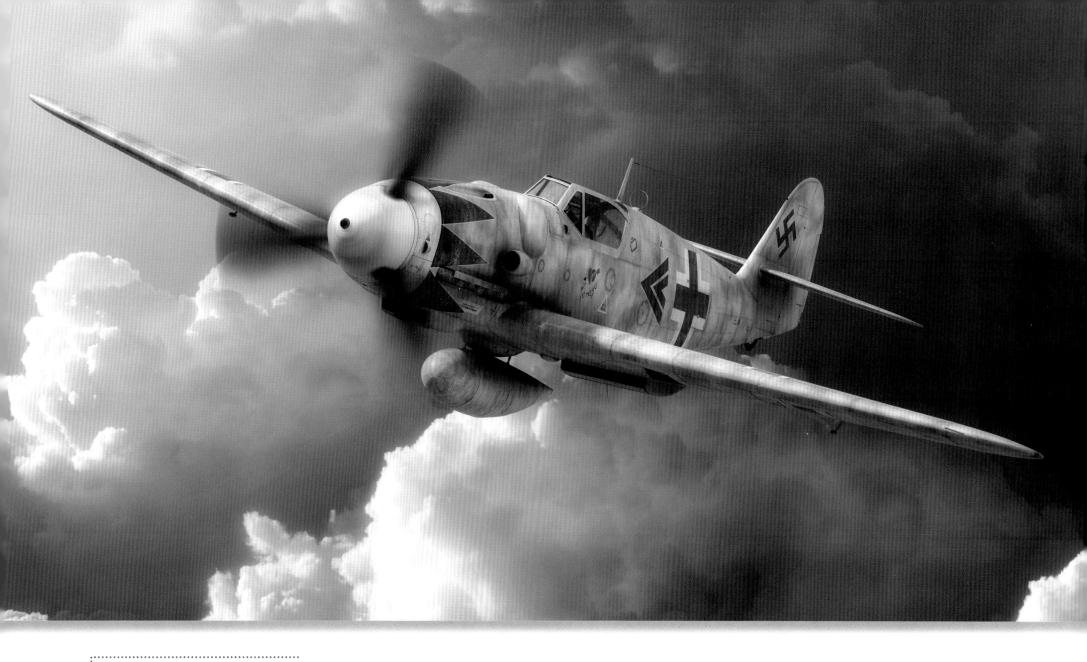

THE BLACK TULIP

Erich Hartmann was the Luftwaffe's highest scoring ace during WW2. Nicknamed 'Bubi' because of his boyish looks, he is credited with 352 kills.

After joining the Luftwaffe in 1940 at the age of eighteen, he was dispatched to Bf 109G-equipped fighter wing *Jagdgeschwader 52* in October 1942 at Maykop in southern Russia. Flying with a number of experienced pilots, he initially proved rather rash. He was even grounded following his first mission after leaving his wingman to attack a number of Russian aircraft, failing to hit any and eventually being forced to crash-land after his 109 ran out of fuel. However, he scored his first kill on 5 November, and by August 1943 his tally stood at fifty, including seven in one day on 7 July during the Battle of Kursk. At the end of August he was downed by debris from a Soviet aircraft he hit and crashed behind Russian lines. After being captured, he faked internal injuries and, during a German air attack, overpowered his guard and escaped back to friendly lines, where he was lucky not to be shot by a German sentry.

By the time he had passed two hundred kills, in March 1944, he was known to the Russians, who had put a 10,000-ruble price on his head. Hartmann had also taken to having a black tulip painted on the nose of his Bf 109G-14, resulting in the Russian nickname of 'the Black Devil'.

By the end of the war, he had flown 1,404 sorties and in 825 engagements he was never once shot down, although he was forced down fourteen times due to debris damage or mechanical failure. Most of those crashes were the result of his preferred method of attack – close to within point-blank, then fire short bursts into his opponent. While this allowed him to accurately hit a target, it left him little time to escape any debris flying from the damaged enemy.

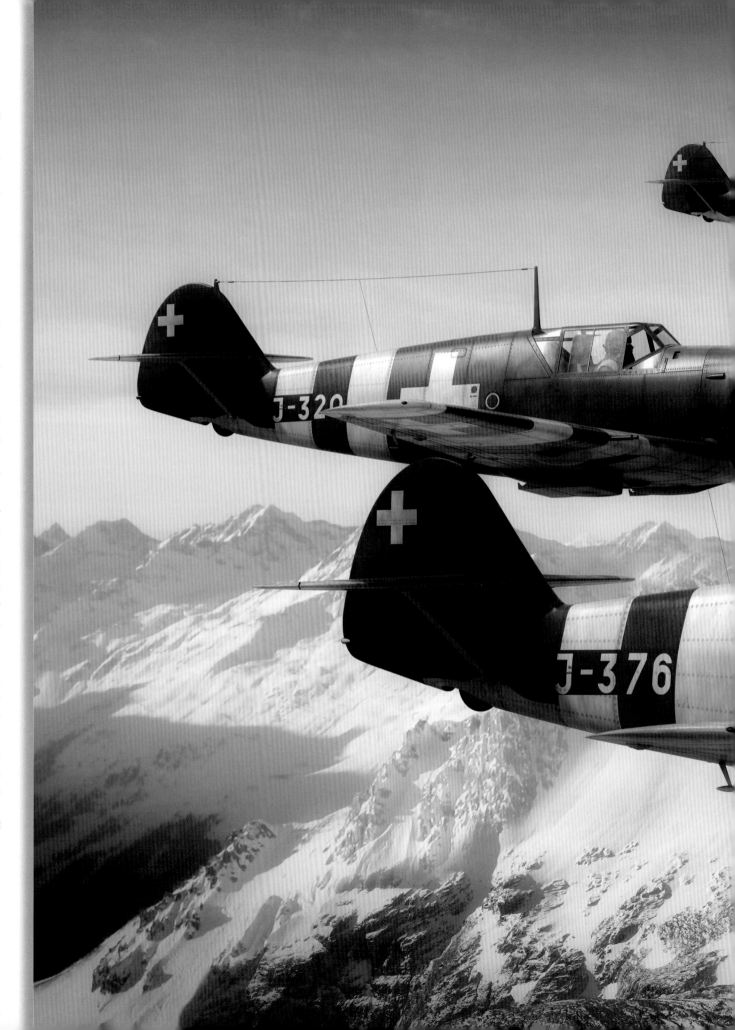

the cockpit. The result was what is considered the definitive Bf 109 – the G-model or 'Gustav', of which more than 30,000 were constructed.

New fighter types on both sides came to overshadow the 109, but, by the end of WW2, Bf 109 pilots had claimed more kills than any other fighter type in the war. Some pilots racked up massive tallies – 105 Bf 109 pilots claimed more than 100 kills, of which thirteen doubled that, while two, Erich Hartmann and Gerhard Barkhorn were credited with 352 and 301 victories respectively.

Few Allied fighter aces broke 50, let alone 100 kills. However, German fighter pilots were often flying against large but disorganised air forces using inferior aircraft, especially on the Eastern Front. In June 1941, at the start of Operation Barbarossa (Nazi Germany's invasion of the USSR), Bf 109 pilots scored heavily against the badly flown and obsolete Soviet aircraft, 3,922 of which were destroyed in the first day alone, for the loss of just 35 German aircraft of all types.

Similarly, Bf 109 pilots also did well against US and RAF heavy bombers, especially in the early years of the campaign, from 1942-43. As the unescorted American bombers lumbered into Germany in daylight, 109 pilots used the long-range power of their 20mm cannons to hit the bombers with little risk from their .50 calibre machine guns, however many they had.

By the end of 1943, the P-51D Mustang and the P-47D Thunderbolt were arriving in significant numbers and able to escort their bomber charges throughout Germany. Now, for the first time, the Bf 109 pilots had a real fight on their hands. Combined with a general reduction in pilot quality and lack of fuel, the Luftwaffe lost the battle for air superiority, but even so, the Gustavs and the later K model 109s remained formidable adversaries right up until the end of the war.

Emils Over the Alps. 109Es of the Swiss Air Force.

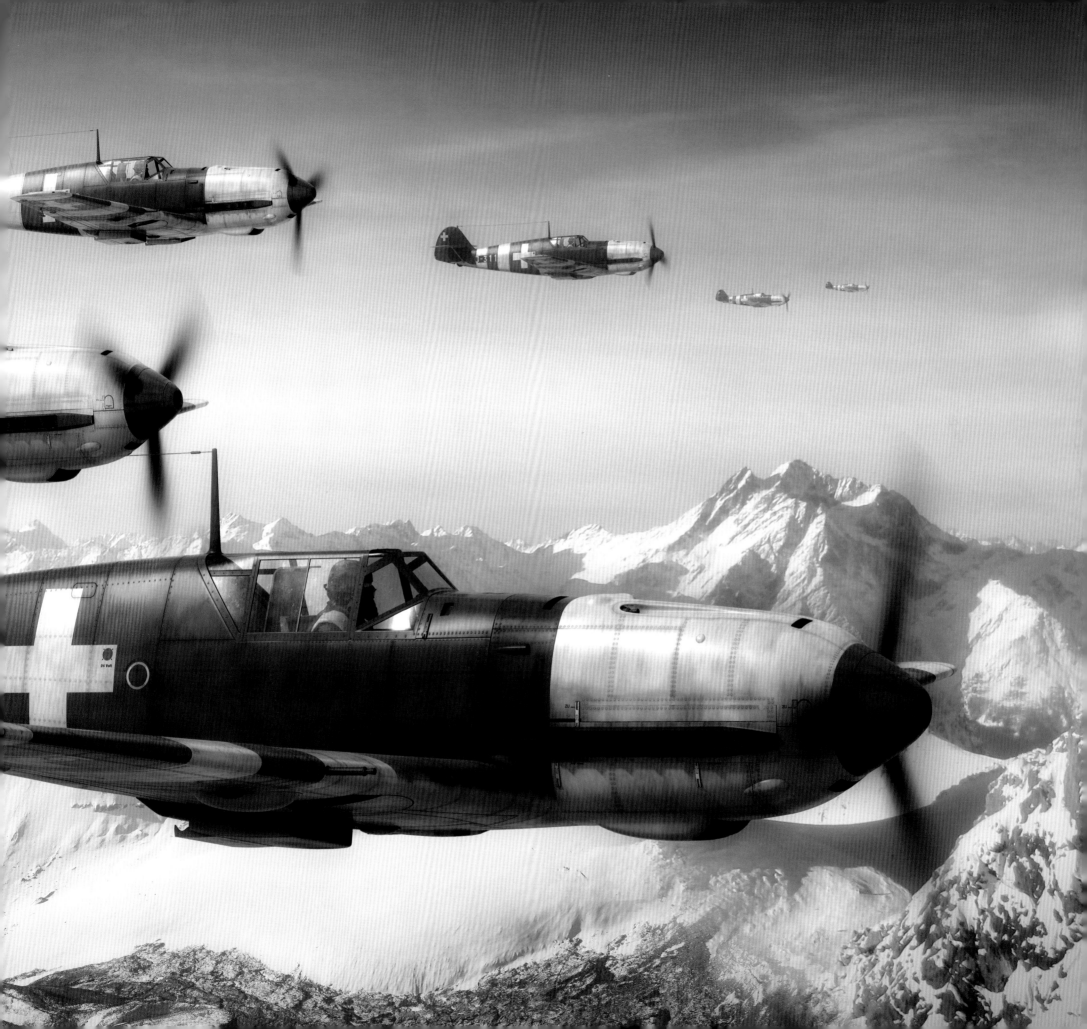

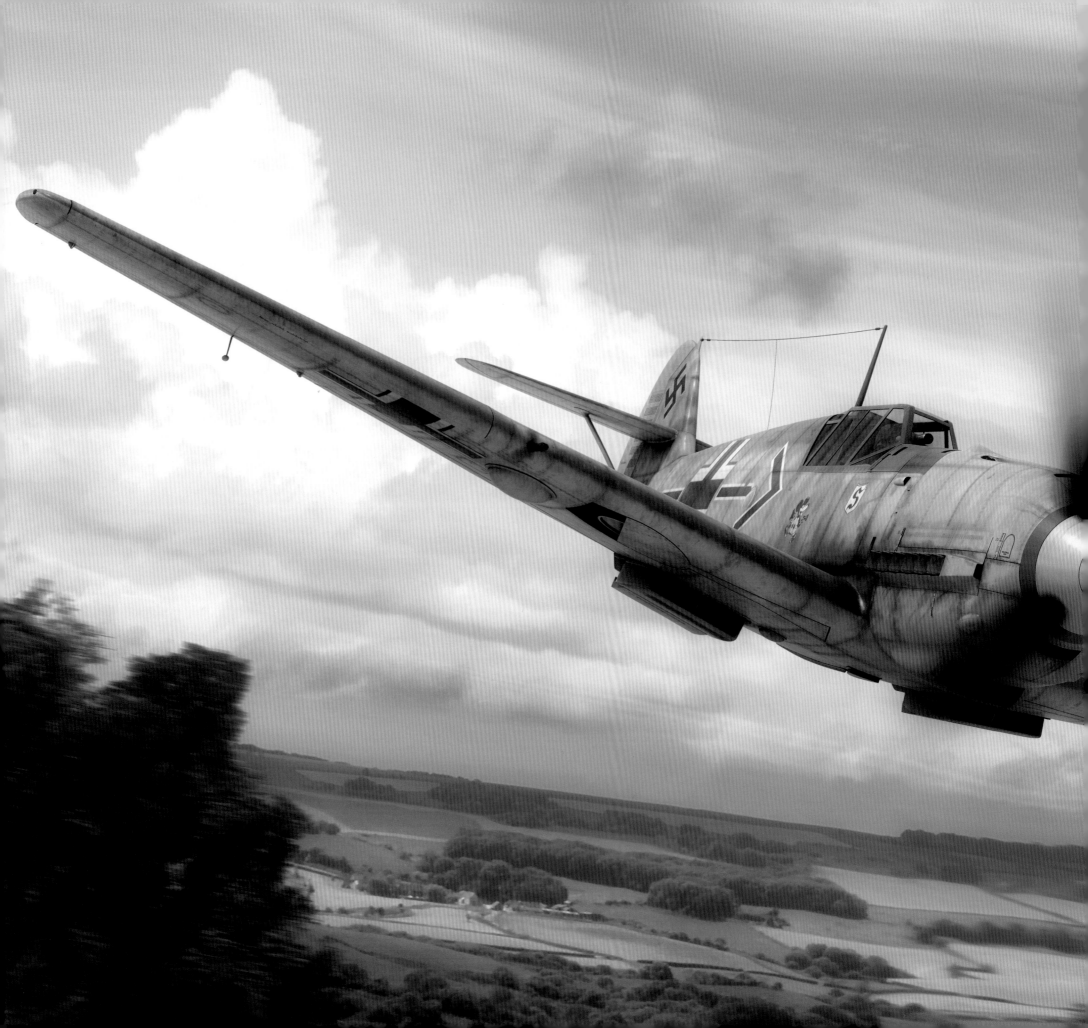

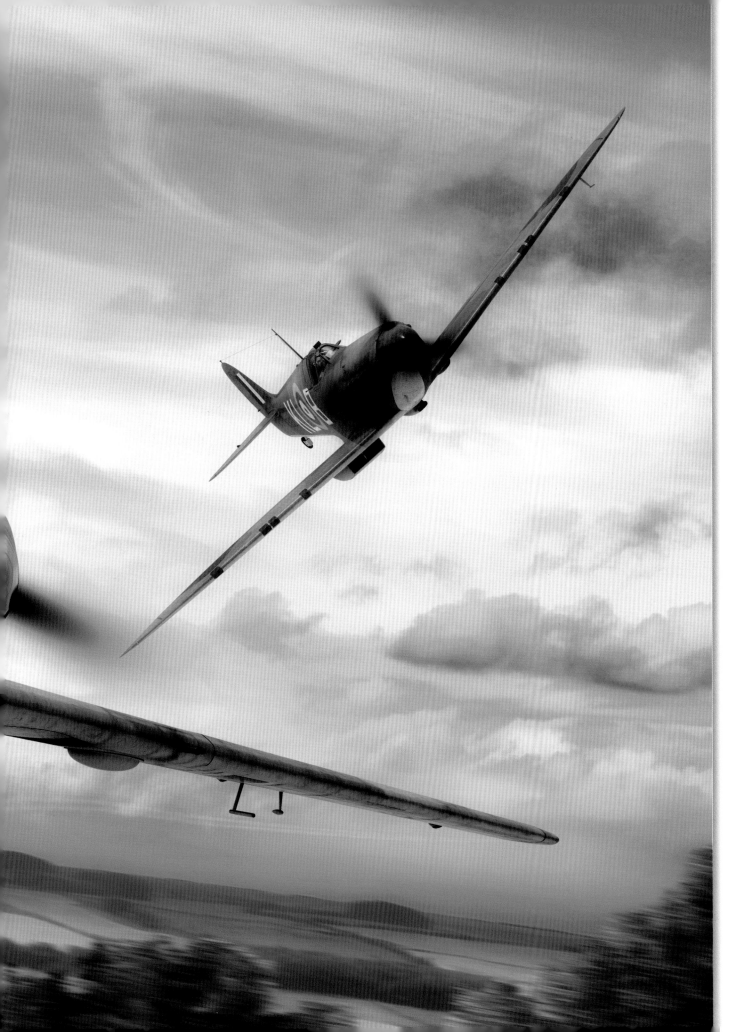

CHECK SIX!

Fighter ace Adolf Galland flew Bf 109Es during the Battle of Britain, engaging RAF Spitfires and Hurricanes over southern England and the English Channel.

By 1940, Galland was already an experienced combat veteran, having flown with the Condor Legion during the Spanish Civil War and conducted ground-attack missions during the invasion of Poland. However, he devoutly wanted to be a fighter pilot and by the start of the Battle of Britain, he got his wish. He finished 1940 with fifty-seven kills.

From 1941, the RAF began conducting fighter sweeps over occupied Europe. Galland continued to score, having raised his tally to ninety-six by the end of the year, but, in November, he took over command of the Luftwaffe's fighter force, which disqualified him from combat. He was soon at loggerheads with the Luftwaffe commander, Reichsmarschall Hermann Göring, over Galland's apparent inability to stem the Allied bombing campaign. Galland retaliated with a steady stream of criticism of Göring and the Luftwaffe leadership. In January 1944, he was relieved of command and arrested, but was saved by a rebellion of senior Luftwaffe pilots and commanders. As a result he was sent back to active duty, flying the new Messerschmitt Me 262 fighter jet and finishing the war with a score of 104 kills.

After the end of WW2, Galland became friends with many of his former opponents in the RAF.

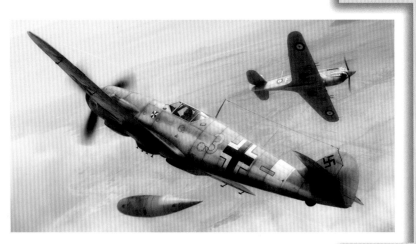

GISELA

Franz Schwaiger, in his Bf 109F, engaging Kittyhawks over North Africa.

Having scored eight kills during Operation Barbarossa (the German invasion of Russia), Schwaiger's unit was then sent to the Mediterranean theatre of operations, and he flew a Bf 109 nicknamed 'Gisela' (after his girlfriend) in North Africa between January and April 1942. He failed to score again until he was sent back to Germany to fly against American bomber attacks.

By 9 March 1944 he had scored sixty-six kills. That day, after scoring his sixty-seventh victory – a P-51 Mustang – his Bf 109G developed engine trouble and he was forced to leave the battle alone. While returning to base, he was attacked by other American fighters and forced down. As he was trying to escape the crashed Bf 109, he was strafed by fire from the US aircraft and killed.

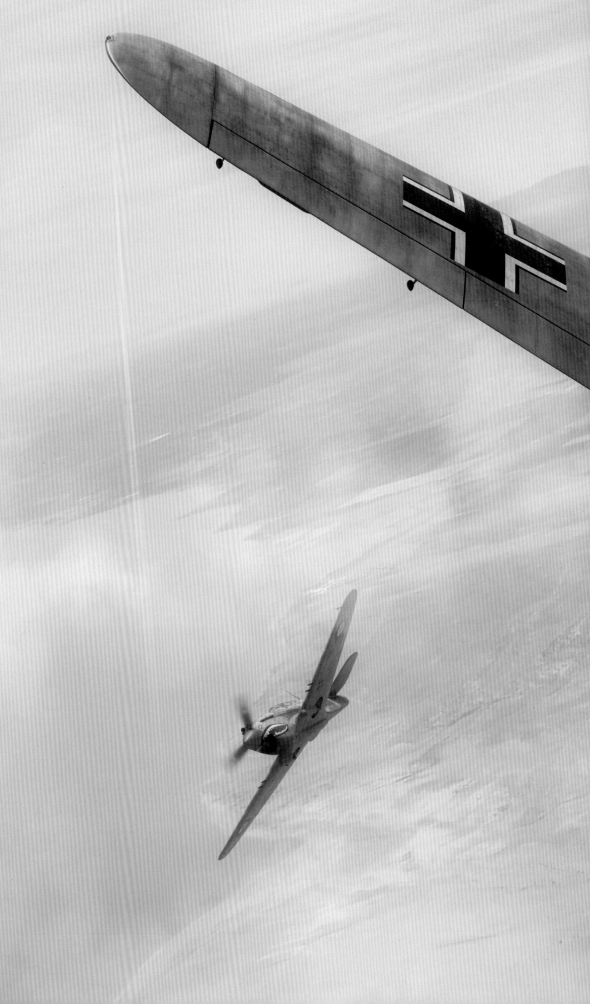

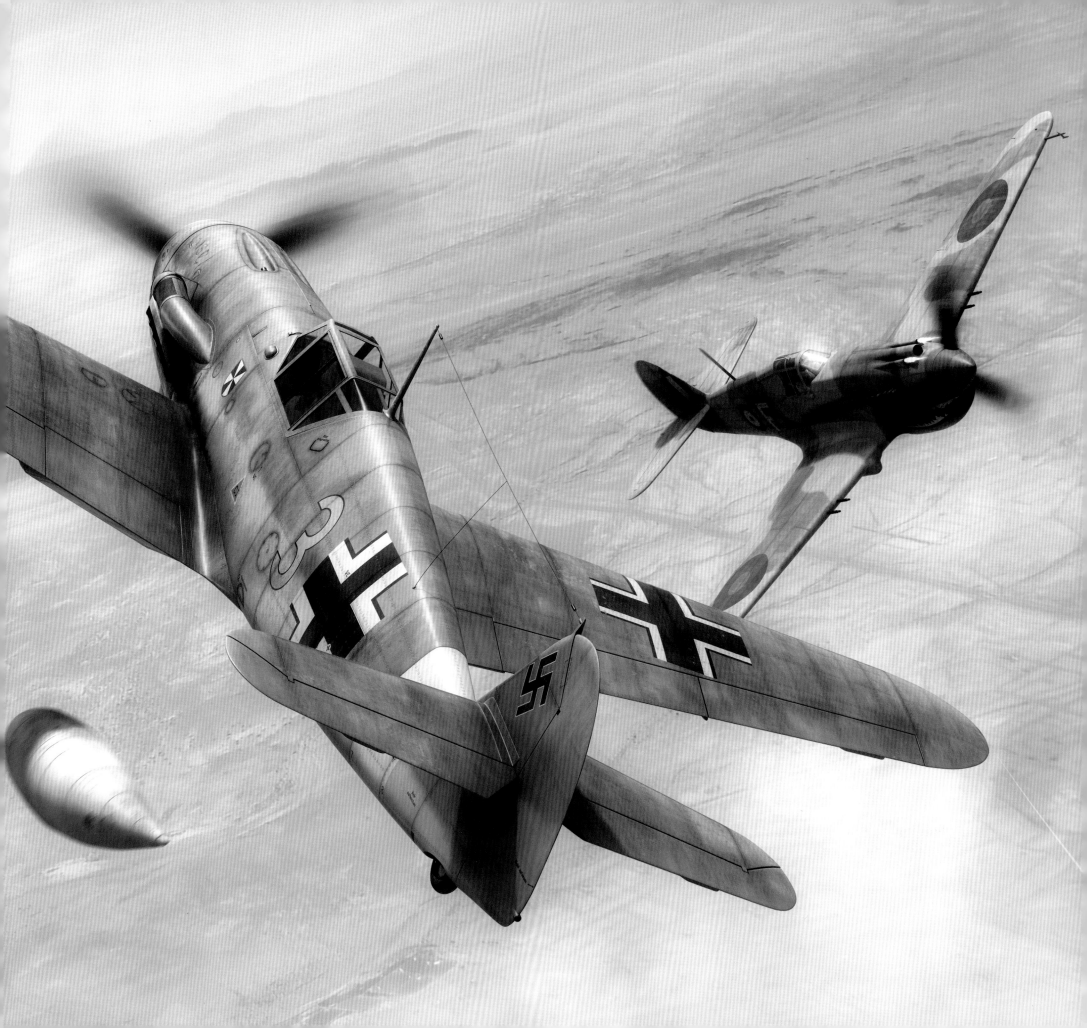

C-47

The C-47 is one of the most beloved, recognisable and famous aircraft of all time. Officially named the Skytrain, it was known as the Dakota by the RAF and was known informally as the 'Gooney Bird' by American servicemen. It operated in every theatre of operations during WW2, taking part in the legendary parachute drops that opened the D-Day landings, and those of Operation Market Garden that resulted in the destruction of the British 1st Parachute Regiment at Arnhem in September 1944. In Southeast Asia, they were instrumental in keeping Allied cargo moving between India and China over 'The Hump' (the eastern end of the

Himalayan Mountains) from April 1942 until the war's end, enabling Chinese forces to keep fighting after the Japanese took the Burma Road.

The C-47 is also one of the very few aircraft built by both sides during WW2, as prior to the outbreak of hostilities, the Japanese had attained the right to build the DC-3 commercial variant under license. Nakajima and Showa built 485 L2Ds, given the Allied nickname 'Tabby'. As the Japanese's most numerous transport type, it served throughout the conflict.

Following the end of WW2, huge numbers of C-47s were soon busy as the Cold War intensified. When Soviet Russia sealed off Berlin from the outside world in June 1948, C-47s participated in the Berlin airlift, codenamed Operation Vittles, bringing in desperately needed supplies for Berlin's population,

often in atrocious weather conditions.

Russia had its own version of Skytrain, the Lisunov Li-2, which was license built between 1939 and 1952. Some 5,000-6,000 aircraft were built.

On the other side of the world, C-47s were busy during the Korean War and, in 1954, supplying French paratroopers trapped during the disastrous siege at Dien Bien Phu in Vietnam. Following the French withdrawal from the region, renewed fighting drew in American forces in the mid-1960s. It was during this war that the C-47 found a new, less benign role as a gunship, the FC-47 and AC-47.

Despite their age, the superlative C-47 remains in use across the globe, especially in South America and Africa, soldiering on as a transport and passenger carrier, while many aircraft remain in private hands.

SPECIFICATIONS

TYPE: transport
MANUFACTURER: Douglas Aircraft Co.
CREW: pilot, co-pilot, radio operator, navigator
PAYLOAD: 6,000lbs (2,700kg) of cargo or 28 passengers
LENGTH: 64.5in (19,660m)
WINGSPAN: 95ft (28.95m)
WEIGHT: 16,865lb (7,649kg) [empty]-25,200lb (11,430kg) [max. take-off weight]
MAX. SPEED: 207mph (333km/h)
SERVICE CEILING: 23,200ft (7,071m)
RANGE: 23,125 miles (37,216km) with max. war load
POWERPLANT: Pratt & Whitney R-1830-S1C3G Twin Wasp radial x 2
ARMAMENT: none
MAIDEN FLIGHT: 23 December 1941
NUMBER BUILT: 13,177 (all versions)

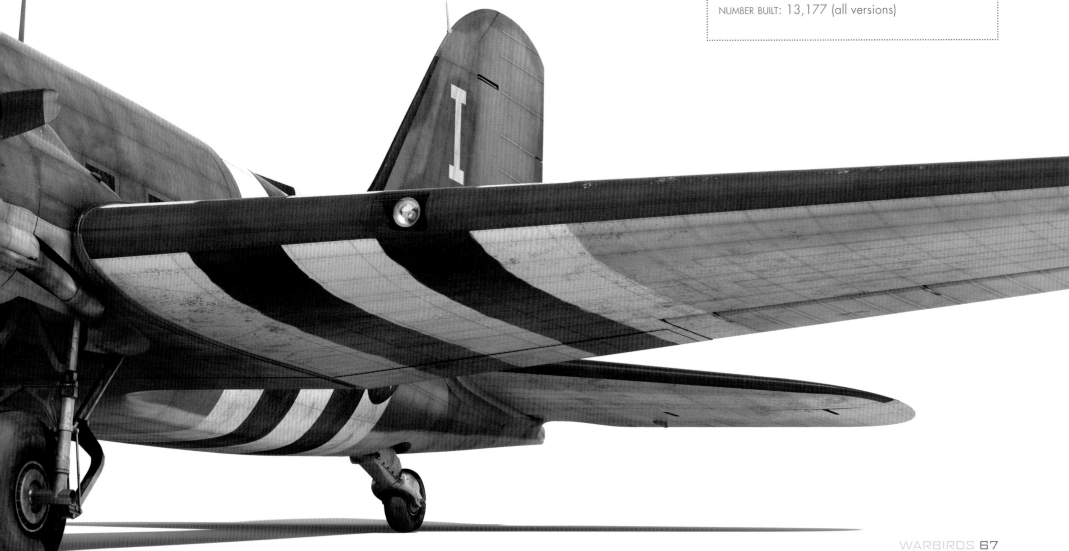

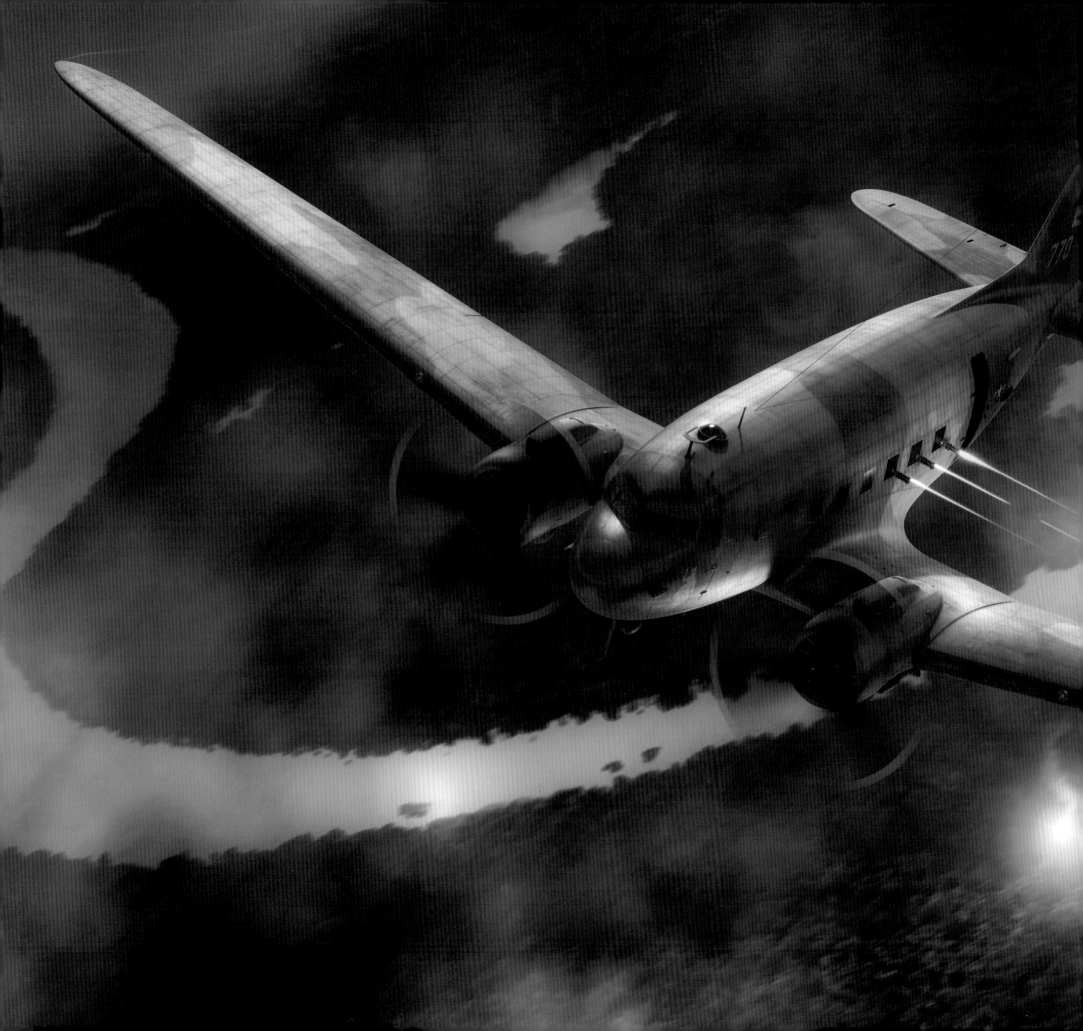

AC-47 SPOOKY

The concept of the gunship arose from a need to deliver air support close to friendly forces with minimal risk of hitting them. During WW2, Lt Col G.C. McDonald hit upon the idea of using slower aircraft types to perform 'pylon turns', a tight, steady turn. Weapons such as machine guns would be mounted on the left of the aircraft and the left wingtip centred on the target, acting as a makeshift sight. This allowed for an accurate delivery of considerable firepower.

In August 1964, an SUU-11A/A gun pod was fitted to a C-47. The gun pod housed a six-barrelled, electrically powered 7.62mm minigun that could fire up to 6,000 rounds a minute. Initial tests proved successful and the following year the system, christened the FC-47D, was tested in Vietnam, mounted with three SUU-11A/A pods, two firing from modified windows, the third from the side door. All three were sighted to fire just behind the trailing edge of the wing. The pilot operated the weapons using a gun sight on his side window and a trigger button fitted to his control wheel. Each pod carried 1,500 rounds, but the aircraft was modified to carry 24,000 replacement bullets.

Flying mainly at night, the FC-47 was used in combat for the first time in December 1964, defending isolated outposts and fire support bases with troops in contact (TICs). It was in defence of one of these bases in the Mekong Delta that the aircraft gained its famous nickname. After seeing the cone of fire raining down from the circling FC-47, and hearing the growl of the guns, a witness commented, "Well, I'll be damned! Puff, the Magic Dragon!" The title of a popular song at the time by folk trio Peter, Paul and Mary, legend has it they were not best pleased.

By 1968, two sixteen-aircraft AC-47 (redesignated with 'A' for attack) squadrons were operational, with flights based throughout South Vietnam and Thailand. The 'Dragonships' also picked up the callsign 'Spooky'. They were kept busy throughout the year by the North Vietnamese Tet Offensive, bringing much-needed fire support to besieged troops at the Marine Corps fire base at Khe Sanh, and even around the South Vietnamese capital, Saigon. However, such was their success in proving the gunship concept that they were soon being replaced by newer, more powerful aircraft, and the USAF handed them over to the air forces of their local allies, South Vietnam, Thailand, Laos and Cambodia.

The Spooky remains in service with the air forces of El Salvador and Columbia.

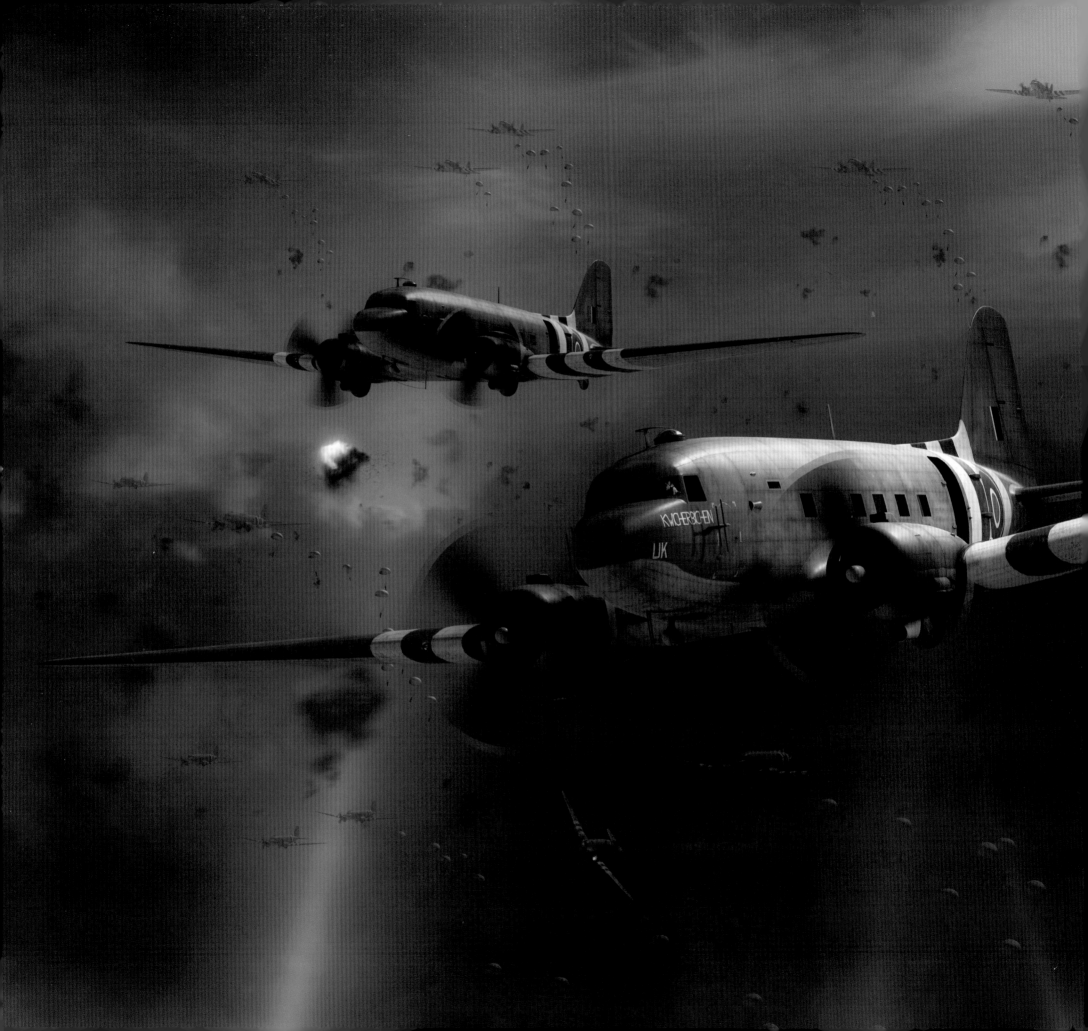

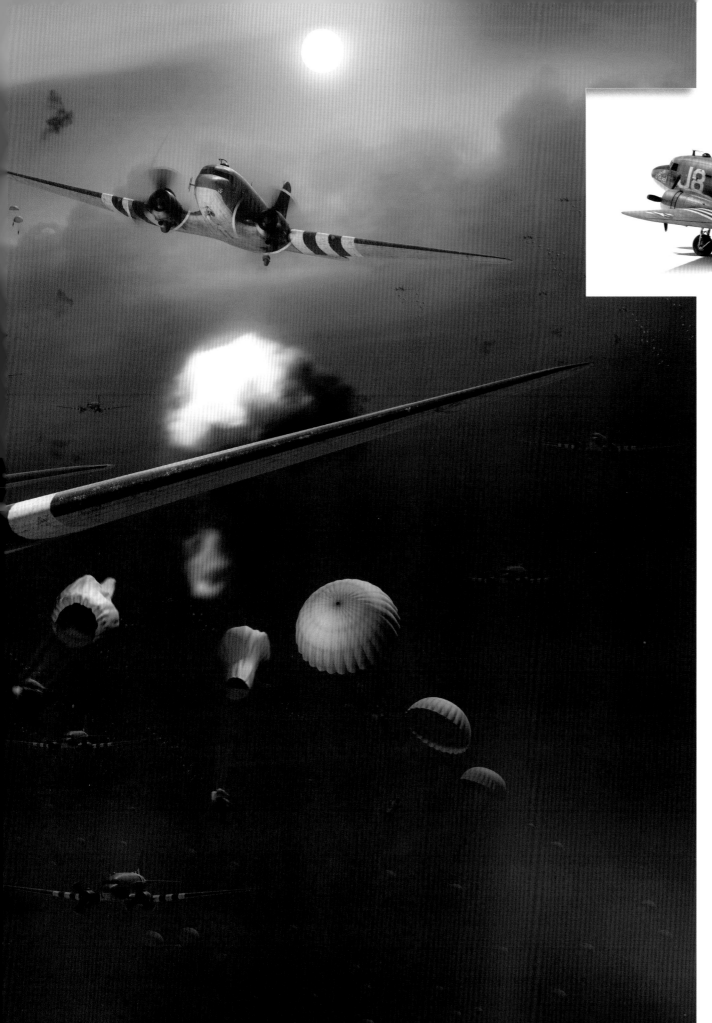

THE DROP

ABOVE: C-47

"Shortly after midnight on 6 June 1944, the great D-Day invasion got underway with Operation Tonga when 108 RAF Douglas C-47 Dakotas dropped paratroopers of the British 3rd Parachute Brigade into Normandy.

"Illuminated by searchlights and flak, Dakotas of 233 Squadron from RAF Blakehill Farm are seen over Drop Zone K, near Caen. In the foreground is C-47 Dakota FZ692, named 'Kwicherbichen' by its crews. All thirty of 233 Squadron's Dakotas flew to Normandy on Operation Tonga; two of them failed to return, victims of German flak."

Squadron Leader Clive Rowley MBE RAF (Retd)

STIRLING

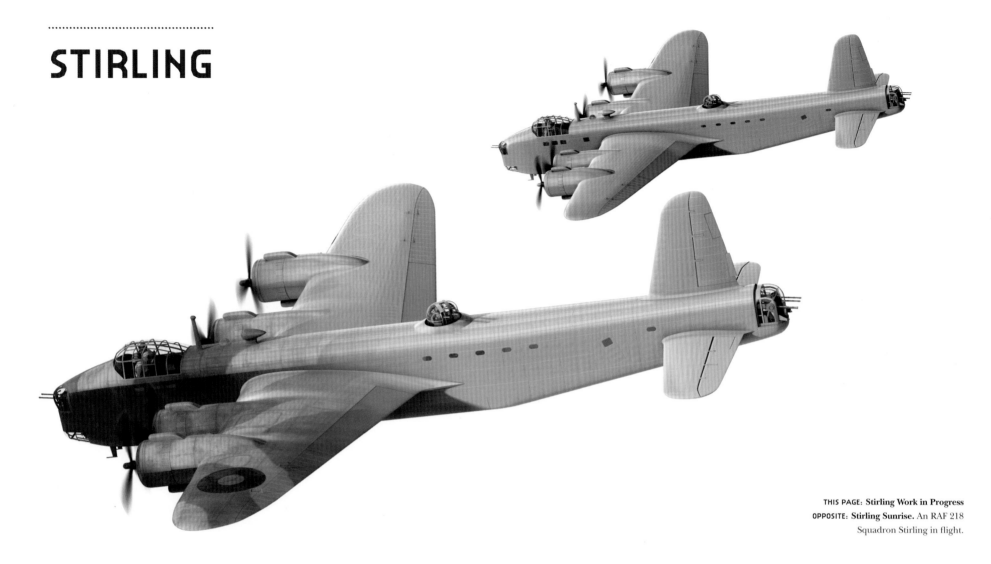

THIS PAGE: **Stirling Work in Progress**
OPPOSITE: **Stirling Sunrise.** An RAF 218
Squadron Stirling in flight.

Developed before the outbreak of WW2, the Short Stirling was the winning design in a 1936 RAF competition for a four-engined bomber. However, the RAF required that the new aircraft have a wingspan not exceeding 100ft (30m), so it could be accommodated in the service's standard hangers, which contributed to a number of subsequent design flaws, exacerbated by Short's unfamiliarity with bomber design.

The company was accomplished in the building of flying boats such as the Short Sunderland and simply took the Sunderland's 114ft (35m) wing and adapted it to take the four engines and a retracting undercarriage while clipping its length down to within the RAF's requirements. The broad wing gave the bomber very good handling and manoeuvrability at low and medium altitudes,

but its shortened length resulted in an inability to generate enough lift to operate at higher altitudes with a full payload.

Test flights highlighted the Stirling's long take-off and landing runs. To help overcome this, the undercarriage legs were raised so that the wing was angled further into the airflow and gained more lift, but this made the undercarriage unduly long and weak. The modification caused problems for the Stirling throughout its career.

By January 1941, the RAF's first Stirling squadron, 7, was declared operational at RAF Leeming and flew its first raid, against Rotterdam, on the night of 10/11 February. However, the poor performance of the Hercules engines soon began to dog Stirling squadrons, as they meant that long-range missions required a severe restriction on bomb load – less

than a quarter of the aircraft's maximum load in some cases. The design of the bomb bay also prevented the use of newer, heavier weapons. The Stirling was restricted to 2,000lb weapons.

Despite new modifications by Short, the Stirling continued to suffer more losses than any other bomber type. Five months after being introduced into action, sixty-seven of the eighty-four delivered Stirling IIIs had been destroyed in action or lost to operational accidents. By the end of 1943, the type was being phased out of service.

But the Stirling's career was not over. It was used in the mining of German ports and on clandestine missions to drop spies and supplies over occupied territory. It was also found to make an excellent troop carrier and glider tug, taking part in the D-Day landings and Operation Market Garden.

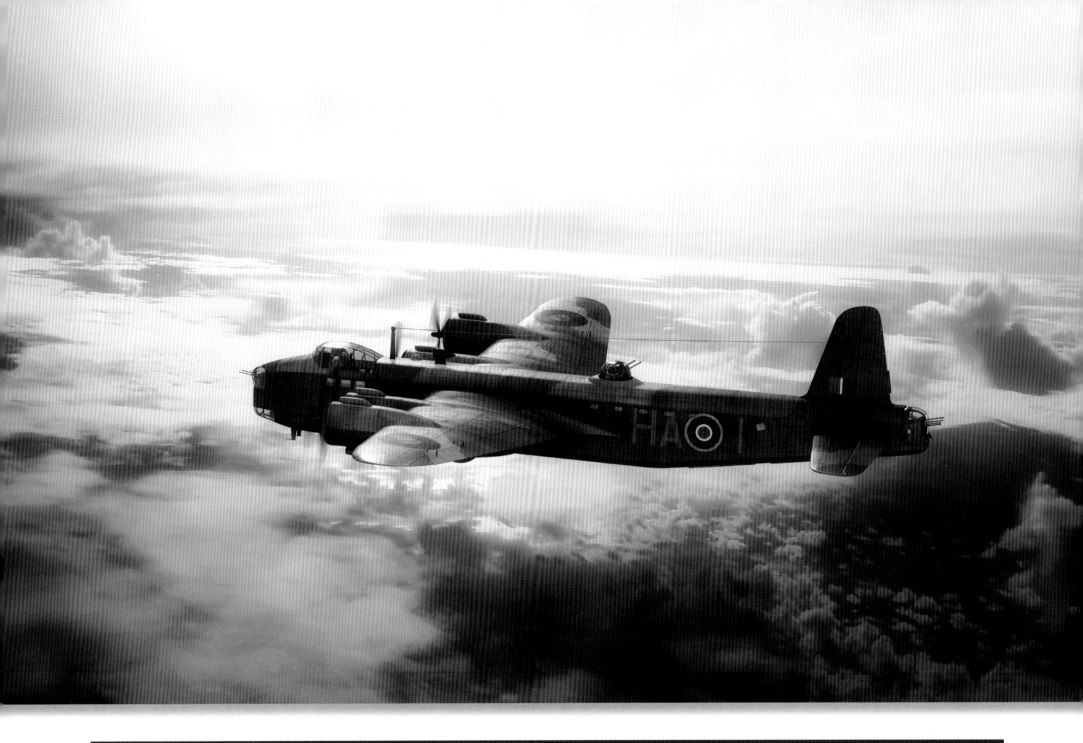

SPECIFICATIONS

FOR MODEL: III
TYPE: bomber
MANUFACTURER: Short Brothers
OPERATORS: UK; Egypt
CREW: pilot, co-pilot, navigator/bomb aimer, forward gunner/radio operator, dorsal gunner, tail gunner
LENGTH: 87.3ft (26.58m)

WINGSPAN: 99.1ft (30.19m)
WEIGHT: 46,900lb (21,274kg) [empty]-70,000lb (31,752kg) [max. take-off weight]
MAX. SPEED: 270mph (435km/h)
SERVICE CEILING: 17,500ft (5,332m)
RANGE: 2,010 miles (3,242km)
POWERPLANT: Bristol Hercules XVI x 4

ARMAMENT: Browning .303in machine gun x 2 in nose and dorsal turrets; Browning .303 machine gun x 4 in tail turret; max. bomb load of 14,000lb (6,350kg)
MAIDEN FLIGHT (STIRLING I): 14 May 1939
IN SERVICE: 1941-1946
NUMBER BUILT: 2,383

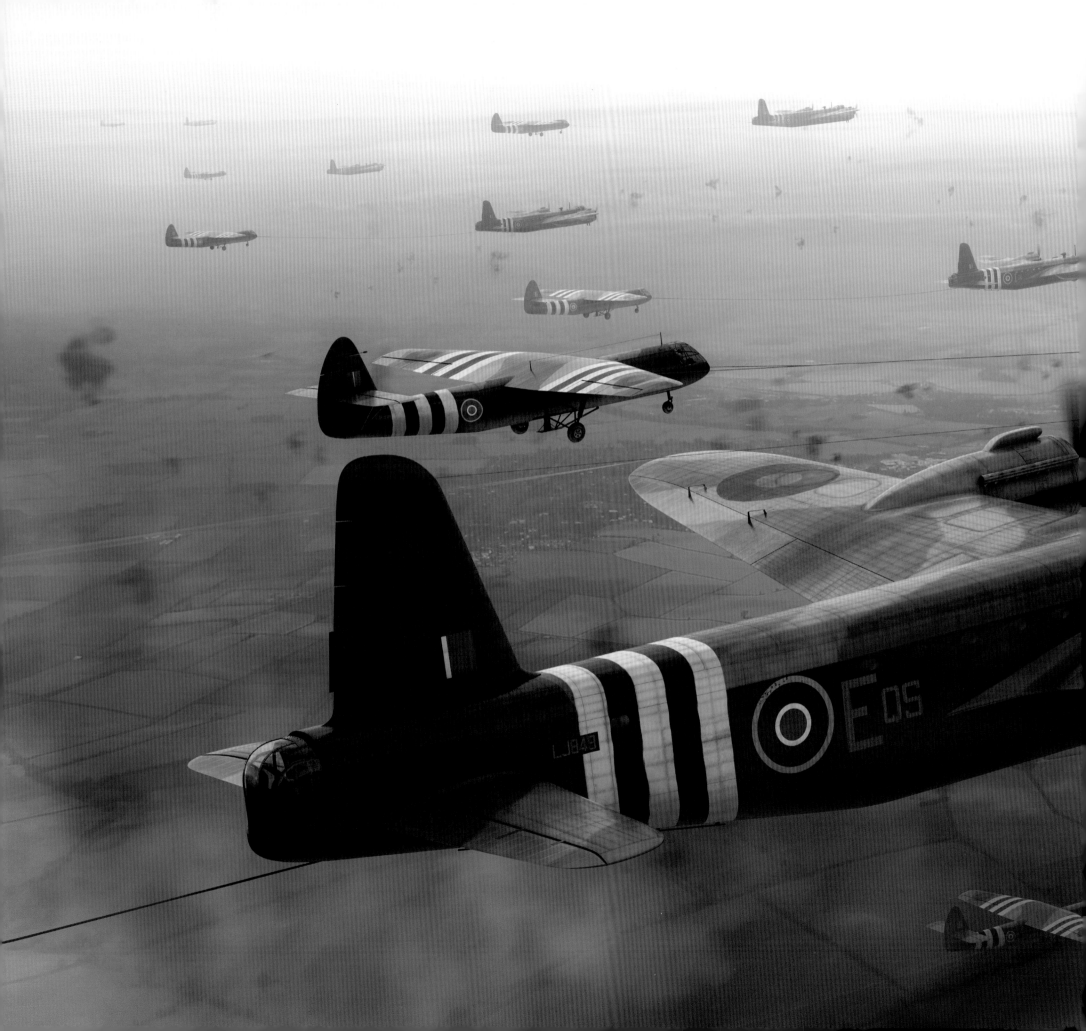

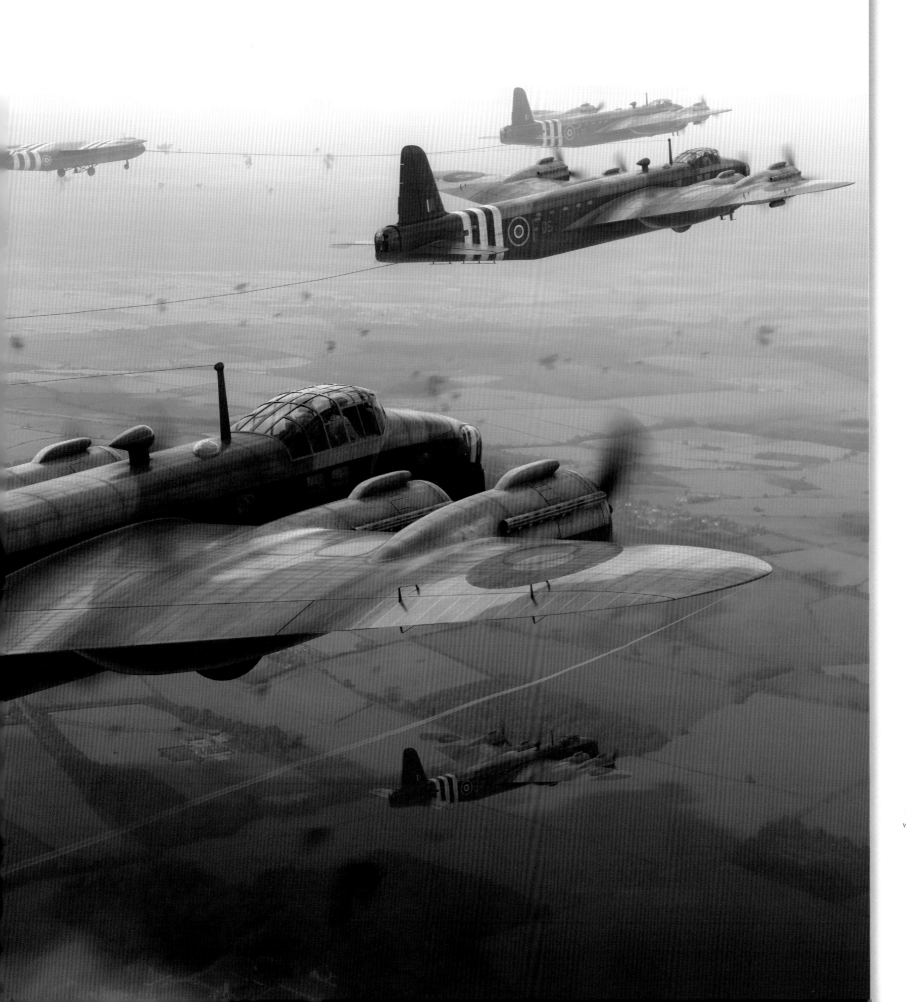

Operation Mallard.
Stirling Mk IVs under fire while towing Horsa gliders and carrying elements of the 6th Airlanding Brigade to their landing zones on the evening of 6 June 1944.

SUNDERLAND

A military version of the S.23 Empire flying boat, the Sunderland was quickly developed to fill an outstanding requirement, set out in 1933, for a maritime patrol aircraft. Production aircraft began entering service in October 1937, joining squadrons in both the UK and Singapore. Forty Mark Is were operational by the outbreak of WW2, and were soon proving their worth, providing vitally needed convoy escort and anti-submarine patrols in the Atlantic, Mediterranean and Middle East, and scoring their first U-boat kill in July 1940 (by a Sunderland of the Royal Australian Air Force).

War service also resulted in an increase in the number of machine guns carried by Mark Is, while the Mark III carried a four-gun FN.7 tail turret and two harder-hitting .50 calibre machine guns, one on each side, as well as more ammunition. After numerous encounters with German aircraft, acquitting itself very well in a number of epic aerial duels, in several cases while heavily outnumbered, the apparently vulnerable flying boat was christened 'the flying porcupine' by its subsequently wary opponents.

But the Sunderland's main enemy was below (or on) the waves. Much of the fighting was technological, with both sides employing radar and anti-radar measures to spot their opponents. By October 1941, the Mark 1 Sunderland was fitted with the ASV Mark II air-to-surface radar, emitted through four 'stickleback' aerials mounted on the aircraft's back. The U-boats hit back with the Metox passive receiver, which picked up the ASV's emissions, allowing the submarine to know when a Sunderland was nearby. In response, the ASV was modified on the Mark III so the radar operated at a different frequency.

By 1943, the U-boats were losing their war and took to staying on the surface, preferring to shoot it out with Allied aircraft. As such, they were fitted with 20mm and 37mm cannon batteries, which were much heavier hitting than the machine guns of the Sunderland, requiring the flying boat to weather the enemy's fire before it could bring its own weapons to bear. Sunderland losses rose accordingly, but one solution was to operate at night, using radar to close on the U-boats then flares to visually spot and engage the sub.

Between 1939 and 1942, the Sunderlands shared in only three U-boat kills. However, as the more powerful and heavily armed versions came into service, that tally rose, with twelve U-boats destroyed in 1943 and another twelve lost in 1944. By the end of the war the number of targets for the flying boats had seriously diminished, no doubt due in part to the efforts of the Sunderlands.

RIGHT: **Sunderland Work in Progress**

OVERLEAF: **U-Boat Attack.** A Sunderland Mk III of RAF 423 Squadron, flying from Castle Archdale, Northern Ireland, attacking a U-boat in 1943.

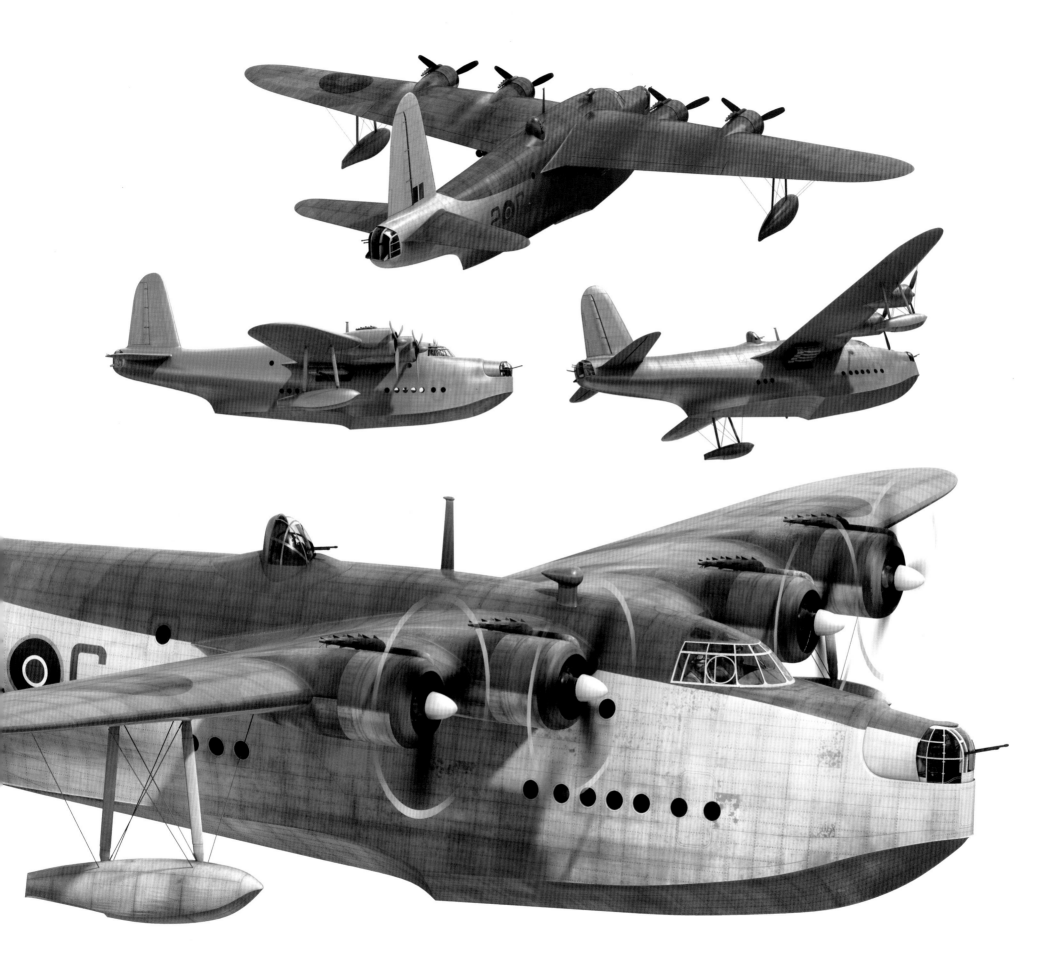

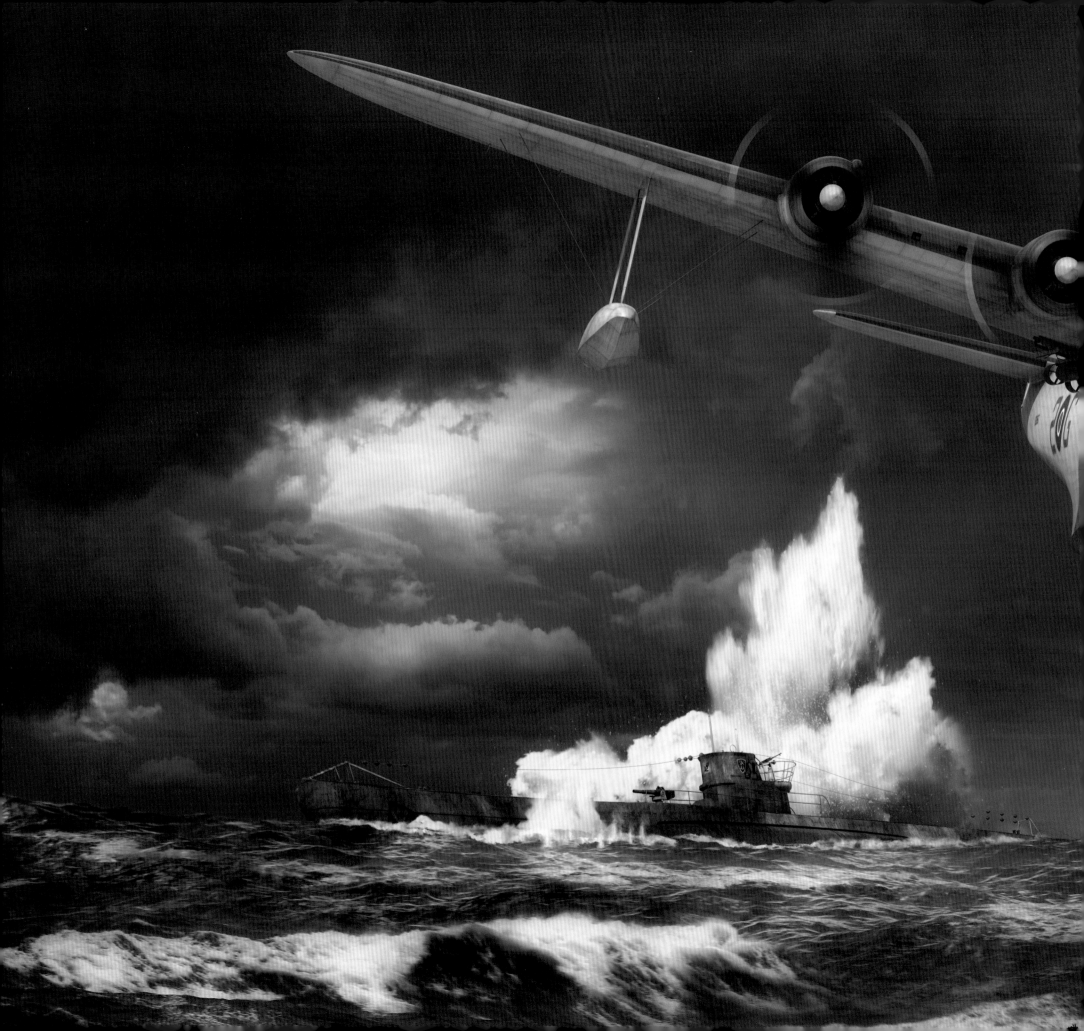

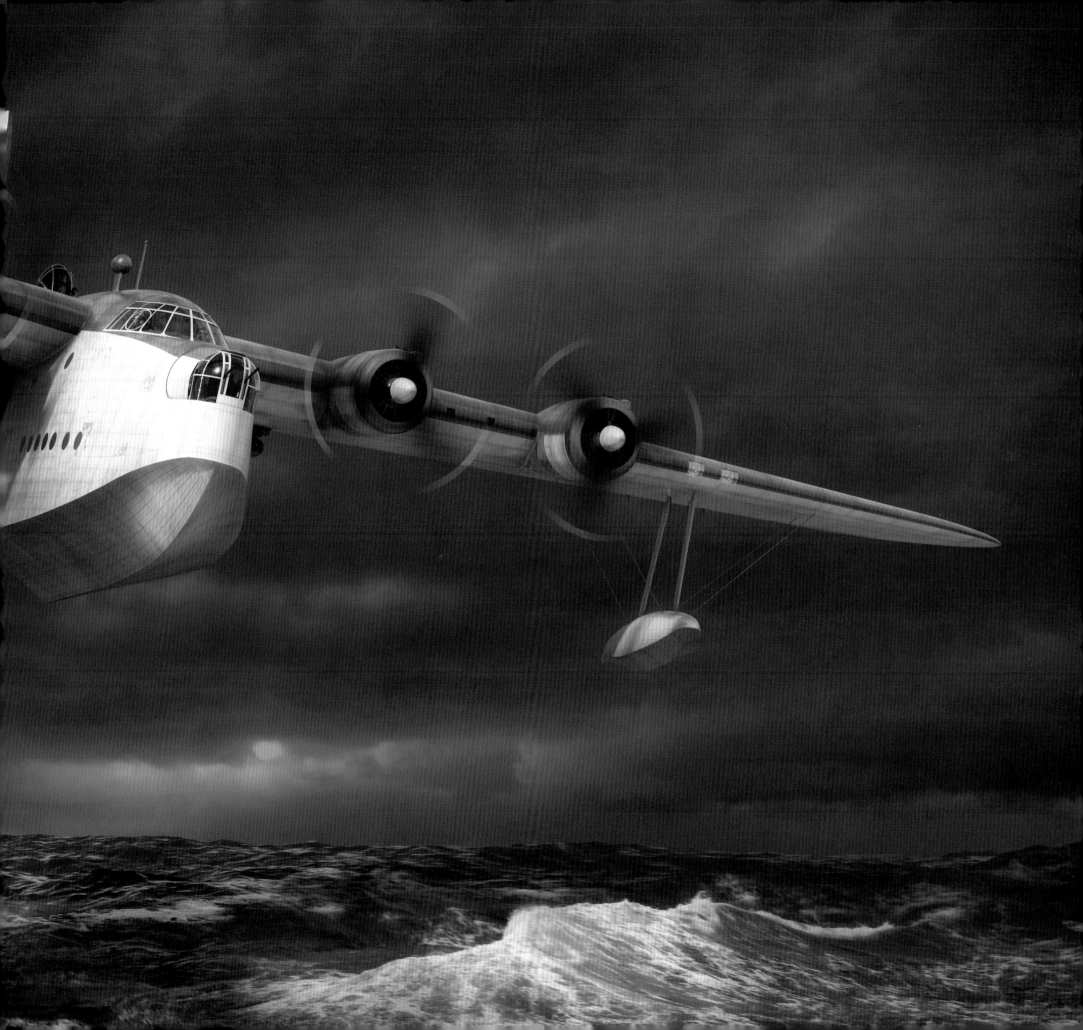

JU-87 STUKA

SPECIFICATIONS

FOR MODEL: Ju-87D
TYPE: dive bomber
MANUFACTURER: Junkers
OPERATORS: Germany; Bulgaria; Italy; Romania
CREW: pilot, rear-gunner
LENGTH: 37.9ft (11.50m)
WINGSPAN: 45.3ft (13.80m)
WEIGHT: 8,600lb (3,900kg) [empty]-14,550lb (6,600kg) [take-off weight]
MAX. LEVEL SPEED: 255mph (410km/h)

SERVICE CEILING: 24,000ft (7,300m)
RANGE: 954 miles (1,535km)
POWERPLANT: Junkers Jumo 211J-1
ARMAMENT: MG 17 7.92mm machine gun x 2 in wings; MG 15 7.92mm machine gun in rear cockpit; maximum payload of 3,968lbs (1,800kg) on belly and 1,102lbs (500kg) on each wing
MAIDEN FLIGHT: 17 September 1935
IN SERVICE: 1936-1945
NUMBER BUILT (ALL TYPES): 5,709

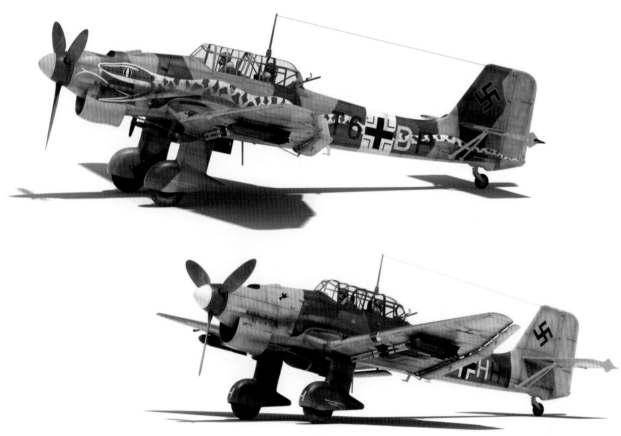

TOP: **Desert Snake Stuka.** This form of desert markings may have been used by unit leaders only.
ABOVE: **Yellow Tail Stuka**
RIGHT: **Stuka Dive**

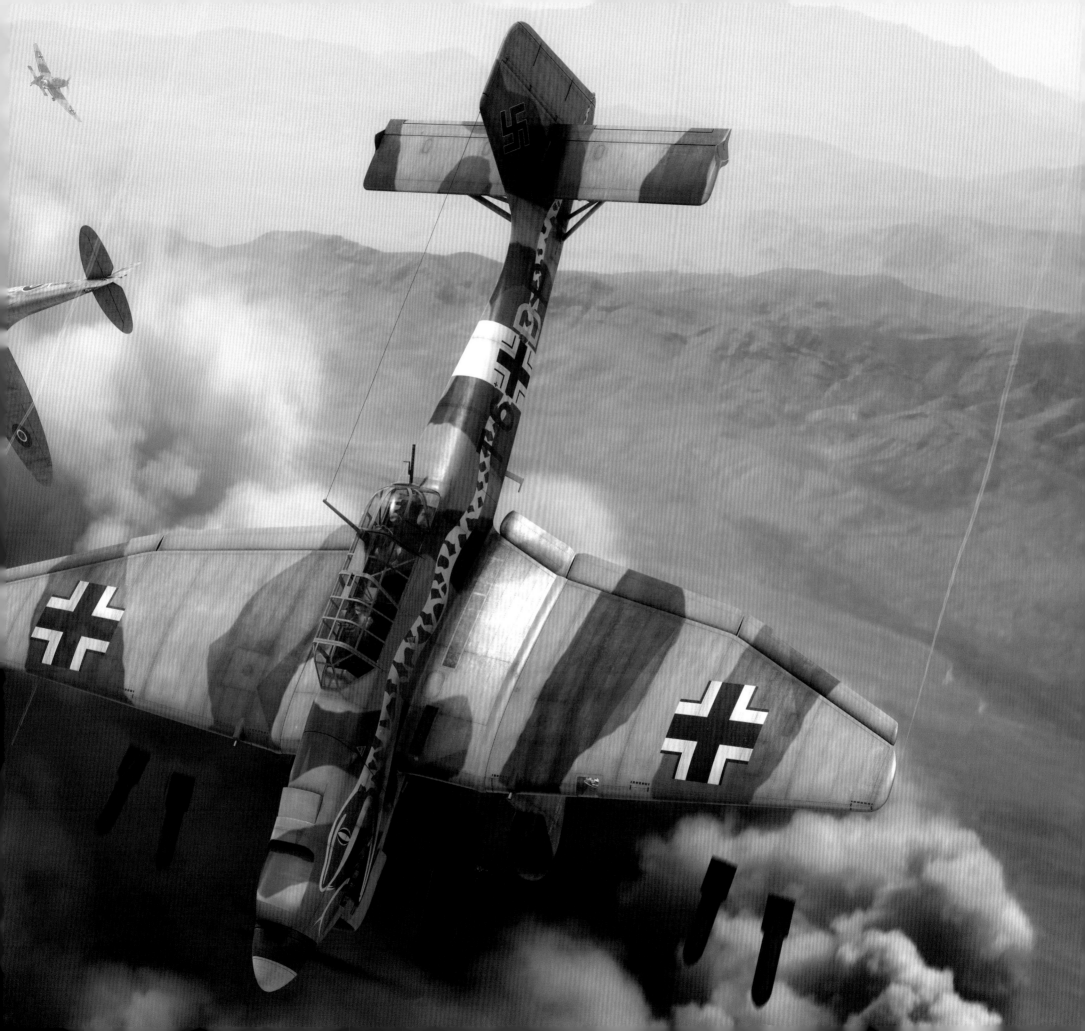

With its inverted 'gull' wings, fixed undercarriage and the distinctive sound of its 'Jericho trumpet' sirens, the Stuka was the aerial face of Nazi Germany's Blitzkrieg tactics early in WW2.

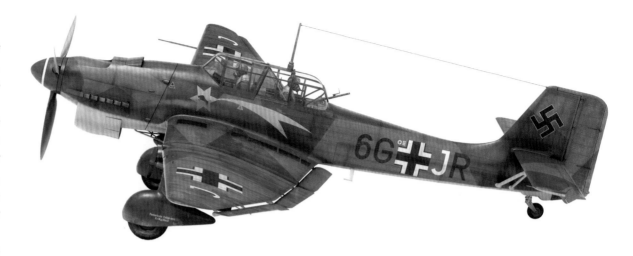

The early development of the Ju-87 reflected the times it originated in. The first prototype was built in 1933, when Nazi Germany was still hampered by post-WW1 treaty obligations. Somewhat ironically, it was powered by a British engine, the Rolls-Royce Kestrel, and was built in Sweden, then secretly smuggled into Germany in late 1934.

Initially fitted with twin fins (as in the Bf 110), the stress on the tail of dive-bombing resulted in them crumpling, leading the aircraft to crash, killing the two test pilots. A single tail was used and the German Jumo engine fitted to later prototypes. The design underwent a series of refinements before being certified ready for production, the strengthened airframe intended to be able to sustain dive speeds of 370mph (600km/h), usually at a sixty-degree angle. Pilots could also be subject to as many as 8.5g when the aircraft pulled out of the dive, so various measures, such as special oxygen masks and pressurised cabins, had to be adopted to prevent crews from blacking out.

Early production models featured an enclosed, 'trousered' undercarriage, and were tested in combat in August 1937 during the Spanish Civil War. In September 1939, 366 Stukas took part in the first Blitzkrieg into Poland. With their screaming sirens mounted on the now-modified and slimmed-down undercarriage, Stukas conducted pinpoint close air support strikes and were seen very much as 'flying artillery'. They made history over Poland by scoring the first air combat kill of the war when a Stuka shot down a Polish PZL P.11c fighter during an attack on the Pole's home airfield.

Things were still going the Stuka's way during the opening moves of the Battle of Britain in June 1940. Units conducted a number of successful attacks against British shipping in the Channel and the North Sea, sinking twenty vessels, and destroying three radar stations. However, they now encountered British Spitfires and Hurricanes in considerable numbers and the dive bomber's weaknesses were

exposed. It was too lightly armed and too slow and unwieldy against the RAF fighters. In six weeks of hard fighting, fifty-nine were destroyed and thirty-three damaged. They were withdrawn from the Battle on 18 August, although they continued to operate against British coastal shipping.

In early 1941, Stuka units – *Stukageschwaders* – arrived in North Africa, helping to shore up the retreating Italian army and hitting British shipping in the Mediterranean. They scored some notable successes, wreaking havoc amongst Royal Navy shipping during the British evacuation of Crete, when they sank six cruisers and destroyers and damaged the battleship HMS *Warspite*.

The Stuka had initially done well in the early stages of the German invasion of Russia in June 1941, repeating the successful tactics employed in earlier Blitzkriegs. *Stukageschwaders* generated huge sorties rates in support of such famous battles as Sevastopol and Stalingrad. However, by the summer of 1943, the Stukas were once more under threat from increasing numbers of high-quality Soviet fighters and were being replaced by Fw 190F and G fighterbomber variants. Despite their seeming obsolescence, the Stukas did continue to serve effectively as tank killers, remodelled as the Ju-87G fitted with 37mm cannons in wing-mounted pods.

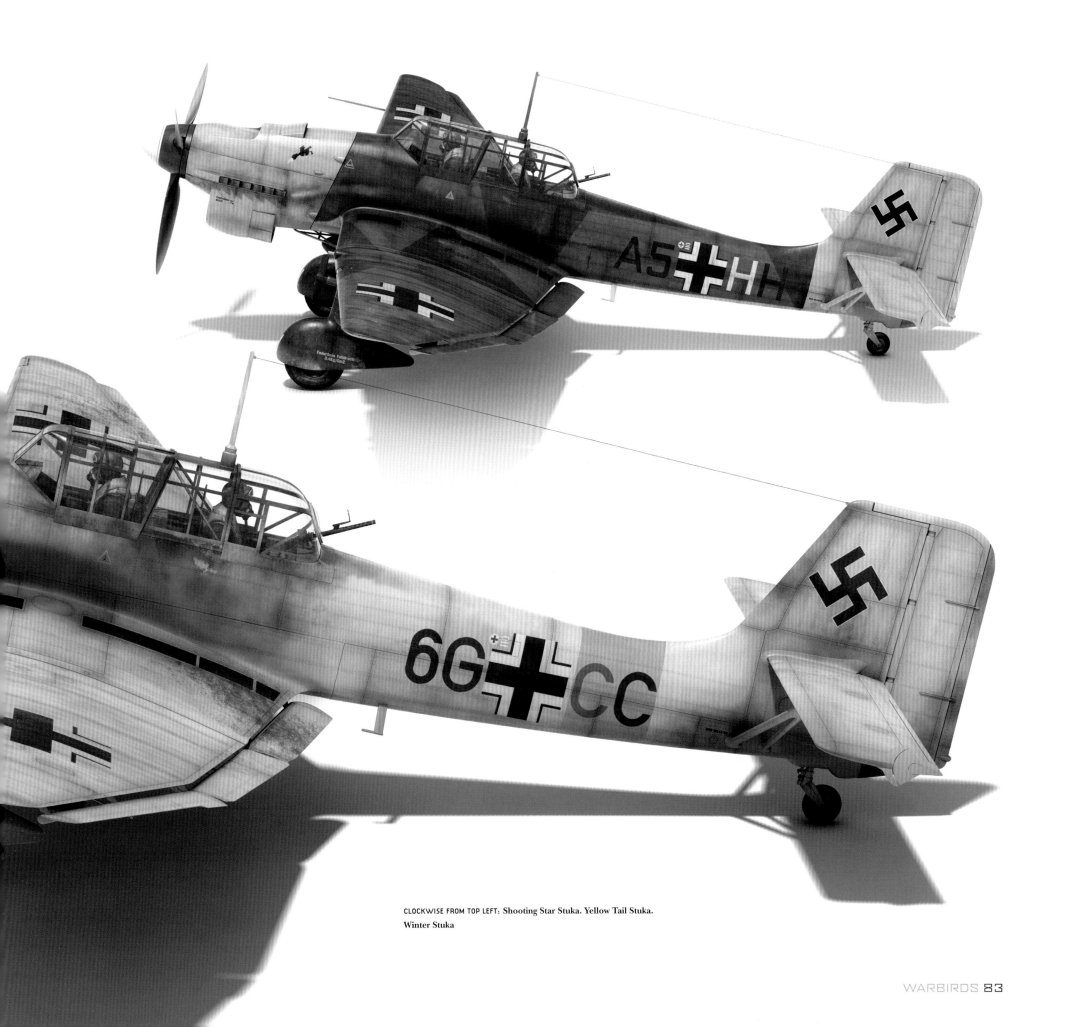

CLOCKWISE FROM TOP LEFT: Shooting Star Stuka. Yellow Tail Stuka.
Winter Stuka

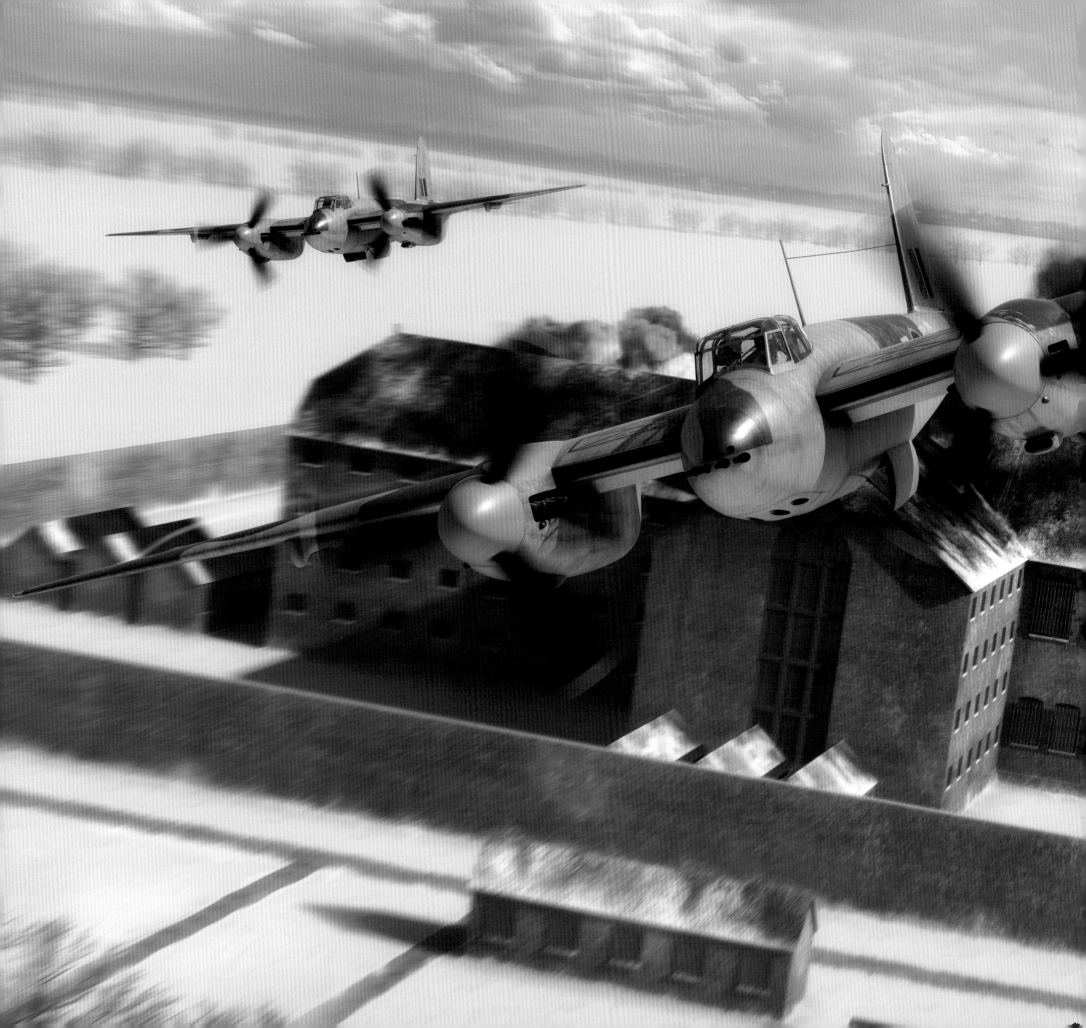

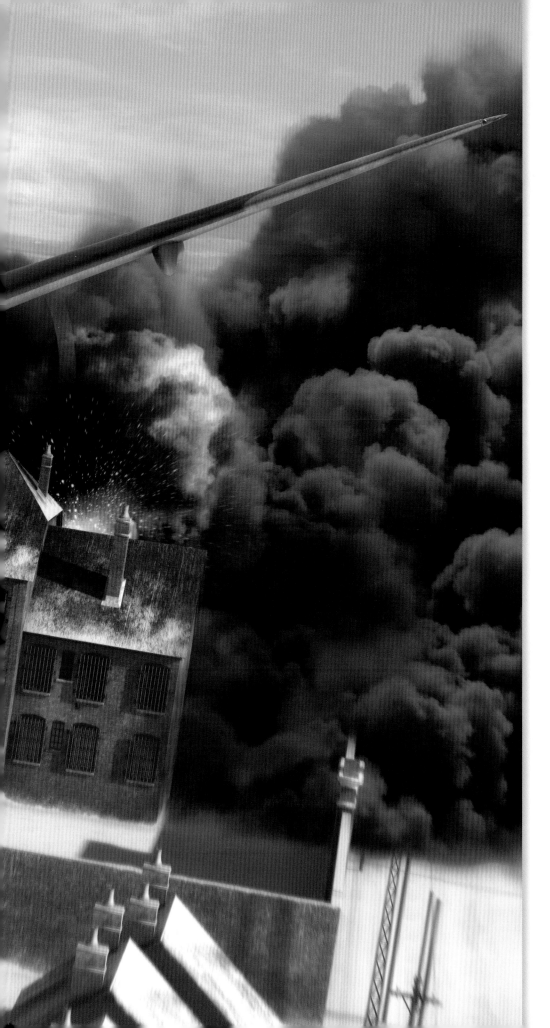

MOSQUITO

SPECIFICATIONS

FOR MODEL: F II
TYPE: fighter-bomber/reconnaissance
MANUFACTURER: de Havilland Aircraft Co.
OPERATORS: UK; Australia; Belgium;
Canada; Israel; Sweden; USA
CREW: pilot, navigator/radio operator
LENGTH: 40.1ft (12.44m)
WINGSPAN: 54.2ft (16.51m)
WEIGHT: 14,300lb (6,486kg) [empty]-
20,000lb (9,072kg) [max. take-off
weight]

MAX. SPEED: 370mph (595km/h)
SERVICE CEILING: 29,000ft (8,839m)
RANGE: 900 miles (1,400m)
POWERPLANT: Rolls-Royce Merlin 21 x 2
ARMAMENT: Hispano Mk II 20mm
cannon x 4 and Browning 0.303in
machine gun x 4 in nose
MAIDEN FLIGHT: 25 November 1941
IN SERVICE: 1941-1961
NUMBER BUILT: 7,781 (all versions)

With concerns about the availability of metals at the outbreak of WW2, an order for fifty Mosquitos, one of the few 'modern' aircraft built from wood, was placed by the RAF in March 1940. One of the fastest aircraft in the world at the time, it entered service in September 1941 as a high-altitude reconnaissance aircraft, its speed and service ceiling putting it beyond the reach of most Luftwaffe fighters. Two months later, the bomber variant, the B Mark IV, became operational, with elite units of Mosquito bombers serving as Bomber Command's Light Night Striking Force.

The first fighter version was soon under development, the clear nose for the bomb-aimer replaced with four 20mm cannons and four .303 machine guns. Others were built as night fighters, equipped with increasingly sophisticated radars, and proved extremely effective, with fifty-nine of their pilots becoming aces. By far the most successful version, however, was the fighter-bomber. The first of 2,257 aircraft built flew on 1 June 1942. Its reinforced wings enabled the fitting of underwing bombs and rockets, making it an extremely effective anti-shipping aircraft. In 1943, some of the anti-shipping Mosquitos were turned into Tsetses, a version fitted with a huge 25-round Molins 6-pounder cannon and additional armour. Intended for use against heavily armed U-boats, the Tsetses proved very effective, sinking as many as seven submarines and a number of surface vessels, and even shooting down aircraft.

Jailbreakers: The 487 Squadron Mosquito FB VI of Group Capt. P.C. Pickard completes its attack on the Gestapo-run Amiens Prison on 18 February 1944. The precision attack breached the walls and buildings, allowing 258 interred French Resistance fighters to escape (although 102 were killed in the raid). This was one of a number of spectacular precision bombing raids conducted by Mosquito fighter-bombers.

TYPHOON

SPECIFICATIONS

FOR MODEL: 1B

TYPE: fighter-bomber

MANUFACTURER: Hawker Aircraft

OPERATORS: UK; Canada

CREW: pilot

LENGTH: 31.11ft (9.73m)

WINGSPAN: 41.7ft (12.67m)

WEIGHT: 9,800lb (4,445kg) [empty]-13,980lb (6,341kg) [max. take-off weight]

MAX. SPEED: 405mph (652km/h)

SERVICE CEILING: 35,200ft (10,729m)

RANGE: 610 miles (982km)

POWERPLANT: Napier Sabre IIA

ARMAMENT: Hispano 20mm cannon x 4; 500lb or 1,000lb bomb x 2 or RP-3 3in rocket x 8

MAIDEN FLIGHT: 24 February 1940

IN SERVICE: July 1941-November 1945

NUMBER BUILT: 3,330

OVERLEAF: **Storm Rising.** 2 Mk 1Bs, OV-Z and OV-C, of 197 Squadron, take off, each carrying 2 500lb bombs. These aircraft were referred to as 'Bomphoons'.

Originally designed to replace the legendary Hawker Hurricane, the Typhoon's development was plagued with problems from its inception. Performance above 20,000ft was poor, as was its rate of climb. The new Sabre engine was unreliable, with a tendency to burst into flames and leak carbon monoxide into the cockpit, and the rear fuselage was prone to catastrophic structural failures. Not surprisingly, cancellation loomed, until the Luftwaffe's introduction of the Focke-Wulf Fw 190 in August 1941. The German fighter quickly proved superior to the RAF's main fighter at the time, the Spitfire Mark V, but a number of improvements to the Typhoon resulted in an excellent low-altitude fighter and the only one capable of catching the Fw 190. The 'Tiffys', as they became known, were soon stymieing the hit and run attacks by Luftwaffe raiders over southern England during late 1942 and early '43, racking up an impressive tally of kills.

The Typhoon really came into its own as a fighter-bomber, a role it was ideal for with its excellent low-altitude handling, stability as a gun platform and powerful engine. Twenty squadrons were assigned to the 2nd Tactical Air Force (TAF) and followed British and Canadian armour into Europe after the Normandy landings in June 1944. Tactical airpower was to prove decisive against the German Panzers in France, where the constant presence of Allied fighter-bombers made German movements difficult and wore down resistance. Typhoons were even credited by Allied Supreme Commander Dwight D. Eisenhower with a major role in the success of his forces there.

Typhoons also carried out a number of pinpoint raids against vital targets, attacking radar sites, key headquarters and shipping while supporting the Allied advance across the Rhine into Germany.

Some 500 Typhoons were lost in combat, the pilots rarely managing to escape at the low levels and high speed they flew at.

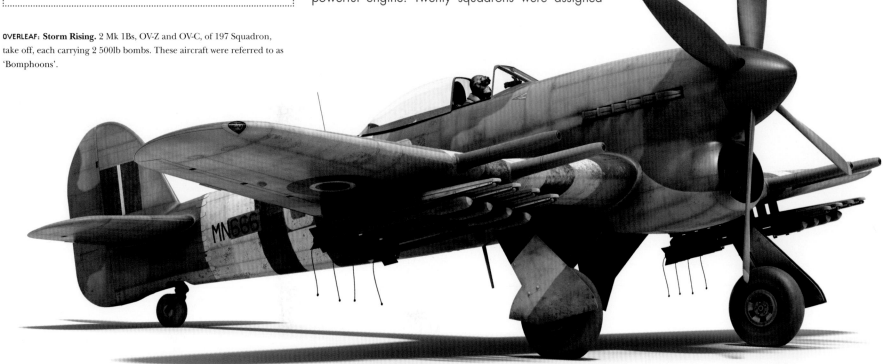

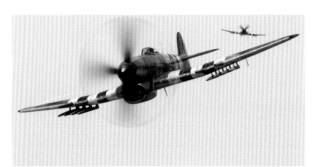

OPPOSITE: **Typhoon Front View on the Ground**

ABOVE: **Typhoon! Step-by-Step**

BELOW: **Typhoon!** Typhoons attacking a column of German armour. *Courtesy of Airfix. © Hornby 2014.*

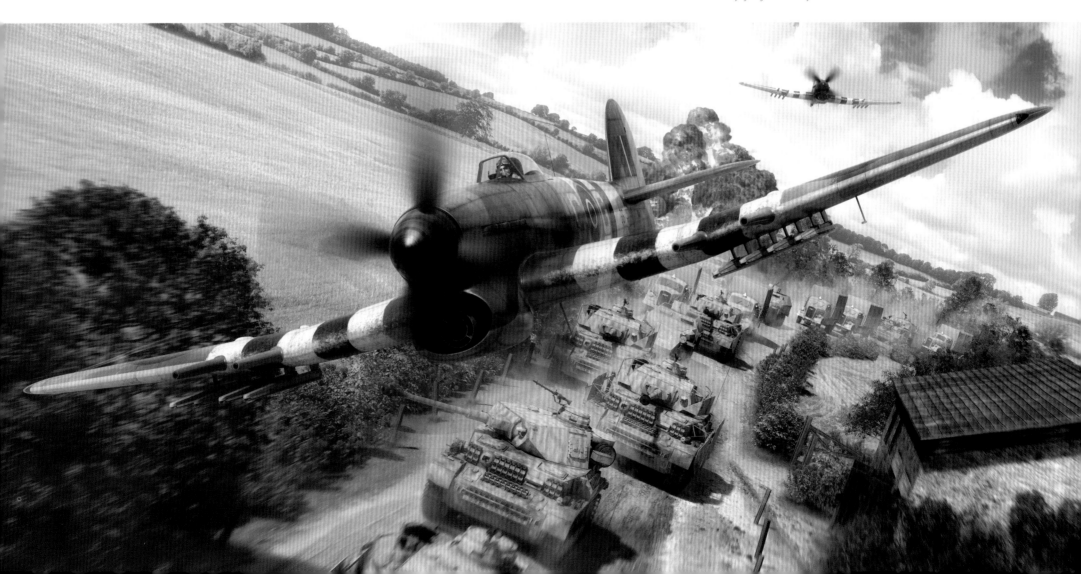

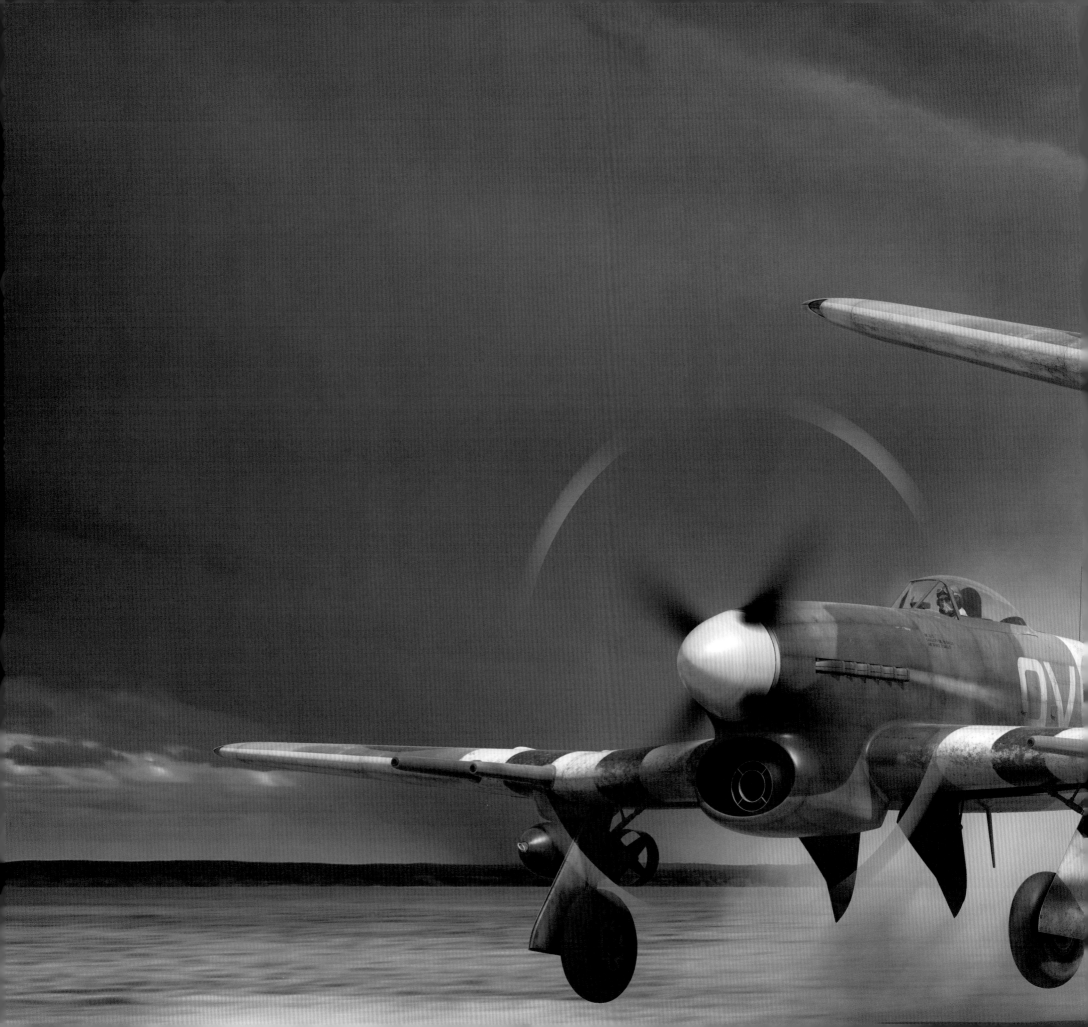

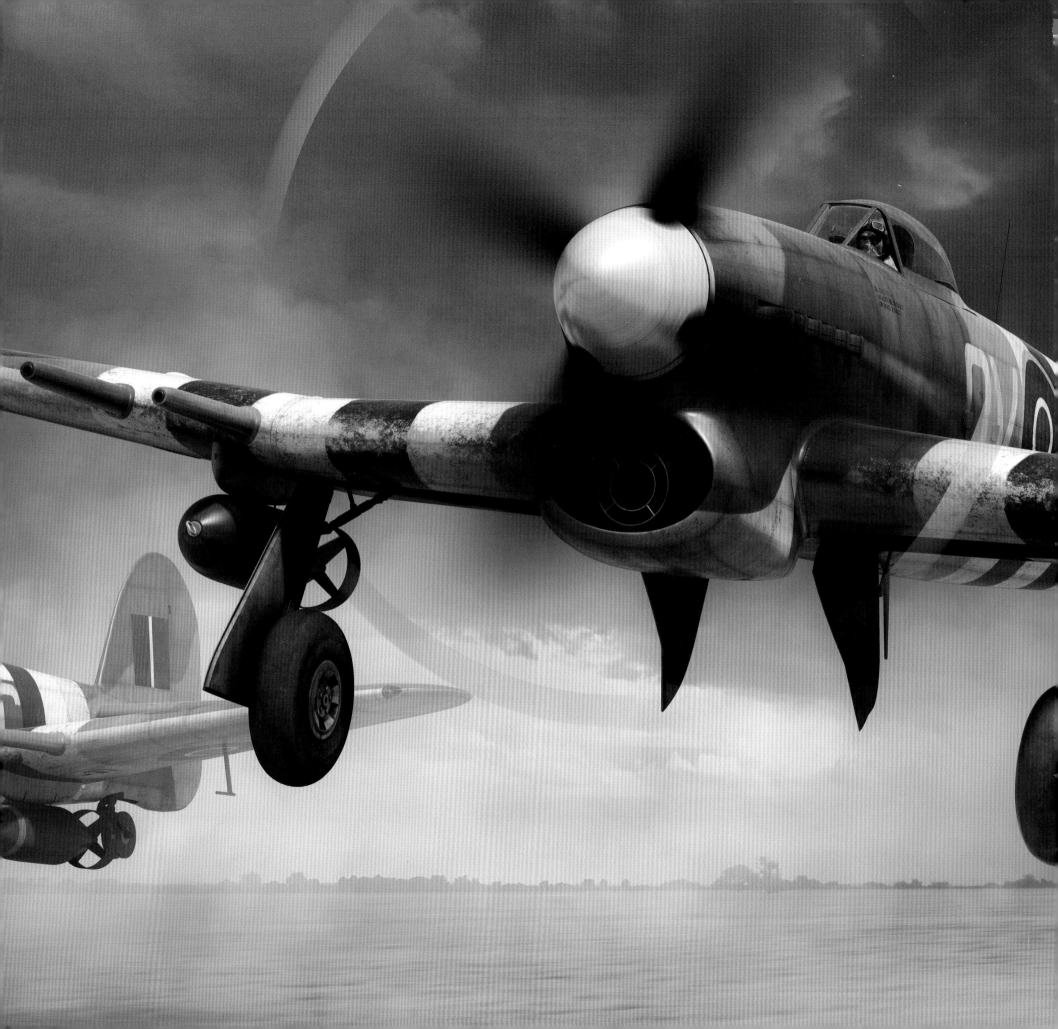

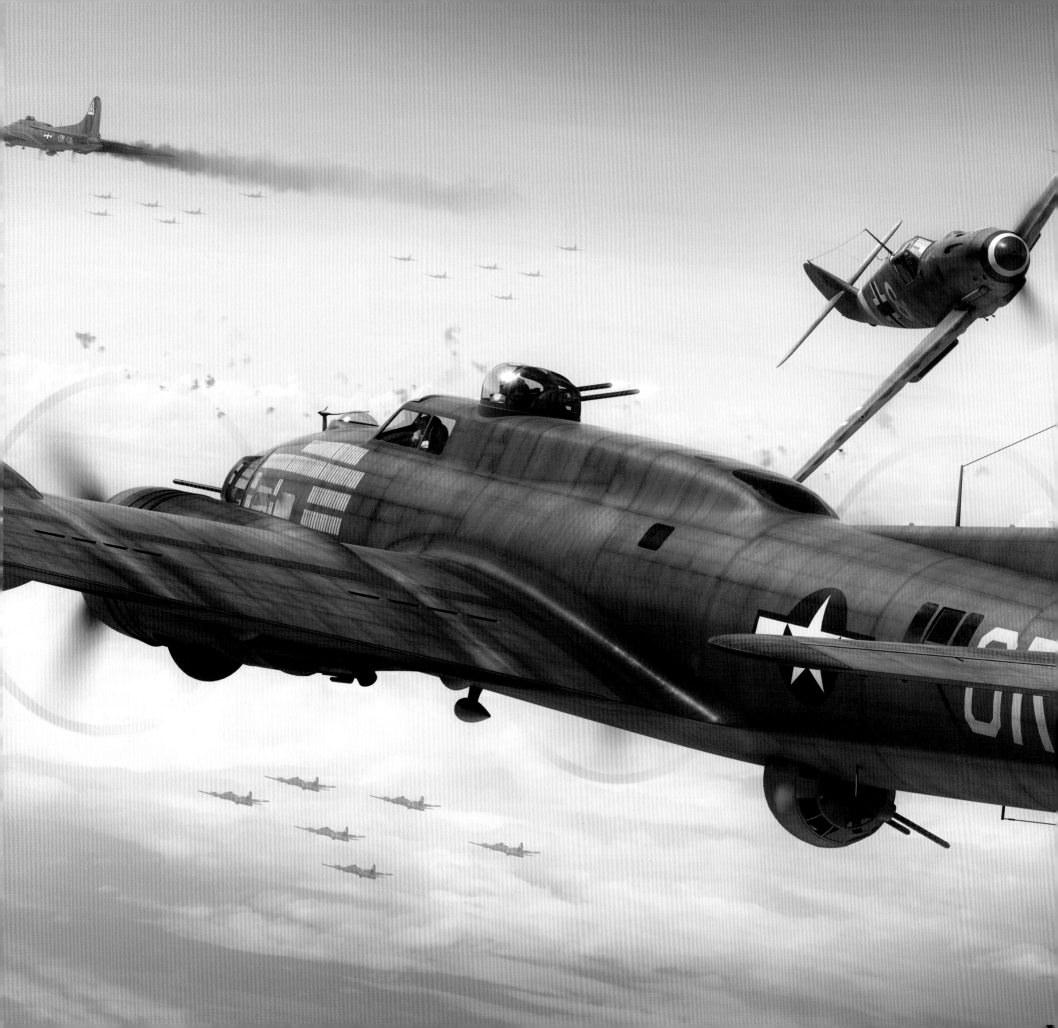

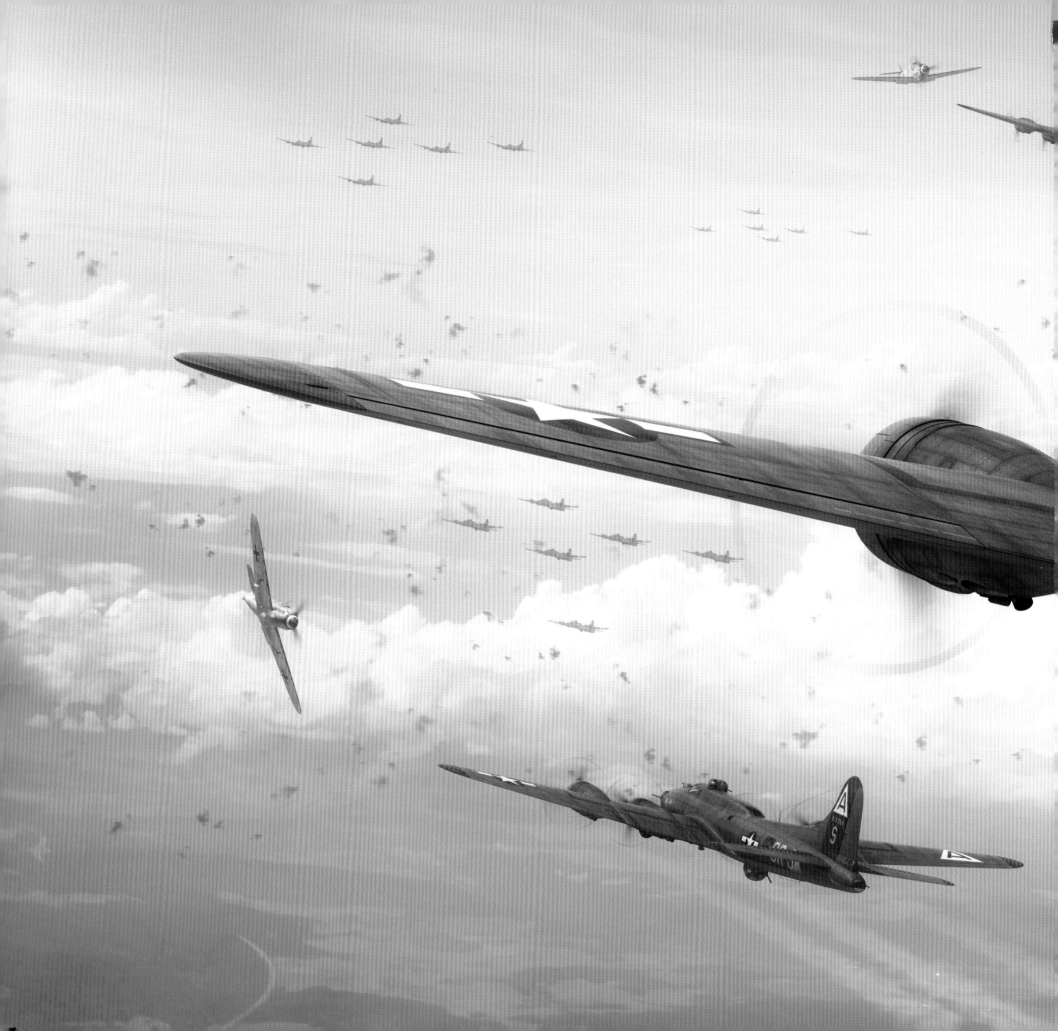

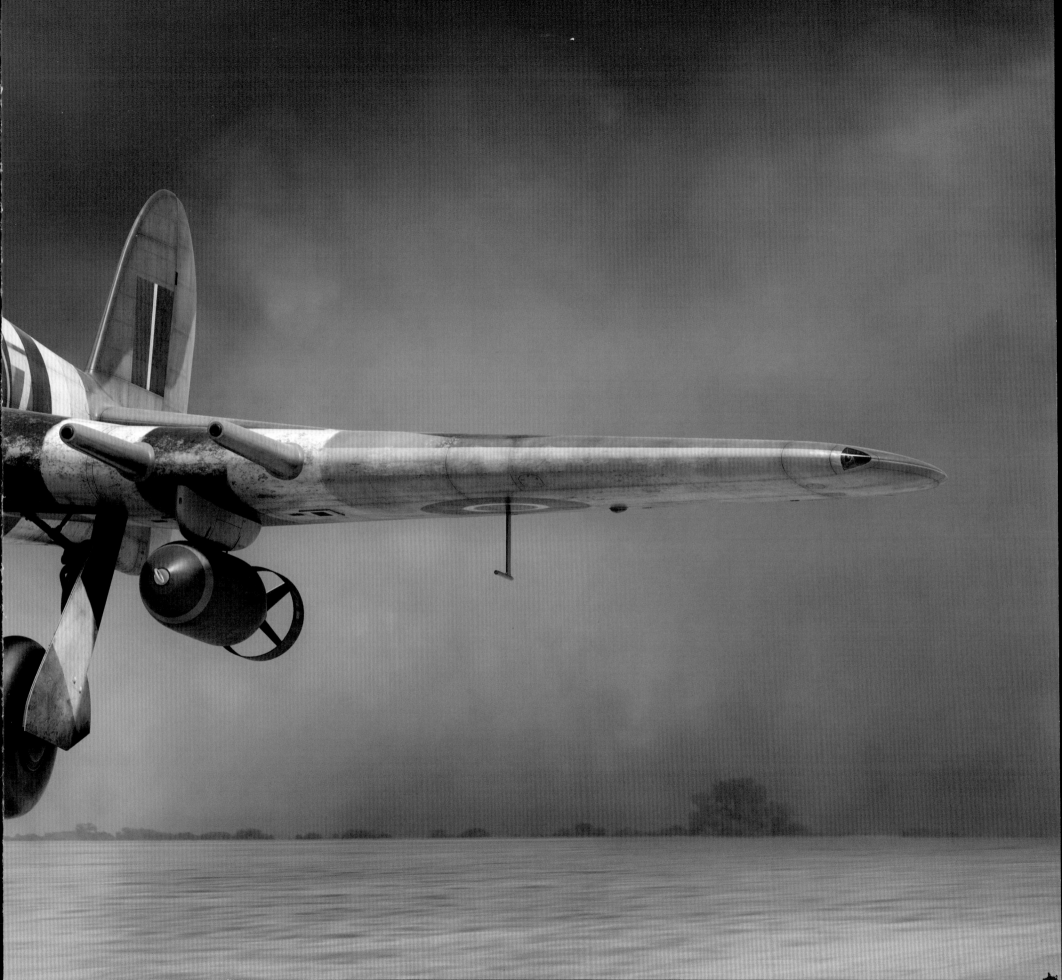

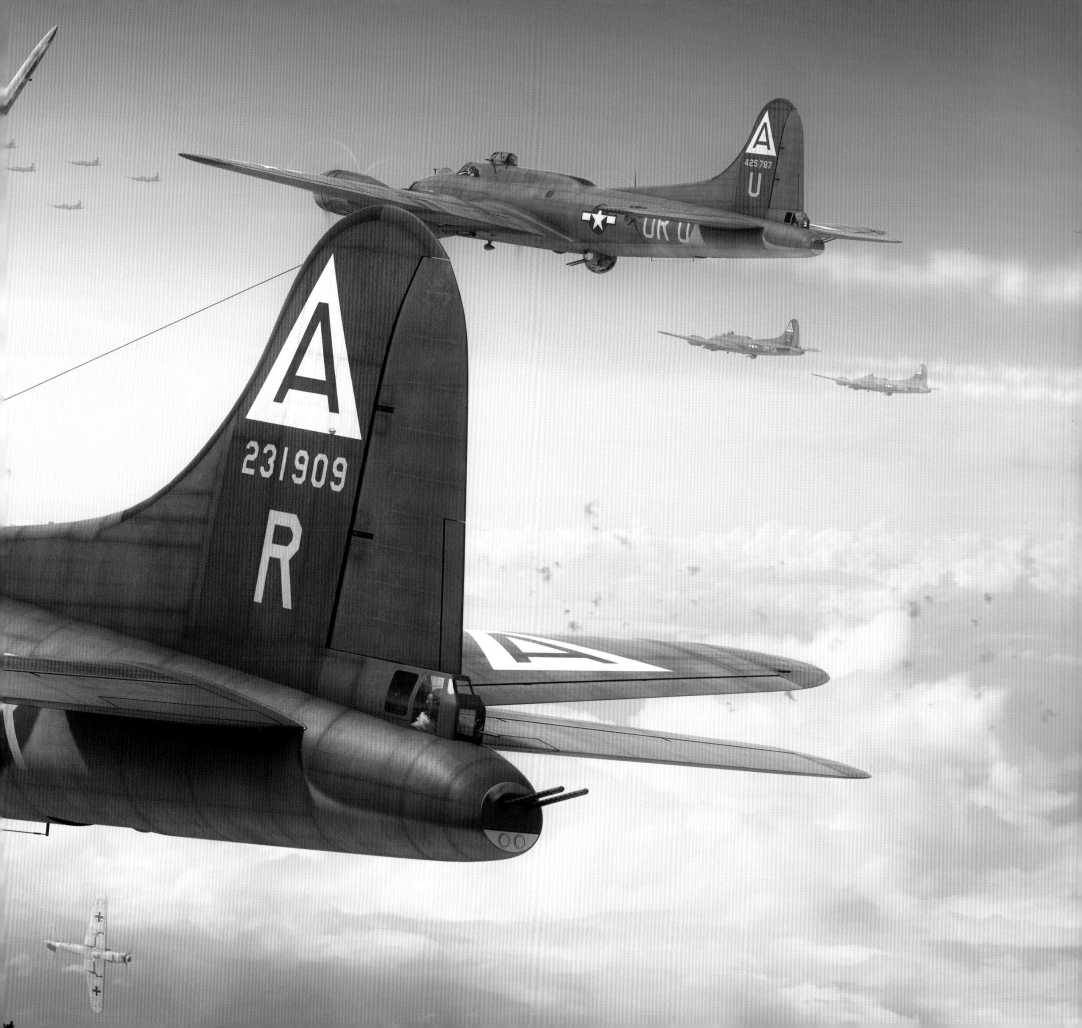

THE MIGHTY EIGHTH

From August 1942 until the end of the war in Europe, the USAAF's Eighth Air Force conducted a continuous daylight bombing campaign against German forces and industry in occupied Europe and the Nazi homeland. The first mission was flown by twelve B-17Es on 17 August 1942 against a railyard in Scotteville, France. Piloting the lead aircraft was Major Paul Tibbets, who would later fly Enola Gay, the B-29 that dropped the atomic bomb on Hiroshima. Only two Flying Fortresses were damaged.

However, this did not set a precedent for subsequent raids. Early variant B-17s, the E and F models, flew increasing numbers of missions, out of range of any Allied fighter, and in the hope that their batteries of machine guns would see off any Luftwaffe fighters, but the more heavily armed German Messerschmitts and Fw 190s began exacting a heavy toll on the American bombers. By the summer of 1943, Eighth Air Force losses were approaching critical level, reaching their nadir on 14 October during a raid on ballbearing factories at Schweinfurt – a

(ALSO PREVIOUS SPREAD)

day that became known as 'Black Thursday'. A mass of some 300 German fighters attacked the raid's 291 B-17s. 77 bombers were lost and 122 damaged.

By now, the definitive version of the B-17, the G model, was in service in considerable numbers, distinguished by the new chin turret to dissuade head-on attacks by fighters. February 1944 marked a turning point for the bomber crews of the 'Mighty Eighth'. Returning to Schweinfurt as part of a major bombing campaign known as 'Big Week', the bombers were escorted by P-47 Thunderbolts, equipped with long-range drop tanks, and the new P-51 Mustang. When the Luftwaffe rose to meet the raids, its fighters were faced with large numbers of opposing aircraft that could meet them on equal terms of quality and in superior numbers. Bomber losses began to fall and by the summer of 1944, flak was the greater menace.

For the B-17s and their stable-mate, the B-24 Liberator, the bombing campaign did not end until 24 April 1945, a few days before the German surrender.

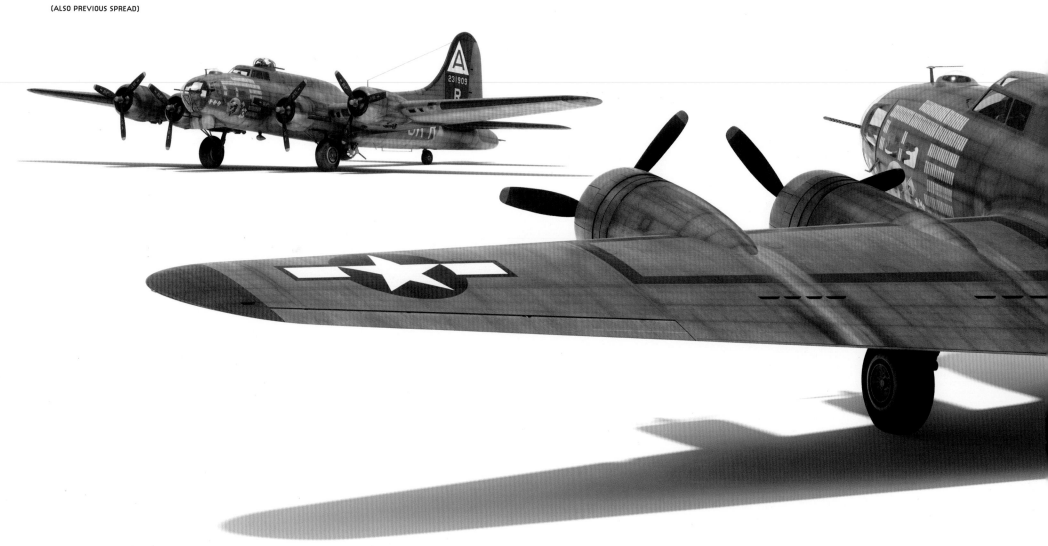

B-17 FLYING FORTRESS

SPECIFICATIONS

FOR MODEL: B-17G
TYPE: bomber
MANUFACTURER: Boeing
OPERATORS INCLUDE: USA; Brazil; Canada; Denmark;
France; Iran; Israel; Mexico; Portugal; South Africa;
Taiwan; Soviet Union; Sweden; UK
CREW: pilot, co-pilot, flight engineer, bombardier/nose
gunner, navigator, radio operator, waist gunners x 2,
dorsal turret gunner, ball turret gunner, tail gunner

LENGTH: 74.4ft (22.66m)
WINGSPAN: 103.9ft (31.62m)
WEIGHT: 36,135lb (16,391kg) [empty]-65,500lbs
(29,710kg) [max. take-off weight]
MAX. SPEED: 287mph (462km/h)
SERVICE CEILING: 35,600ft (10,850m)
RANGE: 2,000miles (3,219km)
POWERPLANT: Wright R-1820-97 Cyclone x 4
ARMAMENT: Browning .50 calibre machine gun x 2 in

chin, dorsal, ball and tail turret; .50 calibre x 2 in
nose, .50 calibre x 1 in radio compartment and two
waist positions; maximum bomb load of 12,800lbs
(5,800kg)
MAIDEN FLIGHT: 28 July 1935
IN SERVICE: April 1938-1968 (Brazil)
NUMBER BUILT: 12,731 (all versions)

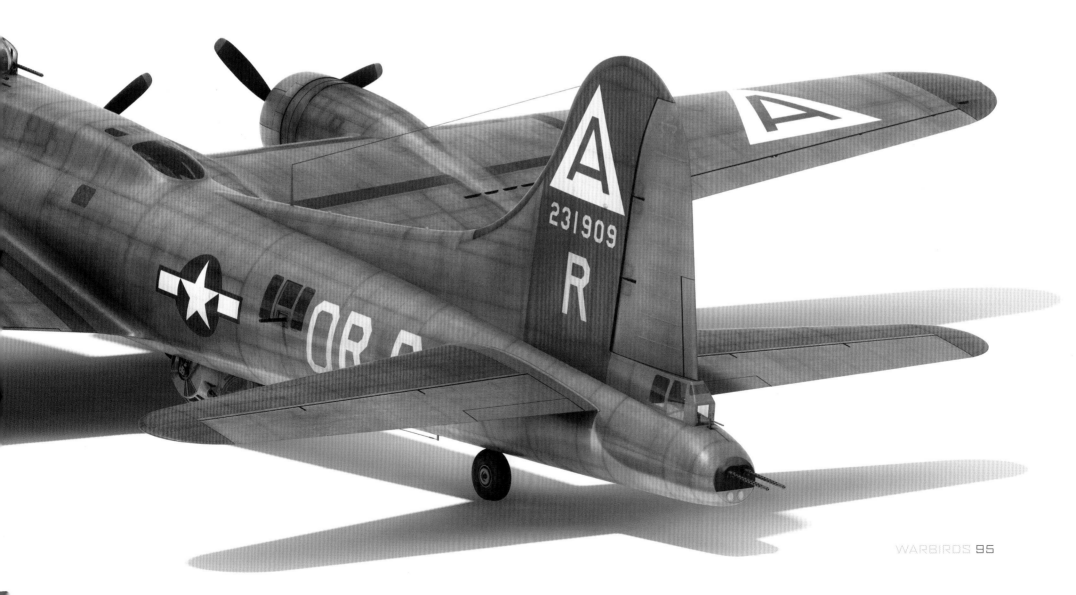

B-25 MITCHELL

SPECIFICATIONS

FOR MODEL: B-25J

TYPE: medium bomber

MANUFACTURER: North American Aviation [NAA]

OPERATORS INCLUDE: USA; Australia; Brazil; Canada; China; Chile; France; Netherlands; Soviet Union; UK

CREW: pilot, co-pilot, bombardier/nose gunner/navigator, radio operator/waist gunner, dorsal turret gunner, tail turret gunner

LENGTH: 52.11ft (16.13m)

WINGSPAN: 67.7ft (20.60m)

WEIGHT: 19,480lb (8,836kg) [empty]-35,000lb (15,876kg) [max. take-off weight]

MAX. SPEED: 272mph (438km/h)

SERVICE CEILING: 24,200ft (7,378m)

RANGE: 1,350 miles (2,173m)

POWERPLANT: Wright R-2600-92 Cyclone x 2

ARMAMENT: Browning .50 calibre machine gun x 4 on nose; .50 calibre x 2 in nose and dorsal and tail turret; maximum payload of 3,000lbs (1,361kgs) in bomb bay, plus wing racks for 5in HVAR High Velocity Aircraft Rocket x 8

MAIDEN FLIGHT: 19 August 1940

IN SERVICE: 1941-1979 (Indonesia)

NUMBER BUILT: 9,984 (all versions)

THIS PAGE: **B-25H Work in Progress**
OPPOSITE: **Powerhouse.** A B-25H employing its forward arsenal during a strafing run.

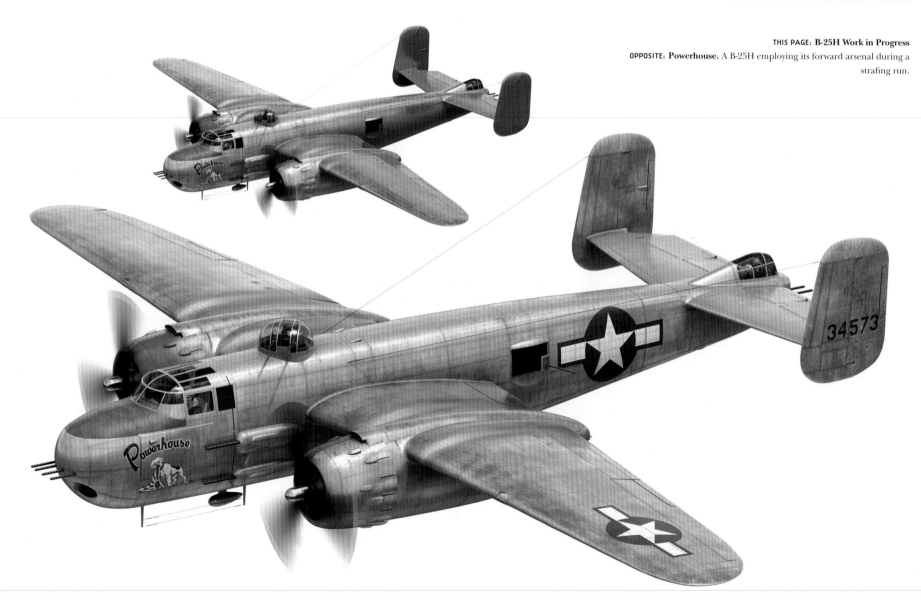

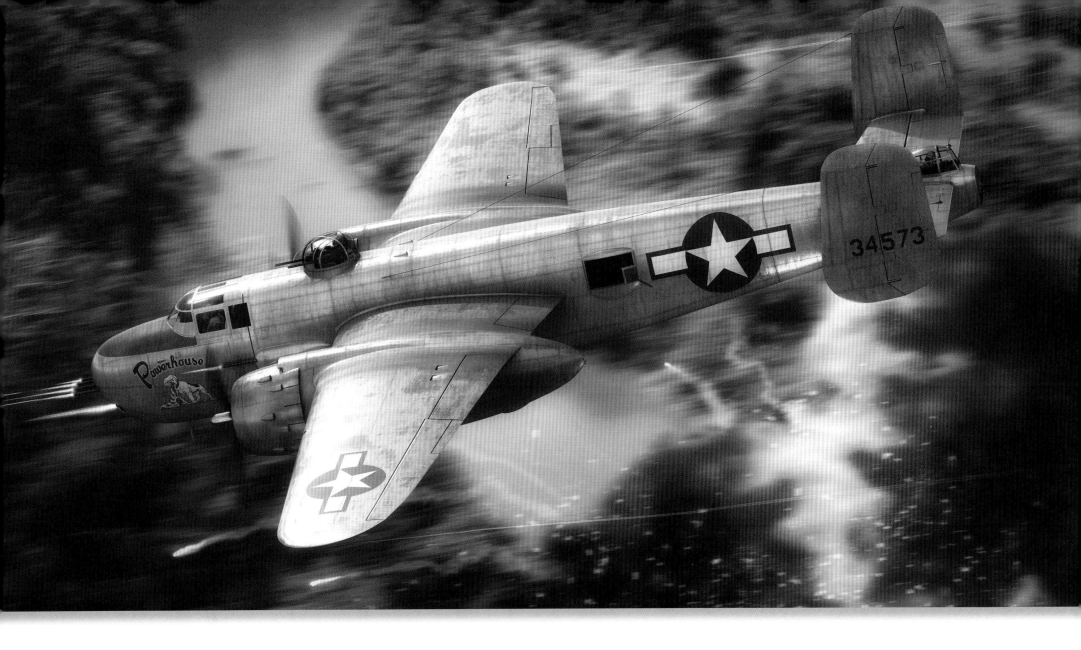

Developed from a USAAC proposal for a medium bomber issued in the mid-thirties, North American adapted their NA-40 prototype, enlarging it and increasing its payload as the NA-62. Although intended for use by the USA, NAA had their eye on exports to the UK and France who, by 1940, were in dire need of a new bomber to bolster their hard-pressed air forces. Both countries chose the A-20 Havoc to fulfil their needs, but, despite the loss of the only prototype in a crash, the USAAC was sufficiently impressed by the concept that they ordered 184 aircraft before a single airframe had been built. The first production aircraft flew on 19 August 1940 and was named the B-25 Mitchell, after the man considered the godfather of American

airpower, William B. Mitchell. This was the only time in US history that a warplane would be named after an individual (unlike US tanks and ships).

The USAAC's enthusiasm for the design proved well founded. It was extremely versatile and tough, its designer having learned the many lessons from the fighting in Europe. The aircraft was heavily armed and armoured, with an emphasis on crew protection, and was fitted with self-sealing fuel tanks.

Entering service in time for the Japanese attack on Pearl Harbor, the Mitchell quickly gained fame during the 'Doolittle raids' by sixteen B-25Bs under the leadership of Colonel Jimmy Doolittle. Having practised on a specially laid out airstrip, the Mitchells took off from the far less stable flight deck of the

aircraft carrier USS *Hornet* on 18 April 1942 to bomb Tokyo. The plan had been for the aircraft to recover in China. However, only one landed safely, many becoming lost and running out of fuel, although most of the crews survived. While of little practical military value, the raid was a huge morale booster for the US after Pearl Harbor, and was something of a shock to the Japanese.

The B-25G and H were built as gunships, fitted with an M4 75mm cannon and as many as eighteen .50 calibre machine guns, with up to eight firing forward in fixed pods. In the H model, the dorsal turret was moved forward to contribute to the forward firepower, making the Mitchell gunships very effective strafing platforms, especially in the anti-shipping role.

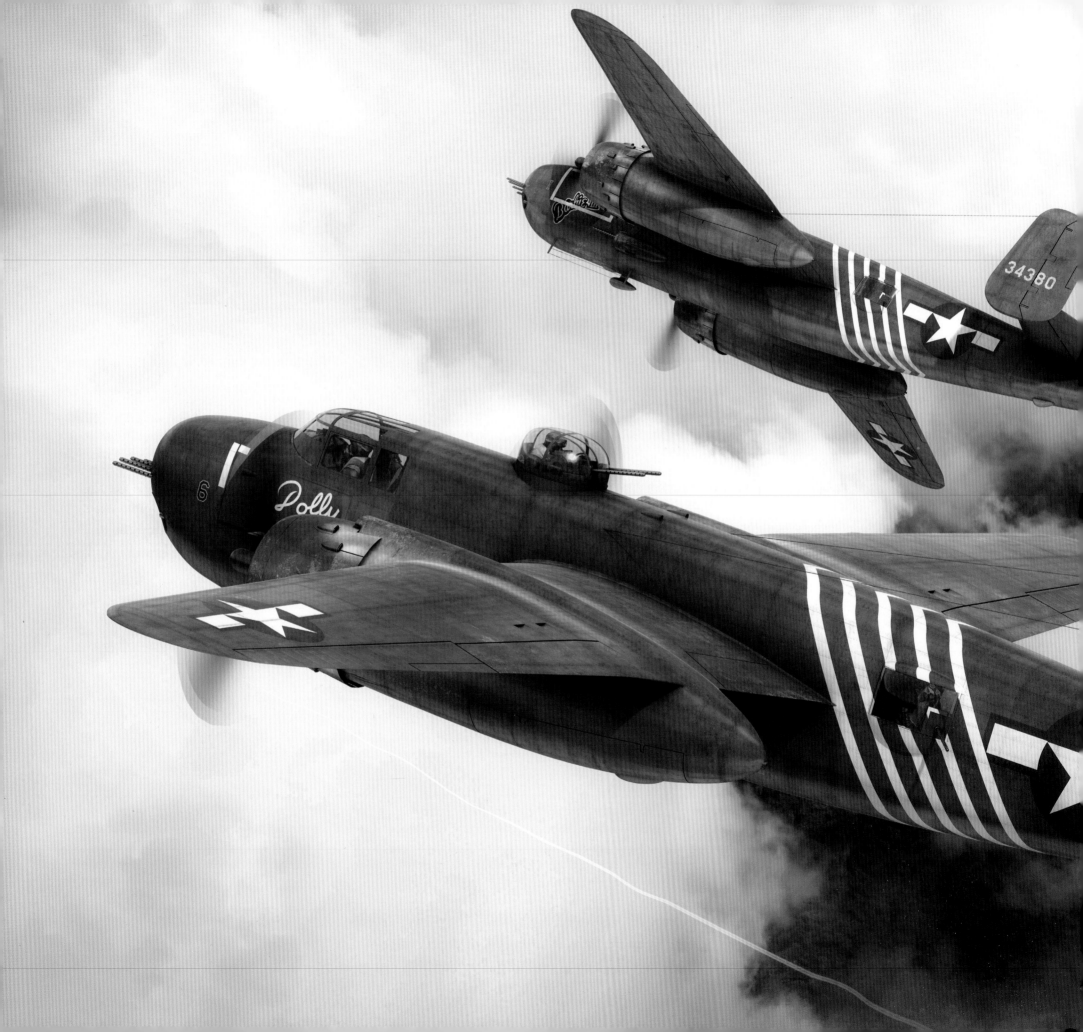

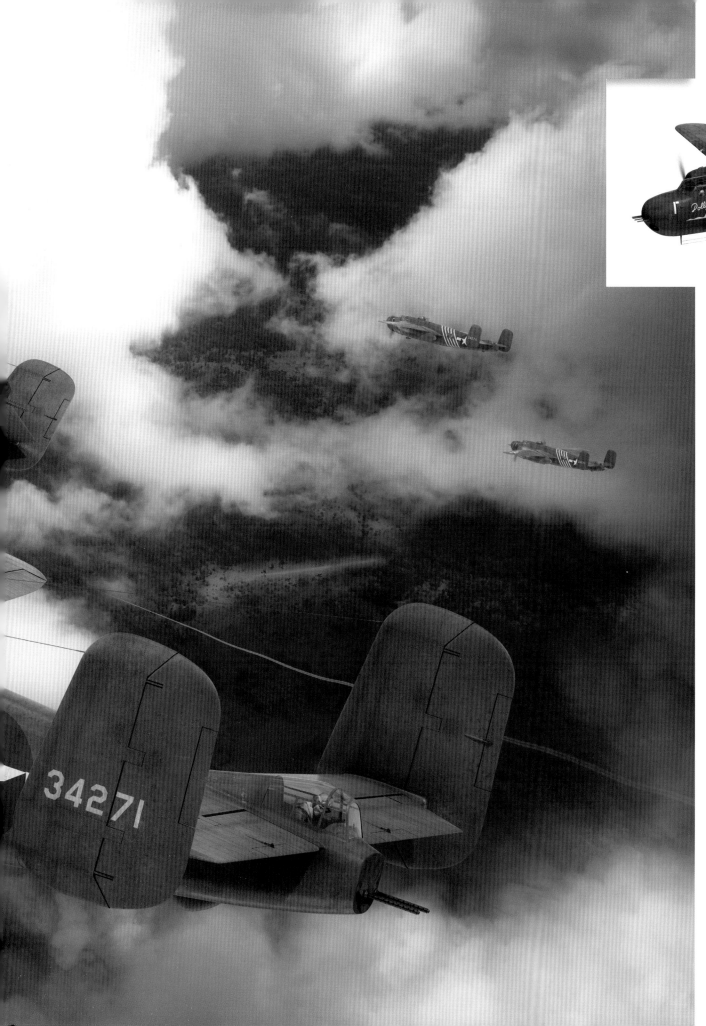

The standard bomber versions also flew well below the expected medium bombing altitudes in the Pacific theatre. Using their fixed machine guns and retarded fragmentation bombs, they were used in low-level attacks against Japanese airfields and shipping.

In the Mediterranean theatre, B-25s were similarly employed in interdicting German air and sea supply routes from Italy to North Africa, sometimes even serving as a very heavy fighter to shoot down lumbering German transport aircraft.

In Europe, the RAF received some 900 Mitchells that replaced a number of elderly and obsolete types. They first saw action in January 1943 and contributed to the air campaign in support of the D-Day landings. After the invasion of Normandy, RAF Mitchell squadrons moved forward airstrips in France and began flying the close air support role for the advancing Allied armies.

The USAAF never used the Mitchell in Europe, using instead B-26 Marauders in the medium bomber role. However, 862 were supplied to the Soviet Union and served with the Red air force until the end of WW2, seeing action throughout the Eastern Front as a medium bomber and even taking part in the defence of Stalingrad.

Such was the excellence of the B-25's design that it stayed in service long after the end of the war, with many smaller countries such as Brazil and Indonesia keeping the type in service until the 1970s.

ABOVE: **B-25 'Dolly'**
LEFT: **Big Guns of Burma.** The majority of USAAF B-25s were used in the Pacific theatre during WW2.

P-51 MUSTANG

SPECIFICATIONS

FOR MODEL: P-51D

TYPE: fighter

MANUFACTURER: North American Aviation [NAA]

OPERATORS INCLUDE: USA; Canada; China; France; Italy; Netherlands; New Zealand; Philippines; Poland; South Africa; Sweden; UK

CREW: pilot

LENGTH: 32.3ft (9.83m)

WINGSPAN: 37ft (11.28m)

WEIGHT: 7,635lb (3,463kg) [empty]-12,100lb (5,488kg) [max. take-off weight]

MAX. SPEED: 437mph (703km/h)

SERVICE CEILING: 41,900ft (12,800m)

RANGE: 850 miles (1,368km)

POWERPLANT: Packard V-1650-7

ARMAMENT: Browning 0.50in machine gun x 6 or M2 20mm cannon x 4; maximum payload of 1,000lbs (454kg)

MAIDEN FLIGHT: 16 October 1940

IN SERVICE: December 1942-1984 (still in civilian use)

NUMBER BUILT: 14,819 (all versions)

RIGHT: **Old Crow.** Major Clarence 'Bud' Anderson in his P-51D-10-NA, nicknamed 'Old Crow' after the famous whiskey. Old Crow carried Anderson through 116 missions, during which time he claimed 16.25 aerial victories.

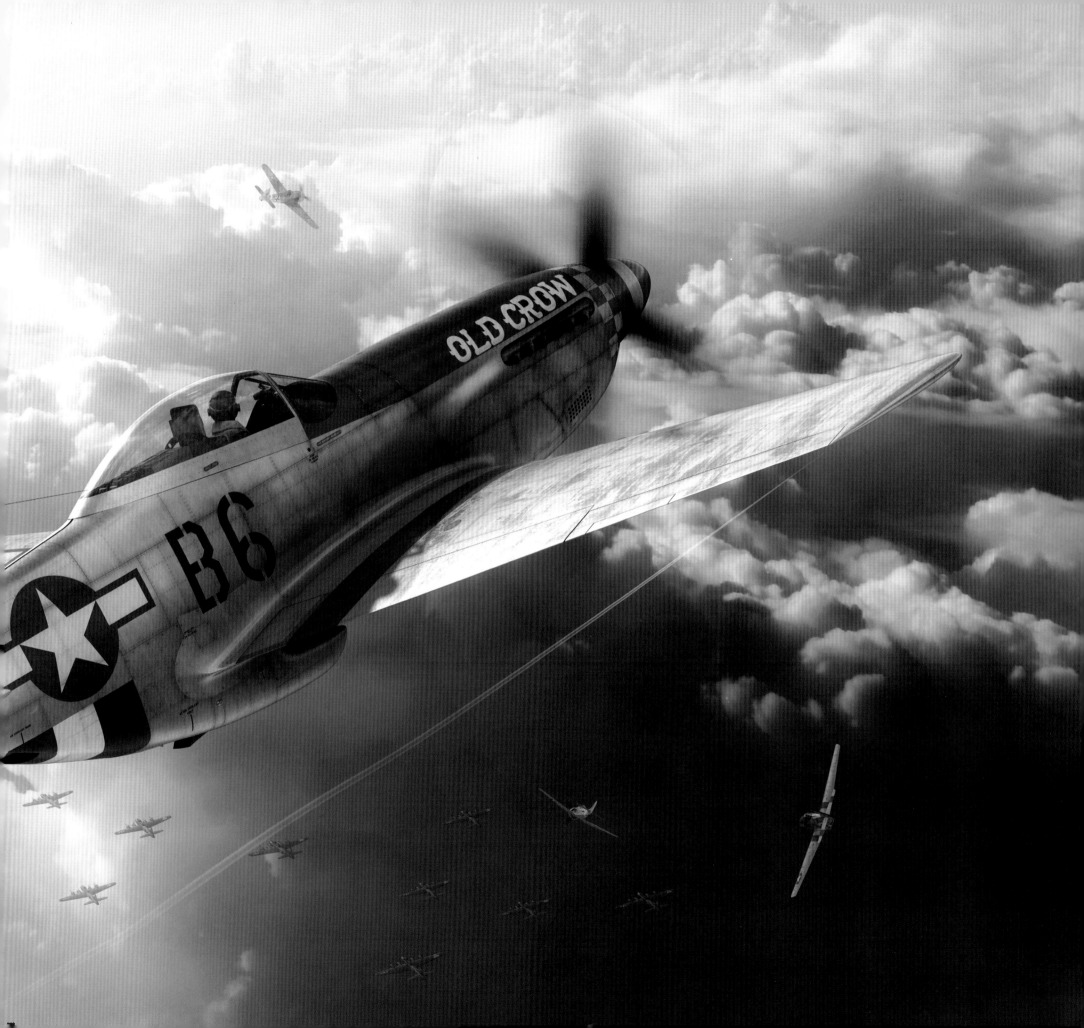

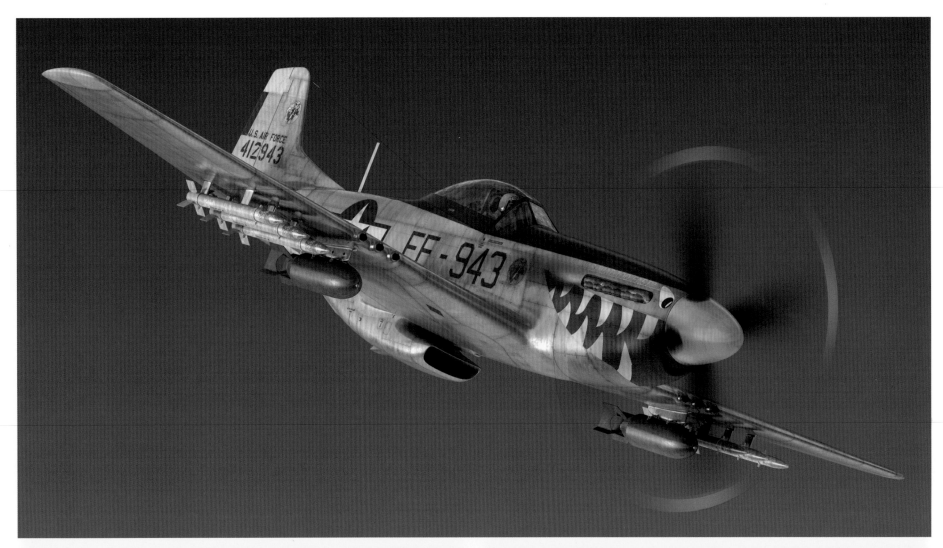

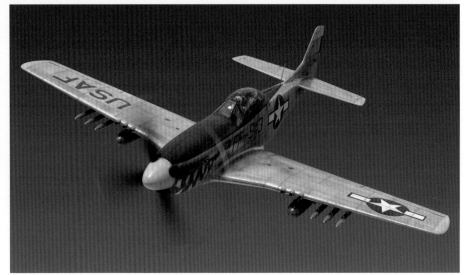

ABOVE AND OPPOSITE: USAF P-51D

Considered by many to be the greatest American fighter of all time, the P-51 actually had its origins in a deal made in April 1940 between Britain and the USA. The RAF was critically short of advanced fighters and had been looking for an American aircraft to supplement the Spitfire. Neither the P-40 or P-39 Airacobra were particularly suitable, so North American Aviation convinced the British government it could deliver a new aircraft superior to either of those on offer and do it quickly. Impressed by NAA's work in supplying the Harvard trainer to the RAF, the British signed a contract on 23 May 1940. True to their word, North American Aviation took just 102 days to deliver the prototype.

Christened Mustang 1 by the British, it was fitted with an Allison V-1710 engine and had an advanced wing design. Initial tests showed the aircraft performed superbly. However, it was soon realised that above 17,000ft, handling became very poor, largely due to the lack of a supercharger in the engine. As such, the 320 Mustangs ordered for the RAF found themselves fitted out with cameras and used for low-level reconnaissance. Not what the British had in mind.

Part of Britain's deal with NAA required that the aircraft be handed over to the USAF for evaluation. There was little interest at first, but finally the aircraft entered service with the USAF as both the P-51A and the A-36 Apache, both in the ground attack role.

Britain still had faith in the basic airframe, which they considered sound if underpowered. An alternate powerplant was sought and eventually it was decided to fit a P-51A with the Rolls-Royce Merlin 61, the same engine used by the Spitfire IX. The subsequent improvement in performance, especially at high altitudes, turned an average fighter into a world-beater. Packard, more famous for its cars, began license-building the Merlin as the V-1650, which were retrofitted to earlier P-51s. Further improvements included the addition of a raised, clear 'bubble' canopy, which greatly improved pilot visibility. The resulting P-51D became the definitive version of the Mustang, with some 8,000 built.

Perhaps the most important attribute of the P-51D was its extended range. By late 1943, the Allied

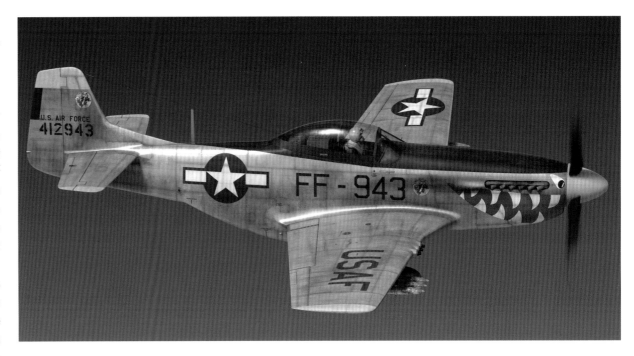

concept of the 'round-the-clock' bombing of Germany was running into serious problems. The American 8th Air Force was bearing the brunt of the daylight raids, but its bombers were often operating beyond the range of fighter escort, deep into the heart of Germany. As such, losses to Luftwaffe fighters were mounting, largely as a result of the heavier weapons of the German fighters, which could open fire beyond the range of the .50 calibre machine guns equipping the American B-17s and B-24s. By October 1943, raids were suffering losses of as much as one quarter of their strength.

Two months later, the P-51D made its combat debut in Europe. With plenty of space for a large internal fuel load and the ability to carry two external drop tanks on the wings, the Mustang could escort bombers all the way into Germany. More to the point, they could out-perform most German fighters and meet the rest on equal terms. When Mustangs arrived over Berlin in 1944, Herman Goering told his staff that the war was over for Germany.

In the run up to the invasion of France in June 1944, Mustangs with the American 9th Air Force switched to the ground attack role, roving across the continent to attack targets of opportunity. On these appropriately

named 'Chattanooga' raids, they conducted strafing attacks on trains and troop convoys, while 'Jackboot' missions were conducted against Luftwaffe airfields.

By the end of the war in Europe, the P-51 had claimed 4,950 aircraft shot down, achieved at a ratio of 11:1. While the Mustang served in the Far East, it was a relatively rare sight until after the defeat of Germany, when more were released to fly escort missions for B-29s attacking the Japanese homeland.

The Mustang continued to serve in Asia as the F-51D during the Korean War, operating largely in the ground attack role. It could fly longer missions and carry higher payloads than early jets and even served as the F-82 Twin Mustang, the last piston-engined fighter ordered by the USAF. Originally conceived as a long-range escort fighter, the end of WW2 saw it flying from Japan and gaining the accolade of shooting down the first North Korean fighters of the war.

OVERLEAF: **Little Duckfoot.** On 18 September 1944, during Operation Market Garden, the USAAF 357th Fighter Group ran into a large number of German Fw 190s over the Netherlands. 1st Lt Gerald Tyler in his P-51D, nicknamed 'Little Duckfoot', was climbing to attack when 8 more Focke-Wulfs appeared. Meeting the formation head on, Tyler fired into the lead Fw 190, hitting the fuselage and sending it down in flames.

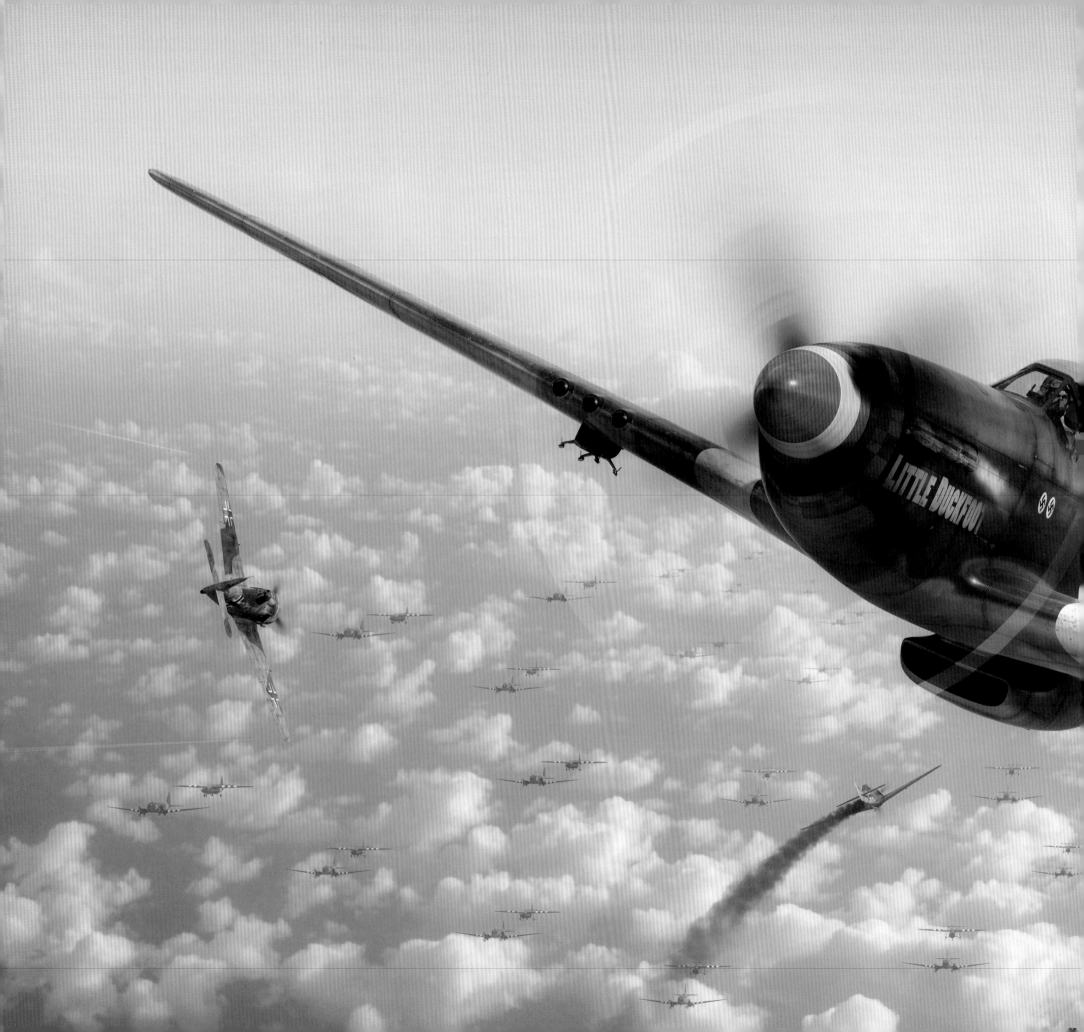

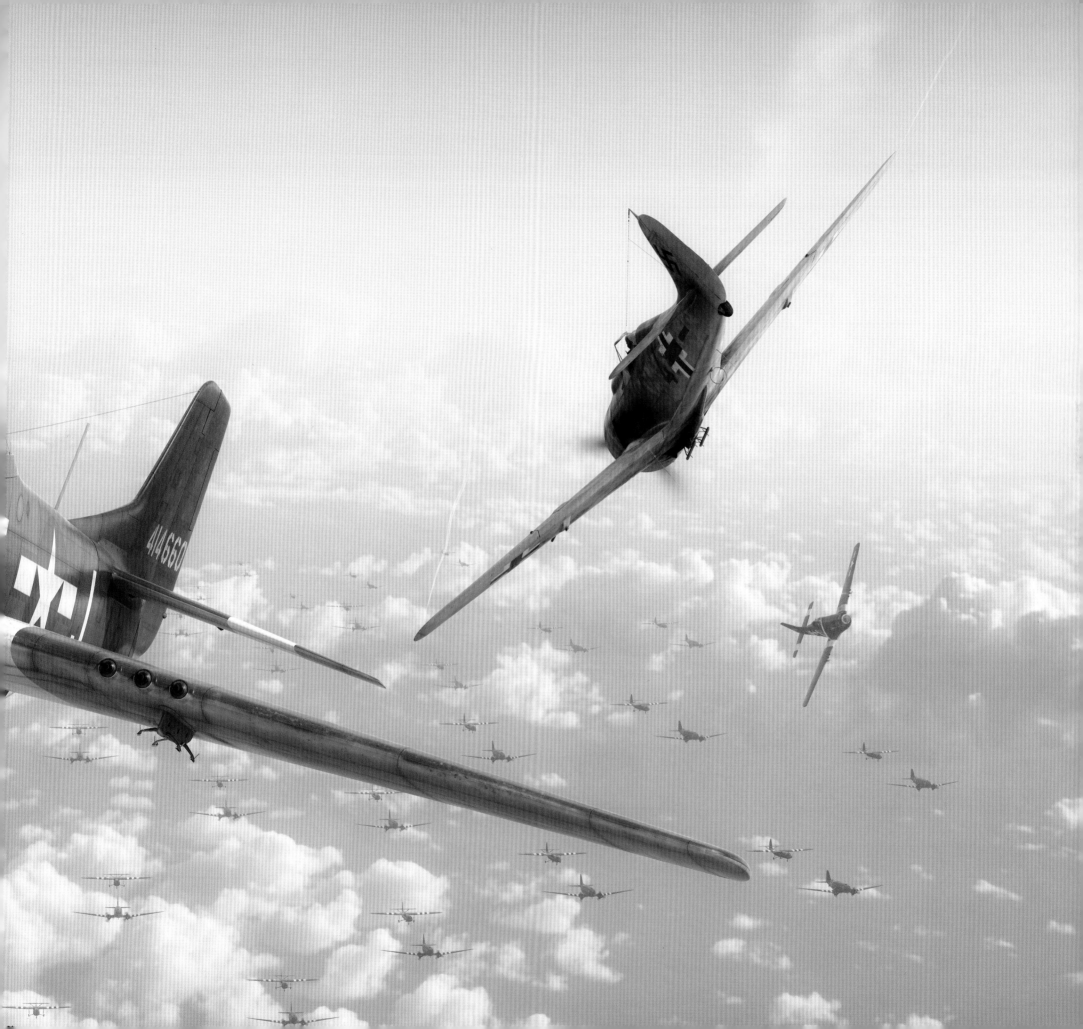

FW 190

CLOCKWISE FROM RIGHT: Hermann Graff's Fw 190. Fw 190 Red Check. Fw 190 Sturmbock Red Bolt. Fw 190 Yellow Bolt. Fw 190 A-8. Fw 190 A-3.

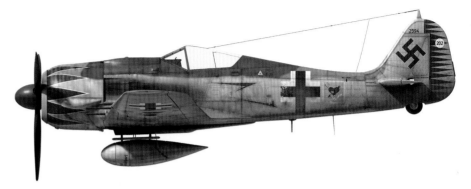

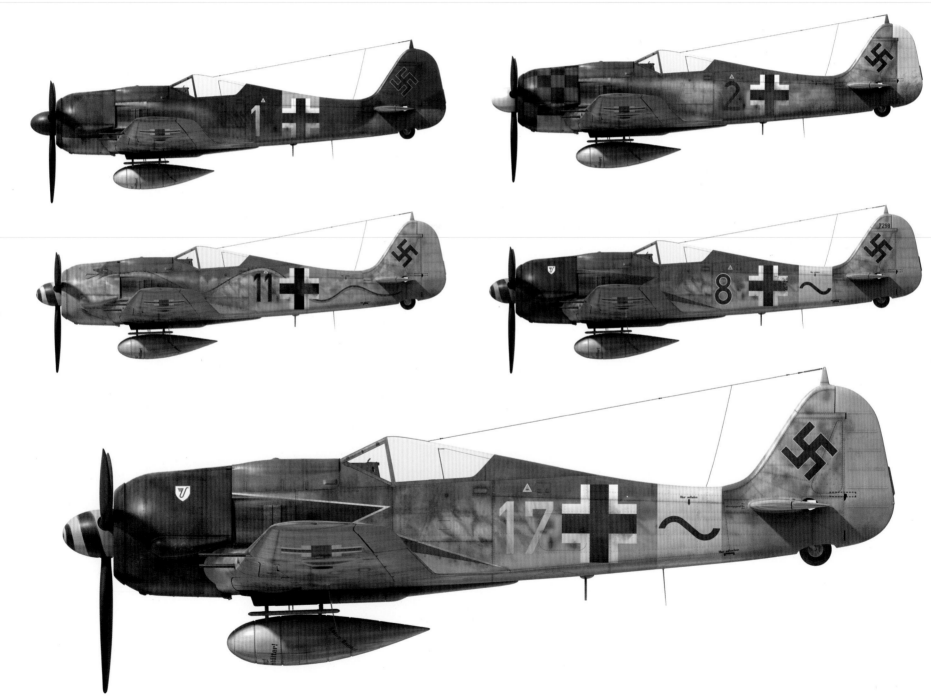

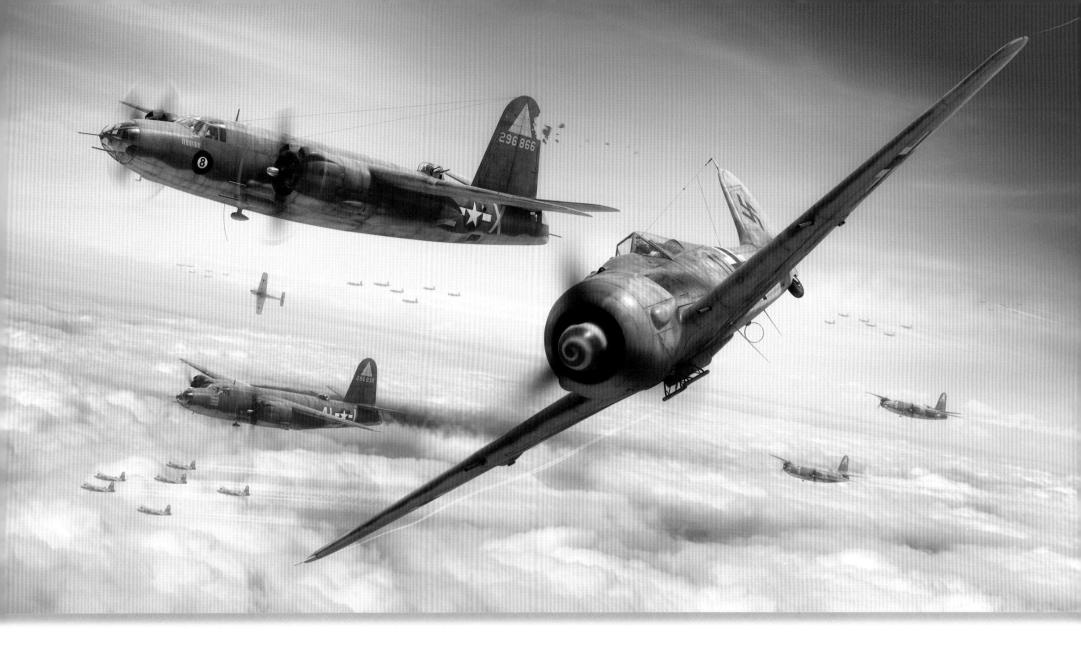

ABOVE: **Marauders.** An Fw 190 engaging B-26 Marauders.

SPECIFICATIONS

FOR MODEL: Fw 190A-3

TYPE: fighter

MANUFACTURER: Focke-Wulf Flugzeugbau

OPERATORS: Germany; Hungary; Turkey

CREW: pilot

LENGTH: 29ft (8.84m)

WINGSPAN: 34.5ft (10.5m)

WEIGHT: 6,393lb (2,900kg) [empty]-8,770lb (43,978kg) [max. take-off weight]

MAX. SPEED: 497mph (615km/h)

SERVICE CEILING: 37,4300ft (11,410m)

RANGE: 497miles (800km)

POWERPLANT: BMX 801D

ARMAMENT: MG 131 13mm (.51in) machine gun x 2 on nose; MG 151/20E 20mm cannon x 2 in wings

MAIDEN FLIGHT: 1 June 1939

IN SERVICE: 1941–1949 (Turkey)

NUMBER BUILT: 19,500+ (all version)

The Fw 190 was intended to be able to take on any new Allied designs that might out-class the venerable Messerschmitt Bf 109. The use of radial engines in land-based fighters was unusual because of the drag the large nose area imposed, but by September 1941, and after a few teething troubles, the Fw 190 had entered service.

The type's first action against the RAF took place when Spitfire Vs supported bomb-carrying Hurricanes in an attack on targets near Bruges, Belgium, on 1 June 1942. Two units of Fw 190s attacked the British formation, shooting down eight Spitfires and damaging five more, for no losses. For the first time, the Luftwaffe appeared to have the edge over the indomitable Spitfires.

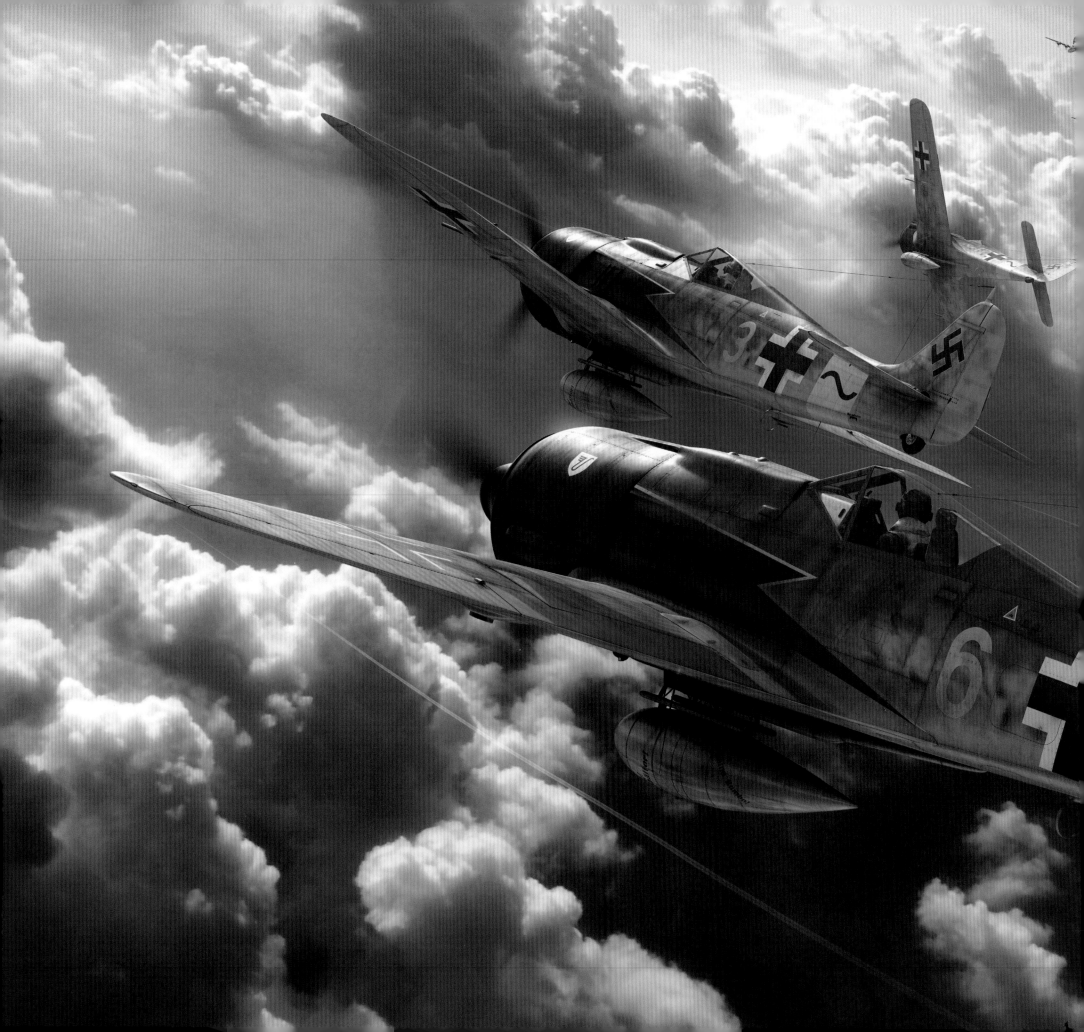

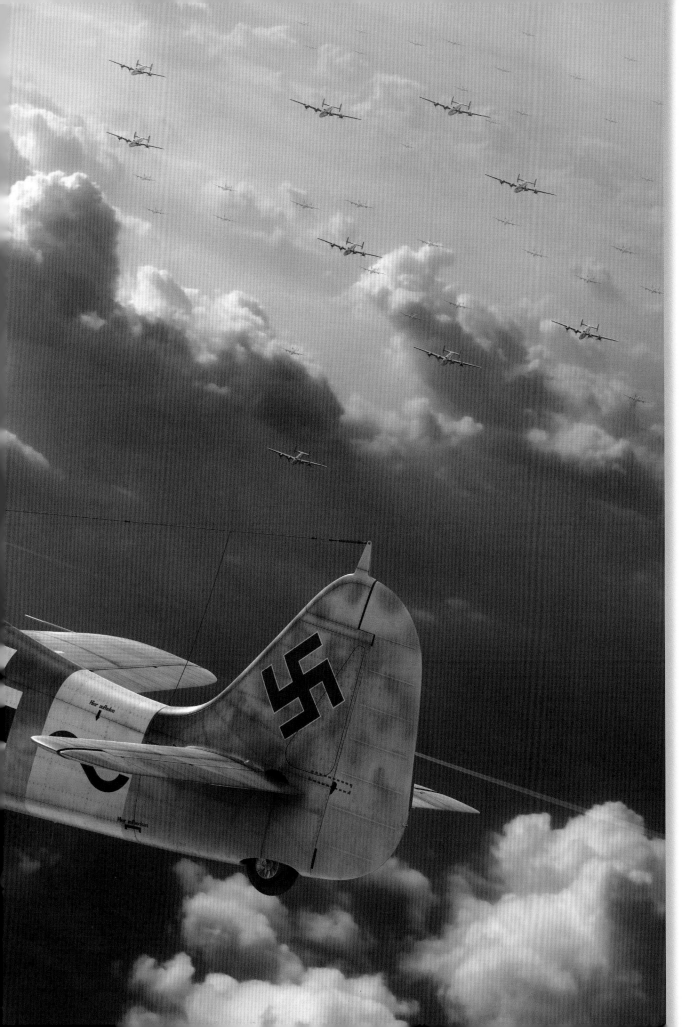

Experiments were under way in Germany to test the 190 as a fighter-bomber, removing two of the cannons so the aircraft could carry a single bomb on its belly. The refitted fighters were successful enough for dedicated variants to be developed, the Fw 190F and 190G models. These new aircraft began replacing obsolete Ju-87 Stukas in frontline units in autumn 1943.

Other versions of the 190 were also heavily engaged against the bomber menace in 1943, employing new weapons such as the WGr 21 rocket and the wing-mounted MK 108 heavy cannon. Due to the cannon's low muzzle velocity, it required the pilot to fly within range of the US .50 calibre machine guns. As such, the 190s were further modified with heavy frontal armour to enable the new 'Sturmbock' (battering ram) to fly as close as possible to the American bombers. However, the extra weight imposed on the Sturmbocks restricted performance. By early 1944, the US bombers were being escorted by the new P-51 Mustang, and made easy prey of the cumbersome 190s.

The Fw 190 received a real boost in capabilities with the arrival of the Fw 190D-9, the *Langnasen*-Dora (long-nosed Dora), in late 1944. Fitted with a Junkers Jumo 213 engine, the new engine improved the Fw 190's high-altitude performance, with an excellent rate of climb and additional power and speed. At last, 190 pilots had a mount to match the P-51D, Spitfires and the latest Russian Yaks.

By the spring of 1945, German resistance was collapsing and amongst the desperate measures being taken to at least slow the approaching Allied armies was the Mistel, a composite of an Fw 190 (or Bf 109) mounted on an unmanned, explosive-laden Ju-88. The pair would fly towards their intended target, then the unmanned bomber would be released and guided to its final destination. The Mistal had been used on D-Day, in an effort to hit shipping off the Normandy beaches, but their final use came on 12 April 1945, when the composite bombers were used against bridges being built by the Soviet army across the River Oder. The attacks failed.

LEFT: **Wulf Pack.** Fw 190s roll in on a formation of B-24 Liberators.
OVERLEAF: **Battering Rams.** Fw 190s modified as the heavily armed and armoured Sturmbock attack B-24 Liberators.

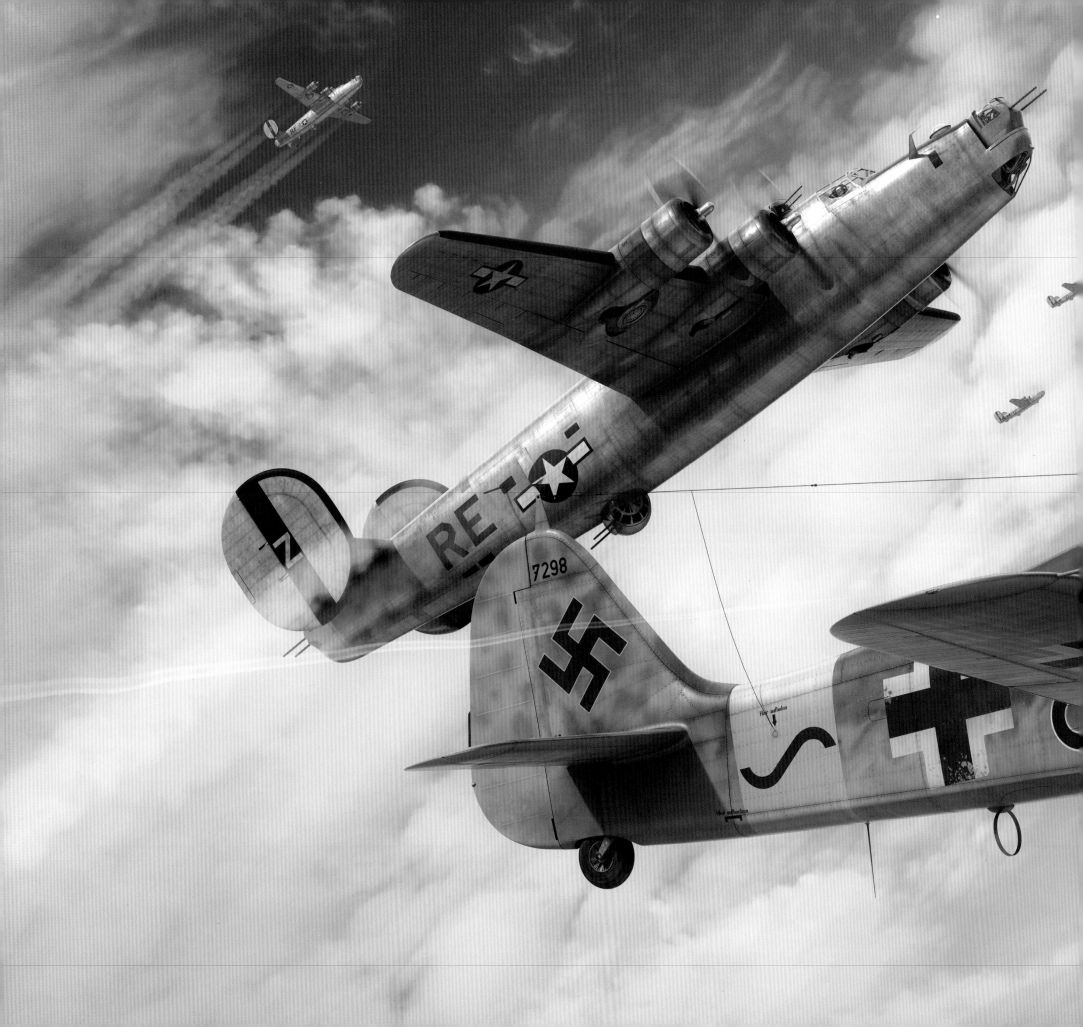

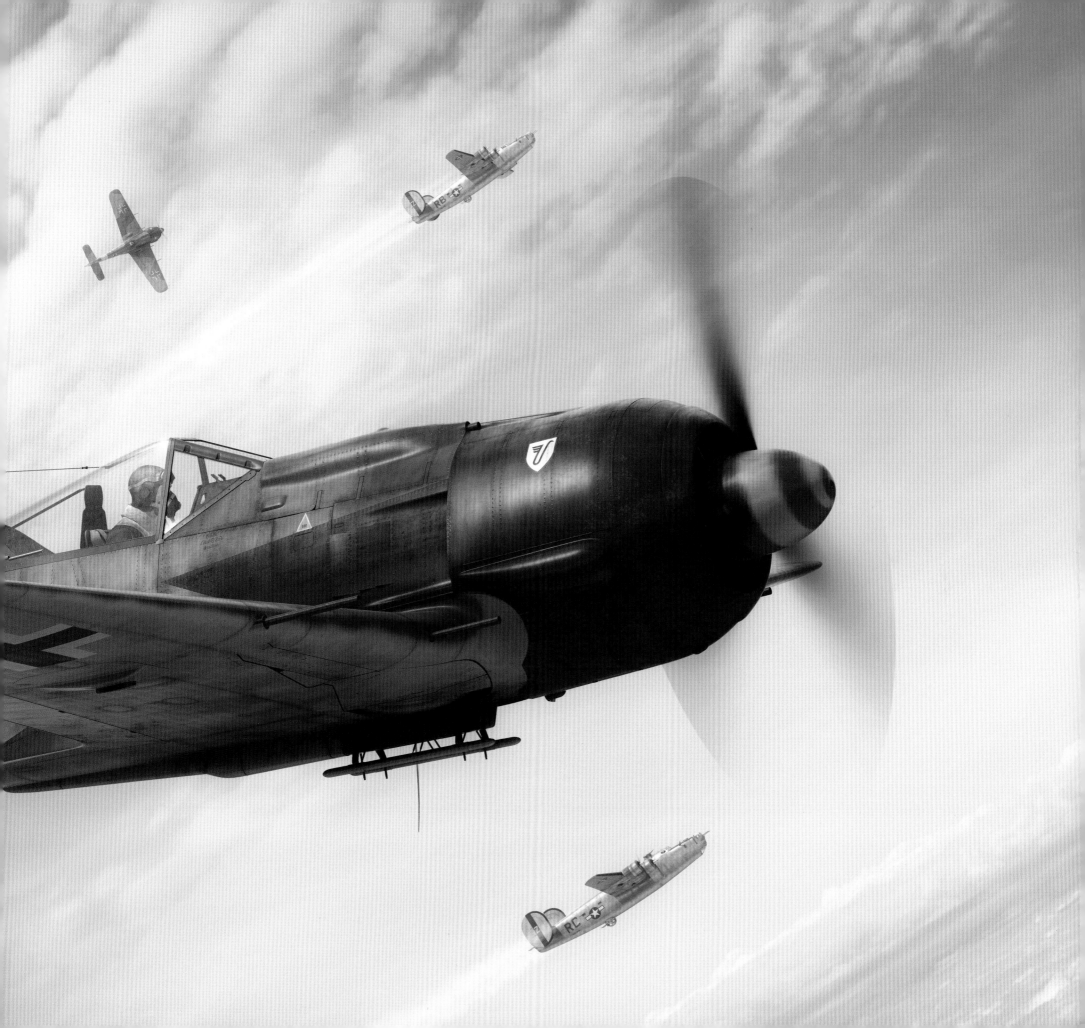

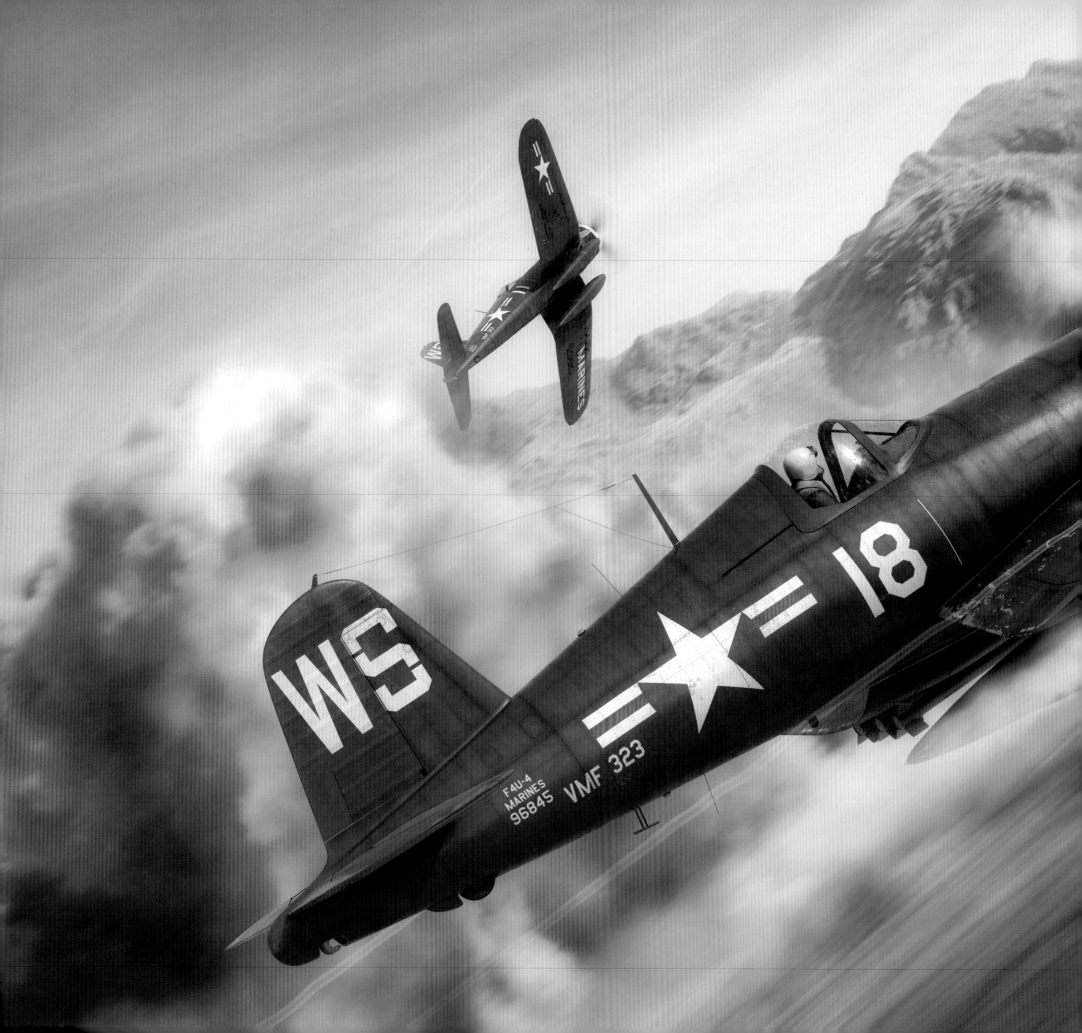

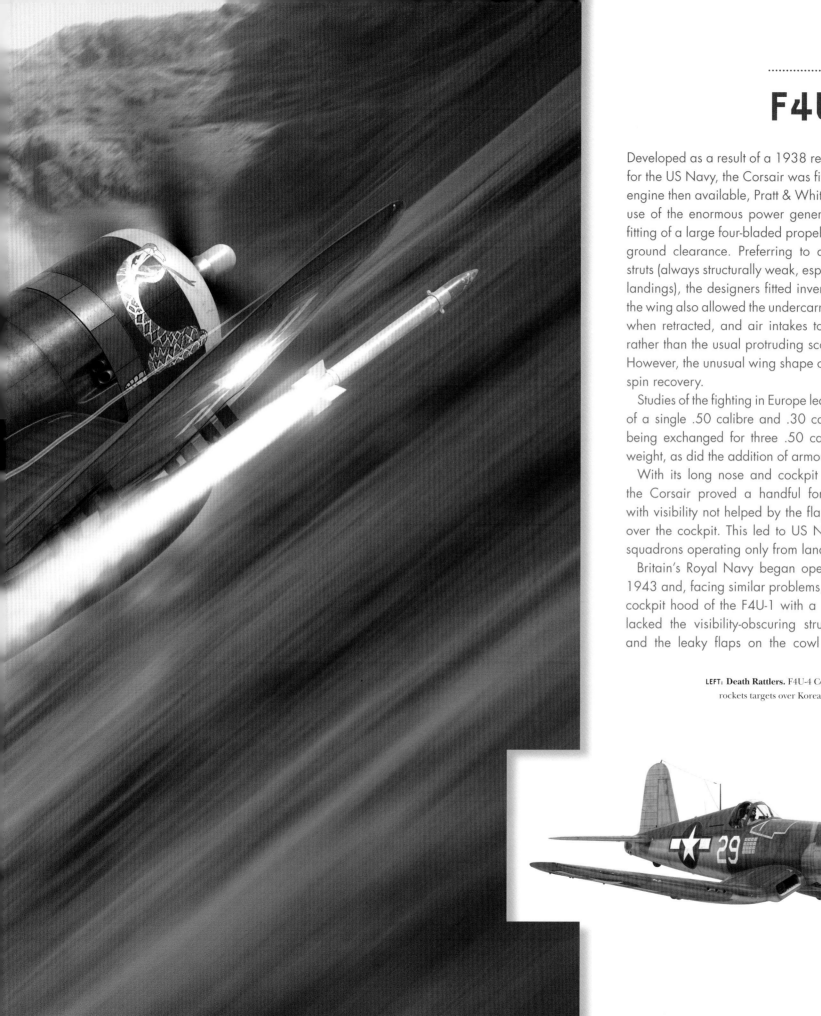

F4U CORSAIR

Developed as a result of a 1938 request for a new single-seat fighter for the US Navy, the Corsair was fitted with the most powerful radial engine then available, Pratt & Whitney's Double Wasp. Making best use of the enormous power generated by the engine required the fitting of a large four-bladed propeller, but this caused problems with ground clearance. Preferring to avoid overly long undercarriage struts (always structurally weak, especially under the impact of carrier landings), the designers fitted inverted gull wings. The thick cord of the wing also allowed the undercarriage to be fully enclosed by doors when retracted, and air intakes to be fitted into the leading edge rather than the usual protruding scoops – both adding streamlining. However, the unusual wing shape caused problems with stalling and spin recovery.

Studies of the fighting in Europe led to the fighter's original armament of a single .50 calibre and .30 calibre machine gun in each wing being exchanged for three .50 calibres. They added considerable weight, as did the addition of armour and a bulletproof windscreen.

With its long nose and cockpit position far down the fuselage, the Corsair proved a handful for pilots during carrier landings, with visibility not helped by the flaps on the nose cowl spraying oil over the cockpit. This led to US Naval and Marine Corps Corsair squadrons operating only from land bases.

Britain's Royal Navy began operating the Corsair in November 1943 and, facing similar problems, replaced the original 'birdcage' cockpit hood of the F4U-1 with a raised 'bubble' version that also lacked the visibility-obscuring struts. The pilot's seat was raised and the leaky flaps on the cowl permanently closed. They also

LEFT: **Death Rattlers.** F4U-4 Corsair WS18 flown by Capt. Dennis C. Hallquist rockets targets over Korea while operating from USS *Sicily* with VMF-323, 'Death Rattlers' squadron, 1951.
BELOW: **F4U-1D Corsair**

SPECIFICATIONS

FOR MODEL: F4U-4

TYPE: fighter

MANUFACTURER: Vought

OPERATORS: USA; Argentina; France; Honduras; New Zealand; UK

CREW: pilot

LENGTH: 33.8ft (10.26m)

WINGSPAN: 40.11ft (12.47m)

WEIGHT: 9,205lb (4,175kg) [empty]-14,670lb (6,654kg) [max. take-off weight]

MAX. SPEED: 446mph (718km/h)

SERVICE CEILING: 41,500ft (12,649m)

RANGE: 1,005 miles (1,617km)

POWERPLANT: Pratt & Whitney R-2800-18W Double Wasp

ARMAMENT: Browning 0.50in machine gun x 6 or M2 20mm cannon x 4; maximum payload of 4,000lbs (1,800kg)

MAIDEN FLIGHT: 29 May 1940

IN SERVICE: 1942-1979 (Honduras)

NUMBER BUILT: 12,571 (all versions)

clipped off 8in (200mm) from the wing tips to accommodate them aboard RN carriers, although the modification gave added aerodynamic benefits. These adaptations, combined with the addition of small spoilers on the wing's leading edge and a strengthened undercarriage, cleared the fighter for carrier operations.

Despite these changes, the F4U did not begin operating from US carriers until April 1944. By then it had acquitted itself well as a fighter, employing its superior speed and power against its principal opponent, the Japanese A6M Zero, which could still out-fight the Corsair at low level and low speed. It served primarily with the US Marine Corps, notching up an impressive combat record in the air and being regarded as the US's finest fighter – especially amongst the Japanese. By the war's end, the Corsair had amassed an impressive kill ratio of 11:1.

The Corsair remained in production until January 1952 and by 1950 was in action over Korea, mainly in ground attack and close air support roles. However, Corsairs did engage in fighter combat against North Korea's Russian-built fighters, such as the Yak-9. In one famous combat, a Corsair, flown by USMC Captain Jesse Folmar, even managed to out-

turn a MiG-15 and shoot the jet down with its 20mm cannons (Folmar was subsequently shot down by one of the MiG's wingmen, bailed out into the ocean and was successfully recovered).

The Corsair's final campaign was the so-called 'Football War' between El Salvador and Honduras. Economic friction between the two nations became open conflict following a trio of qualifying matches for the 1970 World Cup, which saw escalating violence between fans. El Salvador won the decisive match and then severed diplomatic ties with Honduras. The Salvadorans then launched a number of air attacks. However, Corsairs helped establish air superiority for the Hondurans, shooting down a number of Salvadoran planes, including several Mustangs. Honduras finally retired its venerable Corsairs in 1979.

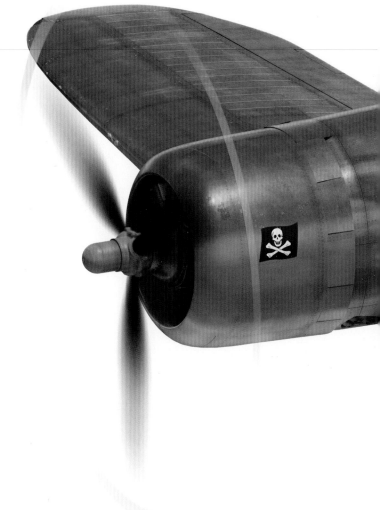

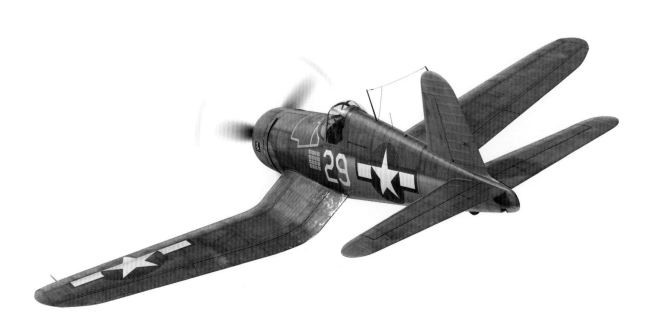

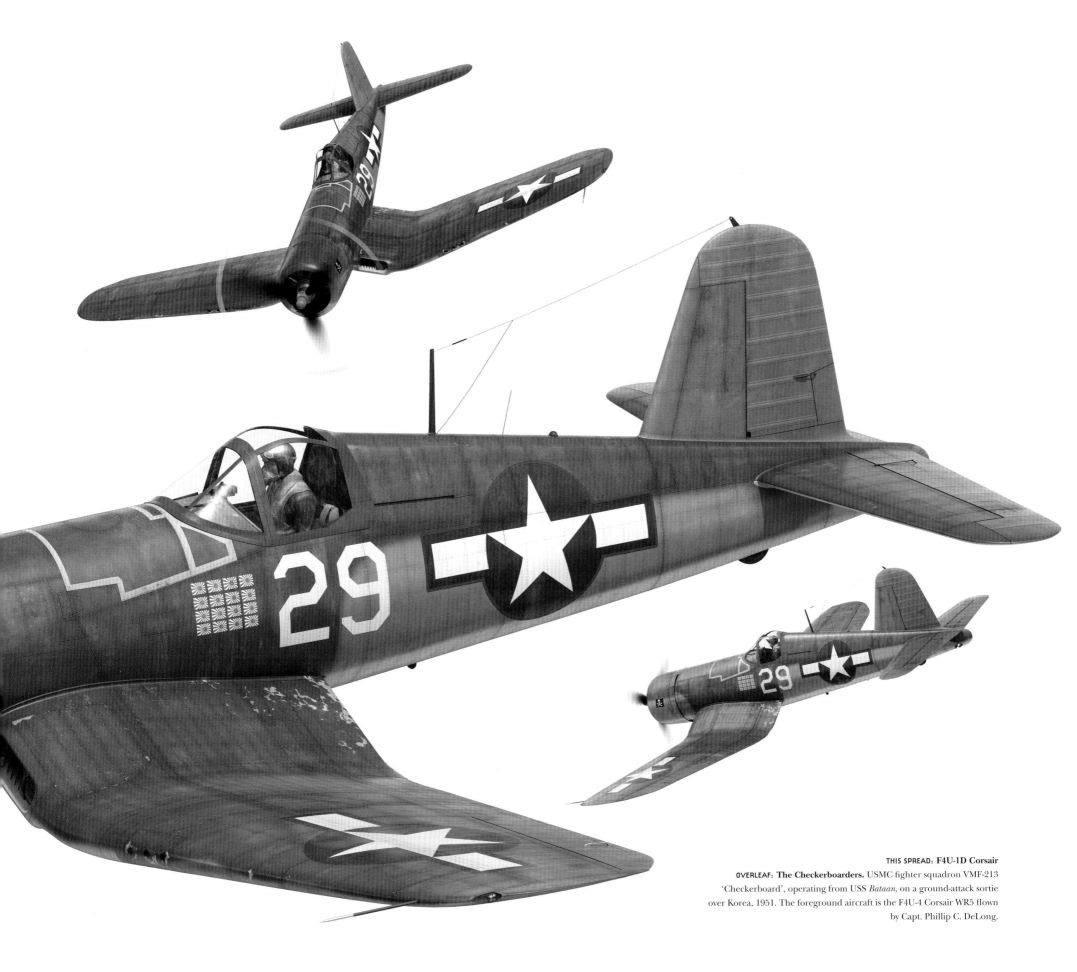

THIS SPREAD: **F4U-1D Corsair**
OVERLEAF: **The Checkerboarders.** USMC fighter squadron VMF-213
'Checkerboard', operating from USS *Bataan*, on a ground-attack sortie
over Korea, 1951. The foreground aircraft is the F4U-4 Corsair WR5 flown
by Capt. Phillip C. DeLong.

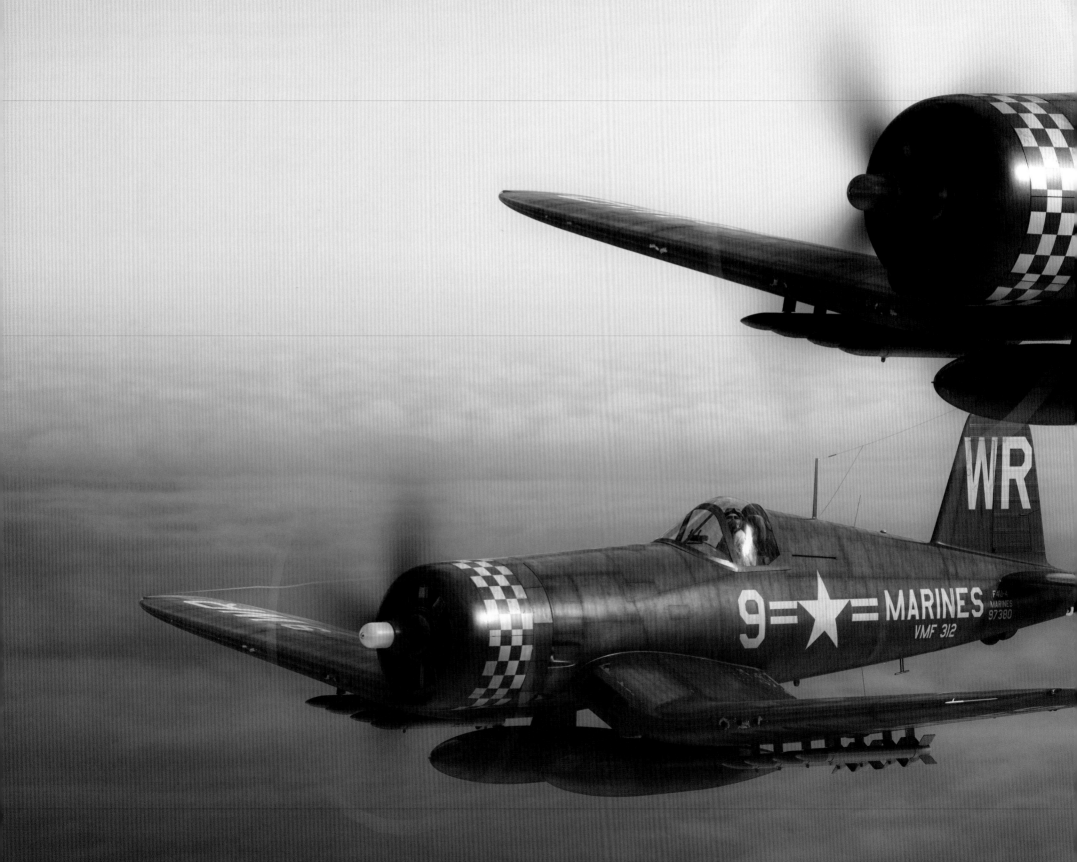

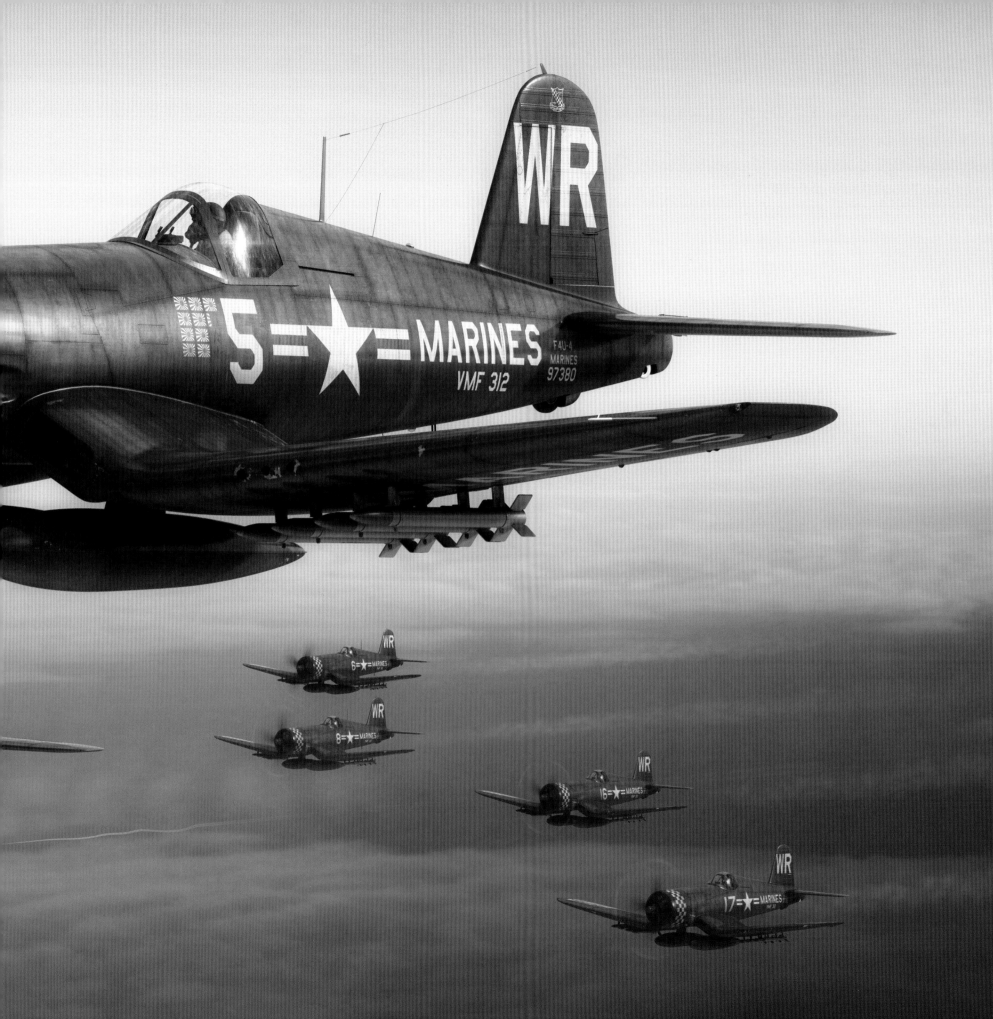

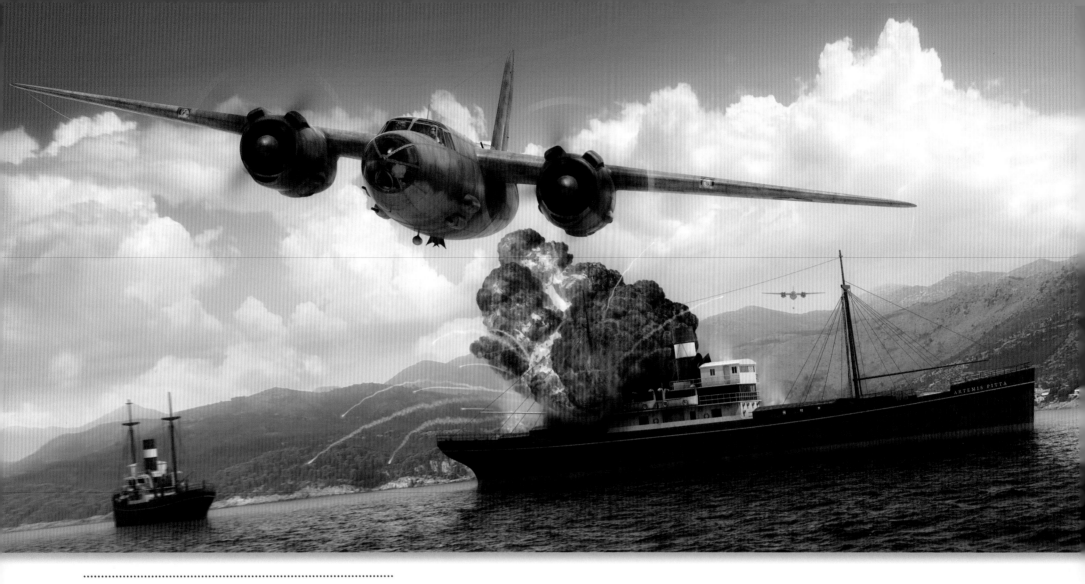

B-26 MARAUDER

Martin had considerable experience building bombers for the USAAC when it entered a hotly contested competition for a new medium bomber design in 1939. Judged the winner based on the promise of its Model 179 prototype, an order was placed for 201 aircraft, followed by another, for 930 B-26s, in September 1940 – before the first aircraft was even built.

Fitted with a tricycle undercarriage, the Marauder had an excellent cruising speed, but also high take-off and landing speeds. It entered service in February 1941 and was soon being hung with the sobriquet 'the widowmaker'. Pilots were not used to its high approach speed, resulting in hard landings

SPECIFICATIONS

FOR MODEL: B-26G
TYPE: medium bomber
MANUFACTURER: Glenn L. Martin Co.
OPERATORS: USA; France; South Africa; UK
CREW: pilot, co-pilot, bombardier/nose gunner, radio operator, gunner x 2 (tail and dorsal)
LENGTH: 56.1ft (17.09m)
WINGSPAN: 71ft (21.64m)
WEIGHT: 25,300lb (11,476kg) [empty]-38,200lb (17,327kg) [max. take-off weight]
MAX. LEVEL SPEED: 283mph (455km/h)

SERVICE CEILING: 21,000ft (6,400m)
RANGE: 1,100 miles (1,770km)
POWERPLANTS: Pratt & Whitney R-2800-43 Double Wasp x 2
ARMAMENT: Browning .50 calibre machine gun x 4 on forward fuselage; .50 calibre in nose; 0.50 calibre x 2 in dorsal and tail turrets, and in ventral position; maximum bomb load of 4,000lbs (1,814kg)
MAIDEN FLIGHT: 25 November 1940
IN SERVICE: 1941-1945
NUMBER BUILT: 5,288

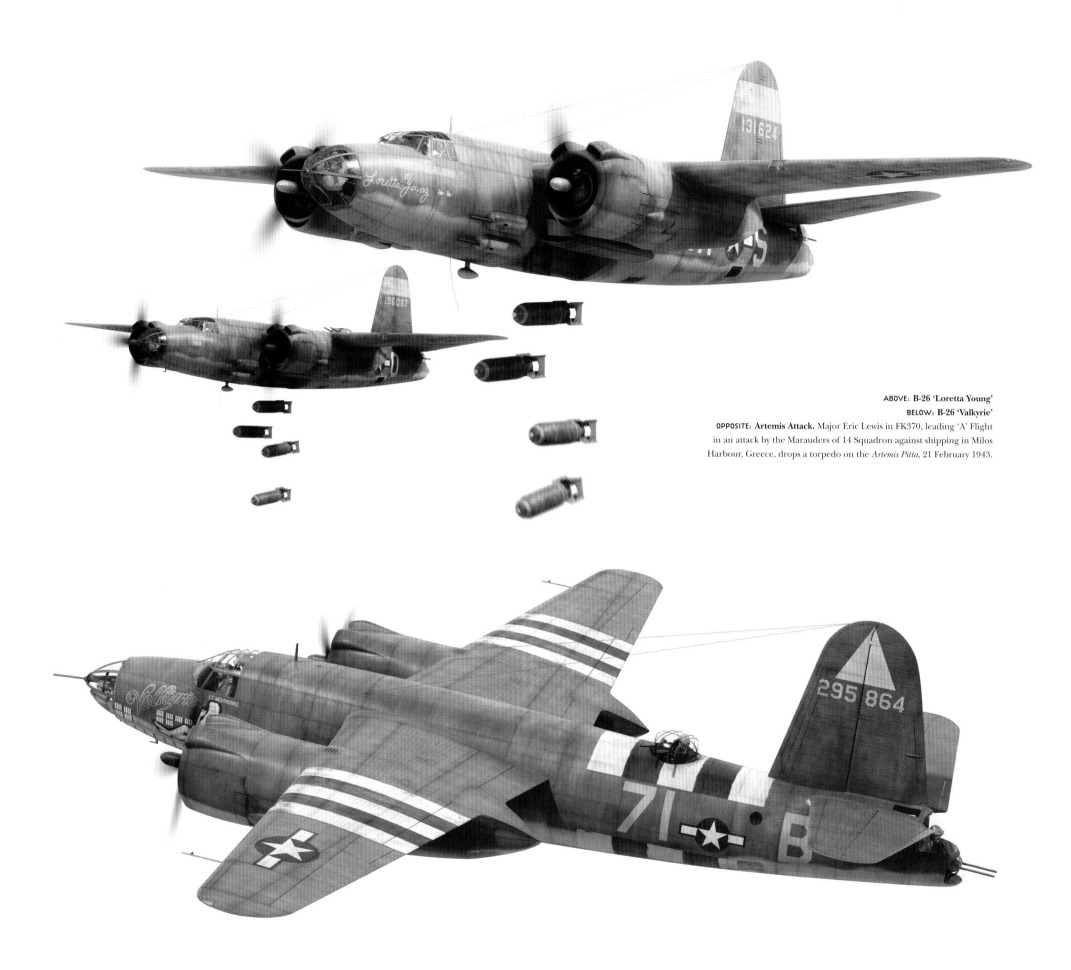

ABOVE: B-26 'Loretta Young'
BELOW: B-26 'Valkyrie'
OPPOSITE: **Artemis Attack.** Major Eric Lewis in FK370, leading 'A' Flight in an attack by the Marauders of 14 Squadron against shipping in Milos Harbour, Greece, drops a torpedo on the *Artemis Pitta*, 21 February 1943.

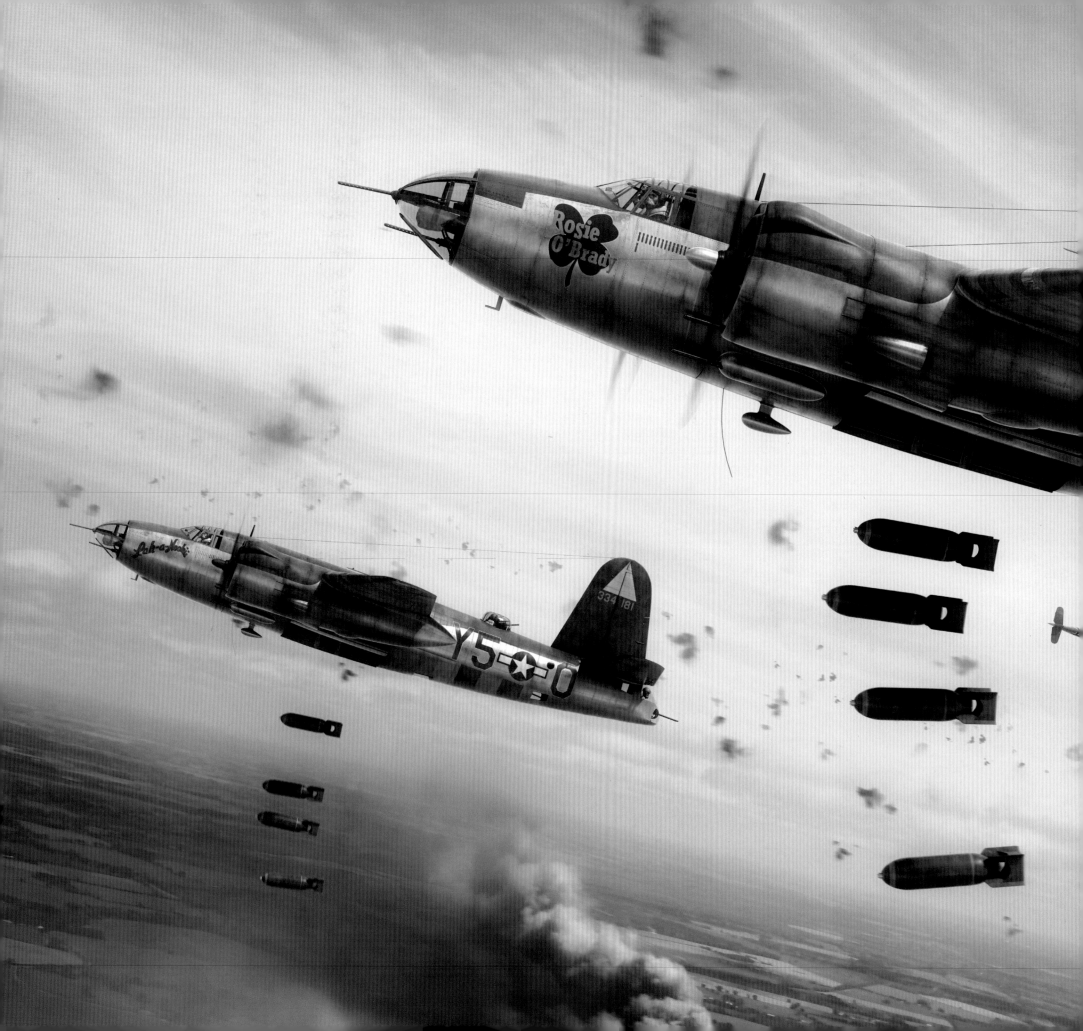

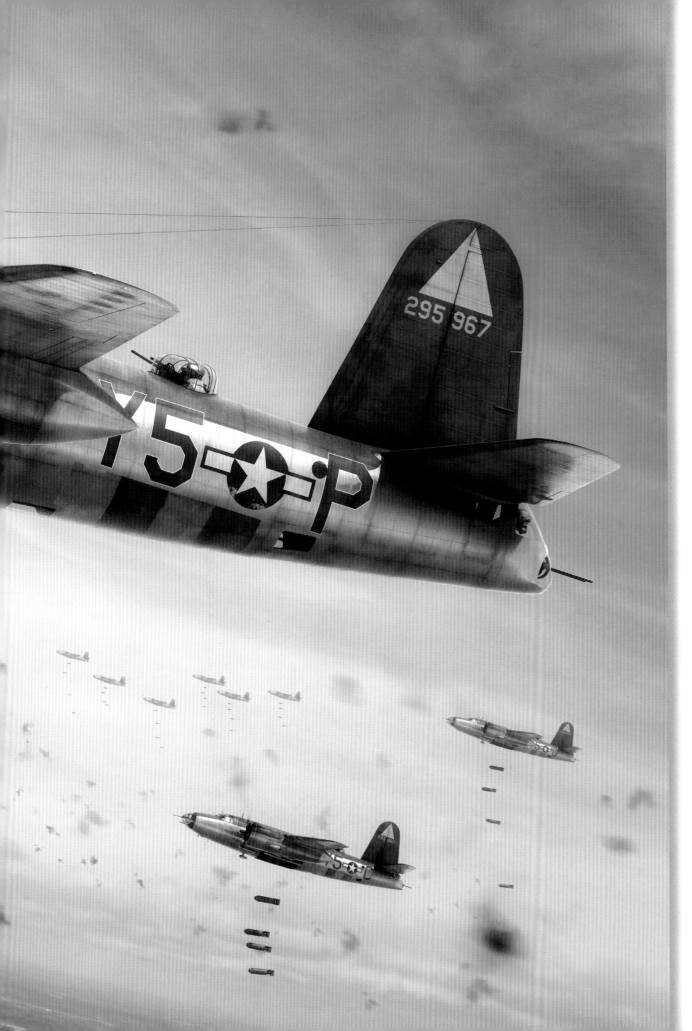

that damaged the undercarriage, especially the nose gear. The complexity of new engines also led to maintenance problems and to over taxing the propellers while still on the ground. If one of the engines lost power on take-off, the results were often fatal crashes. As such, it was not an aircraft for inexperienced pilots, but once war broke out in December 1941, the need to rush pilots through training led to alarming crash rates. Training crews to fly the Marauder proved a long and arduous, as well as dangerous, process, even after Martin modified the aircraft, fitting it with longer wings and a higher tail.

However, once in the air, the Marauder proved to be an outstanding aircraft. Serving mostly in Europe and the Mediterranean, it had the lowest loss rate of any American bomber. Initial missions at low level did lead to heavy losses, but once the eight bomber groups equipped with the type began flying at medium altitudes (between 10,000-15,000ft [3,000-4,600m]), it proved very effective. Its primary role was attacking targets in support of the upcoming invasion of Europe, hitting bridges, transport hubs, and troop and armour concentrations, a role it continued to fulfil after D-Day. By then it had also added V-1 launch sites to its roster of targets.

The RAF and South African Air Force acquired some 500 Marauders, which served throughout North Africa and the Mediterranean. The RAF found a new use for the type as a torpedo bomber, sinking a number of vessels while operating from Egypt. It also served as a 'heavy fighter', shooting down German transport aircraft trying to supply the beleaguered Afrika Korps.

US Marauders also operated in the Pacific. Unlike their European counterparts, USAAF units did use the B-26 in the torpedo bomber role, taking part in the Battle of Midway in June 1942. It proved unsuccessful, with no recorded sinkings attributed to the type, but it did well in its more conventional medium-bomber operations. However, by January 1944, it had been phased out in favour of the B-25 Mitchell.

LEFT: **The Marauders.** 344th Bomb Group B-26Gs Y5-O 'Lak-a-Nookie' and Y5-P 'Rosie O'Brady' bombing in a typically flak-speckled European sky in October 1944. Both aircraft survived the war.

P-38 LIGHTNING

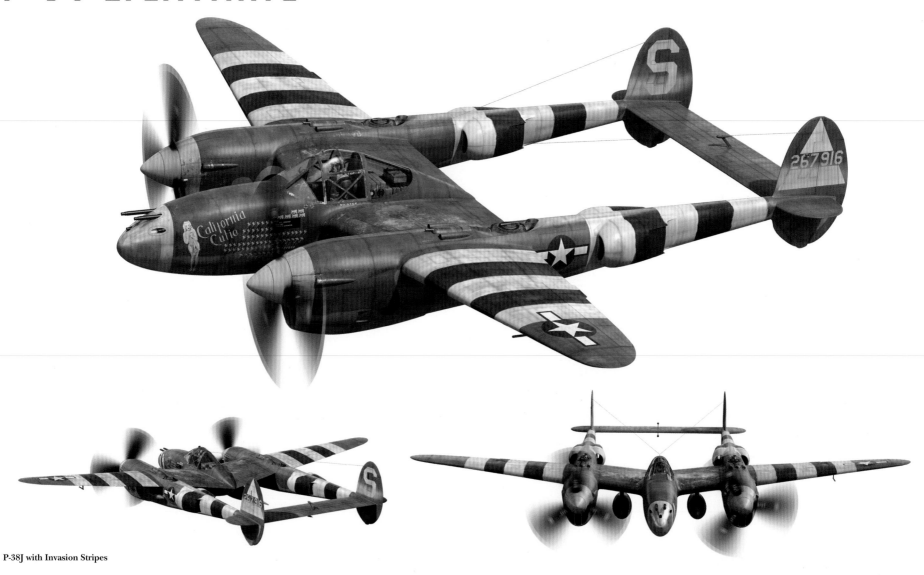

P-38J with Invasion Stripes

SPECIFICATIONS

FOR MODEL: P-38J

TYPE: heavy fighter

MANUFACTURER: Lockheed Corp.

OPERATORS: USA; France; Honduras

CREW: pilot

LENGTH: 37.1ft (11.53m)

WINGSPAN: 52ft (15.85m)

WEIGHT: 12,780lb (5,797kg) [empty]-21,600lb (9,798kg) [max. take-off weight]

MAX. SPEED: 414mph (666km/h)

SERVICE CEILING: 44,000ft (13,000m)

RANGE: 475 miles (764km)

POWERPLANT: Allison V-1710-89 x 2

ARMAMENT: Hispano AN-M2 'C' 20mm x 1 and

Browning .50 calibre machine gun x 4 in nose; payload of up to 3,200lbs (1,451kg) on underwing hardpoint x 2

MAIDEN FLIGHT: 27 January 1939

IN SERVICE: 1941-1965 (Honduran Air Force)

NUMBER BUILT (ALL TYPES): 10,037

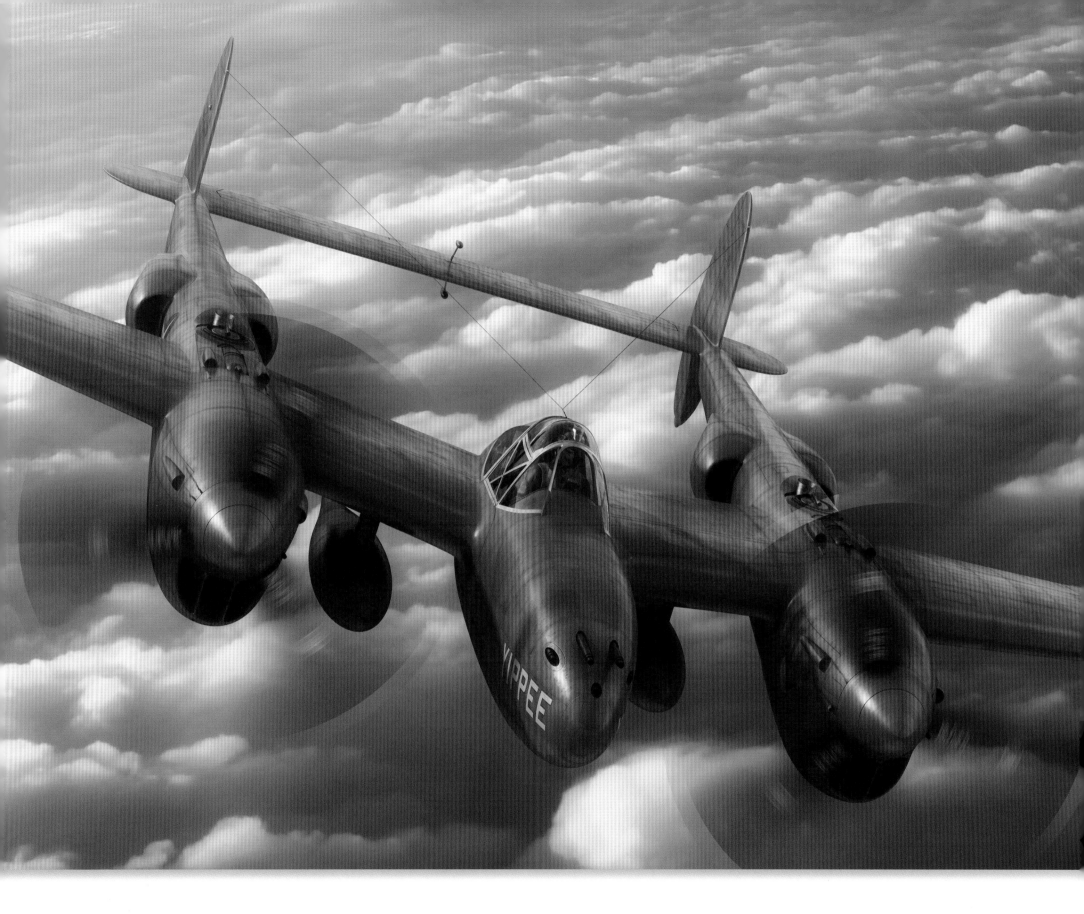

Yippee! P-38J-20-LO, serial no. 44-23296, the 5,000th Lightning, produced by Lockheed in May 1944.

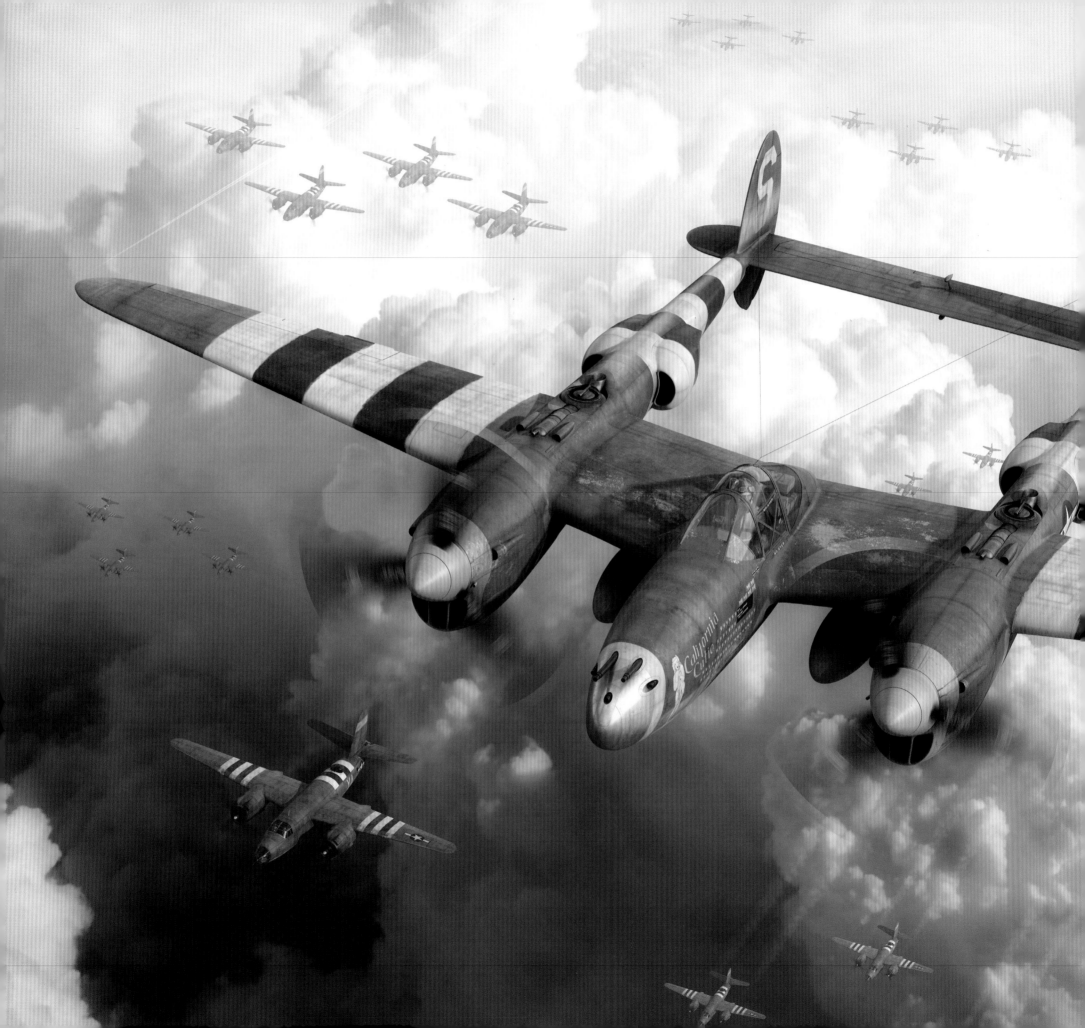

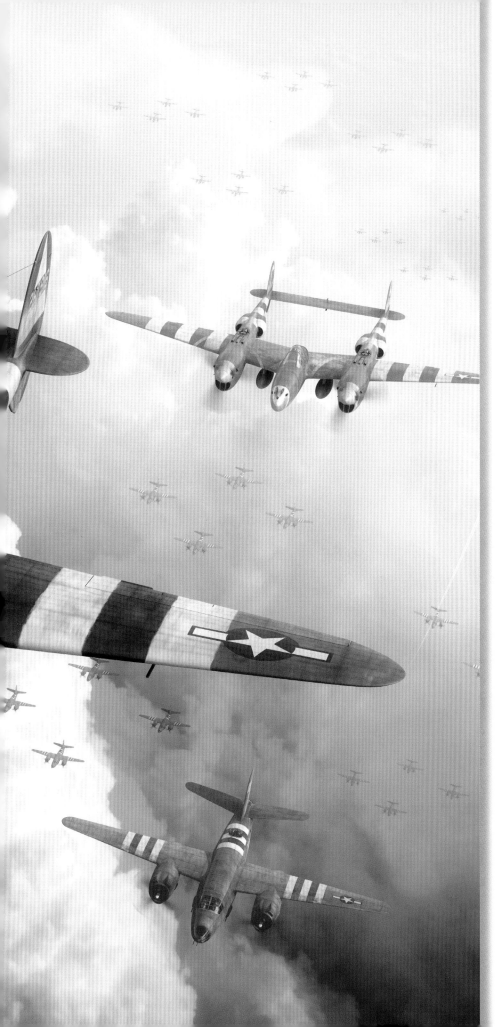

Developed following a request by the USAAC for a new long-range interceptor, the Lightning's twin-engine, twin-boom, single-nacelle layout, heavy armament and top speed of 360mph (579.36km/h) were far better than anything in service with the Americans at the time, but its large size affected its agility. The USAAC was nevertheless sufficiently impressed to order an initial batch of sixty-six aircraft.

Britain and France were also interested in the P-38 and jointly ordered 667, but the fall of France in June 1940 and problems with performance following modifications to meet British service led the British to withdraw from the sale, despite serious recriminations from Lockheed.

Half the USAAC order had been delivered by mid-1941 and, following studies of the air fighting in Europe at the time, the second batch was fitted with self-sealing fuel tanks and improved armour. The Japanese attack on Pearl Harbor soon saw the aircraft, christened the Lightning by the British, pressed into American service.

P-38s also began arriving in Britain and were used as bomber escorts, but experienced problems with their engines in the colder climes of Europe and were easily outflown by German single-engine fighters, suffering heavy losses during missions.

The P-38's size, speed and power made it more useful in other roles. F-4 and F-5 reconnaissance variants replaced the armament with cameras. Improved flaps and dive brakes on the wing also turned later versions into an effective dive-bomber and ground-attack aircraft, but by September 1944 it had largely been replaced by the P-51 Mustang.

The Lightning did better as a fighter in the Pacific theatre, scoring more kills than any other US type. Its long range and power made it ideal for the wide open spaces of the Pacific battlefield, and while it experienced the same problems in a manoeuvring dogfight with Japanese fighters as with German ones, its heavy hitting armament could tear apart its lightly armoured opponents.

Perhaps the most memorable mission by Pacific P-38s – indeed, by any Lightning – was Operation Vengeance. American codebreakers had discovered that Admiral Isoroku Yamamoto, architect of the attack on Pearl Harbor, was flying to Bougainville, part of the Solomon Islands chain, on 18 April 1943. Sixteen aircraft flew some 500 miles at low altitude and intercepted two Mitsubishi G4M 'Betty' bombers acting as Yamamoto's transports and their escorting Zero fighters just as they arrived at Bougainville. Four of the Lightnings homed in on the Bettys while the others engaged the escorts, and the Japanese admiral transport was hit, crashing into the Bougainville jungle. One Lightning was lost, but this was considered a small price for the killing of such a hugely important figure whose loss was felt deeply by the Japanese Navy.

California Cutie. The P-38J flown by Lt. Richard Loehnert of the 55th Fighter Squadron escorts B-26 Marauders on a daylight bombing raid in support of the D-Day landings. The aircraft are bedecked in the 'invasion stripes' worn by all Allied aircraft on and after that momentous day.

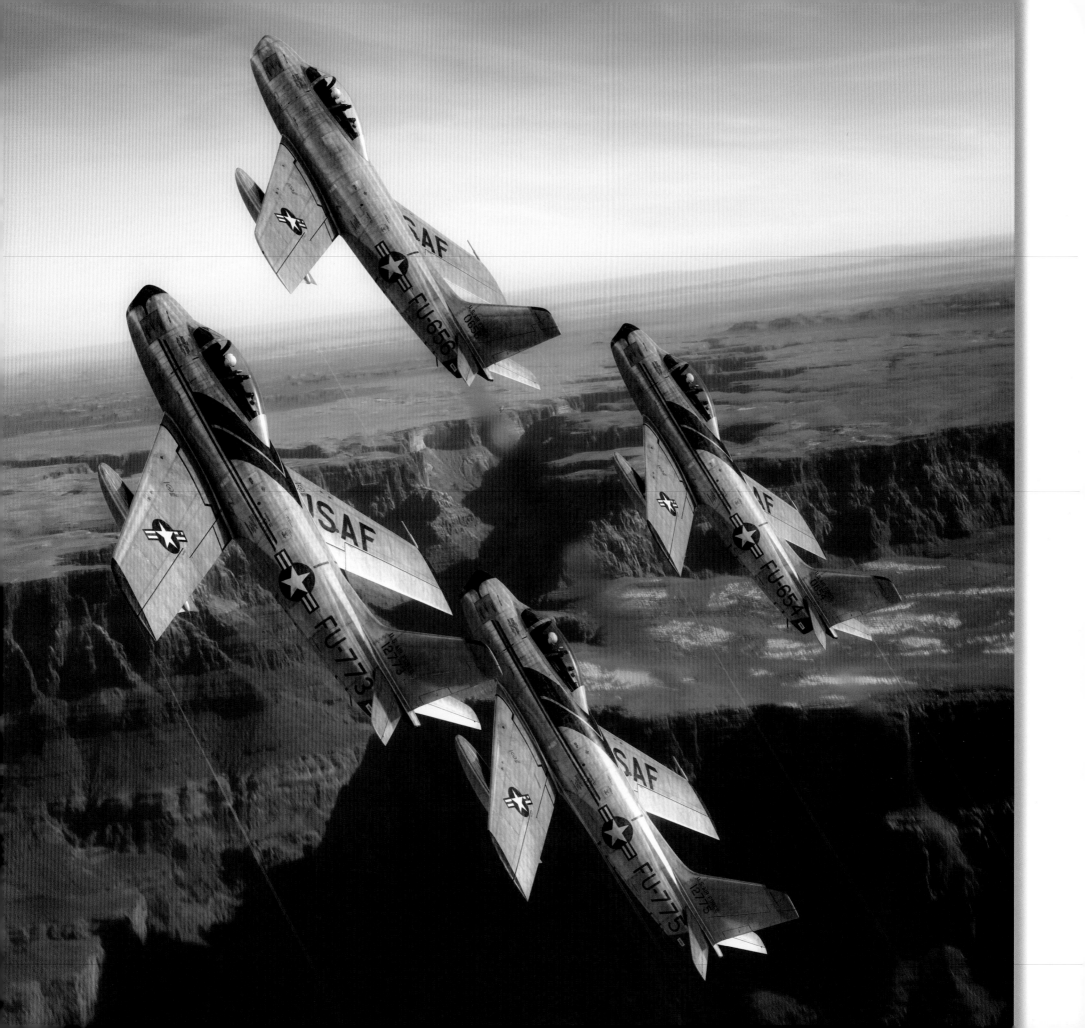

F-86 SABRE

SPECIFICATIONS

FOR MODEL: F-86A

TYPE: fighter

MANUFACTURER: North American Aviation [NAA]

OPERATORS INCLUDE: USA; Argentina; Belgium; Canada; Ethiopia; West Germany; Italy; Japan; Norway; Pakistan; Philippines; Portugal; Taiwan; Thailand; South Korea; Spain

CREW: pilot

LENGTH: 37.1ft (11.32m)

WINGSPAN: 37.1ft (11.32m)

WEIGHT: 10,093lb (4,578kg) [empty]-16,223lb (7,359kg) [max. take-off weight]

MAX. SPEED: 679mph (1,093km/h)

SERVICE CEILING: 50,000ft (15,240m)

RANGE: 660 miles (1,060m)

POWERPLANT: General Electric J47-GE-13

ARMAMENT: Browning M-2 .50 calibre machine gun x 6; maximum payload of 2,000lbs (907kg) on underwing hardpoint x 2

MAIDEN FLIGHT: 1 October 1947

IN SERVICE: 1949-1994 (Honduras)

NUMBER BUILT: 9,860 (all models)

A transonic jet fighter, the Sabre was the first swept-wing fighter used by the USAF, being the first aircraft in America to utilise the results of research into high-speed flight undertaken by Germany during WW2. The F-86A set an official world speed record of 670mph in September 1948.

As America's primary air combat fighter during the Korean War, the Sabre was a great success, with all but one of the American pilots who became aces during the conflict flying the aircraft.

From the mid-1950s the F-86 was gradually replaced in USAF by newer fighters, with the old aircraft moving to the Air National Guard or passing to allied nations, including Taiwan and Pakistan. The Sabre was also by far the most produced Western jet fighter, with variants being manufactured in Canada and Australia. As a result, the aircraft was used in several conflicts, including the Second Taiwan Strait Crisis of 1958, the Indo-Pakistani Wars of 1965 and 1971, and the Guinea-Bissau War of Independence. The last Sabres in active front line service were retired by the Bolivian Air Force in 1994.

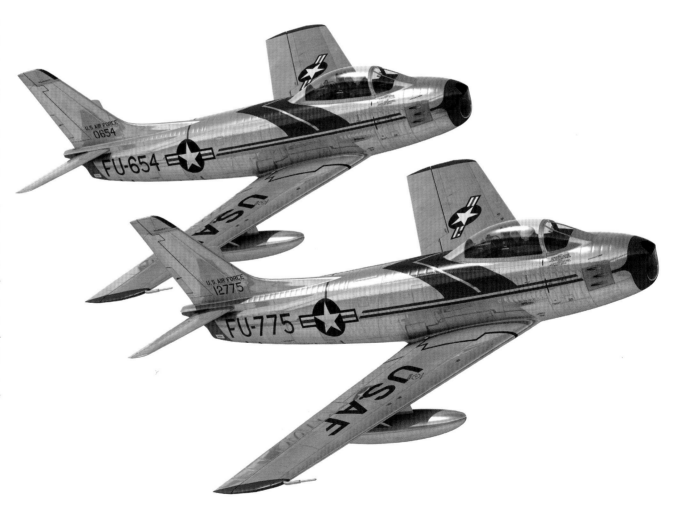

OPPOSITE: **Pleasing the Crowds.** F-86A Sabres of the 60th Fighter Interceptor Squadron Aerobatic Team, 1952.

THIS PAGE: **F-86As**

TO THE RESCUE!

Having already shot down one MiG-15 on the morning of 5 December 1951, the USAF's Major George Davis, in an F-86D of the 34th Fighter Squadron, 4th Fighter Wing, came across a dogfight between American and Korean jets. Spotting a MiG about to open fire on another Sabre, Davis dove down on the attacker, who broke away and began climbing to the northeast. Having built up speed and energy, Davis pulled up and chased after the MiG until he got within gunnery range. An excellent aerial marksman, he opened fire and scored hits, sending the Korean jet spinning out of control, the pilot ejecting. These were Davis' seventh and eight kills of the Korean War.

The experienced pilot succumbed to 'MiG madness' only two months later, on 10 February 1952, when, keen to make up for lost time after a lull in the number of kills he'd scored, he pushed his luck after his fourteenth victory, and was himself killed by one of the downed MiG's wingmen. He had been awarded the Congressional Medal of Honor, the USA's highest decoration for valour, for his actions in combat on 27 November 1951.

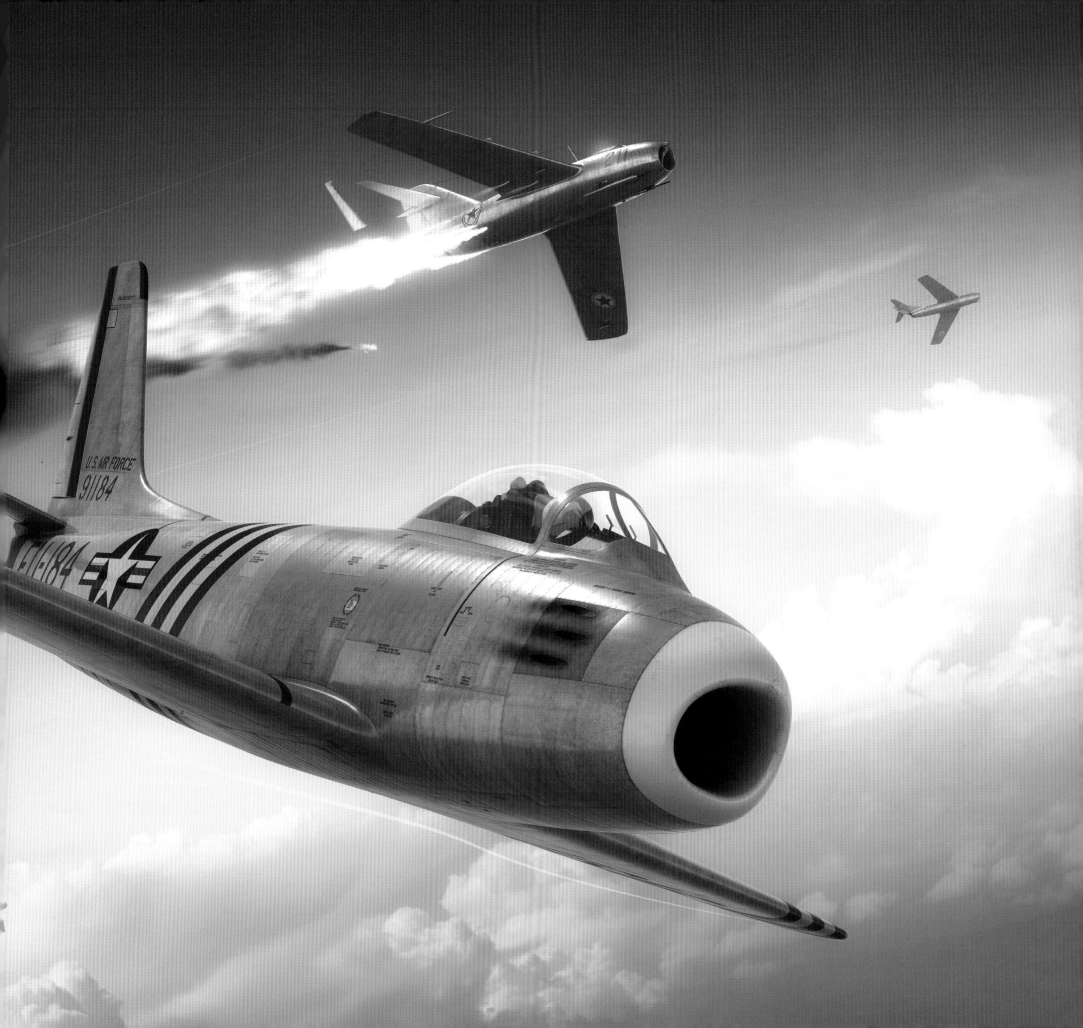

JAVELIN

The Javelin is unique in that it remains the only delta-winged fighter to serve with the RAF. It was also the last aircraft to bear the title Gloster, an illustrious name in the annals of British aircraft development. Because of its unusual shape, it garnered a number of nicknames, including the 'Ace of Spades', 'Flying Triangle' and 'Flying Flatiron'. It was also known as the 'Harmonious Drag Master' because of the distinct

Punching the Sky. The FAW Mk 9 flown by Sqn Ldr George H. Beaton, Commanding Officer, RAF 228 Operational Conversion Unit, 1966.

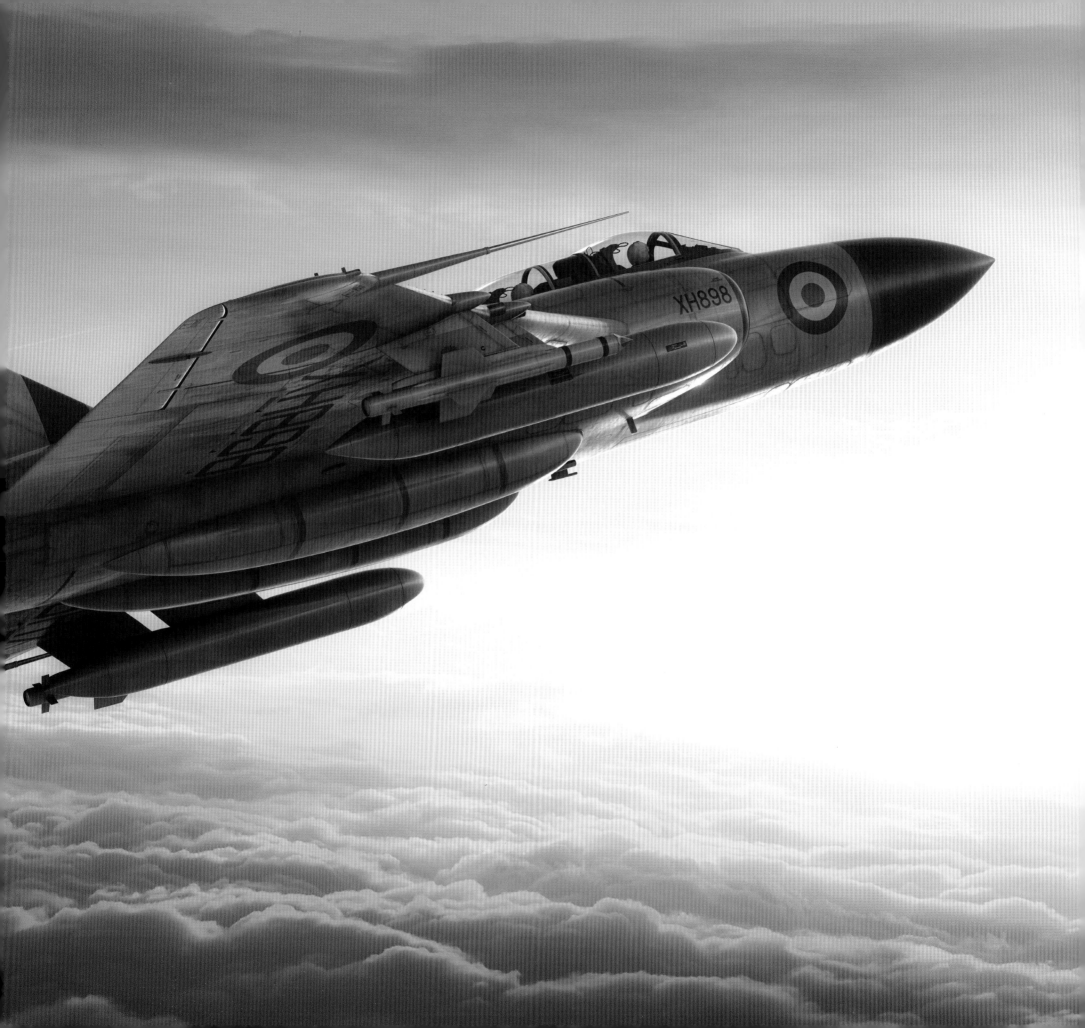

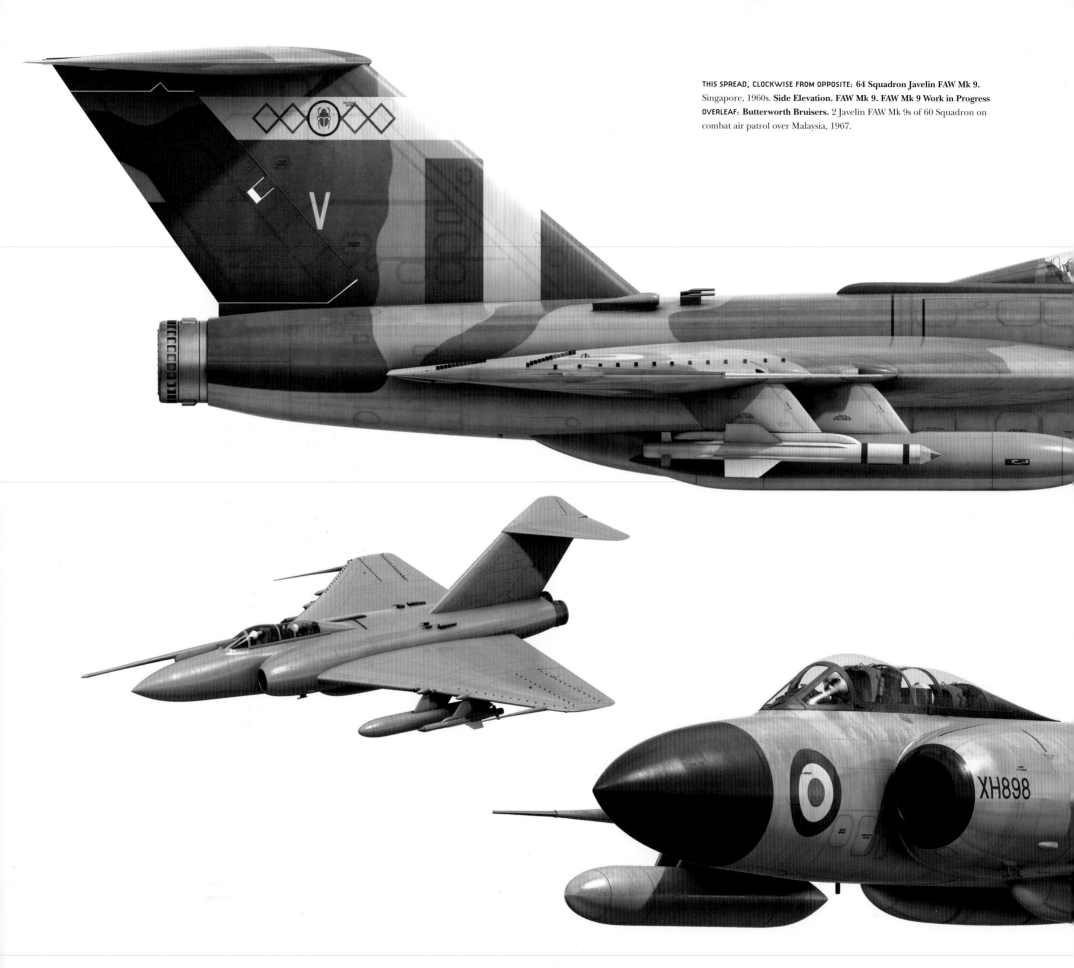

THIS SPREAD, CLOCKWISE FROM OPPOSITE: 64 Squadron Javelin FAW Mk 9. Singapore, 1960s. **Side Elevation. FAW Mk 9. FAW Mk 9 Work in Progress OVERLEAF: Butterworth Bruisers.** 2 Javelin FAW Mk 9s of 60 Squadron on combat air patrol over Malaysia, 1967.

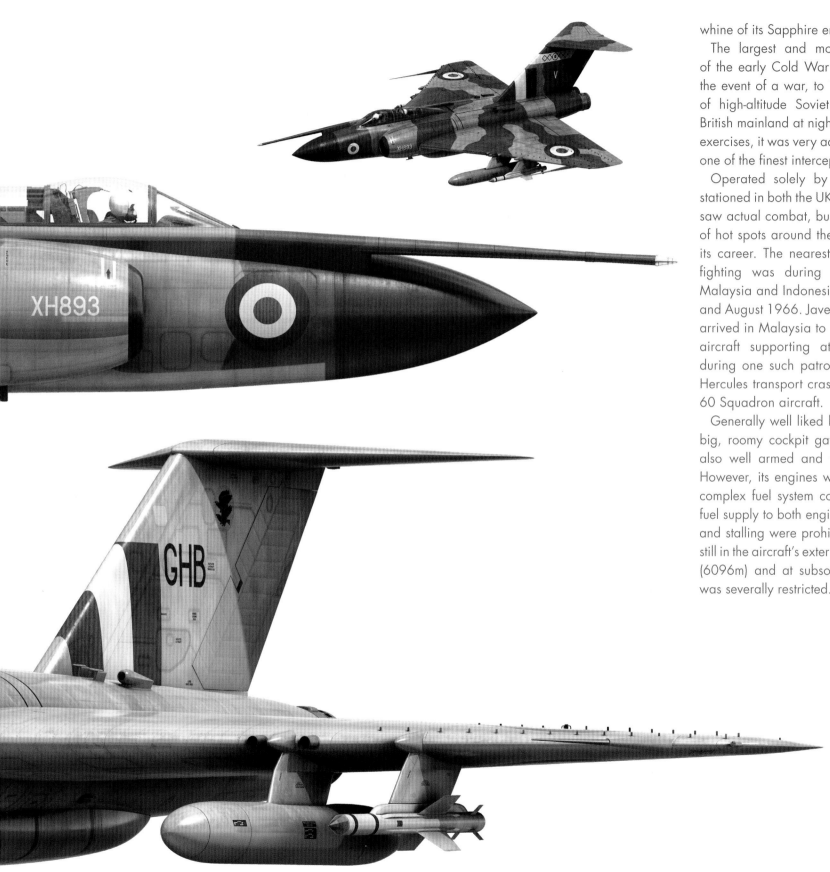

whine of its Sapphire engines.

The largest and most complicated RAF fighter of the early Cold War period, it was designed, in the event of a war, to intercept the new generation of high-altitude Soviet bombers approaching the British mainland at night and in all weathers. During exercises, it was very adept at the role, proving to be one of the finest interceptors in the world at the time.

Operated solely by the RAF, it was generally stationed in both the UK and West Germany. It never saw actual combat, but was deployed to a number of hot spots around the world during the course of its career. The nearest the Javelin came to actual fighting was during the confrontation between Malaysia and Indonesia between September 1963 and August 1966. Javelins of 60 and 64 Squadrons arrived in Malaysia to see off forays by Indonesian aircraft supporting attacking insurgents. It was during one such patrol that an Indonesian C-130 Hercules transport crashed while trying to evade a 60 Squadron aircraft.

Generally well liked by its air crews, the Javelin's big, roomy cockpit gave excellent visibility. It was also well armed and was a stable gun platform. However, its engines were under-powered, while a complex fuel system could inadvertently cut off the fuel supply to both engines so that spinning, looping and stalling were prohibited. Also, if there was fuel still in the aircraft's external fuel tanks above 20,000ft (6096m) and at subsonic speeds, manoeuvrability was severally restricted.

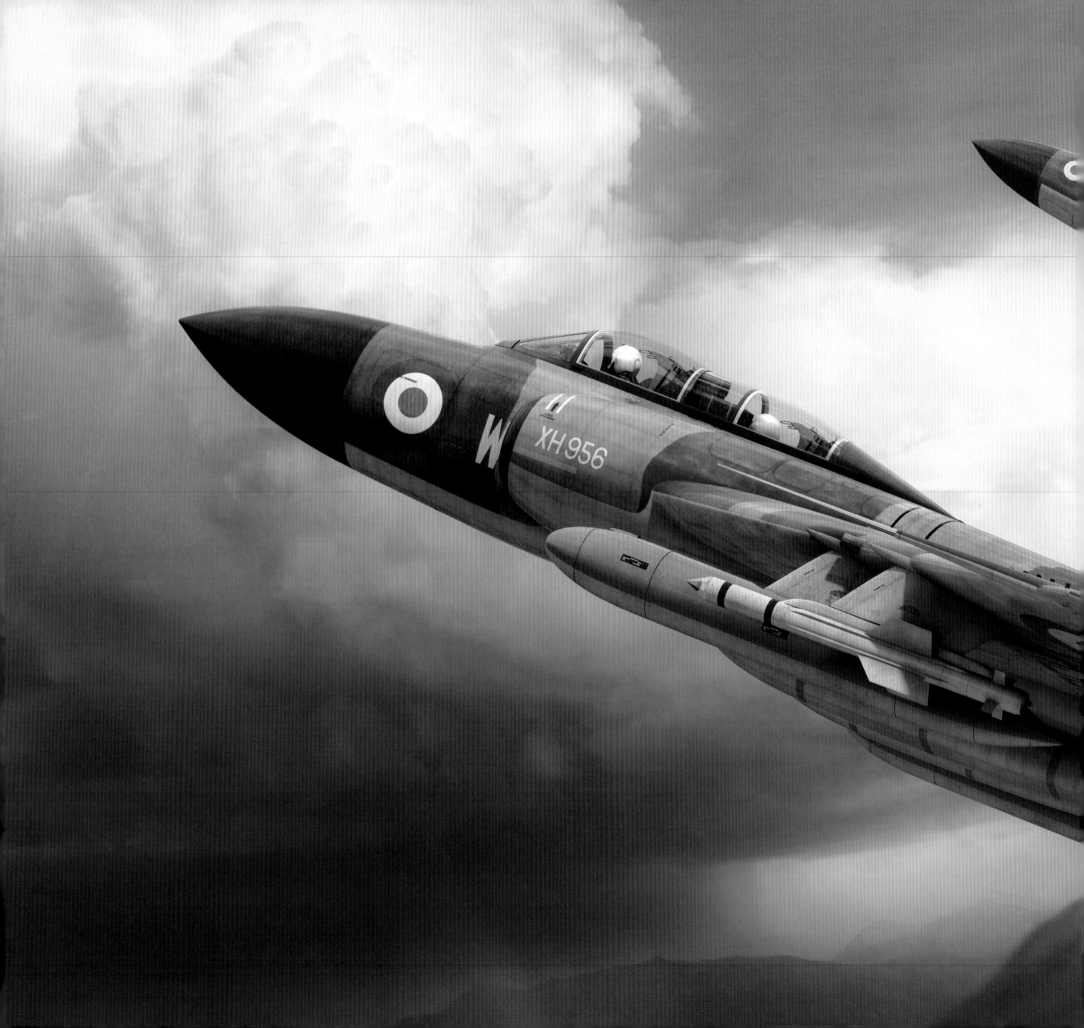

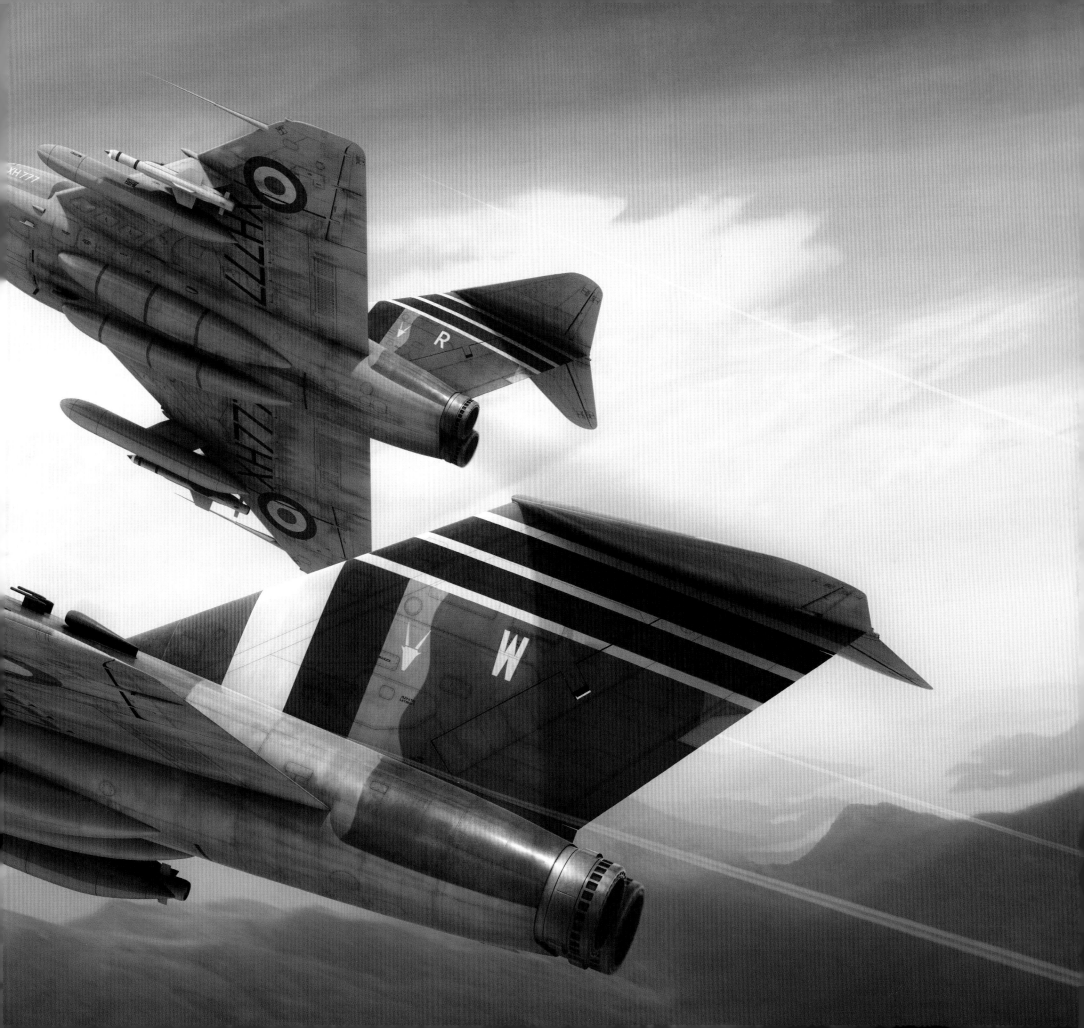

F-104C STARFIGHTER

SPECIFICATIONS

TYPE: interceptor/fighter-bomber

MANUFACTURER: Lockheed

OPERATOR: USA

CREW: pilot

LENGTH: 54.8ft (16.70m)

WINGSPAN: 21.9ft (6.675m)

WEIGHT: 12,760lb (5787.83kg) [empty]-19,470lb (8831.44kg) [max. take-off weight]

MAX. SPEED: 1,588mph (2555.64km/h) at 50,000ft (15240m)

SERVICE CEILING: 58,000ft (17,678m)

RANGE: 850 miles (1367.9km) [without drop tanks]

POWERPLANT: General Electric J79-GE-1 turbojet

ARMAMENT: M61A1 Vulcan 20mm cannon; wingtip-mounted AIM-9 Sidewinder AAM x 2; up to 2000lb (907.18kg) of ordnance on wing-mounted hardpoint x 2 and single underbelly pylon

RADAR: AI.17 wide-scan radar

MAIDEN FLIGHT: 24 July 1958

IN SERVICE: September 1958 to July 1975

NUMBER BUILT: 77

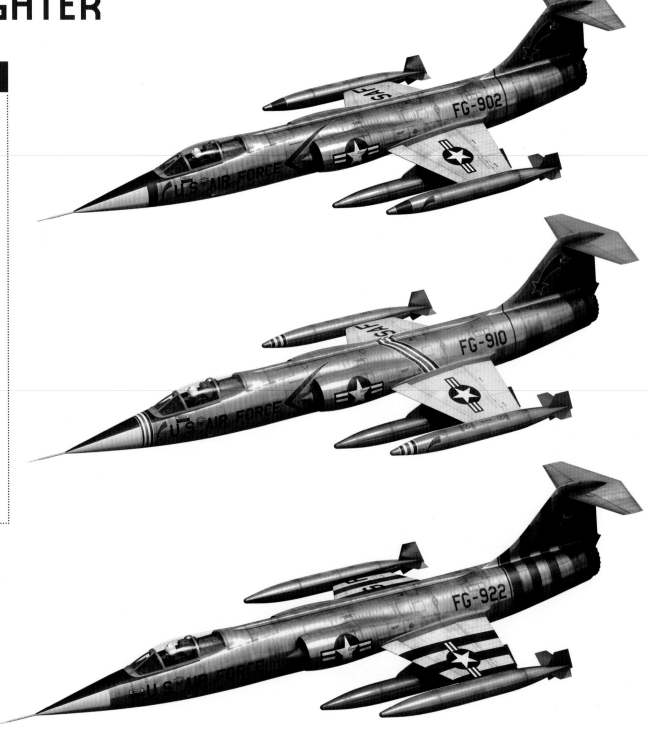

THIS PAGE, TOP TO BOTTOM: **F-104C, serial no. 56-0902.** Of the 435th Tactical Fighter Squadron 'Screaming Eagles', 479th Tactical Fighter Wing, George AFB, 1959. **F-104C, serial no. 56-0910.** Of the 479th Tactical Fighter Wing, George AFB, 1959. **F-104C, serial no. 57-0922.** Of the 436th Tactical Fighter Squadron, 479th Tactical Fighter Wing, 1964.

OPPOSITE: **F-104C, serial no. 56-0923.** Of the 436th Tactical Fighter Squadron, 479th Tactical Fighter Wing, high over the Mojave Desert, September 1959.

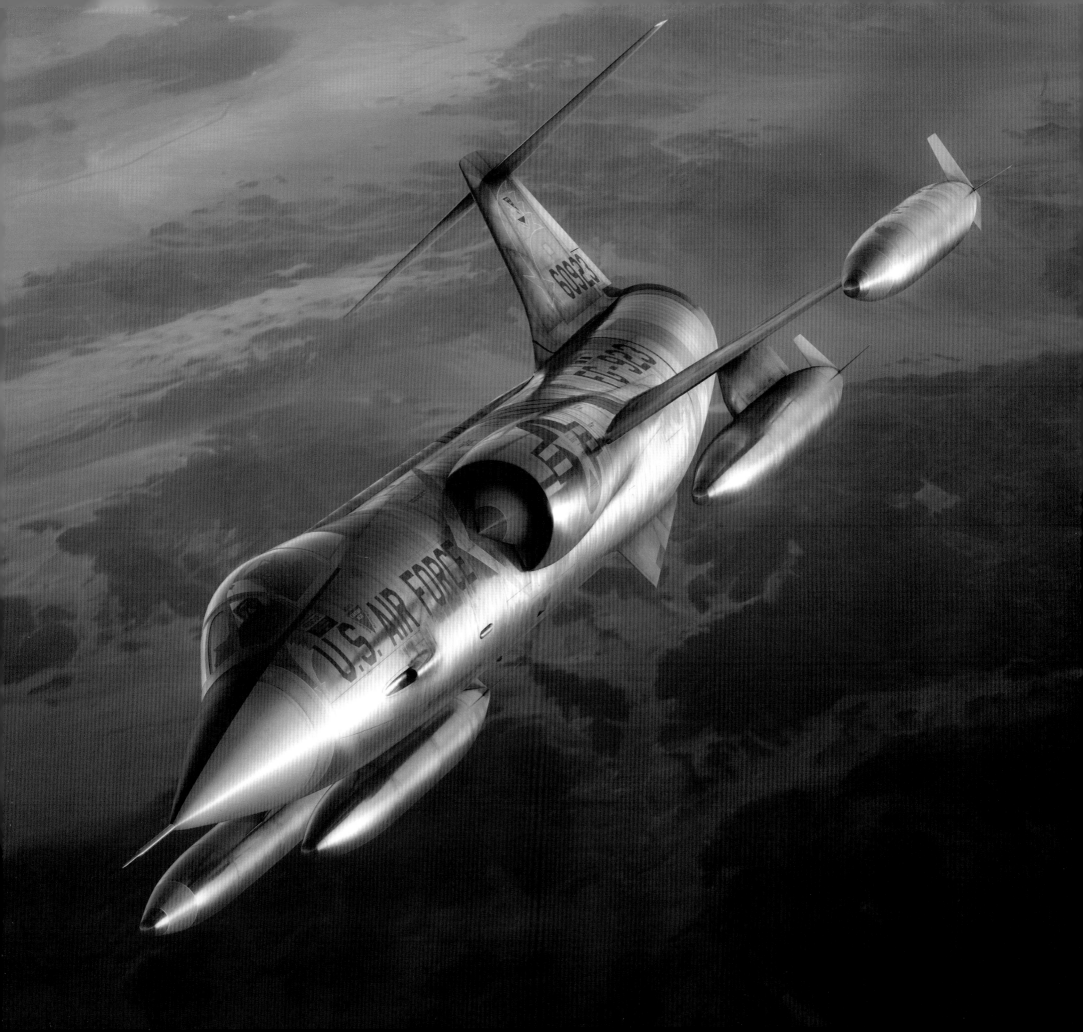

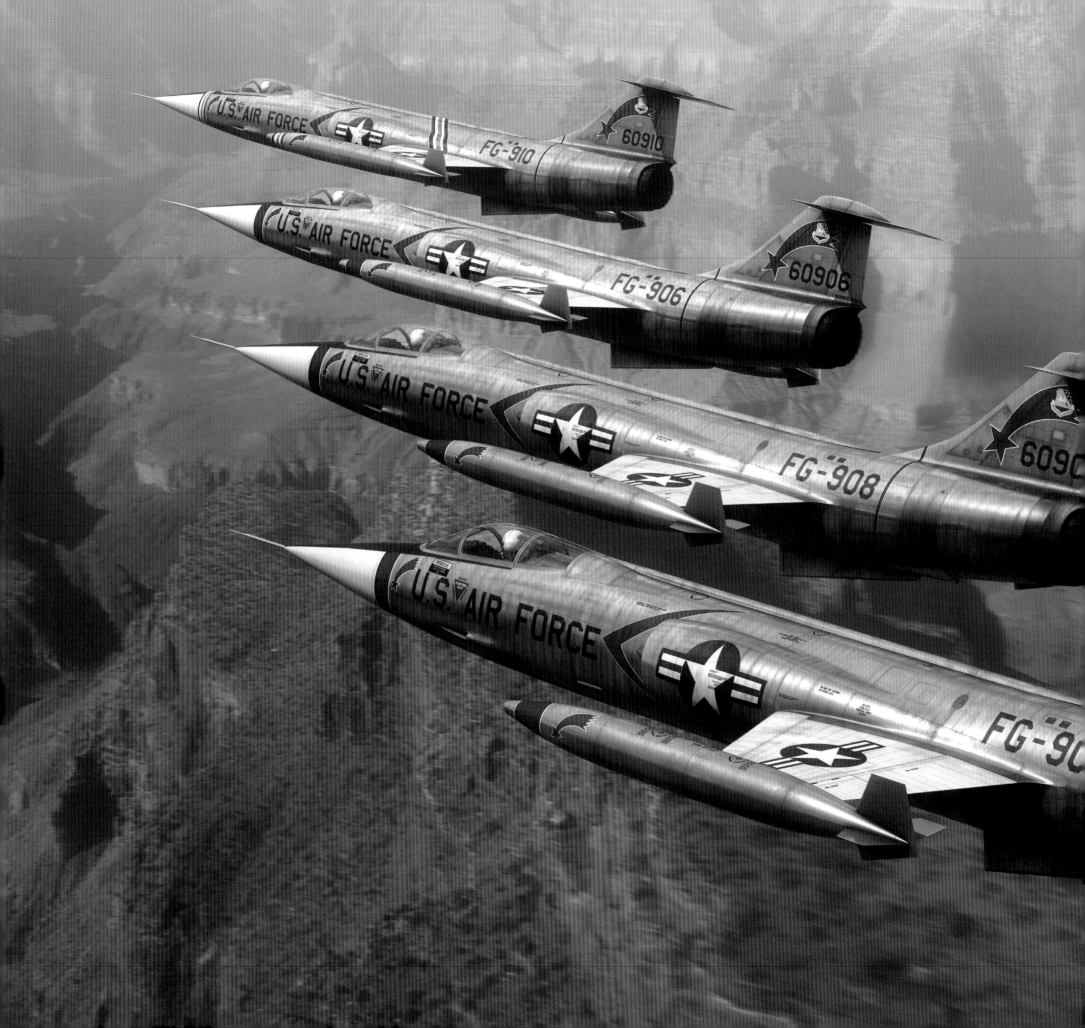

Originally designed as a high-speed interceptor that could climb to high altitude quickly and shoot down incoming Soviet bombers, the F-104C variant was conceived as a strike fighter to deliver both conventional and nuclear weapons.

The C model was equipped with an uprated J79, giving it almost a thousand pounds more thrust than the F-104A. This boost enabled an F-104C, piloted by Captain 'Joe' B. Jordan to set a new world altitude record of 103,389ft (31,513m) – the first time an aircraft had used its own power to take it from ground level to beyond 100,000ft. He also set a new time-to-climb record, taking 904.92 seconds to reach 98,000ft (30,000m).

With improved avionics and fire control systems, the F-104C's weapon load was intended to be the freefall MK28 and MK43 nuclear bombs. The aircraft was solely used by the 479th Tactical Fighter Wing, 476th Tactical Fighter Squadron, of the USAF, based at George AFB in California.

In April 1965 the 476th Tactical Fighter Squadron was dispatched to Kung Kuan AB in Taiwan to fly cover for American airborne early warning aircraft operating over the Gulf of Tonkin in support of air strikes into North Vietnam. North Vietnamese MiG pilots steered clear of the F-104s, who never had an opportunity to engage their adversaries, although they did have frequent encounters with Chinese MiGs flying harassing raids from nearby Hainan Island. With the air threat diminishing as a result of the F-104C's deterrent effect, the Starfighters took on weather reconnaissance and, flying from Da Nang AB in South Vietnam, began close air support missions. The aircraft proved to be a reliable and highly accurate weapon platform despite its lack of all-weather capability and small payload, while its small size and slim shape also made it a difficult target for anti-aircraft gunners. However, four aircraft were lost in combat, including one shot down on 20 September 1965 by Chinese MiGs after it became lost as a result of an avionics failure. Two of its squadron mates were destroyed in a mid-air collision while searching for their colleague, although both pilots safely ejected.

The 479th's Starfighters were replaced by F-4 Phantoms in November 1965. Though in early 1966, when the North Vietnamese deployed the MiG-21 – an aircraft far more capable than the previous types flown – Starfighters headed for RTAB Udorn, in Thailand, as part of the famous 8th Tactical Fighter Wing, nicknamed the 'Wolf Pack'. Because they lacked modern warning equipment to detect incoming missiles, two were lost, both on 1 August, and the Starfighters were relegated to close air support missions in South Vietnam and in neighbouring Laos. However, by late 1966, the F-104s were upgraded with new radar warning gear and once more flying into North Vietnam.

The Starfighter's US service was reduced after 1965 and it ceased active service in 1969, though it remained in use by the Puerto Rico Air National Guard until 1975.

Grand Canyon Thunder. Members of the 1st unit to operate the type, 4 Lockheed F-104Cs of the 479th Tactical Fighter Wing fly over the Grand Canyon on their way home to George Air Force Base, California, 1958. The aircraft wear the red falling star fin flash of the 476th Tactical Fighter Squadron and are led by 56-0910, the Wing Commander's aircraft.

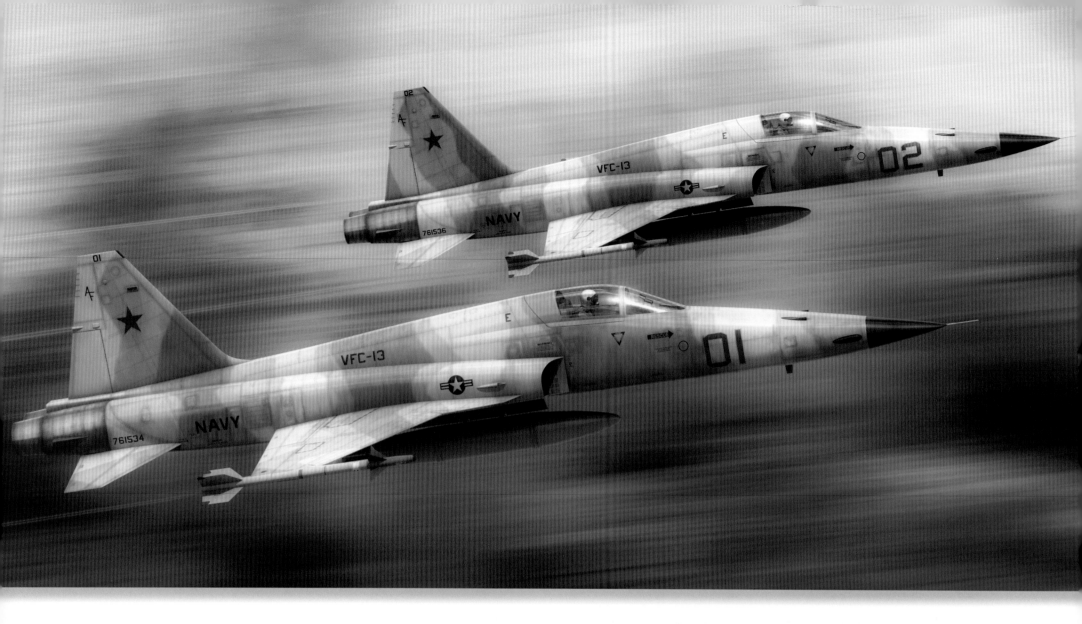

F-5

The first models of the F-5 were originally developed in the 1950s with a view to equipping the US Navy's line of escort carriers, which were too small to take the large, sophisticated types of fighter, such as the F-4 Phantom. However, the navy chose to retire those carriers instead, leaving the F-5 with an uncertain future. Even so, the USAF retained an interest in the two-seat F-5B model and it evolved into the famous T-38 Talon, which entered service in 1961 and trained countless USAF pilots.

The single-seat version, known as the Freedom

SPECIFICATIONS

FOR MODEL: F-5E Tiger II
TYPE: fighter-bomber
MANUFACTURER: Northrop Corp.
OPERATORS INCLUDE: USA; Austria; Bahrain; Brazil; Canada; Greece; Malaysia; Mexico; Netherlands; Norway; Philippines; Saudi Arabia; South Korea; Spain; Switzerland; Taiwan; Turkey; Vietnam
CREW: pilot
LENGTH: 47.4ft (14.45m)
WINGSPAN: 26.67ft (8.13m)
WEIGHT: 9,722lb (4,410kg) [empty]-24,723lb (11,214kg) [max. take-off weight]
MAX. SPEED: 1,077mph (1,734km/h)

SERVICE CEILING: 51.804ft (15,790m)
RANGE: 1,543 miles (2,483km)
POWERPLANT: General Electric J85-GE21 turbojet x 2
ARMAMENT: M29A2 20mm cannon x 2; AIM-9 Sidewinder AAM x 2 on wingtips; up to 7,000lbs (3175.14kg) of ordnance on four underwing hardpoints and single centreline hardpoint
RADAR: Emerson Electric AN/APQ-153 (later updated to the An/APQ-159)
MAIDEN FLIGHT (F-5E): 11 August 1972
IN SERVICE: 1962-present
NUMBER BUILT: 2,246 (all versions)

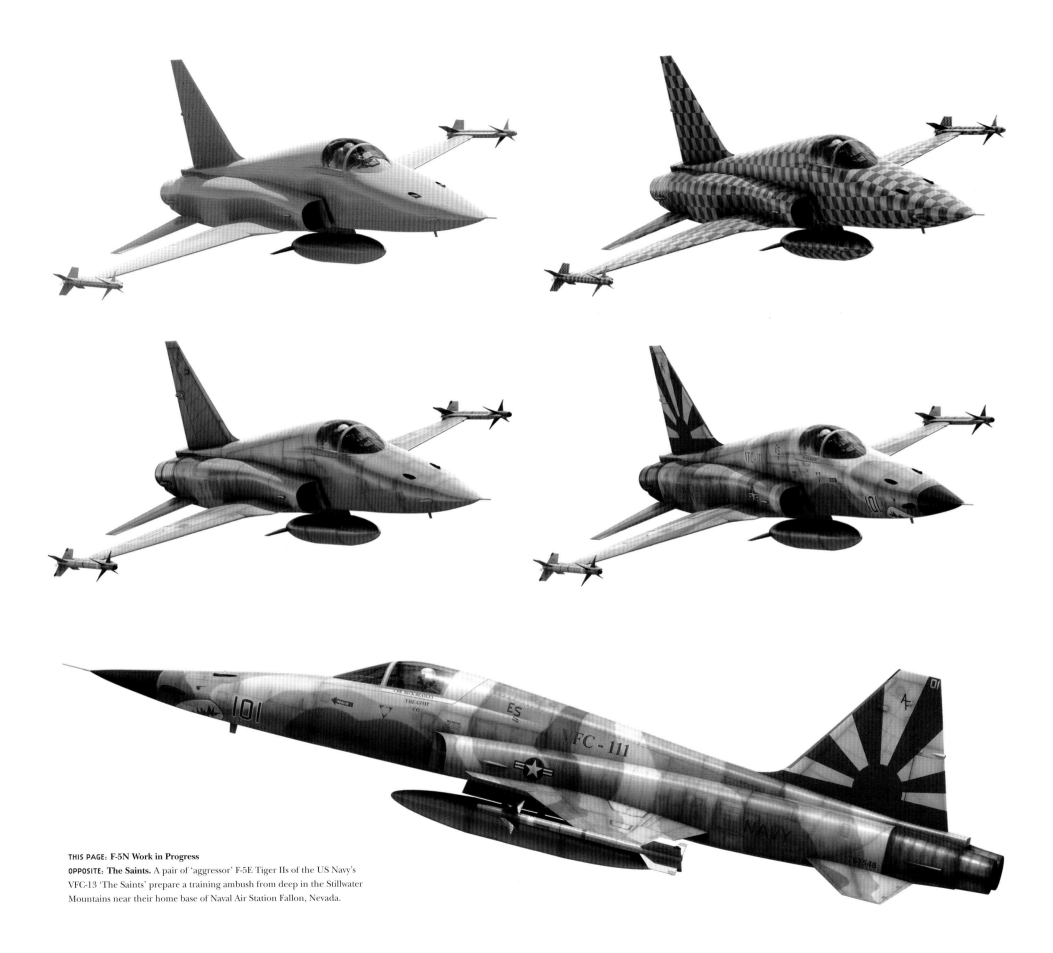

THIS PAGE: **F-5N Work in Progress**
OPPOSITE: **The Saints.** A pair of 'aggressor' F-5E Tiger IIs of the US Navy's VFC-13 'The Saints' prepare a training ambush from deep in the Stillwater Mountains near their home base of Naval Air Station Fallon, Nevada.

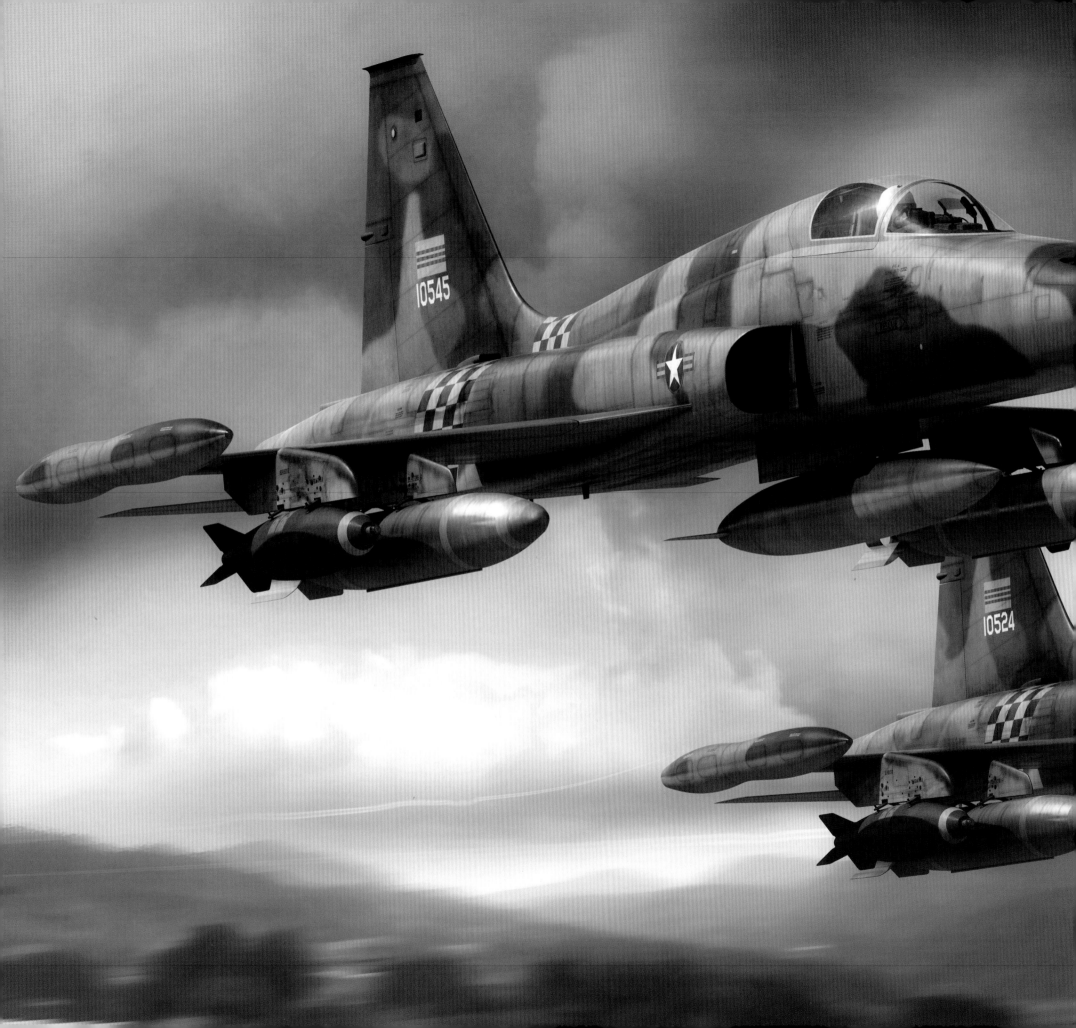

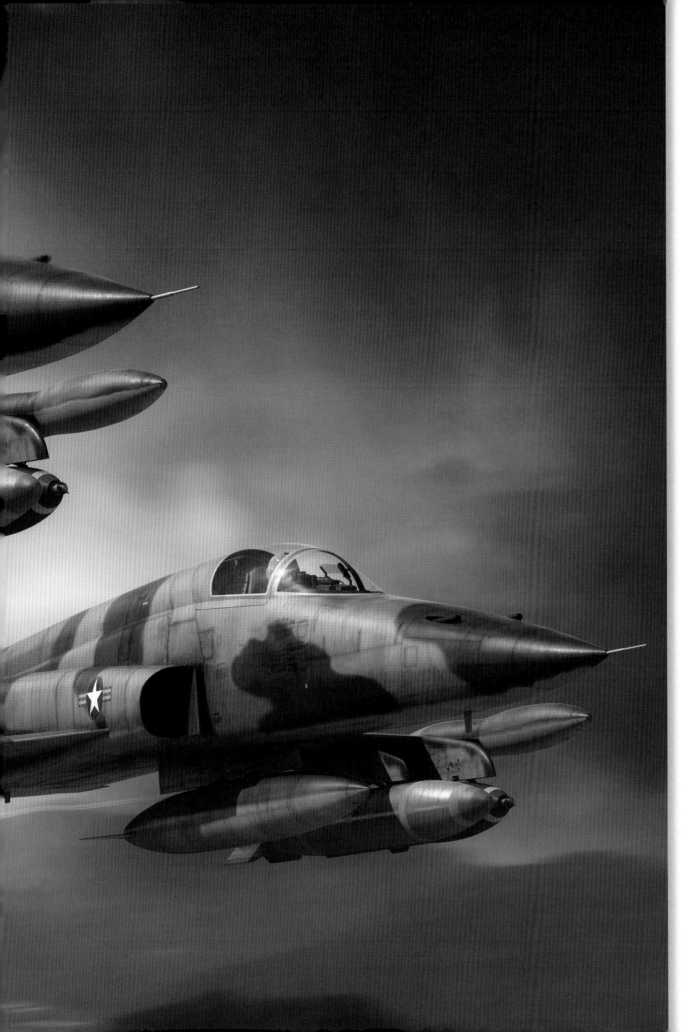

Fighter and intended to be a low-cost, lightweight, austere fighter, failed to garner much interest with the Air Force. Although supersonic, it lacked an all-weather capability and was built in an almost counter-intuitive style to American fighters of the time. With excellent manoeuvrability, it was a dogfighter at a time when most manufacturers were building interceptors equipped with missiles and the powerful radars to guide them to the Soviet bombers they were intended to destroy.

Northrop pressed ahead with development of the Freedom Fighter and succeeded in selling some 800 to US allies across the world, the first orders coming from Norway in 1962. Many NATO countries, including Canada, the Netherlands, Greece and Turkey, followed. However, USAF interest was piqued following America's embroilment in the Vietnam War. In the bombing campaigns against the North and the guerrilla war in the South, the big fighter-bombers of the USAF and USN were found to be flying a war they were ill equipped for.

Under the programme Skoshi Tiger, a single squadron of F-5As were sent to Vietnam for evaluation between October 1966 and March 1967. Equipping the 4503rd Tactical Fighter Squadron, the twelve aircraft were retrofitted with in-flight refuelling probes and 90lbs of addition armour. They were designated F-5Cs and were named Tigers.

During the six month trial, the Tigers flew some 2,600 sorties. Seven were lost in combat to ground fire, another two to operational causes, but the evaluation was considered a success, despite the F-5A's lack of range and small payload.

Skoshi Tiger was, in the end, considered nothing more than showboating for potential foreign buyers; the USAF never had any real intention of buying the aircraft. After the evaluation, the surviving F-5s were handed over to the South Vietnamese Air Force (VNAF). These were the first batch of 126 delivered

Tiger Take-Off. A pair of South Vietnamese F-5A Freedom Fighters of the 522nd Fighter Squadron of the Republic of Vietnam Air Force take off from Bien Hoa AB on a close air support mission in March 1971. Loaded with modified finned napalm tanks and ML-117 750lb general purpose bombs, the aircraft are wearing the distinctive black and yellow checkerboards of the 23rd Tactical Wing.

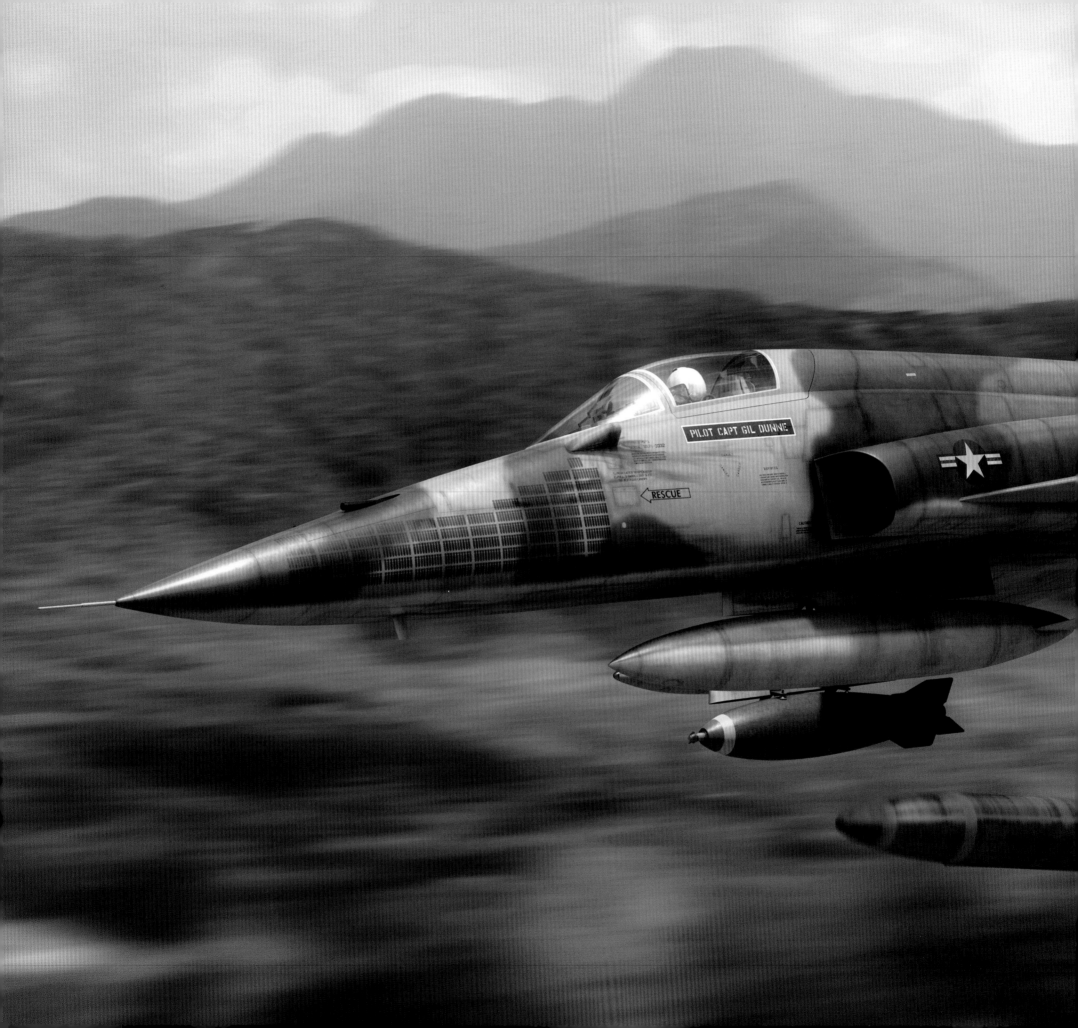

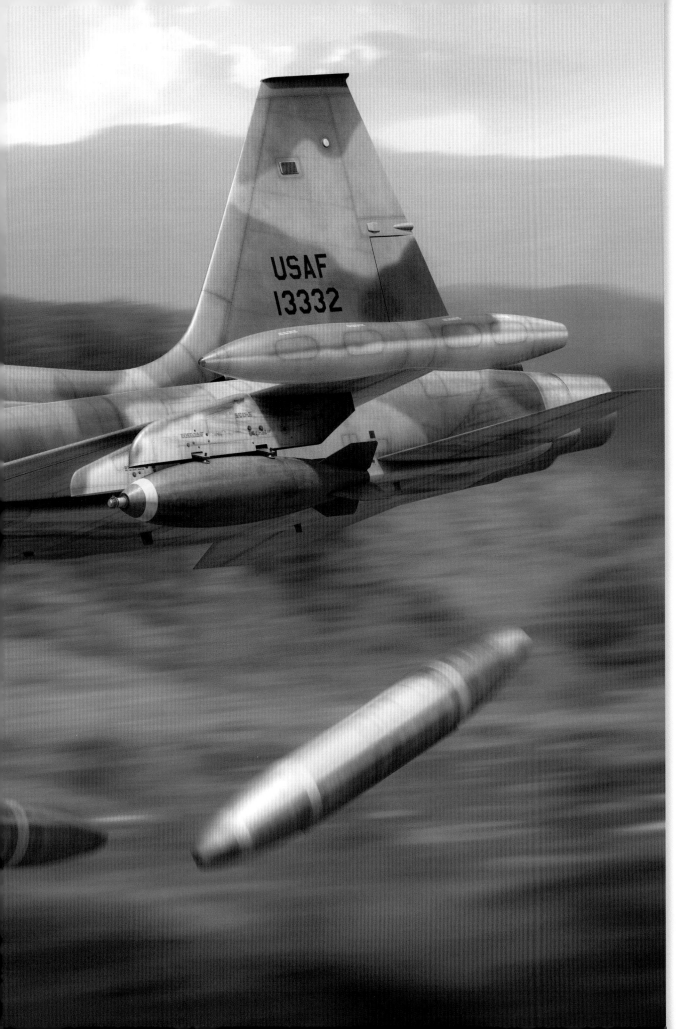

to the VNAF and performed very well in the ground attack and close air support roles, the twin engines offering a better chance of survival against ground fire.

After the fall of South Vietnam in 1975, a number of F-5s were pressed into service by the new and unified Communist state. Many saw action against the North Vietnamese former allies the Khmer Rouge following the outbreak of war between the new Vietnamese state and Pol Pot's Kampuchea.

In 1970, a new generation of F-5, the E model, won the International Fighter Aircraft competition. Named the Tiger II, the F-5E was intended to provide a cheap and reliable supersonic fighter-bomber to America's allies. Incorporating lessons from Vietnam, featuring improved design and avionics, and more powerful engines, more than 1,400 were built for many operators, mainly 'Third World' countries from across the globe. They also replaced earlier Freedom Fighters amongst NATO operators. Many still remain in use.

The USAF and USN did finally operate the F-5E, but, somewhat ironically, they were to serve as a simulator for the ubiquitous Soviet MiG-21. With a performance and appearance not unlike the Russian fighter, sixty-five flew with two 'Aggressor' squadrons in the USAF, and thirty-six at the US Navy's famous Naval Fighter Weapons School at NAS Miramar, in California, better known as Top Gun. Emulating Soviet tactics and even paint schemes, the F-5Es flew against the new generation of US fighters to verse their pilots in air combat against their possible opponents.

Skoshi Tiger. Capt. Gil Dunne of the 10th Fighter Commando Squadron drops a pair of BLU-18 napalm canisters during an interdiction mission from Bien Hoa, South Vietnam, 1967. The aircraft, also carrying a pair of M-117 750lb general purpose bombs, is F-5A Freedom Fighter 64-13332, one of the 12 Skoshi Tiger programme F-5Cs.

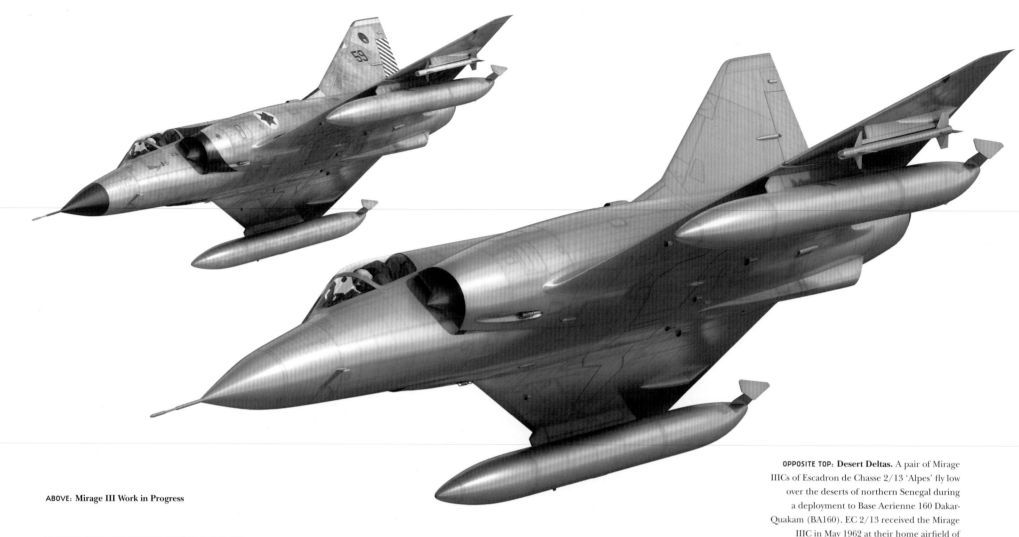

ABOVE: **Mirage III Work in Progress**

OPPOSITE TOP: **Desert Deltas.** A pair of Mirage IIICs of Escadron de Chasse 2/13 'Alpes' fly low over the deserts of northern Senegal during a deployment to Base Aerienne 160 Dakar-Quakam (BA160). EC 2/13 received the Mirage IIIC in May 1962 at their home airfield of Colmar-Meyenheim (BA132) in eastern France, near the German border.

OPPOSITE BOTTOM: **Mirage IIIC Work in Progress**

MIRAGE III

SPECIFICATIONS

FOR MODEL: IIIE

TYPE: fighter/interceptor

MANUFACTURER: Dassault Aviation

OPERATORS INCLUDE: Australia; Belgium; Egypt; France; Israel; Pakistan; South Africa; Switzerland; Venezuela

CREW: pilot

LENGTH: 49.4ft (15.03m)

WINGSPAN: 27ft (8.22m)

WEIGHT: 15,542lb (7,050kg) [empty]-30,205lb (13,700kg) [max. take-off weight]

MAX. SPEED: 1,460mph (2,350km/h) at 12,000ft

(39,370m)

SERVICE CEILING: 55,775ft (17,000m)

RANGE: 1,000 miles (1,610km)

POWERPLANT: SNECMA Atar 09C turbojet

ARMAMENT: DEFA 552A 30mm cannon x 2; payload of 8,818lbs (4,000kg) of weapons on underwing hardpoint x 4 and centreline hardpoint x 1

MAIDEN FLIGHT: 17 November 1956

IN SERVICE: July 1961-present

NUMBER BUILT: 1,422 (all versions)

Essentially a beefed-up, single-engined version of the earlier, lighter and twin-engined Mirage I, the Mirage III's delta winged, tailless design greatly reduced drag and gave an impressive turn of speed. It became the first aircraft built in Western Europe to fly at *Mach 2+* in level flight.

The first production model, the Mirage IIIC, was fielded by the French Air Force in 1961 and was soon proving to be a popular alternative to American and Russian combat aircraft, quickly entering service with both South Africa and Israel. Intended very much as a fighter, the design proved versatile enough for ground attack, reconnaissance and two-seat trainer variants to be developed.

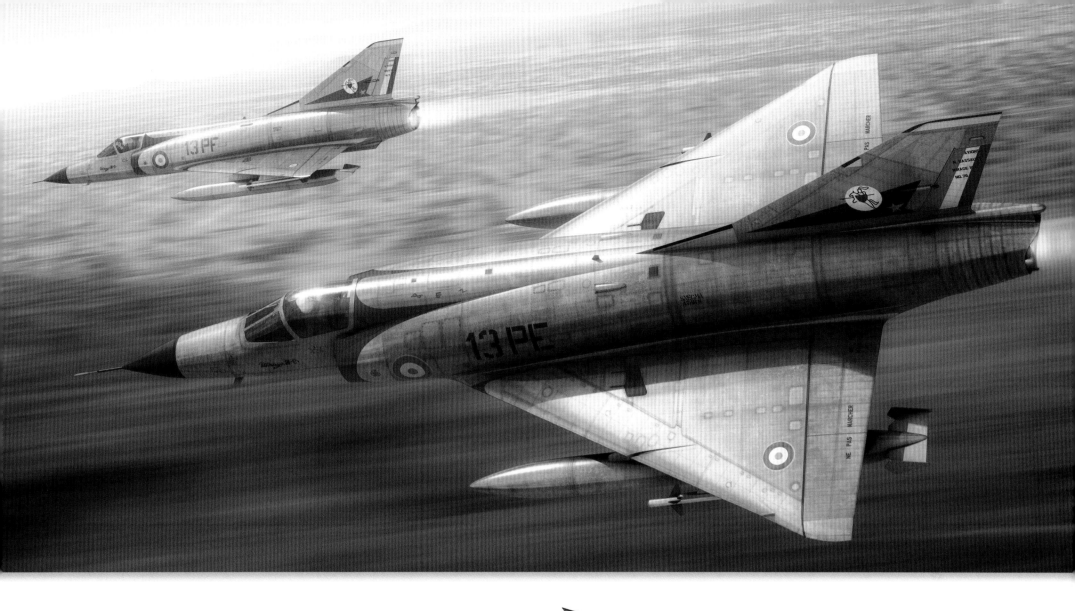

Israel acquired seventy Mirage IIICs (as well as four trainers and two Mirage IIIRJ reconnaissance versions) between April 1962 and July 1964, and the type scored its first kills in aerial skirmishes over the border between Israel and Syria in 1966. The Mirages were also in the thick of the action during the Six-Day War and accounted for forty-eight of the fifty-eight Arab aircraft shot down in the war. This was quite a feat considering the aircraft were without modern radars and their pilots required to dogfight using visual inspection (or the 'Mark I Eyeball') at high speeds.

The aircraft's success in 1967 triggered a wave of overseas orders and the Mirage was soon in action again, this time in the hands of the Pakistan Air Force during the 1971 war with India. Here again the aircraft performed extremely well, mainly in the ground-attack role and is still presently in service in Pakistan.

Dassault continued to improve the design, developing the multi-role Mirage IIIE, the prototype flying in April 1961. Featuring a stretched fuselage to accommodate more avionics and fuel, 532 were built not just in France but also under license in Australia and Switzerland.

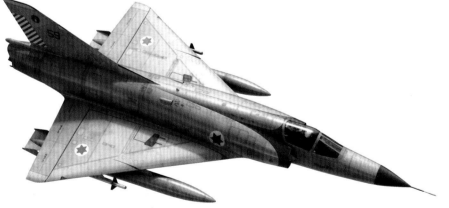

OVERLEAF: **First MiG Down.** Yoram Agmon of 10 Squadron, flying a Mirage IIICJ (known as the Shahak), made history on 14 July 1966, achieving two firsts with one kill. He became the first Israeli pilot to claim a MiG-21 and was the first to shoot down another aircraft while flying a Mirage IIICJ. Flying low over the Yarmouk Gorge, Agmon intercepted a pair of MiG-21s, downing the lead aircraft. He and his aircraft, Shahak 59, went on to achieve ace status with 13 confirmed kills.

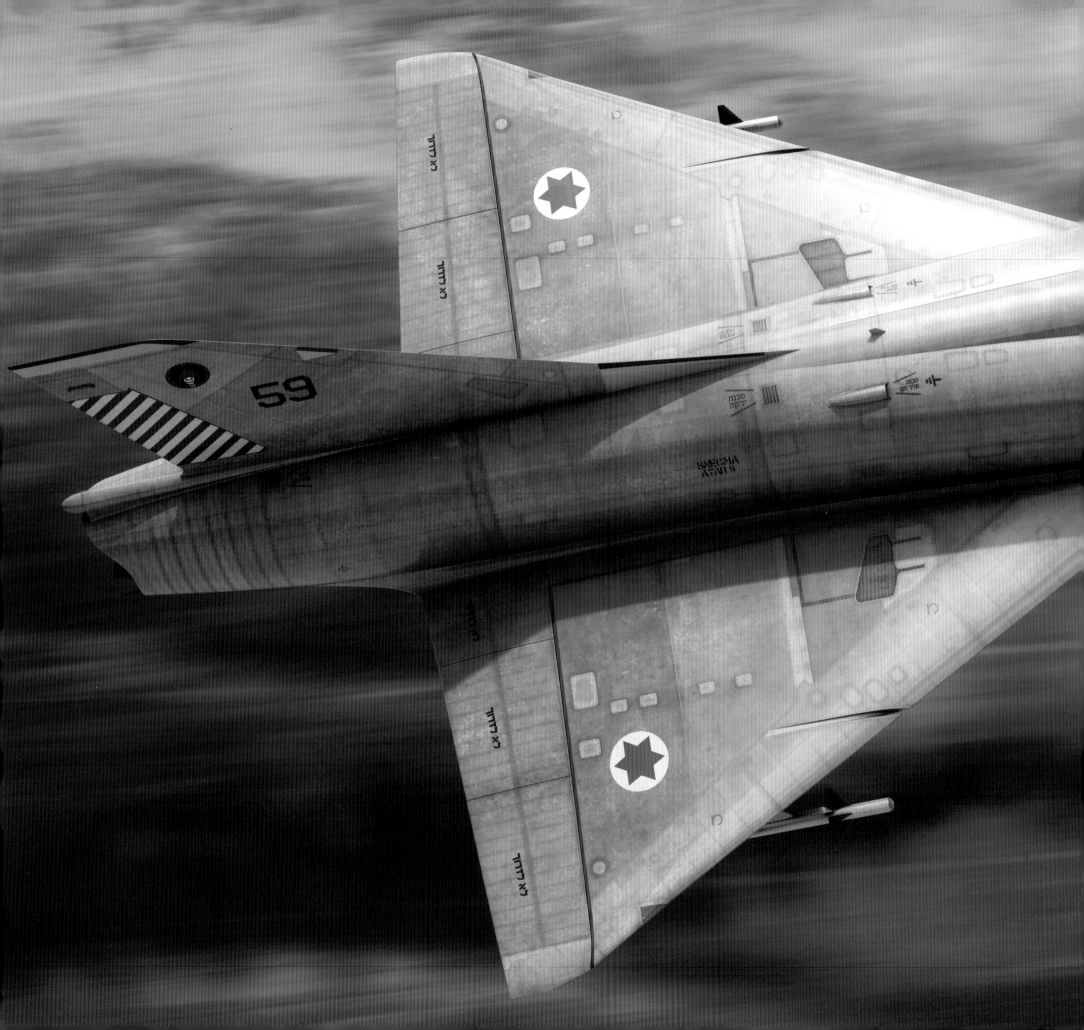

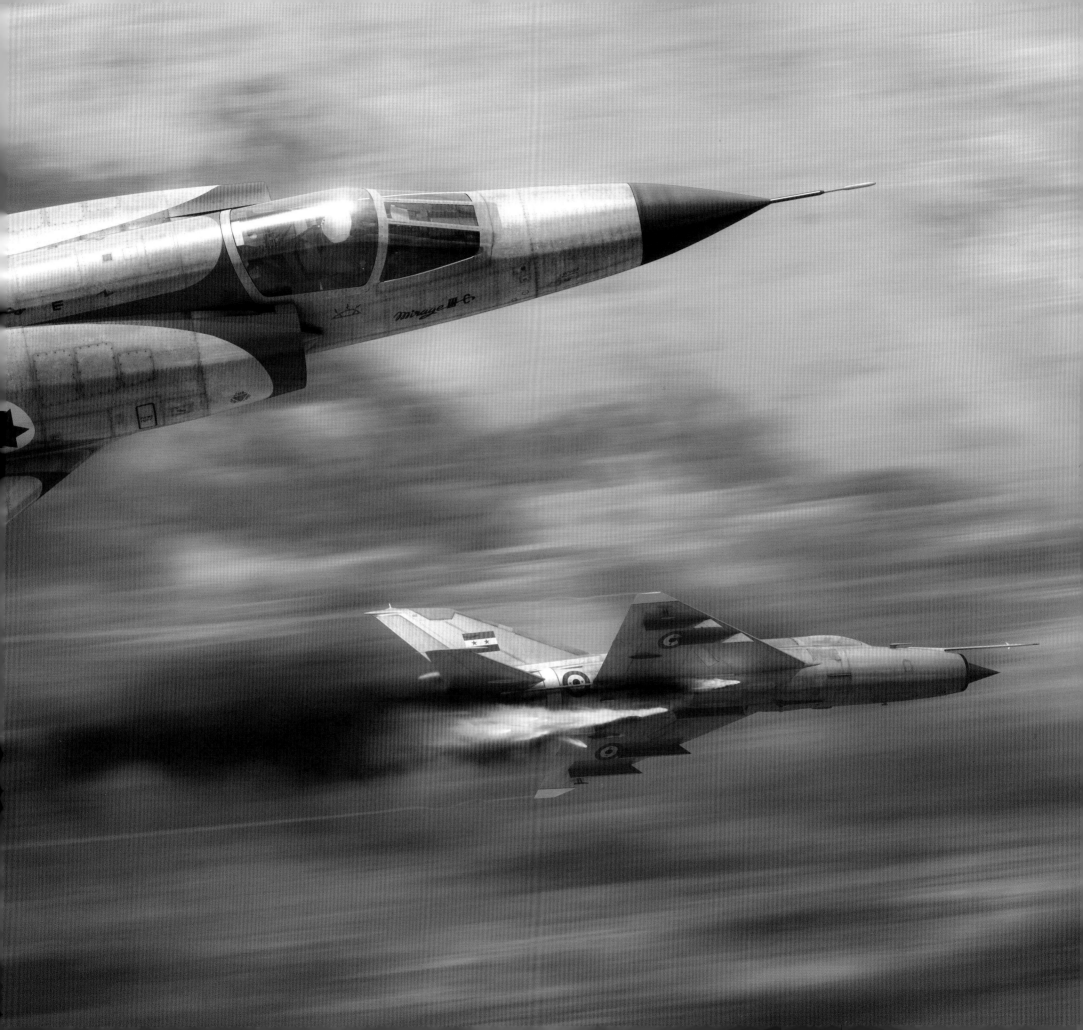

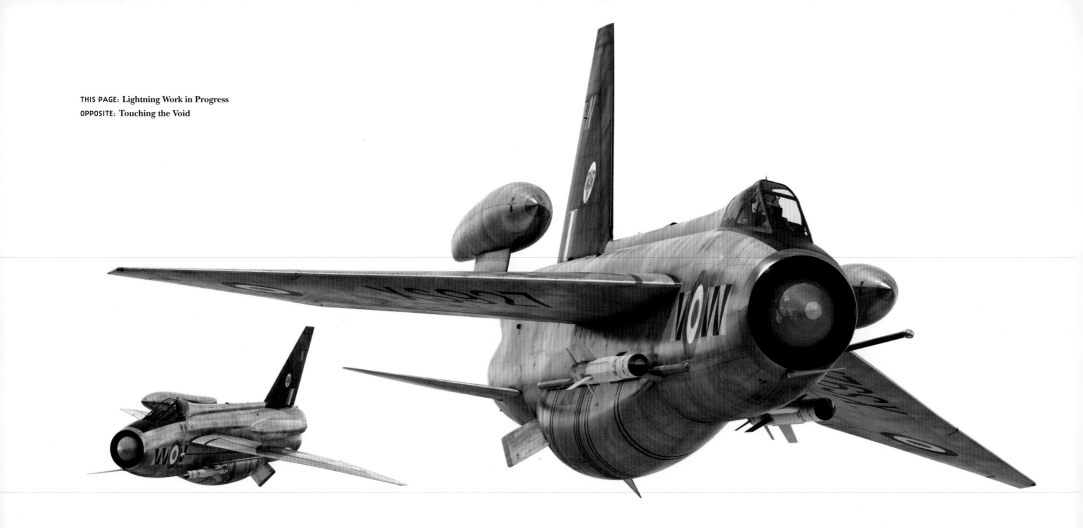

LIGHTNING F2A

SPECIFICATIONS

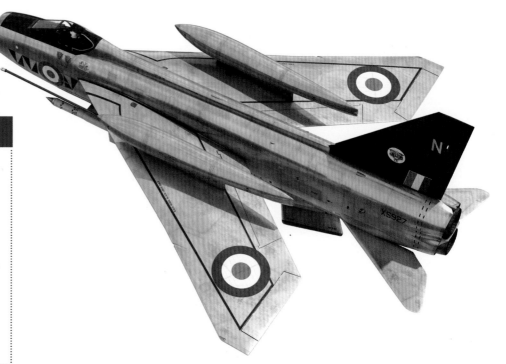

FOR MODEL: F6

TYPE: fighter/interceptor

MANUFACTURER: English Electric

OPERATORS: UK; Kuwait; Saudi Arabia

CREW: pilot

LENGTH: 55.25ft (16.84m)

WINGSPAN: 34.84ft (10.62m)

WEIGHT: 28,036lb (12,717kg) [empty]-
41,991lbs (19,047kg) [max. take-off
weight]

MAX. SPEED: 1,312mph (2,112km/h)

SERVICE CEILING: 55,020ft (16,770m)

RANGE: 802 miles (1,290km)

POWERPLANT: Rolls-Royce Avon 301 x 2

ARMAMENT: Aden 30mm cannon x 2;
de Havilland Firestreak IR AAM x 2 or
Hawker Siddley Red Top IR AAM x 2

MAIDEN FLIGHT: 4 April 1957

IN SERVICE: 1960-1988

NUMBER BUILT: 337 (all versions)

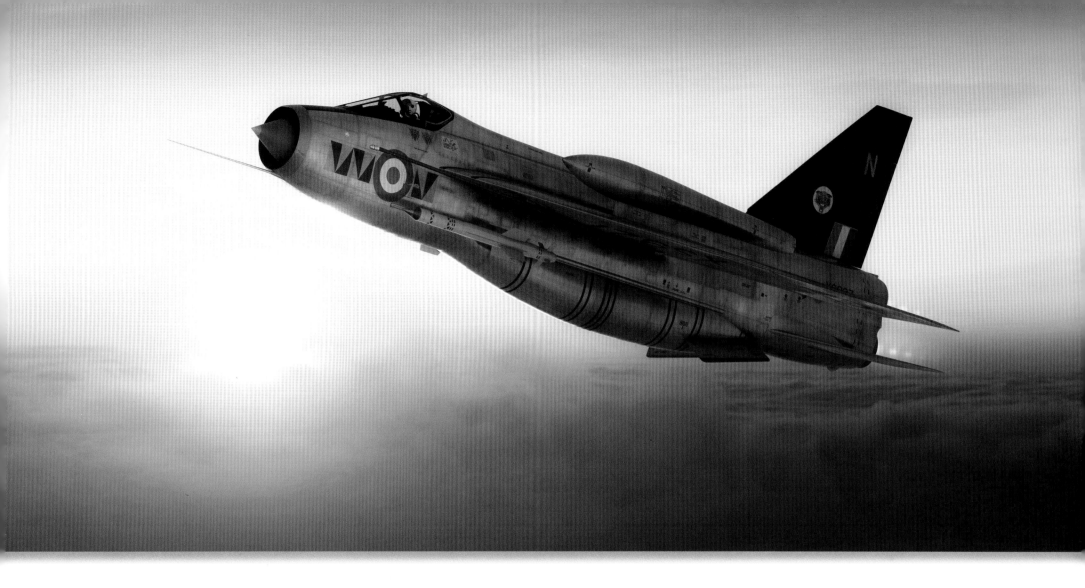

The UK's only indigenous fighter to reach *Mach 2*, the Lightning was also the last fighter to be developed solely by a British company; all subsequent aircraft were international ventures.

Very much a product of the Cold War, the Lightning was designed to climb rapidly and intercept Soviet bombers approaching the UK. With its unusual stacked engine design, it was the first aircraft capable of 'supercruise' – the ability to reach supersonic speeds without the need for afterburners (or 'reheat', in RAF vernacular).

Development began in August 1954, the P.1 prototype exceeding *Mach 1* during its third flight. It became clear that the aircraft had an incredible rate of climb and acceleration. Pilots described flights in the Lightning as more akin to being strapped to a rocket. Under ideal conditions, it could climb at a rate of 20,000ft/min at about *Mach 0.87*. The aircraft's

actual service ceiling was, during its development, kept secret. However, records show the aircraft was capable of climbing as high as 88,000ft (26,800m). The Lightning also remains the only fighter at the time capable of intercepting Concorde! With the arrival of new high-speed Soviet bombers such as the Tu-22M 'Backfire' in the mid-1980s, Concorde was used as an 'aggressor' simulator of the Russian aircraft so that NATO fighters could practice intercepts. In subsequent air combat exercises during April 1985, the only aircraft capable of overhauling the airliner in a stern chase was the Lightning, out-flying even the latest generation of US fighters.

British government policy at the time of the Lightning's inception was fixated on an all-missile air force, and a number of very promising programmes were cancelled. The Lightning was only saved from the scrapheap of history by its excellent performance

and the advanced stage of its development. It finally entered service in July 1960.

Generally equipped with cannons and missiles, the Lightning could also be equipped with conformal rocket packs in the fuselage, carrying forty-eight two-inch rockets to inflict damage on larger targets, especially the big four-engined Soviet bombers. The F3 variant dispensed with the cannons altogether, improvements in the radar and missiles making them apparently redundant. The F3 also included modifications to its nose intake and wings, and more powerful Avons, allowing the aircraft to at last exceed *Mach 2* operationally; earlier models had been restricted to *Mach 1.7*. The downside was higher fuel consumption, resulting in shorter range. In the F6 (considered the finest variant of the Lightning), this was rectified with the addition of overwing pylons to carry a pair of 260-gallon fuel tanks. Not for use in

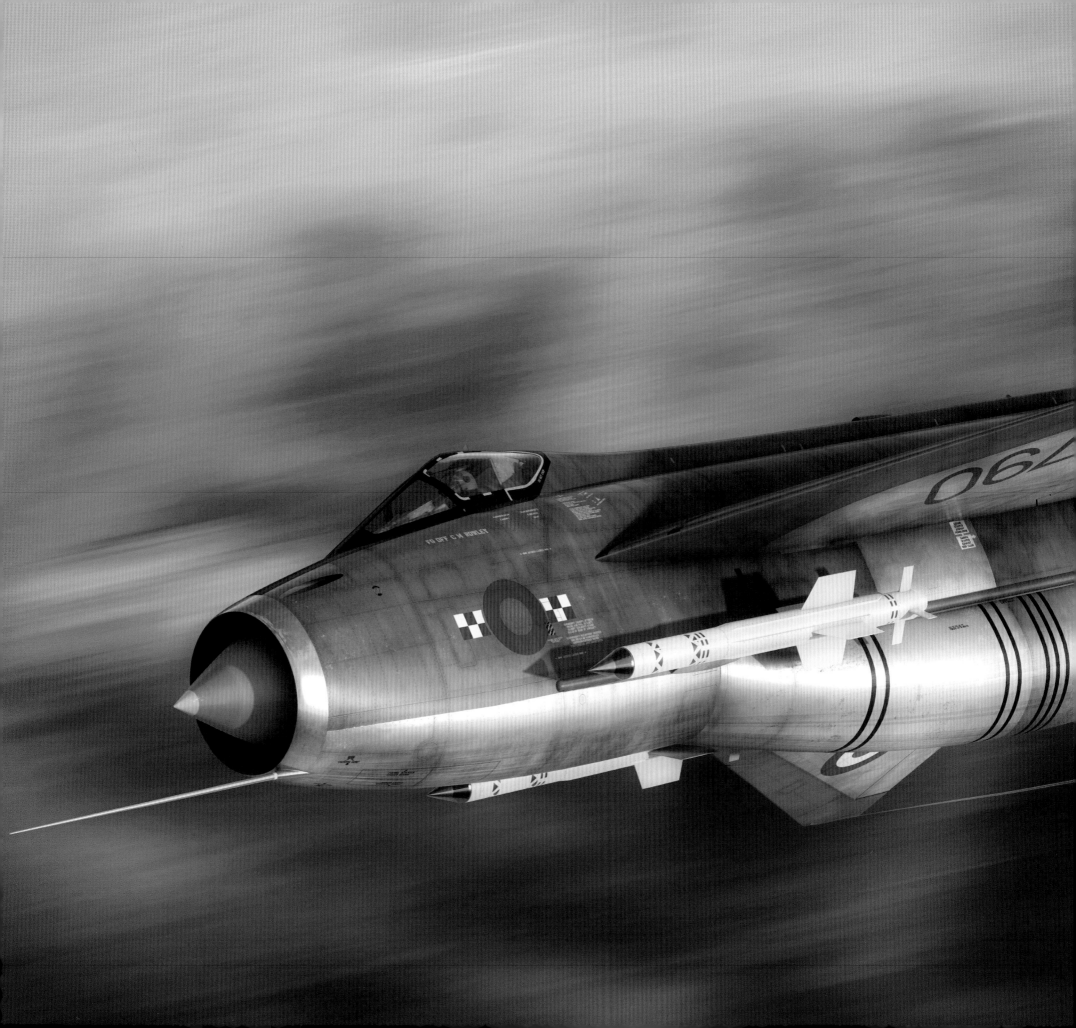

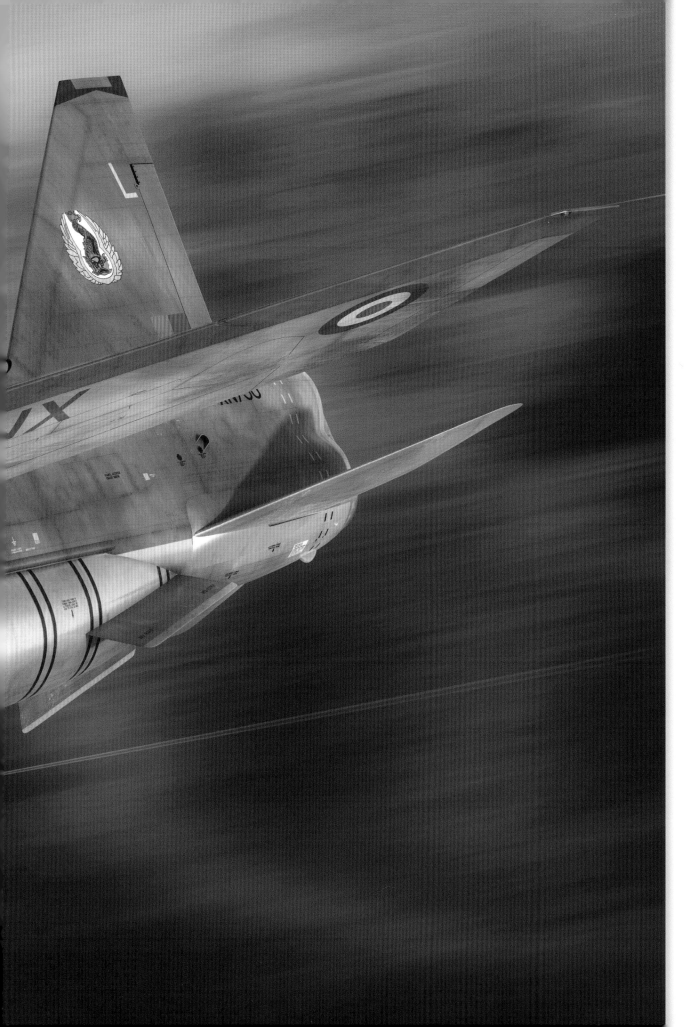

combat, they could however increase the aircraft's ferry range, allowing for deployments further afield.

The F6 also saw the return of the Aden cannons in the form of a modified belly tank.

The Lightning never actually saw combat in British service, although it is credited with one air-to-air kill. Following a suspected engine failure, an RAF pilot ejected from his Harrier. When the aircraft continued to fly unpiloted towards the then border with East Germany, a Lightning intercepted the Harrier and downed it to avoid an international incident.

Lightnings did see combat while operating with the Saudi Air Force, carrying out ground-attack missions against targets on the Saudi/South Yemen border during a dispute between the two countries. However, by the 1980s, the Saudis joined the RAF in phasing out the Lightning whose short range and light payload made it increasingly obsolete. The last aircraft were replaced by Tornado F3s in 1988.

XN790. "Speed and power – brute force, even – are my over-riding thoughts when I look at this superb picture of a Lightning F2A of 19 Squadron, flying low and fast over Germany. It certainly brings back some good memories. This Lightning, XN790, was my personal aircraft when I served on 19 Squadron from January 1974 to December 1976. I can vividly remember, even though it was 40 years ago, 'stooging' around the LOCAPS in the flat Westphalian plains south of RAF Gutersloh looking for 'trade'. When I spotted another military aircraft it would become a target for me to practice my fighting and killing skills. Full cold power accelerating rapidly from 350 knots cruise speed up to 500-600 knots, turning to 'cut the corner' and to get into a firing position, staying as low as possible to skyline the target and make it more difficult for its pilot to spot me. If I was spotted and the target reacted, no matter, I loved a fight, but I had learned that (as all the great fighter aces have proved) an unseen kill against an unaware target was the most effective way, if less fun. We were based only 68 miles from the border with the Soviet Bloc in the midst of the Cold War and if it had turned 'hot' there is no doubt that we were ready and willing to take on all comers, although we knew that we would almost certainly be overwhelmed in days. At the time, this was just our job and it was a serious business; looking back it was also 'licensed hooliganism' and what a job – serious, but serious fun!"
Squadron Leader Clive Rowley MBE RAF (Retd)

MIG-21

FOR MODEL: MiG-21F

TYPE: fighter/interceptor

MANUFACTURER: Mikoyan-Gurevich

OPERATORS INCLUDE: USSR; Angola; China; Cuba; former East Germany; Finland; India; Libya; Mongolia; Nigeria; North Korea; Poland; Ukraine; Vietnam

CREW: pilot

LENGTH: 51.8ft (15.76m)

WINGSPAN: 23.7ft (7.15m)

WEIGHT: 11,795lb (5,350kg) [empty]-20,018lb (9,080kg) [all-up weight]

MAX. SPEED: 1,320mph (2,125km/h)

SERVICE CEILING: 58,400ft (17,800m)

RANGE: 808 miles (1,300km)

POWERPLANT: Turmanskii MNPK 'Soyuz' R11F2S-300

ARMAMENT: GSh-23 23mm cannon in nose; payload of up to 3,307lbs (1,500kg) of air-to-air missiles, rockets and bombs on underwing hardpoint x 4

MAIDEN FLIGHT: 14 February 1955 (prototype)

IN SERVICE: 1959-present (with over 30 countries)

NUMBER BUILT: 11,496 (all versions)

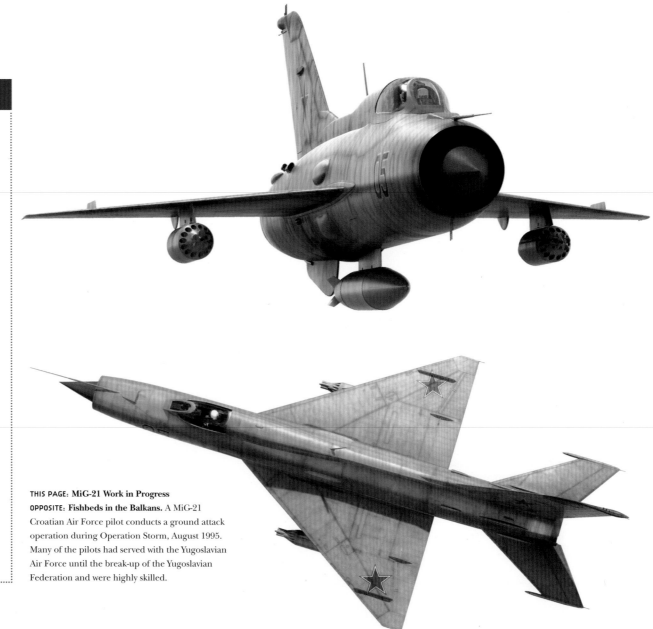

THIS PAGE: **MiG-21 Work in Progress**
OPPOSITE: **Fishbeds in the Balkans.** A MiG-21 Croatian Air Force pilot conducts a ground attack operation during Operation Storm, August 1995. Many of the pilots had served with the Yugoslavian Air Force until the break-up of the Yugoslavian Federation and were highly skilled.

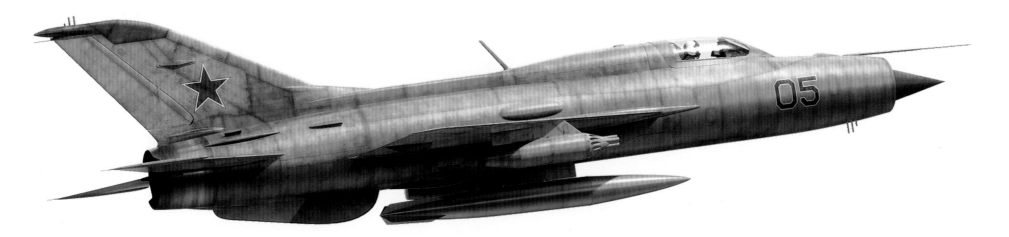

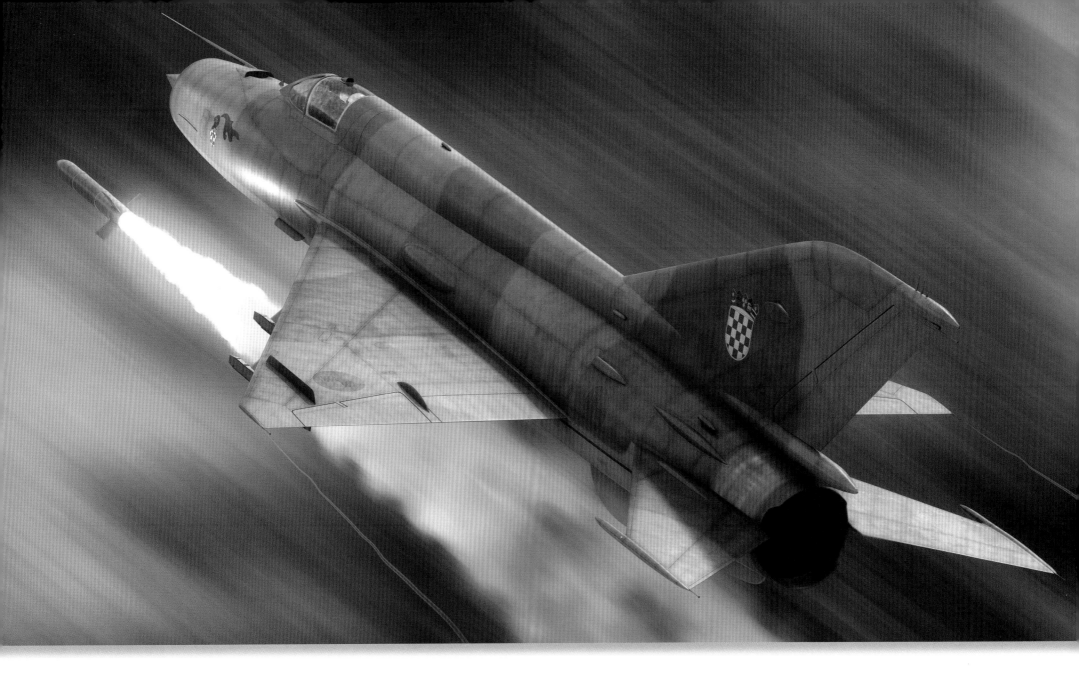

The most widely produced and one of the most widely operated jet fighters in history, the MiG-21 is over half a century old but remains in widespread use throughout the world.

Designed as an interceptor in the aftermath of the Korean War, and incorporating many lessons from the hard fighting, its elegant delta-winged design was light and fast – capable of nearly *Mach 2*. To aid in this, the nose cone in early versions had three settings extending forward with increases in *Mach* number.

In true Soviet style, early versions had austere avionics and were simple to maintain but suffered from short range and small payloads, which restricted them very much to the daylight fighter and interceptor role. It also suffered from problems with its ejection seat. Following ejection, the seat formed a capsule with the front-hinged canopy, with the intention of protecting the pilot from the airwash during high-speed ejections. Once free of the aircraft, the canopy detached and the seat could deploy its parachute. However, at low altitudes, the time taken for the canopy's separation was too long and a number of pilots were killed when their seats crashed to the ground before the parachute deployed. In later models, the canopy was hinged on the right side and the seat departed without the need of the capsule.

Later models were fitted with a raised fin that extended to the top of the canopy. This accommodated more fuel and more powerful avionics. The increased weight was offset by improvements in the engine that also allowed the carrying of heavier armament. The result was a truly multi-role aircraft, the MiG now capable of hauling enough ordnance to effectively fulfil the ground-attack role.

With so many users, it's not surprising that the aircraft has been involved in a number of wars. First

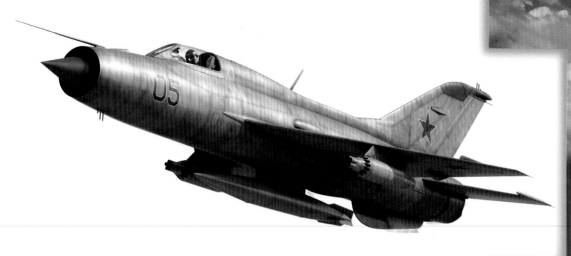

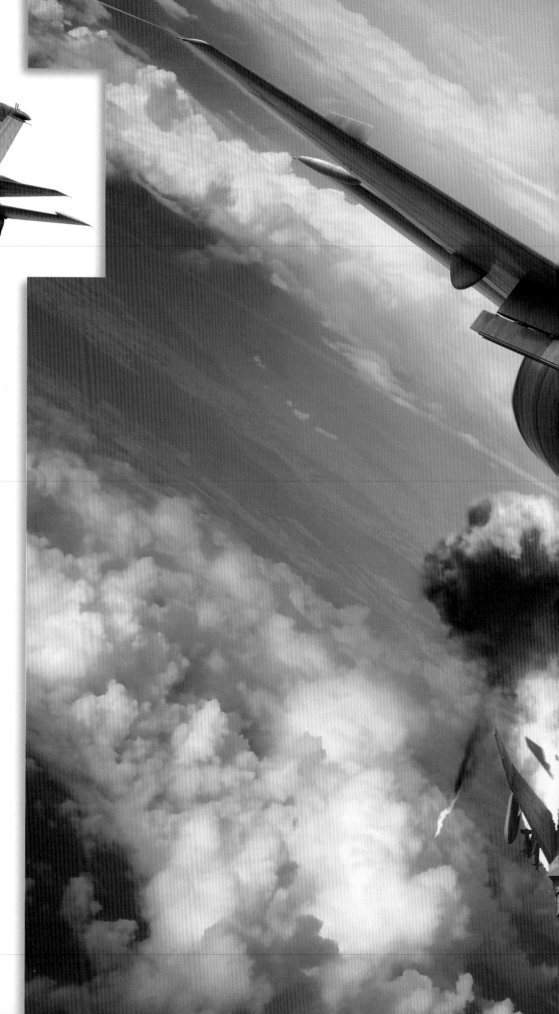

to use it in action, if only in a limited capacity, was India, during the Indo-Pakistan War of 1965. Its success resulted in the fielding of some 1,200 MiG-21s, 657 built locally. It did see extensive service in the 1971 Bangladesh Liberation War, claiming four Pakistani F-104s, apparently superior in air combat to the similarly built Starfighter.

Egyptian and Syrian MiGs took part in all the various Arab/Israeli wars throughout the sixties, seventies and eighties, suffering badly at the hands of the Israelis. Egypt alone lost 100 of its 110-aircraft fleet during the Six-Day War in 1967, most while still on the ground. The MiGs, some in the hands of Soviet pilots, did better in 1973 until a well-planned Israeli ambush led to the deaths of three Russian pilots.

By the eighties, the MiGs were up against some of the best fighters in the world, the F-15 Eagle and F-16 Fighting Falcon, both now in service with Israel. During the 1982 invasion of Lebanon by Israel, heavy air fighting resulted in the claims of forty-five 21s downed for only minimal losses.

In the Vietnam War, some 200 MiG-21PF and PFMs were fielded against the American bombing campaign against the North, beginning in 1966. Some thirteen pilots claimed ace status. Using Soviet-style ground-controlled interception (GTC) and 'hit-and-run' tactics, the MiGs were tough adversaries for US fighters, while their very appearance could force strike aircraft to dump their bomb loads so they could manoeuvre or escape. By the restart of the bombing campaign in 1972, the better-trained US pilots fared better against the MiGs, claiming more victories, although exact numbers remain disputed. But the Vietnamese pilots did claim the destruction of two American B-52 Stratofortresses, both at night and at very high altitudes, during Operation Linebacker II, the eleven-day bombing of Hanoi and Haiphong by the high-flying bombers.

MiG Kill. A Vietnam People's Air Force (VPAF) 927th Fighter Regiment MiG-21PFM attacks a USAF F-4E fighter-bomber during Operation Linebacker II, July 1972. Supplies of new aircraft to North Vietnam by the Soviet Union in the late 1960s and early 1970s proved to be so massive that at all times the number of available MiG-21s was higher than the number of VPAF pilots trained on the type. A good many MiG-21PFMs were therefore placed in long-term storage. Such a resource eventually proved very useful in 1972, at a time of heavy attrition of aircraft due to the US air attacks against all known VPAF airfields.

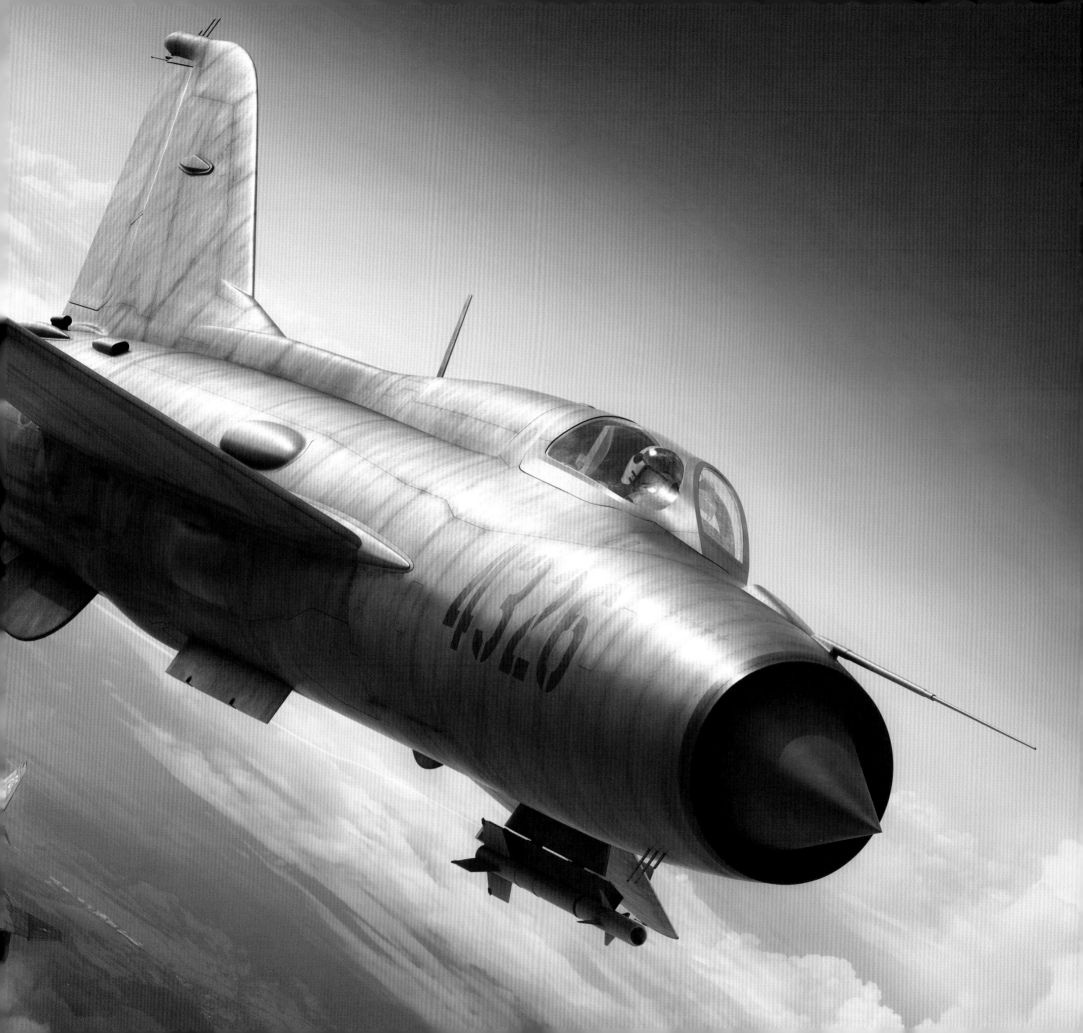

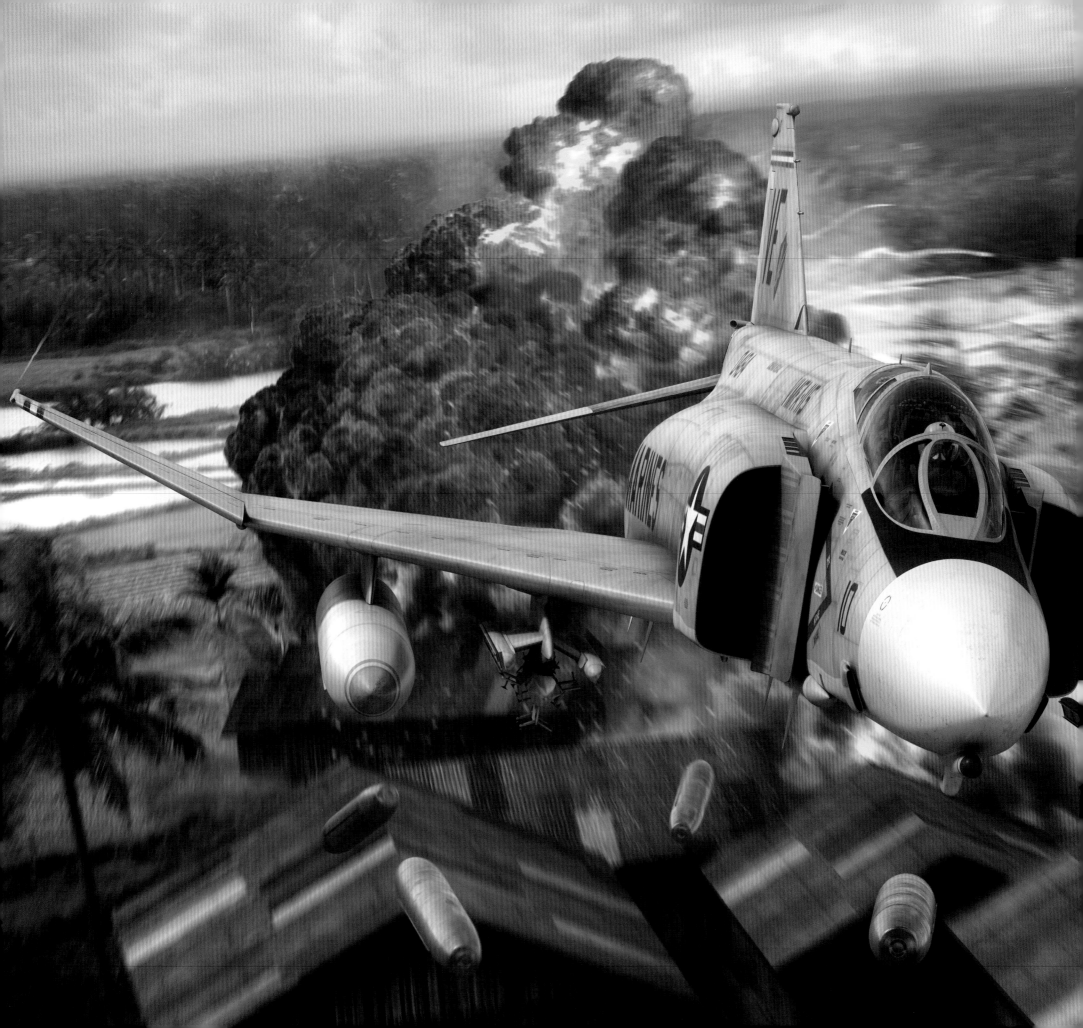

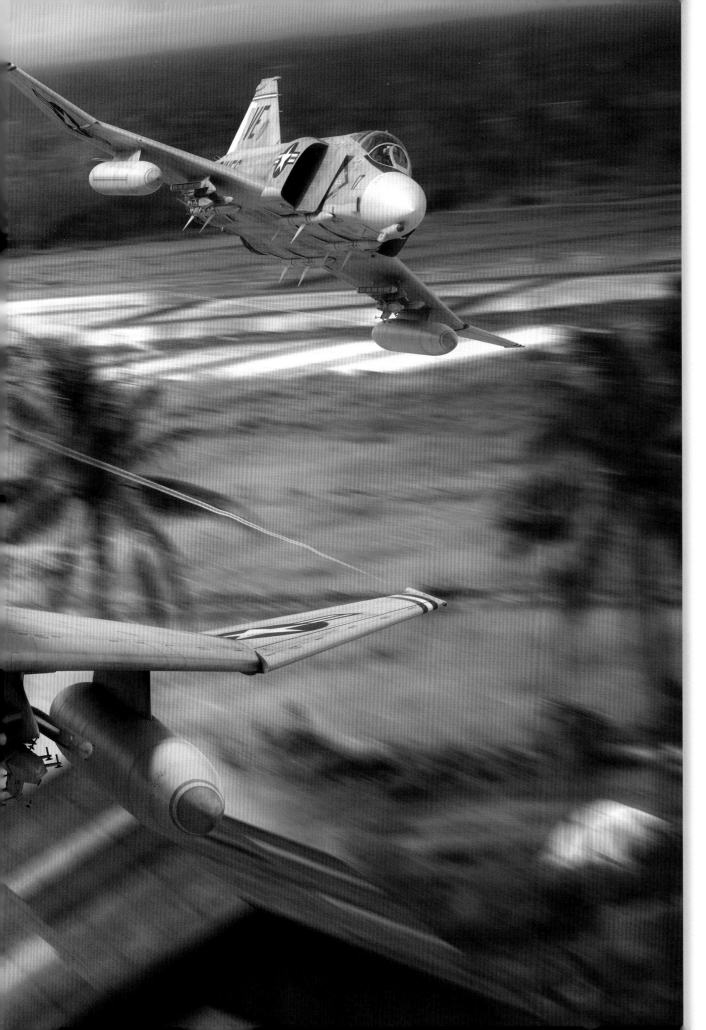

F-4 PHANTOM II

SPECIFICATIONS

FOR MODEL: F-4J
TYPE: fighter-bomber
MANUFACTURER: McDonnell Douglas
OPERATORS: USA; Egypt; Germany; Greece; Iran; Israel; Japan; South Korea; Spain; Turkey; UK
CREW: pilot, co-pilot/radar intercept officer
LENGTH: 58.4ft (17.79m)
WINGSPAN: 38.5ft (11.72m)
WEIGHT: 30,770lb (13,957kg) [empty]-56,000lb (25,410kg) [max. take-off weight]
MAX. SPEED: 1,415mph (2,264km/h) at 40,000ft (12,190m)
SERVICE CEILING: 60,000ft (18,300m)
RANGE: 1,900 miles (3,040km)
POWERPLANT: General Electric J79-GE-17A turbojets x 2
ARMAMENT: 16,000lbs (7,257kg) of air-to-air missiles (usually AIM-9 Sidewinder x 4 on wing, AIM-7 Sparrow x 4 in recessed belly troughs); bombs, rockets and/or air-to-ground missiles
MAIDEN FLIGHT: 27 May 1958
IN SERVICE: 1960 to present (South Korea, Turkey)
NUMBER BUILT: 5,195 (all versions)

The Phantom was originally designed for carrier-borne operations with the US Navy, and was intended to fulfil a number of roles, as a bomber as well as a fighter and interceptor. Such was the success of the twin-engined, two-seat design that it was soon also adopted by the US Marine Corps and the USAF. However, it was operational first with the USN following successful deck trials in February 1960.

Silver Eagles. F-4B Phantoms of VMFA-115, based at Chu Lai, South Vietnam, attacking buildings using a typical napalm strike, December 1968.

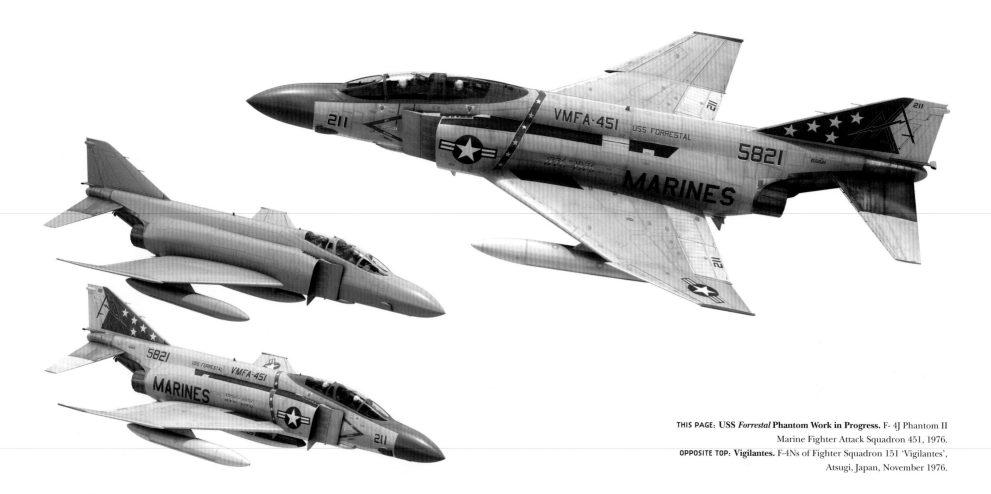

THIS PAGE: **USS *Forrestal* Phantom Work in Progress.** F- 4J Phantom II
Marine Fighter Attack Squadron 451, 1976.

OPPOSITE TOP: **Vigilantes.** F-4Ns of Fighter Squadron 151 'Vigilantes',
Atsugi, Japan, November 1976.

Its massive powerplants gave the Phantom incredible thrust, enabling it to exceed *Mach 2.2* and, following a competitive fly-off between various aircraft in which the F-4 was the clear winner, it entered service with the Air Force in December 1964 as the F-4C. Unlike the Navy, the weapon systems operator ('Whizzo') was a rated pilot and the rear cockpit was fitted with flying controls so that, despite his restricted view, he could fly and land the aircraft.

By the sixties, America's involvement in Vietnam was well under way. On 5 August 1964, F-4s operating from the USS *Constellation* flew their first combat missions as escort CAPs for bombers attacking targets in North Vietnam. On 7 June 1965, a USN F-4B scored the first MiG kill of the Vietnam War. By May of that year, the first USMC F-4 squadrons had also arrived at Da Nang airbase in South Vietnam, flying close air support missions. USAF F-4Cs had begun operating out of RTAB Ubon, Thailand, in April, and they scored their first aerial victory in July.

The Phantom's war had begun in earnest, with USN and USAF types flying ground attack and close air support missions north and south of the Demilitarised Zone. When F-4s flew MiG CAP fighter sorties in support of bombing attacks the Phantom's weaknesses as a fighter began to expose themselves, particularly the lack of a gun. All three NVAF fighters, the MiG-17, -19 and -21, were more manoeuvrable than the F-4, while the longer reach of the Phantom's weapon systems were negated by rules of engagement that required crews to visually identify the aircraft type before engaging. When they did engage, their AIM-9 and AIM-7 missiles and the tactics needed to fire them effectively proved unreliable.

When President Johnson called a bombing halt in October 1968, the kill ratio of the American crews was a poor 2:1, perhaps even 1:1 (one Vietnamese aircraft destroyed for every US fighter lost). Analysis of these results led to a number of efforts to improve the skills of F-4 fighter crews. In the case of the USN,

the Fighter Weapons School, 'Top Gun', was opened on 3 March 1969 and pilots versed in the tactics and capabilities of the NVAF pilots and aircraft. The USAF's own programme, named 'Red Flag', was established in 1975. The Air Force also introduced the F-4E in June 1967. This new mark incorporated a number of lessons from Vietnam; it was longer and heavier, had improved avionics and radar, and a re-designed wing to increase agility. Most importantly it had an M-61 Vulcan cannon in the nose. Efforts to improve the Sparrow and Sidewinder missiles had also reached fruition.

By March 1972, when President Richard Nixon unleashed US airpower in unprecedented force following North Vietnam's invasion of the South, the fighters were in much better shape. By the end of the war, US fighters, mainly F-4s, had scored 145.5 kills. The ratio had risen to 3.73:1.

F-4Es were also ordered by Israel, with initial deliveries of fifty Phantoms (including six RF-4s) in

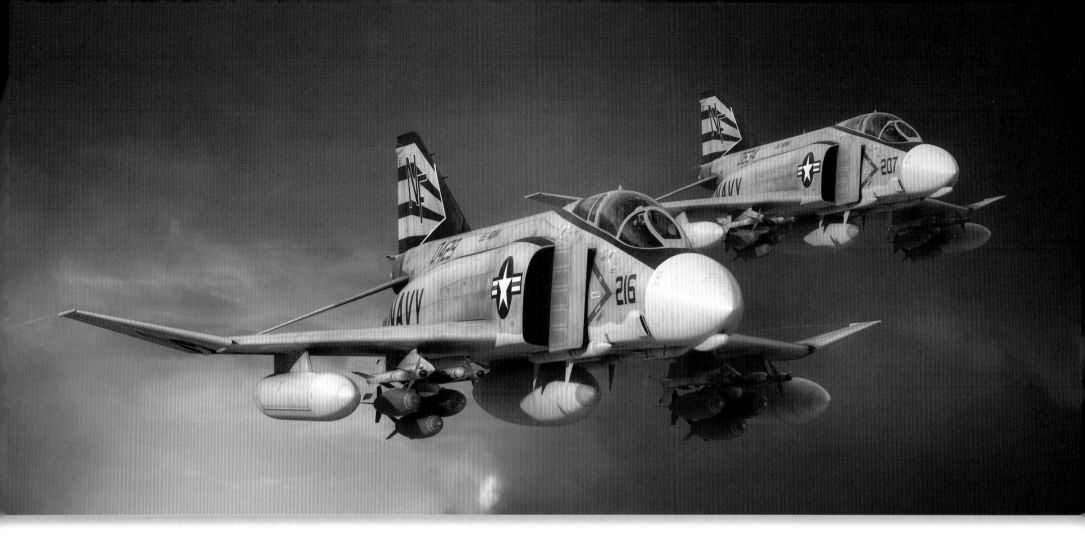

1969-71. They received their baptism of fire during the War of Attrition, flying their first mission on 22 October 1969. A month later, the F-4E scored its first aerial victory, shooting down an Egyptian MiG-21. 127 F-4Es and RF-4Es were in service when the combined armed forces of Egypt, Syria and Jordan launched their offensive on 6 October 1973. While the Phantoms faired well in the aerial battle, they ran into trouble against the new tactics and weapons of the integrated Arab air defences. The Israeli air force was soon in serious trouble and the USA was required to divert thirty-six USAF F-4Es to Israel to replace combat losses. By the end of the fighting twenty-seven Phantoms had been lost.

American F-4s last saw action in 1991 when USAF F-4G Wild Weasel SEAD aircraft and six RF-4Cs deployed to Bahrain following the Iraqi invasion of Kuwait. They were soon heavily engaged following the start of the Coalition air campaign on 17 January 1991. The USAF retired its last Phantoms in 1996.

BELOW: **Pedersen.** The USN Fighter Squadron 111 'Sundowners' F-4B flown by CAG Cdr Dan Pedersen, 1975.
BOTTOM: **Jolly Rogers.** A Fighter Squadron 84 'Jolly Rogers' F-4N, USS *Franklin D. Roosevelt.*
FOLLOWING SPREAD: **Phantom Strike.** Two F-4B Phantoms of VF-111 attack enemy positions under heavy flak on a typical mid-level bombing approach, Vietnam, 1972.

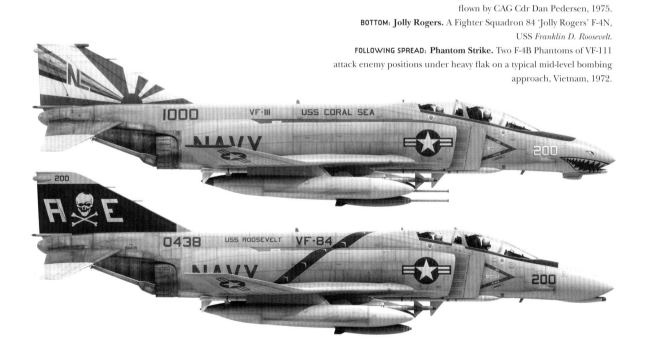

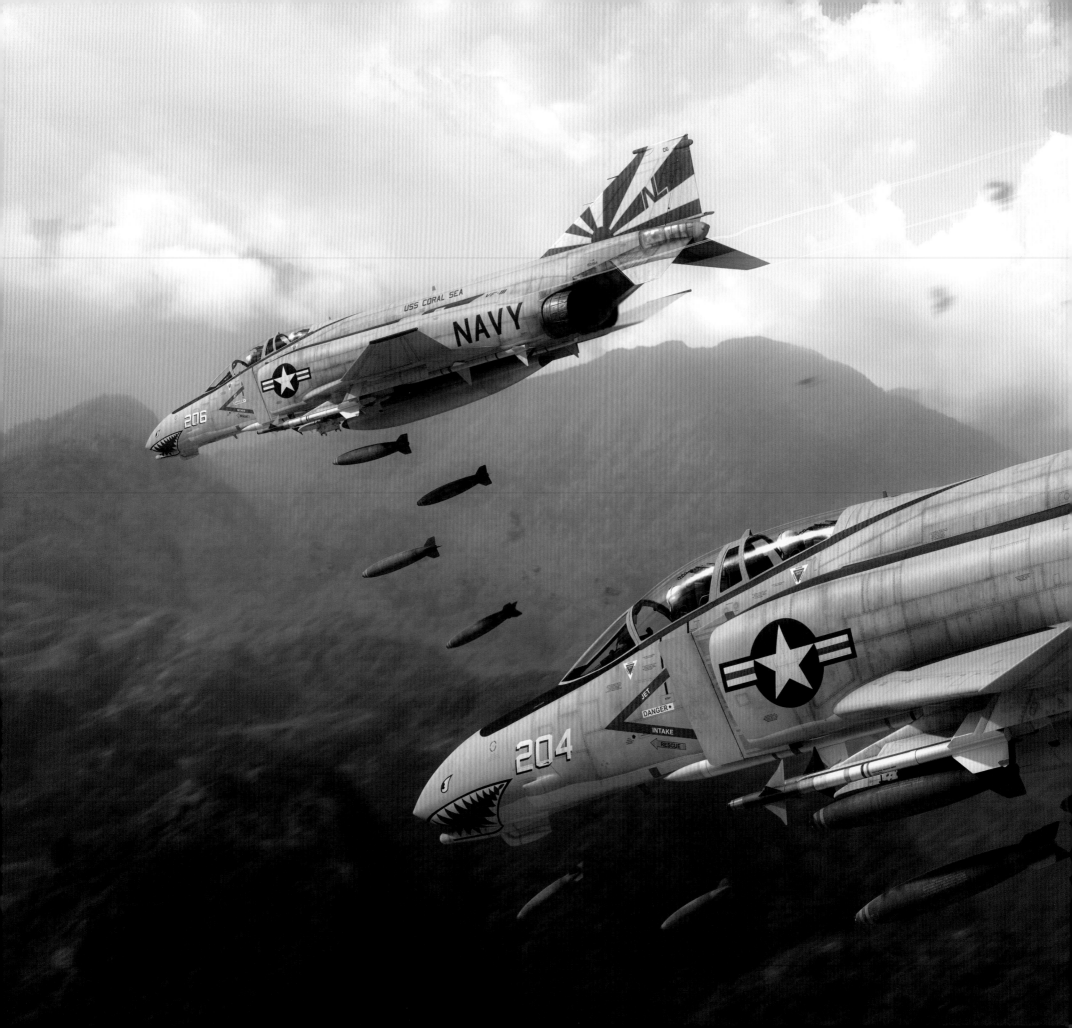

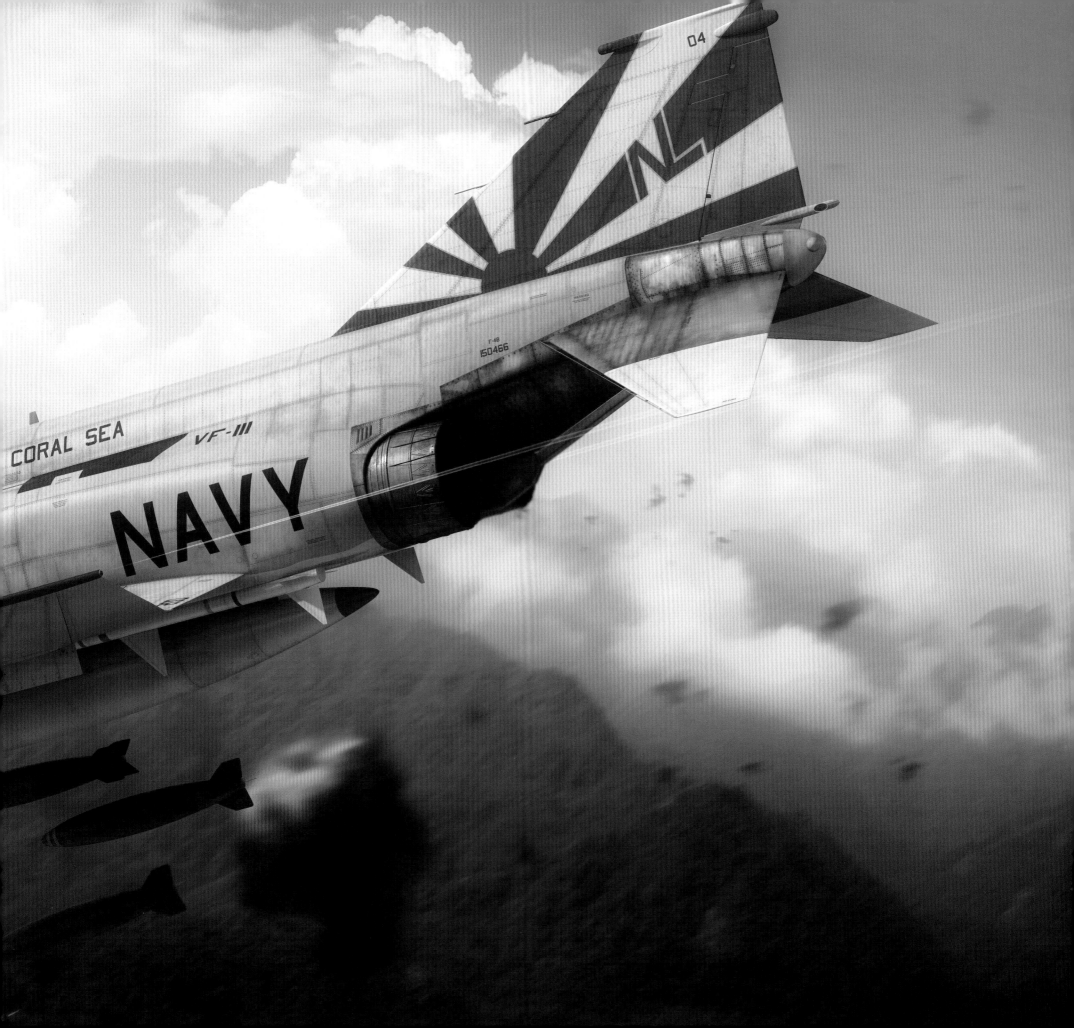

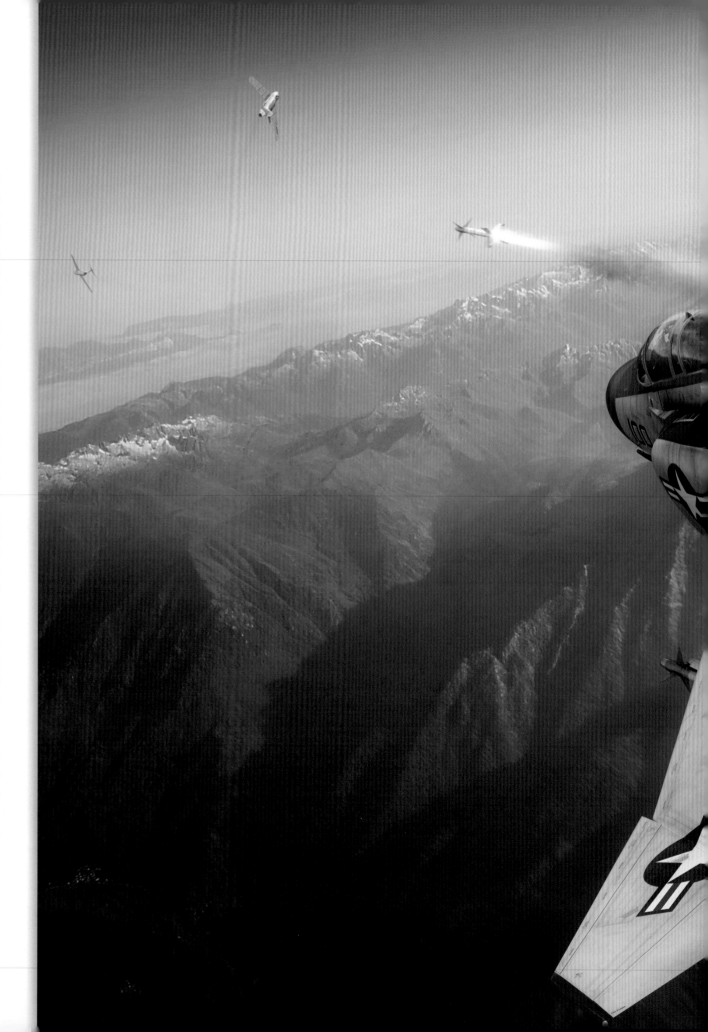

THE FOURTH KILL

Lt Randy 'Duke' Cunningham and his RIO, Lt (JG) Willie 'Irish' Driscoll, were part of a strike package attacking rail yards southeast of Hanoi on 10 May 1972. As Cunningham and his wingman pulled off their target, they were intercepted by a pair of North Vietnamese MiG-17s. Cunningham broke hard and forced the leader to overshoot, shooting him down with a Sidewinder AAM.

Having repositioned their F-4, Cunningham and Driscoll saw three other Phantoms surrounded by eight MiGs. They rolled in to help and ended up pursuing three MiGs, two 17s and a 21, in pursuit of one of the F-4s. Cunningham was so close to the F-4 and its pursuers that his heat-seeking Sidewinder missiles could not tell friend from enemy. He was calling for the F-4 to break when Driscoll spotted more MiGs behind them. Driscoll kept his eye on the MiGs while Cunningham continued to call desperately for the other F-4 to break, but the crew couldn't see the nearest MiG flying just underneath them and didn't realise the danger they were in. Finally, the other Phantom broke hard. Cunningham launched a Sidewinder that hit the MiG, destroying it, the pilot ejecting: Cunningham and Driscoll's fourth kill.

With the sky still full of enemy fighters, they headed for the coast and safety. They encountered a lone MiG-17 and decided to engage it. After a long and epic duel, Cunningham finally managed to shoot down the MiG and score their fifth kill, making them America's first fighter aces of the Vietnam War.

But the fight wasn't over yet...

As they exited North Vietnam, heading for the *Constellation*, their F-4 was hit by a SAM. With the aircraft ablaze, Cunningham nursed the fighter out to sea, where he and Driscoll were able to safely eject. They were quickly picked up by rescue helicopters and were soon aboard the aircraft carrier to a rousing welcome.

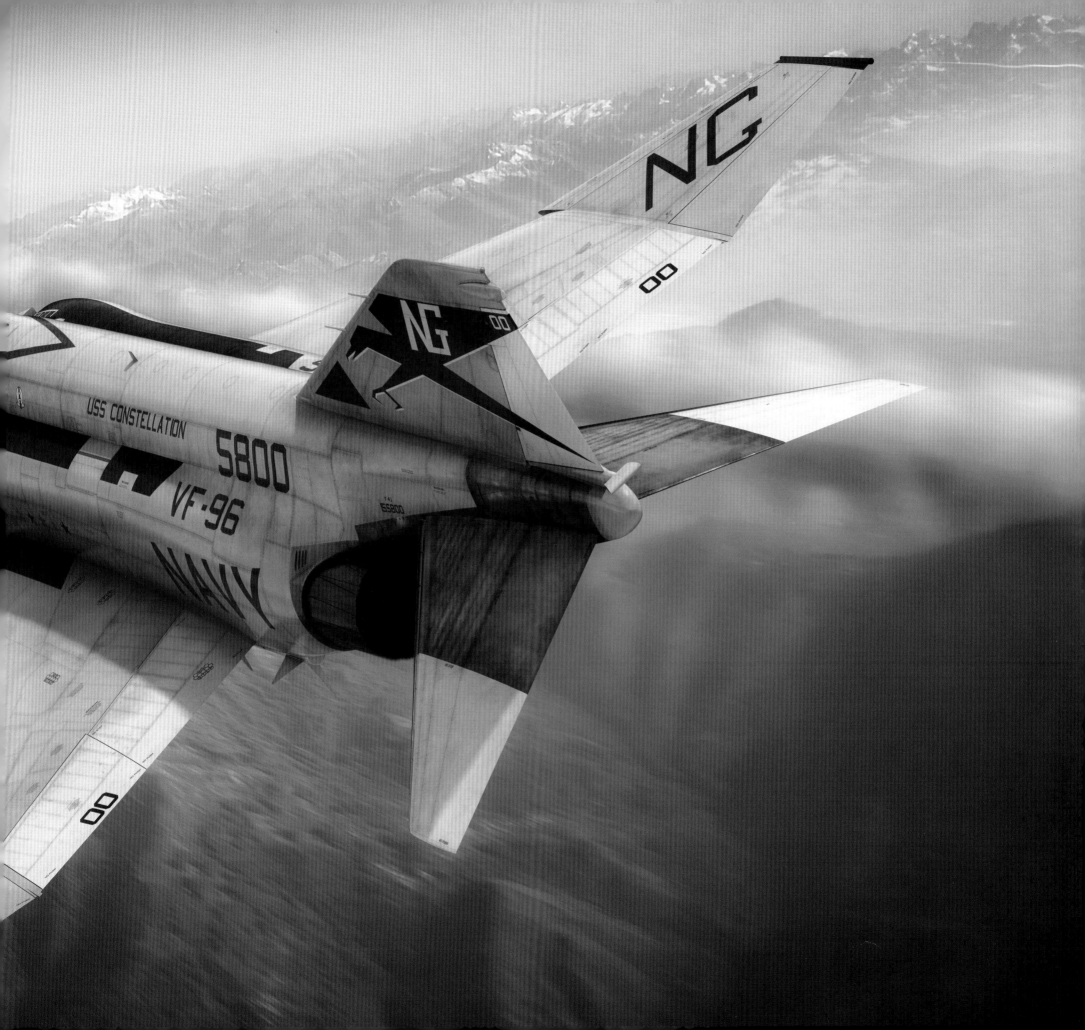

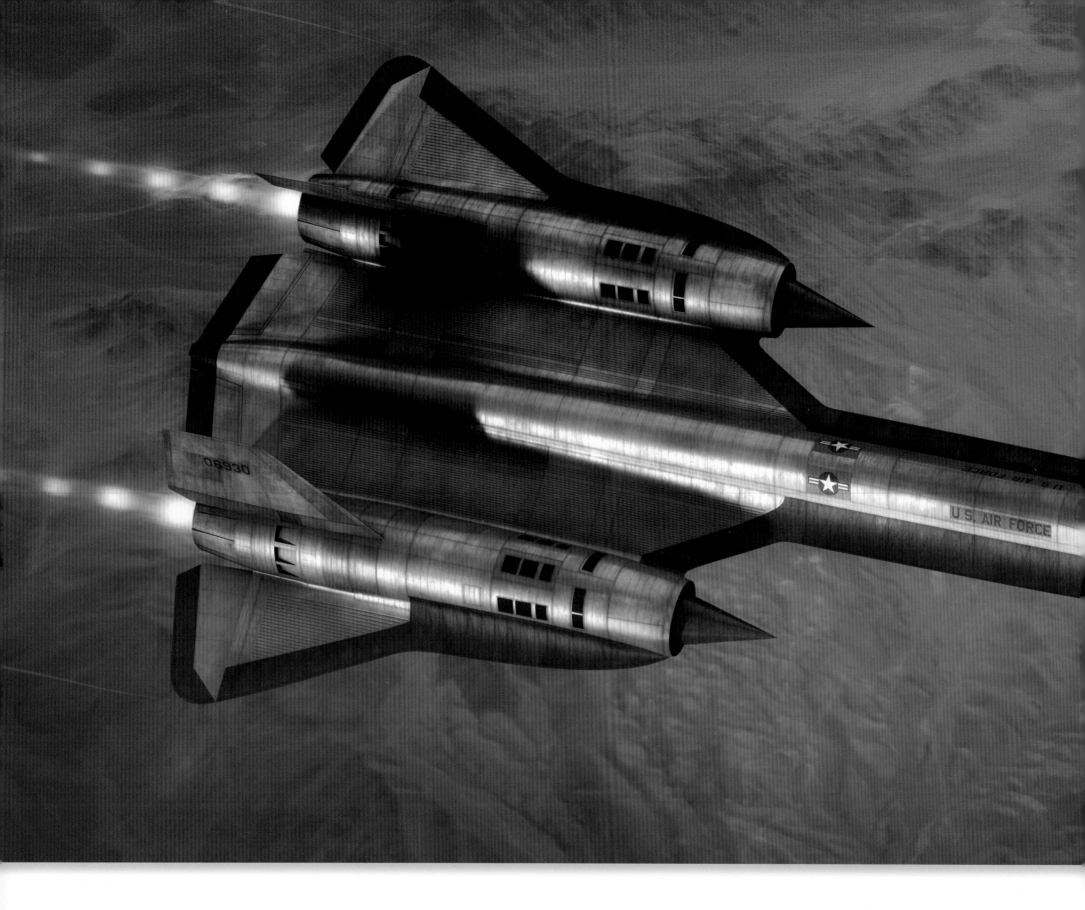

ABOVE: Operation Black Shield. Flying at *Mach 3*, an A-12 out-runs SAM-2 missiles over the Gulf of Tonkin.

A-12

The A-12 was built in response to the growing threat from increasingly sophisticated Soviet air defences to the CIA's very high-flying but slow Lockheed U-2 spy planes. The U-2 had been designed to overfly Soviet Russia beyond the reach of any anti-aircraft system or aircraft of the time, but the CIA was still keen to reduce the U-2's radar cross-section, making it less vulnerable to Soviet air defence networks. When the programme, codenamed Angel, failed, the Agency asked Lockheed's famously secret Skunk Works to develop a new aircraft to safely overfly hostile territory. The result was the Archangel programme, hence the coding 'A'.

The A-12 intended using speed and height to stay out of trouble. Twelve aircraft were ordered by the CIA in January 1960. Then on 1 May a U-2 was shot down by the new Russian SAM-2 in the Ural region of the USSR. Development of the A-12 was consequently accelerated under the auspices of Project Oxcart in conditions of great secrecy. Test flights from the legendary Groom Lake facility in Nevada – the infamous 'Area 51' – exceeded *Mach 3.2*, but the programme lost its first aircraft in May 1963, the

SPECIFICATIONS

TYPE: high-altitude reconnaissance aircraft

MANUFACTURER: Lockheed Corp.

OPERATOR: USA

CREW: pilot

LENGTH: 101.6ft (30.97m)

WINGSPAN: 55.62ft (16.95m)

WEIGHT: 54,600lb (24,800kg) [empty]-124,600lb (56,500kg) [max. take-off weight]

MAX. SPEED: 2,210mph (3,560km/h) at 75,000ft (23,000m)

SERVICE CEILING: 95,000ft (29,000m)

RANGE: 2,500 miles (4,000km)

RATE OF CLIMB: 11,800ft/min (3,596.6m/min)

POWERPLANT: Pratt & Whitney J58-1 turbo jet x 2

ARMAMENT: none

MAIDEN FLIGHT: 26 April 1962 (unofficial), April 30 1962 (official)

IN SERVICE: 1967-68

NUMBER BUILT: 13

RIGHT: A-12 Side Profiles

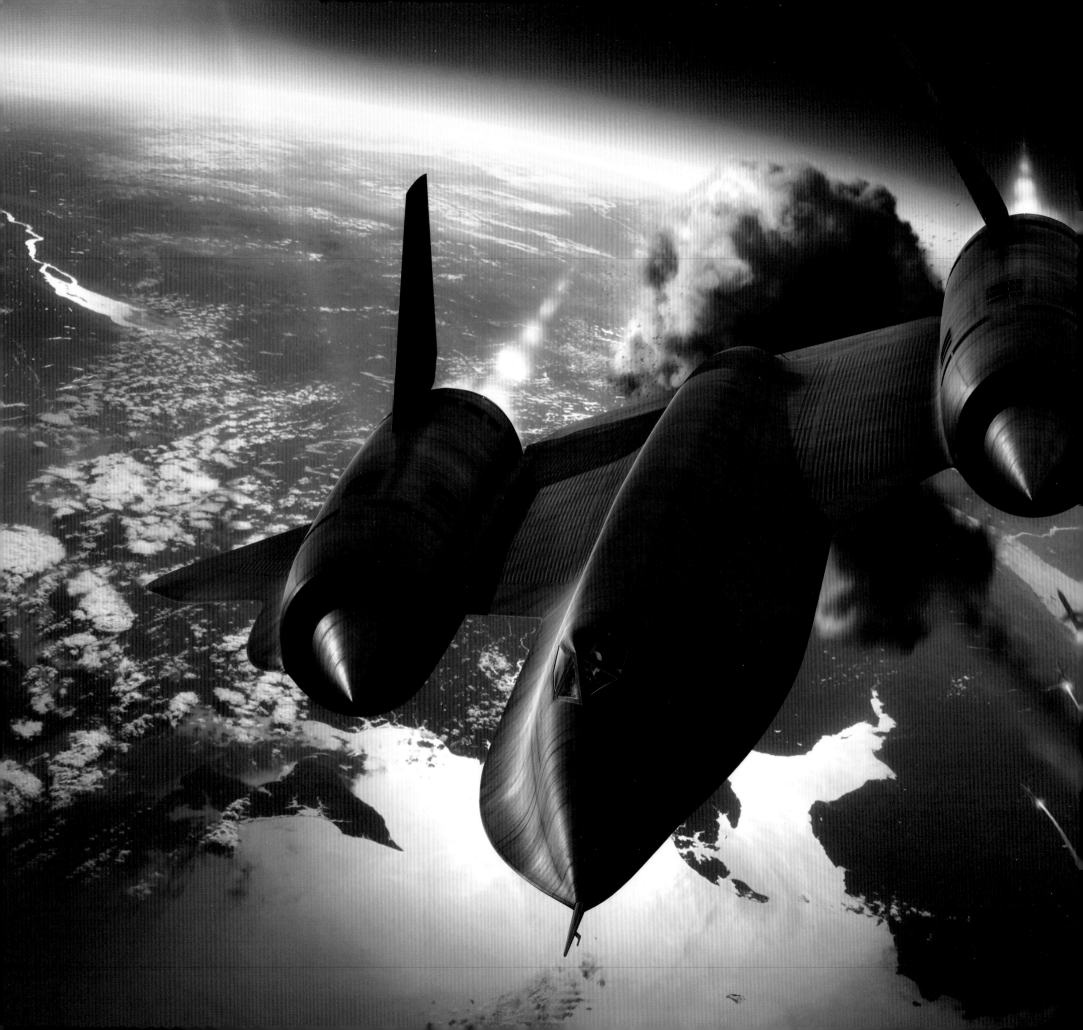

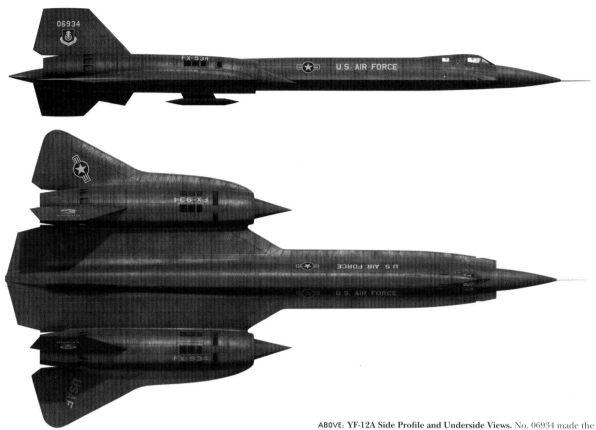

A-12 coming down in Utah. Such was the covert nature of A-12 operations, the CIA said the crashed aircraft was in fact an F-105 Thunderchief. They also paid local policeman and eyewitnesses $25,000 each to buy their silence, while warning them of the consequences of revealing what they'd seen.

Following the shooting down of the U-2, flights over the Soviet Union had been discontinued. Lockheed instead developed the twin-seat SR-71 Blackbird, modelled on the A-12 via the YF-12 intermediary prototype interceptor aircraft but intended for the USAF. Powerful side-looking radars and cameras meant the Blackbird could operate safely from international airspace.

The A-12 did fly operational missions over North Vietnam while stationed at Kadena Air Base in Japan, flying reconnaissance flights as part of Operation Black Shield from the 31 May 1967. Flying at over 80,000ft (24,000m) and at speeds of over *Mach 3*, the A-12s defied efforts made by Chinese and North Vietnamese forces to shoot them down, although one did return to Kadena with a piece of SAM-2 shrapnel embedded in its right wing.

In November 1967, Blackbirds joined A-12s at Kadena, and a series of fly-off missions were flown between the two types to test which was superior. While the results were inconclusive, the A-12 programme had already been shut down due to budgetary concerns and because of its overflight requirements. By March 1968, SR-71s were replacing A-12s at Kadena. The latter were retired a month later, the final flight taking place on 21 June, when the last A-12 was flown to Palmdale, California, for storage.

All surviving A-12s now serve as 'gate guardians' or museum pieces across the USA.

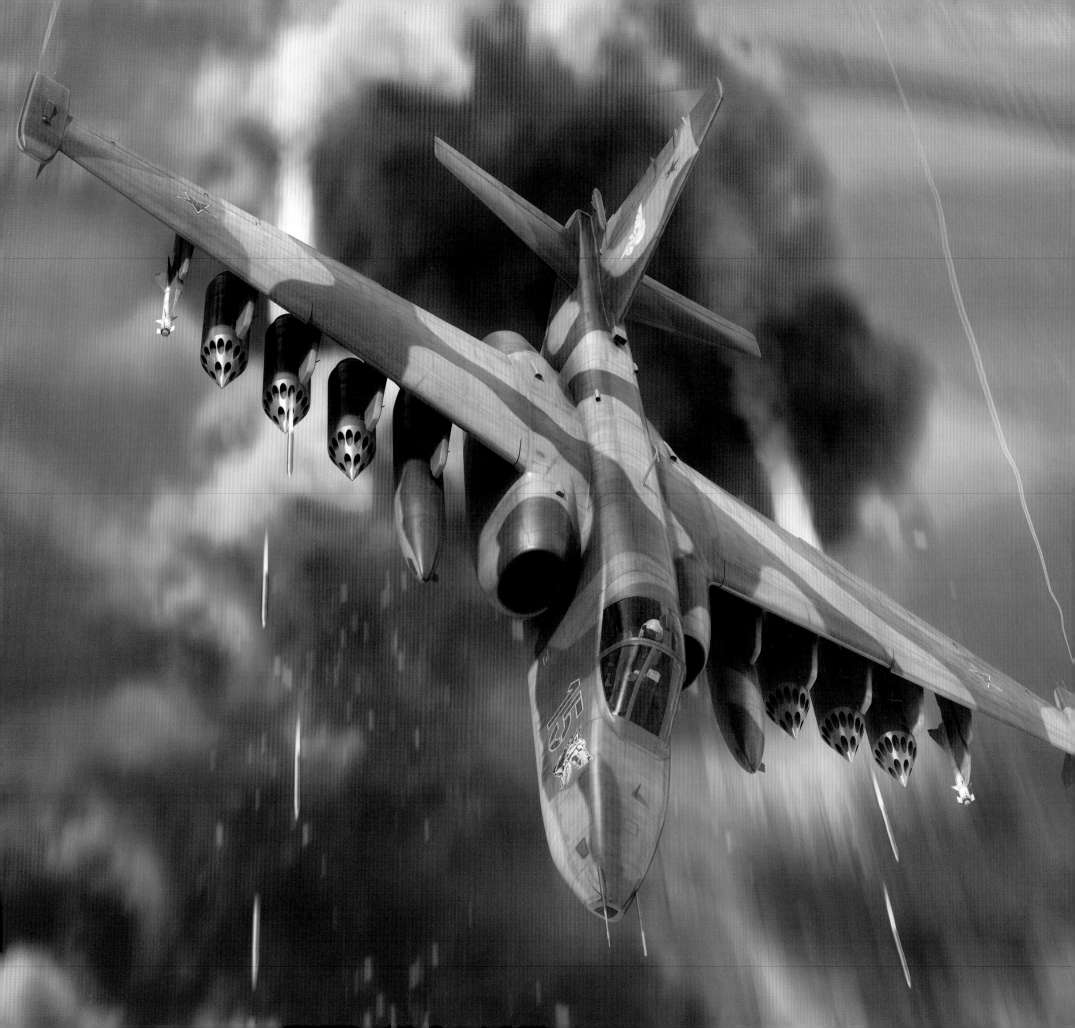

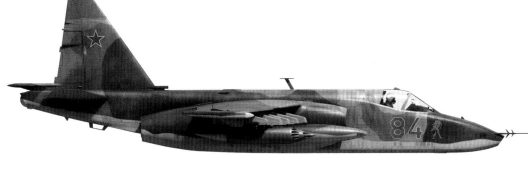

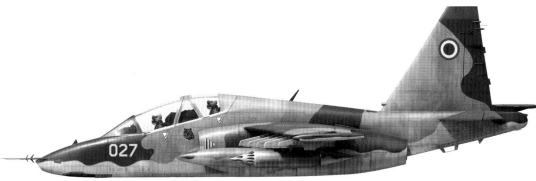

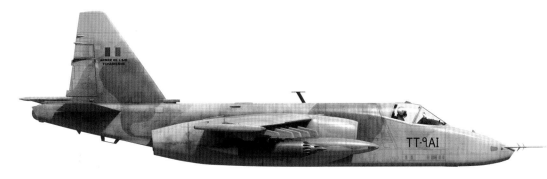

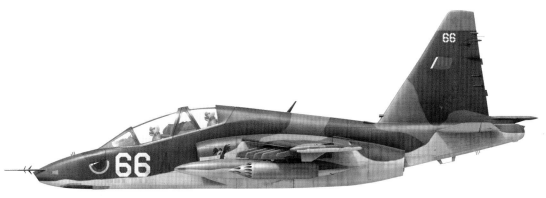

SU-25

SPECIFICATIONS

FOR MODEL: Su-25K

TYPE: ground attack/close air support

MANUFACTURER: Sukhoi Design Bureau

OPERATORS INCLUDE: Russia; Angola; Azerbaijan; Belarus; Chad; Iraq; Iran; North Korea; Peru; Ukraine

CREW: pilot

LENGTH: 50.11ft (15.53m)

WINGSPAN: 47.1ft (14.36m)

WEIGHT: 21,605lb (9,800kg) [empty]-32,187lb (14,6000kg) [max. take-off weight]

MAX. SPEED: 606mph (975km/h)

SERVICE CEILING: 16,400ft (5,000m)

RANGE: 466 miles (750m) with full load

RATE OF CLIMB: 7.24 minutes to 40,000ft (12,192m), 9.25 minutes to 50,000ft (15,240m)

POWERPLANT: Soyuz/Gavrilov R-195 turbojet x 2

ARMAMENT: GSh-30-2 30mm cannon; payload of 8,818lbs (4,000kg) on underwing hardpoint x 10 and centreline hardpoint x 1

MAIDEN FLIGHT: 22 February 1975

IN SERVICE: May 1981-present

NUMBER BUILT: 1,024 (all versions)

FAR LEFT: **2008 South Ossetia War.** A Russian Air Force Su-25 of the 461st ShAP (Attack Aviation Regiment), subordinated to the 1st Attack Division of the 4th Air Army, on the 2nd day of the Five-Day War, 9 August. The Frogfoots of the 2 squadrons of the regiment have worn the 'chained dog' badge, created by one of the regiment's pilots, on both sides of the nose since 1998.

LEFT, TOP TO BOTTOM: **T8-4 Prototype 01002 Side Profile.** The T8-4 production-standard specimen, employed for all controllability and stability tests and evaluation trials, as well as various performance-defining trials and spin characteristics testing, built in Tbilisi and flown for the first time on 19 September 1979. **Equatorial Guinea 2-Seat Su-25UB.** Purchased from Ukraine and reportedly upgraded to the Su-25UBM1 standard, 2009. The UB variant is the armed 2-seat trainer type. **Chad Single-Seat Frogfoot.** Purchased from Ukraine, 2008. **Belarusian 2-Seat Su-25B.**

Built as a new incarnation of the legendary Ilyushin Il-2 Sturmovik ground attack aircraft of WW2, the Su-25 was designed to support Soviet armour and ground troops as well as destroying enemy tanks. When it first appeared in 1975, it was seen as being the Russian answer to the American A-10 Thunderbolt II (aka the 'Warthog'), then under development.

However, it had been created after studies by Soviet analysts showed that the then current generation of ground-attack aircraft and fighter-bombers were ill-suited to fly the close support mission required by the Red Army (the A-10 had originated as a result of similar experiences by the Americans in Vietnam).

What was needed was a heavily armed and armoured aircraft capable of loitering over future battlefields (then assumed to be during a possible Third World War in Europe) in a high-threat

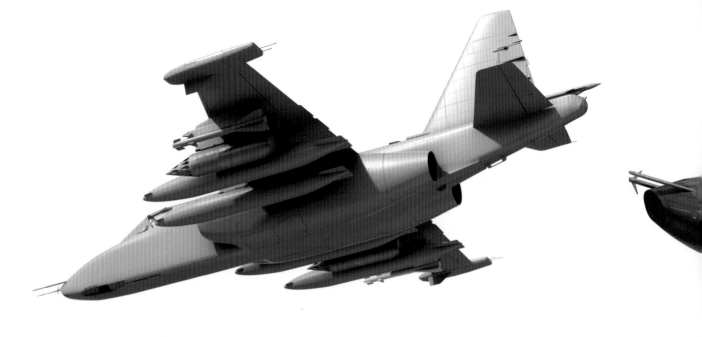

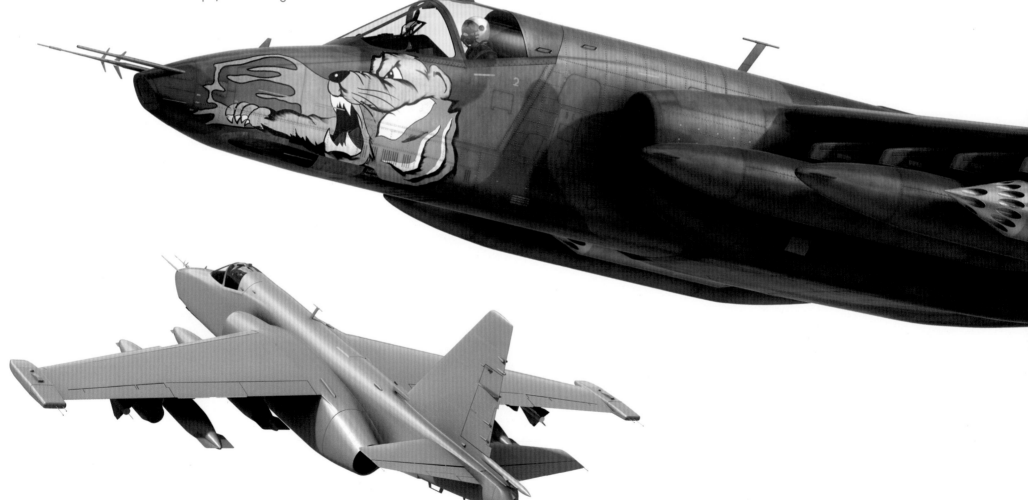

Peruvian Air Force Su-25UB Work in Progress

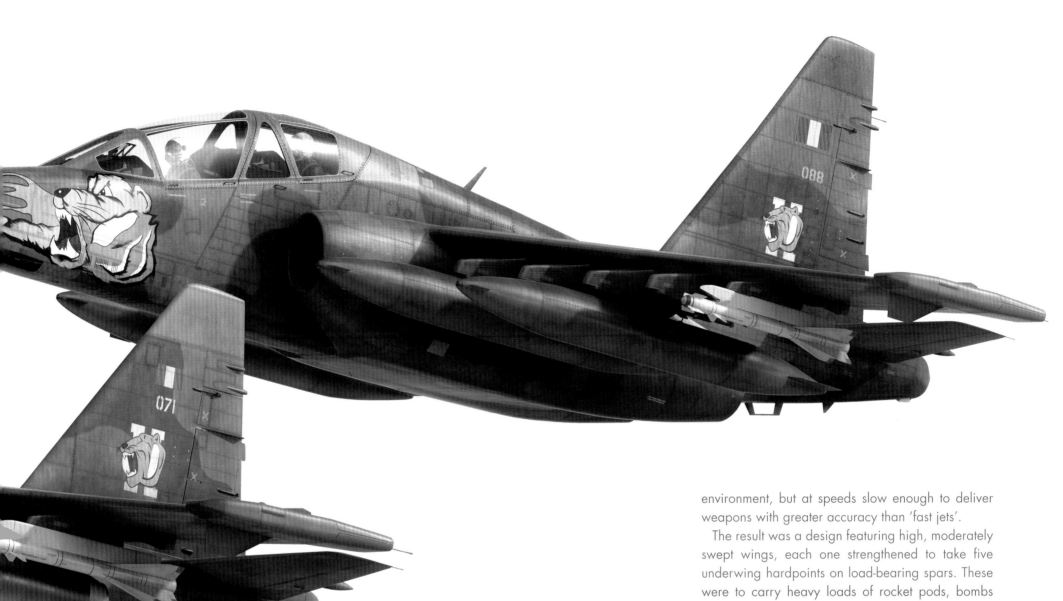

environment, but at speeds slow enough to deliver weapons with greater accuracy than 'fast jets'.

The result was a design featuring high, moderately swept wings, each one strengthened to take five underwing hardpoints on load-bearing spars. These were to carry heavy loads of rocket pods, bombs and air-to-ground missiles, but the main weapon was to be the 30mm cannon fitted in the nose beneath the cockpit. The nose also houses a laser target designator for laser-guided weapons. The cockpit, meanwhile, sits in a 'bathtub' of titanium armour, while a steel headrest protects the pilot's head.

The first production aircraft entered service in May 1981, a year after the Soviets had intervened in Afghanistan. In July, the first squadron of Su-25s arrived in-country and were soon embroiled in operations against the Mujahedeen. By the time of the Soviet withdrawal in late 1989, some fifty aircraft had flown over 60,000 sorties, losing twenty-one to enemy fire or operational cause. One was shot down by a Pakistani F-16 after straying

into Pakistan's airspace. Its pilot, Major Alexander Rutskoy, ejected safely and later became acting President of Russia in 1993.

Su-25s also saw service in the Middle East. Iraqi aircraft flew some 900 combat sorties during the Iran-Iraq War, seeing almost constant action after they became operational in 1987. Later, in the 1991 Gulf War, USAF F-15s shot down two Sukhois on 6 February as they attempted to flee to safety in Iran. Seven did make it to the safe haven of their former enemy and ended up operating with the Iranian air force.

Russian Su-25s were back in action during the wars in Chechnya. As many as eleven were shot down during the heavy fighting, despite the lack of any kind of integrated Chechen air defences. Poor tactics and the use of unguided weapons such as iron bombs and rockets (as opposed to longer-reaching guided weapons) were blamed for the losses.

In a strange twist of fate, both sides were using the Su-25 during the 2008 Russia-Georgia conflict, both sides losing three or four aircraft each. Russian aircraft even attacked the factory in Tbilisi where Georgia was building its own Sukhois.

Later versions of the type were equipped with a second seat and advanced avionics and weapons for all-weather, day-and-night operations. They were re-designated the Su-39 and fitted with a multi-mode radar that enabled the new aircraft to engage not just ground targets but ships and even other aircraft.

Drug War. A Peruvian Air Force Su-25UB engages a light aircraft transporting cocaine with a Russian R-60 short-range heat-seeking AAM. Between 1998 and 2005, Peru's Su-25s claimed 25 drug transports. *Courtesy of Osprey Publishing.*

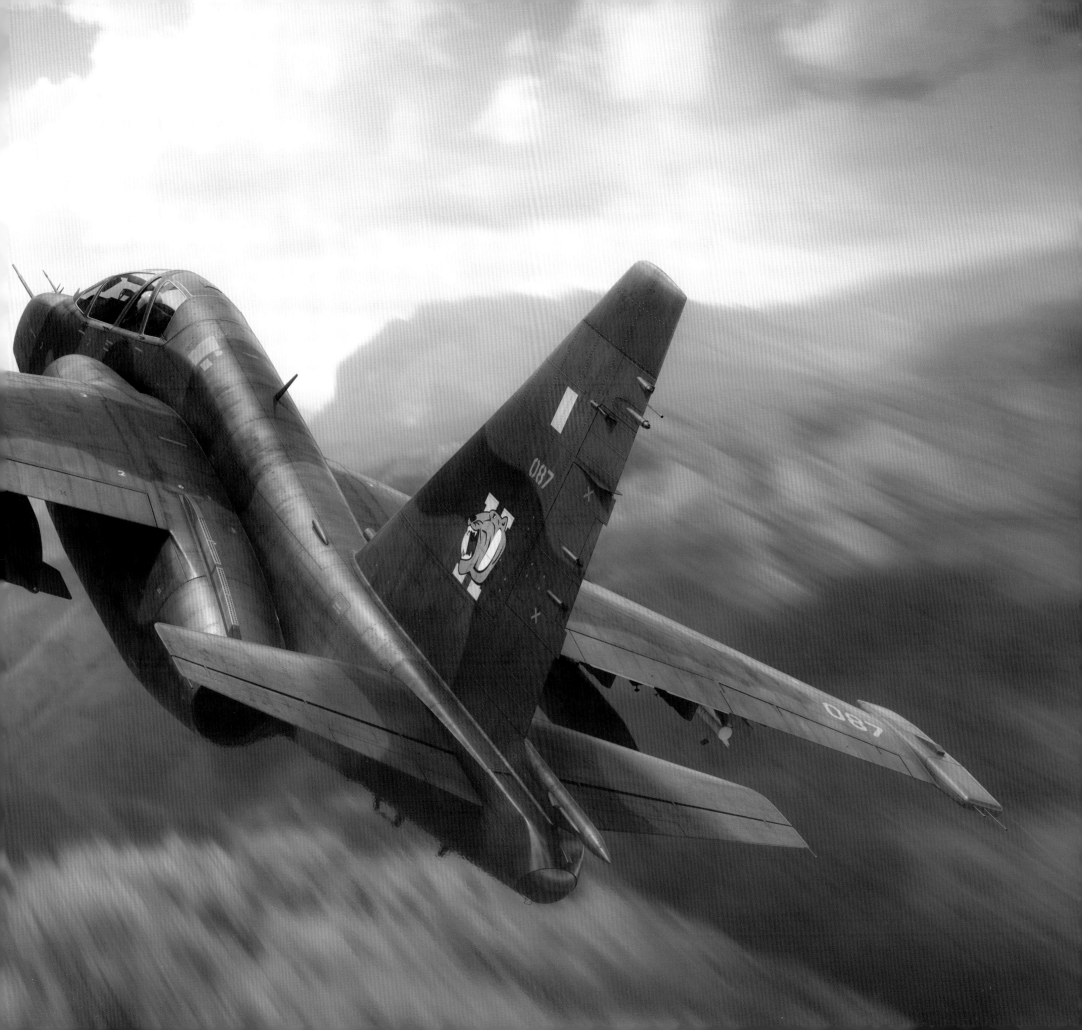

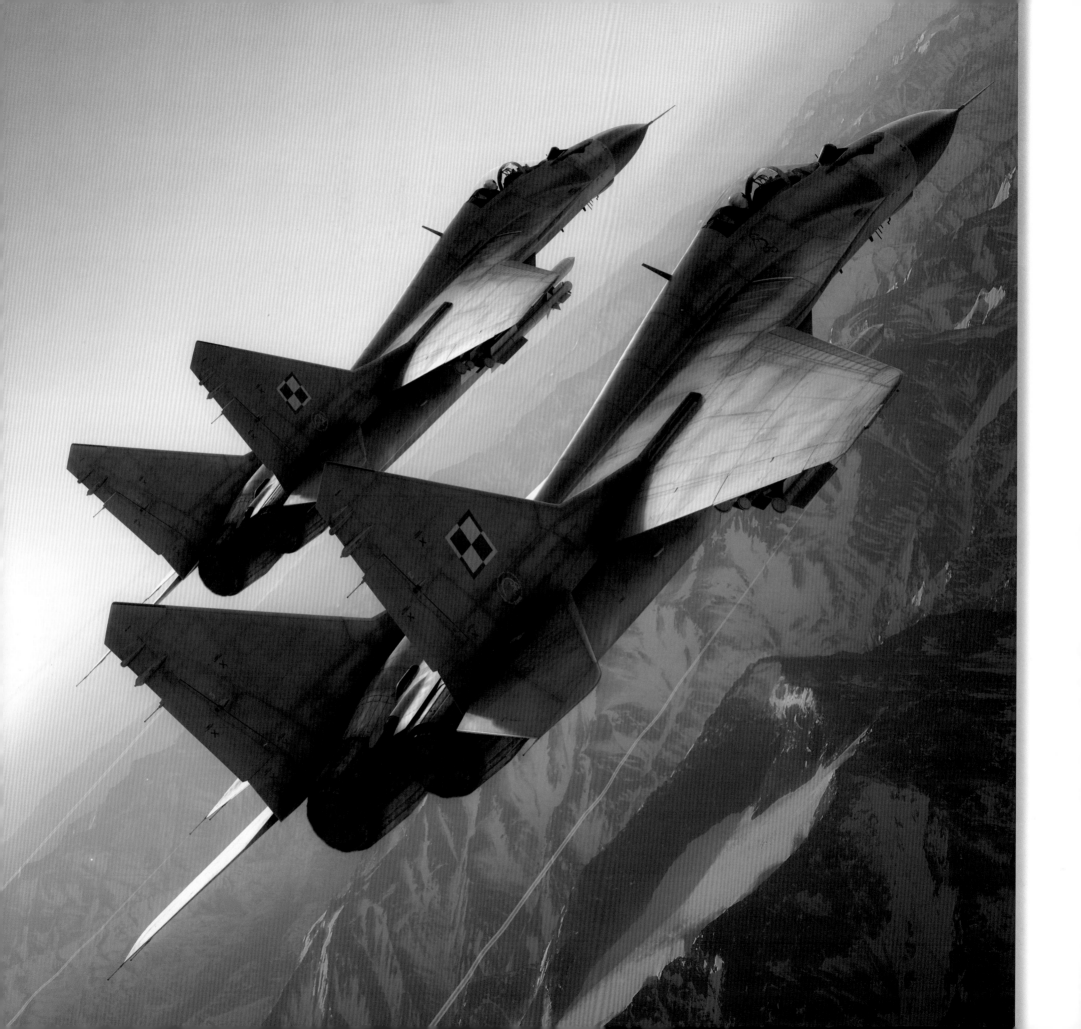

MIG-29

SPECIFICATIONS

TYPE: fighter/fighter-bomber

MANUFACTURER: Mikoyan-Gurevich

OPERATORS INCLUDE: Russia; Bulgaria; India; Iran; Malaysia; North Korea; Peru; Poland; Slovakia; Sudan; Syria; Ukraine

CREW: pilot

LENGTH: 57ft (17.37m)

WINGSPAN: 37.3ft (11.4m)

WEIGHT: 24,250lb (11,000kg) [empty]; 44,100lb (20,000kg) [take-off weight]

MAX. SPEED: 1,490mph (2,400km/h)

SERVICE CEILING: 59,100ft (18,013m)

RANGE: 888 miles (1,430km)

POWERPLANT: Klimov RD-33 turbofan x 2

ARMAMENT: GSh-30-1 30mm cannon; maximum payload of 7,720lbs (3,500kg) on underwing hardpoint x 6, including AAMs, unguided bombs and rocket pods

MAIDEN FLIGHT: 6 October 1977

IN SERVICE: July 1983-present

NUMBER BUILT: 1,600 (still in production)

An advanced 'fourth generation' fighter, the MiG-29 is similar to such US types as the F/A-18 and F-15. Its wings feature advanced control surfaces and LERXs (Leading Edge Root eXtensions) that blend with the fuselage as far forward as the nose. While the airframe is narrow, the engines are mounted low on the fuselage in long, slender pods. All these features make the aircraft very agile, with excellent rates of turn and resistance to uncontrolled spins.

The MiG-29 (NATO reporting name 'Fulcrum') also features two sensor systems that, when it appeared in 1986, had yet to enter service in the West. The first is a helmet-mounted cuing system or HMS (helmet-mounted sight) that allows the pilot to engage targets by firing missiles that then track along his line of sight. The Fulcrum's pilots were no longer reliant on the nose-mounted radar with its limited arc for tracking and engaging targets. Now they could attack an enemy aircraft across a much broader engagement zone – almost at forty-five degrees

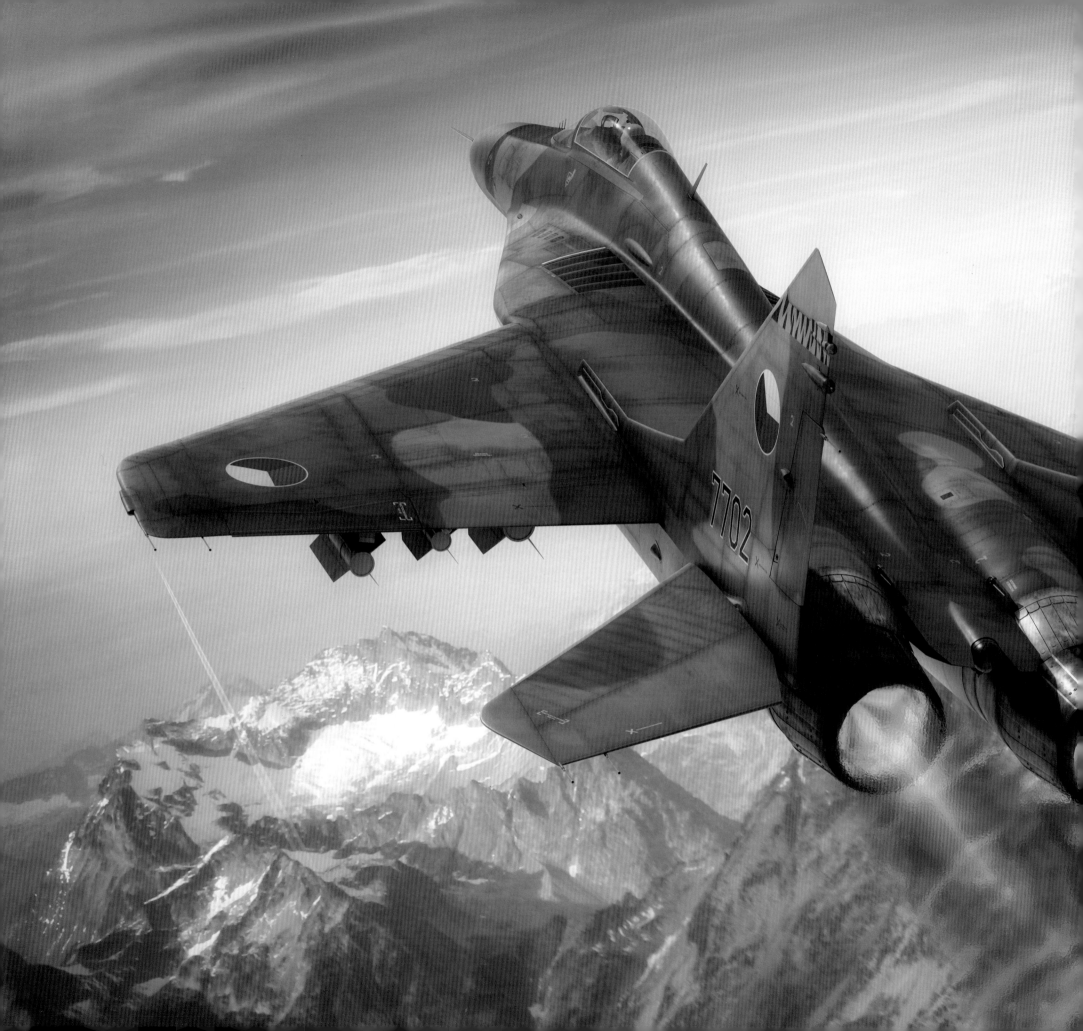

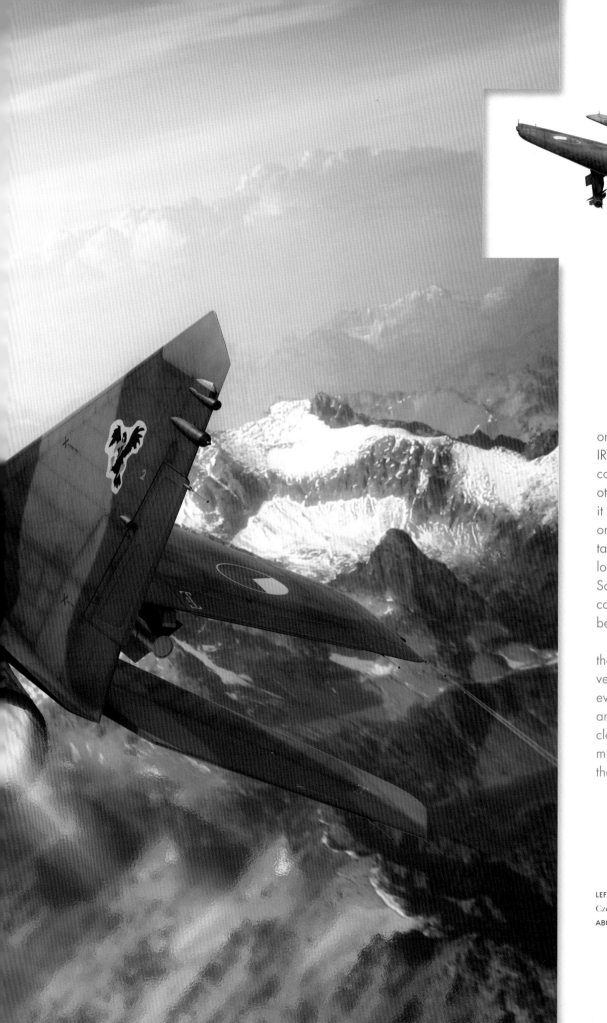

on either side of the nose – simply by looking at it. The second sensor is the IRST (infra-red search and track) ball, just forward and to the right of the cockpit, essentially a heat-seeking radar. It picks up heat emissions from other aircraft. The big advantage of this over a conventional radar is that it generates no emissions itself. A radar, no matter how advanced, relies on the reflection of the radio waves it emits to find, track and engage a target. Any aircraft fitted with the right receivers will know when a radar is looking at it and, if necessary, can take the appropriate countermeasures. So, without such emissions, the IRST radar is essentially a stealth radar; it can monitor other aircraft, close on and shot them down without the target being any the wiser.

These and more advanced radar and electronic warfare systems make the Fulcrum an excellent fighter. In air combat exercises between German versions and NATO fighters, it performed well at low and slow speeds, even out-flying the vaunted F-15C Eagle. While US sensors gave the Eagle an advantage in long-range engagements, once the two opponents had closed to within ten miles, the MiG began to gain the upper hand. By five miles, the MiG was superior, the HMS providing a major advantage for the German pilots. HMSs did not enter service with the USAF until 2003.

LEFT: **Fulcrum.** A Czech Air Force MiG-29, 1st Squadron, 11th Air Fighter Regiment, Zatec Air Base, Czech Republic, 1993.
ABOVE: **Czech Air Force MiG-29, 1st Squadron, 11th Air Fighter Regiment**

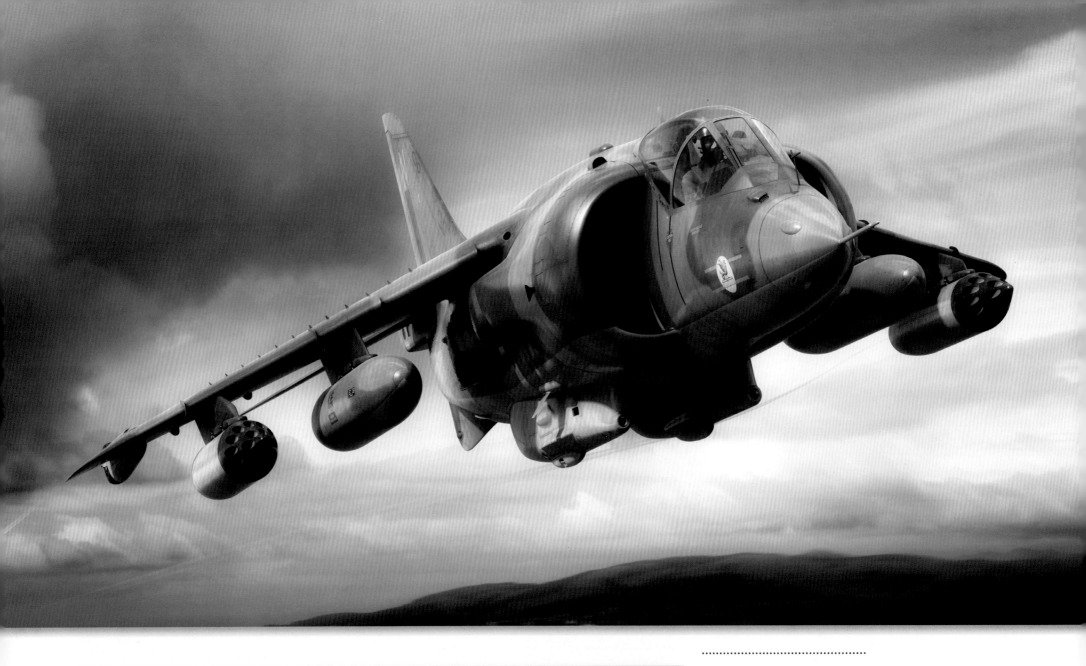

SPECIFICATIONS

FOR MODEL: GR.3

TYPE: ground attack/close air support

MANUFACTURER: Hawker Siddeley

OPERATOR: UK (RAF)

CREW: pilot

LENGTH: 46.8ft (14.27m)

WINGSPAN: 25ft 3in (7.7m)

WEIGHT: 13,535lb (6,140kg) [empty]-25,200lb (11,430kg) [max. take-off weight]

MAX. SPEED: 730mph (1,176km/h)

SERVICE CEILING: 51,200ft (15,600m)

RANGE: 230 miles (370km) with max. war load

POWERPLANT: Rolls-Royce Pegasus 11/Mk 103

ARMAMENT: 30mm Aden cannon x 2; up to 5,000lbs (2,268kg) of Matra rocket pods, Paveway laser-guided bombs, BL755 cluster bombs, AIM-9 Sidewinder missiles or reconnaissance pod on underwing hardpoint x 4 and underbelly hardpoint x 1; can also carry drop tanks x 2

MAIDEN FLIGHT: 1976

IN SERVICE: 1977-1994

NUMBER BUILT: 61

HARRIER

The Harrier was a revolutionary warplane, pioneering the use of V/STOL (vertical/short take-off and landing) in combat operations. Developed in the UK by Hawker Siddeley in the late sixties, the first-generation Harriers were built around a revolutionary engine configuration known as an aerodyne. Developed by Rolls-Royce, it didn't use the single conventional engine exhaust, but, instead, had four swivelling outlets that could be rotated to direct the engine's jetwash downwards. This enabled the Harrier to land and take off vertically.

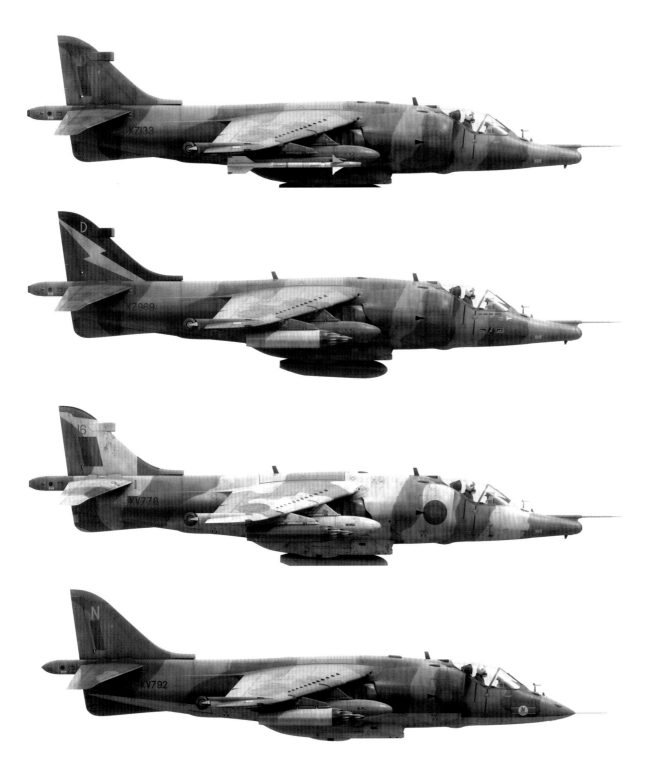

ABOVE, TOP TO BOTTOM: **GR.3 with Sidewinder Missile. GR.3 with Low-Level Reconnaissance Pod. Winter GR.3. GR.1**
OPPOSITE: **GR.1.** *Courtesy of Airfix. © Hornby 2014.*

The logic behind this approach stemmed from Cold War concerns that airfields were easy targets for Soviet nuclear missiles, against which there was little or no defence. Free from using conventional runways, the Harrier could be deployed anywhere – forest clearings, highway underpasses, car parks – big enough to take them, making them much harder to destroy on the ground. It also meant they could be deployed closer to the fighting, allowing quicker reaction times to developments on the battlefield.

With its small size, low speed and light payload, many airmen and commanders initially greeted the Harrier with scepticism. With its unusual control systems and strange engine configuration, it was also something of a handful for pilots and initially had a high accident rate. However, forward thinking members of the US Marine Corps saw the aircraft's potential and ordered the Harrier in 1969, to be known in USMC service as the AV-8A. They began operating the aircraft from a number of amphibious assault carriers (usually equipped with just helicopters) and the AV-8A was also able to quickly operate from forward operating bases on beachheads following any Marine landings.

The early version of the Harrier had only limited speed and payload (another reason to keep it near the battle front), and no version of the Harrier ever reached supersonic speeds – unusual amongst Cold War tactical fighters. Later versions, such as the RAF's GR.3 and the USMC's AV-8B, gave the Harrier more power and better sensors, the GR.3 being easily recognisable for its extended nose housing a laser ranger/marked target seeker.

Initially based in West Germany (at RAF Gutersloh) as part of the NATO force positioned to resist any Soviet invasion, the Harrier's primary role was anti-armour, intended to strike from hidden locations to help stymie the advance of Russia's massive tank armies. The USMC was expected to perform similar duties, supporting NATO's northern flank, with the AV-8s to be deployed into Norway.

The RAF's GR.3s' first taste of combat came following Argentina's invasion of the Falkland Islands in April 1982. Initially seen as replacements for any losses amongst the Royal Navy's Sea Harriers, they were actually put to good use in their primary close air

support role, though the ten aircraft operated not from ground bases but from the Royal Navy carrier HMS *Hermes*. Flying their first missions on 20 May, the little fighters acquitted themselves well, even claiming the historical accolade of being the first British aircraft to ever successfully drop a laser-guided bomb in combat, hitting an Argentine headquarters on 13 June. Ultimately, four were lost, all shot down by ground fire or SAMs.

The US Marine Corps Harriers had entered service too late to fly combat in Vietnam, so it was not until 1991 that they received their baptism of fire during the Gulf War. Deploying from as far away as Japan, four full squadrons and a six-aircraft detachment operated from Saudi Arabia, supporting coalition efforts to remove Iraqi forces from Kuwait. They saw some success, destroying considerable amounts of Iraqi armour. Three AV-8Bs were lost in combat, but the coalition's commander-in-chief, General Norman Schwarzkopf, named the aircraft as one of its seven most important weapons.

The Harrier found a number of customers aside from the UK and the US. The Spanish, Italian and Thai Navy operated AV-8As. In Spanish service, it was known as the Matador.

30 April 1985 saw the first flight of a much-updated version of the Harrier. Built around an uprated version of the Pegasus engine, the Harrier II's airframe made use of lighter but stronger composite materials, a raised cockpit to improve the pilot's view and a more advanced wing, allowing the aircraft to carry a 6,700lb (3,035kg) payload on six hardpoints. Its cockpit was also much advanced, using new technology such as head-up display (HUD), multi-purpose colour displays (MPCDs) and HOTAS (hand on throttle and stick).

Entering service with the RAF as the GR.5 in December 1989 and later, from 1994, as the GR.7 and GR.9, the Harrier IIs also carried newer, more advanced weapons, such as AGM-65 Maverick air-to-ground missiles and later versions of the Paveway LGB. It saw combat over the former Yugoslavia, flying over 120 ground-attack sorties, mainly using laser-guided weapons. The aircraft was back in the Balkans in 1999 for NATO's controversial air campaign against Serbia, where, after attracting heavy anti-aircraft artillery from the Serbs at low level over Kosovo, the Harrier IIs began operating at medium altitudes, with mixed results.

2001 saw USMC AV-8Bs in action during the invasion of Afghanistan, while 2003 had Harriers once more in action against Iraqi forces. GR.7s, alongside their Marine Corps colleagues in late-model AV-8Bs, flew numerous ground-attack and reconnaissance missions. The RAF put the AGM-65 Maverick to good use, destroying a large number of Iraqi armoured vehicles, as well as reportedly knocking out a number of infamous SCUD missile launchers. Both American and British aircraft flew deployments to Afghanistan in the ongoing war against the Taliban, until the RAF was, somewhat controversially, required to retire its Harrier IIs in December 2010.

RIGHT: Iraqi Freedom. Harrier II GR.7s of RAF 20 (Reserve) Squadron, Ahmed Al Jaber Air Base, Kuwait, 2003.

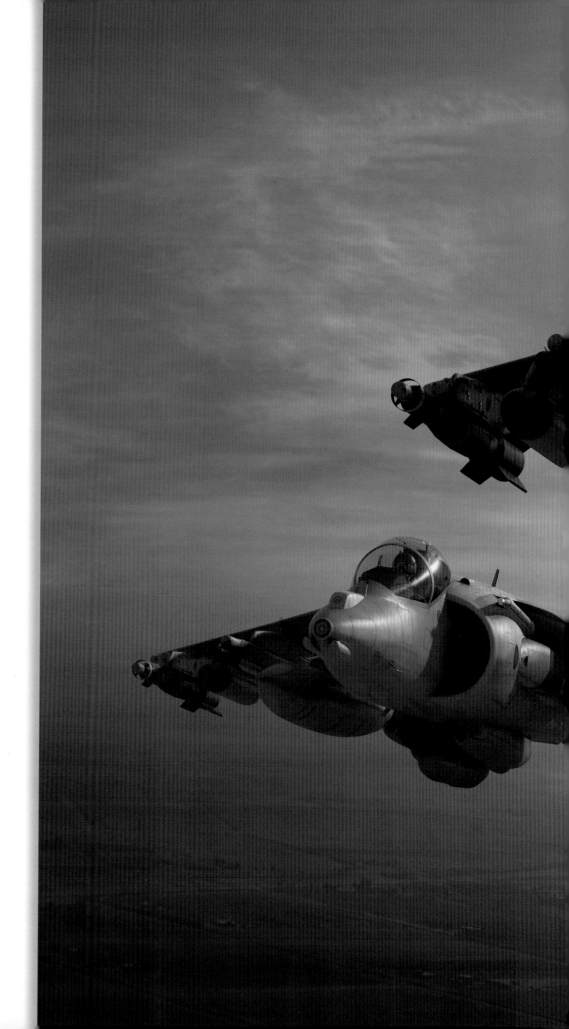

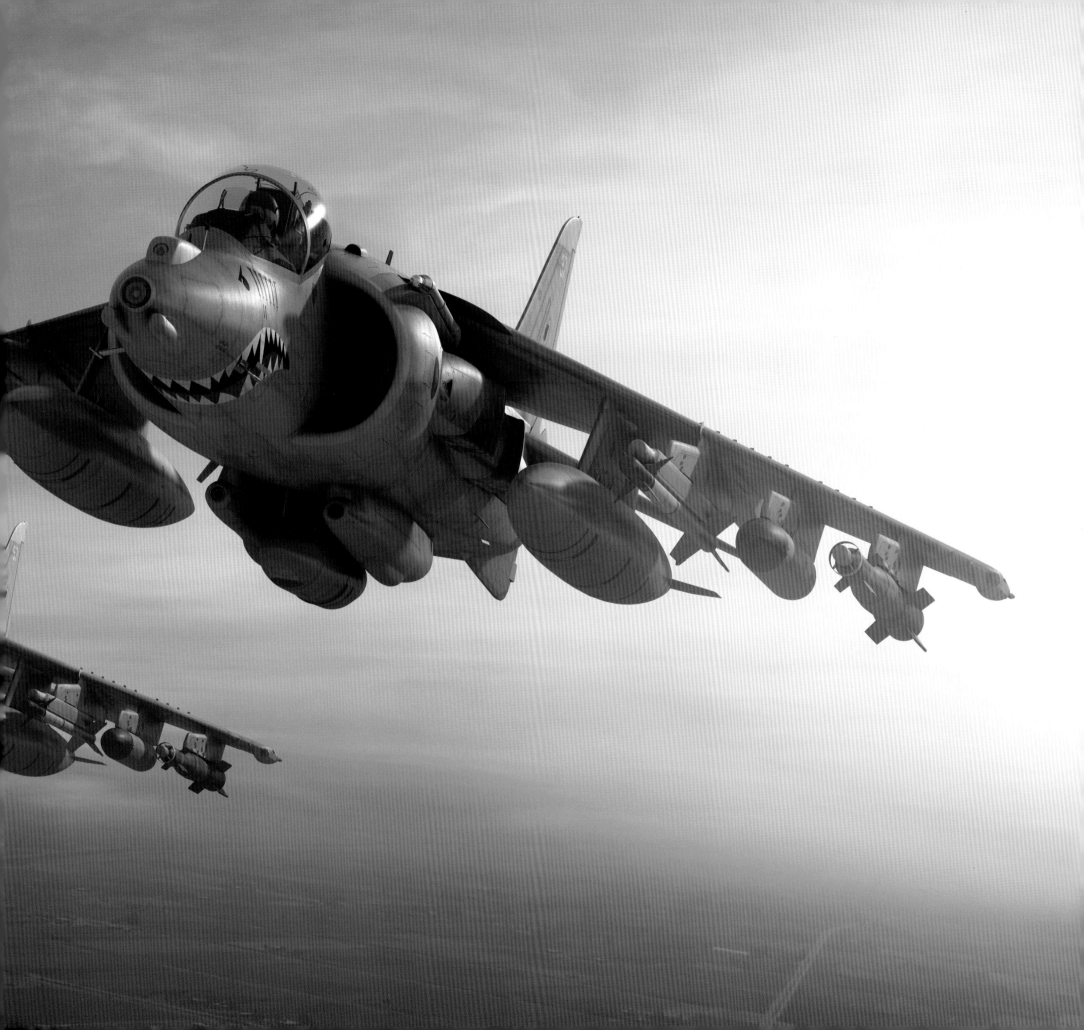

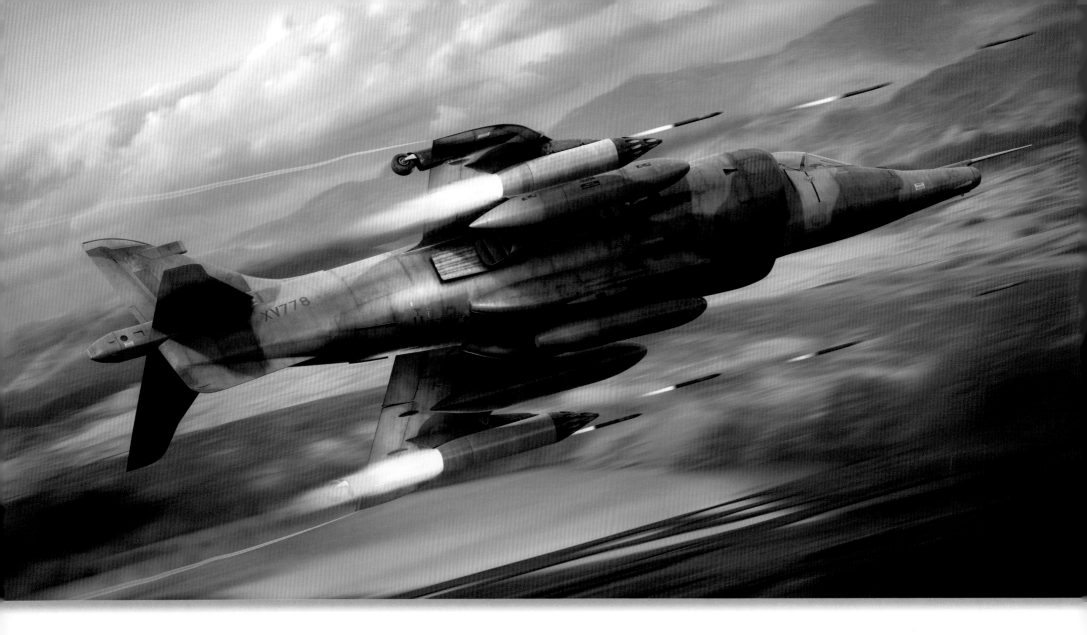

SPECIFICATIONS

FOR MODEL: FA2

TYPE: naval multi-role fighter

OPERATORS: Royal Navy; Indian Navy

CREW: pilot

LENGTH: 46ft 6in (14.2m)

WINGSPAN: 25ft 3in (7.70m)

WEIGHT: 14,052lb (6,374kg) [empty], 26,200lb (11,900kg) [max. take-off weight]

MAX. SPEED: 735mph (1,182km/h)

SERVICE CEILING: 51,000ft (16,000m)

RANGE: 620 miles (1,000km)

POWERPLANT: Rolls-Royce Pegasus 11/Mk 104 or Mk 106

ARMAMENT: 30mm Aden cannon x 2; up to 8,000lbs (3,630kg) of weapons on underwing hardpoint x 4 and underbelly hardpoint x 1; can also carry drop tank x 2

RADAR: BAe Systems Blue Vixen pulse-doppler multi-mode, all-weather radar

MAIDEN FLIGHT: August 1988

IN SERVICE: 1993-2006 (RN); still in service with India

NUMBER BUILT: 56

Like the US Marine Corps, Britain's Royal Navy realised the sea-borne applications of the Harrier and developed a unique version designed to operate from its new *Invincible*-class aircraft carriers. The new radar-equipped variant was intended not just for ground attack, but for air combat, for which it was initially equipped with a pair of short-range Sidewinder AIM-9 heat-seeking missiles and a raised cockpit to improve the pilot's all-round vision. It also carried Sea Eagle anti-shipping missiles, as well as more conventional ground-attack weapons. To aid in take-off, the RN's carriers were fitted with a seven-degree 'ski ramp' that lifted the aircraft during short take-off runs.

The initial Sea Harrier (soon nicknamed the 'Shar')

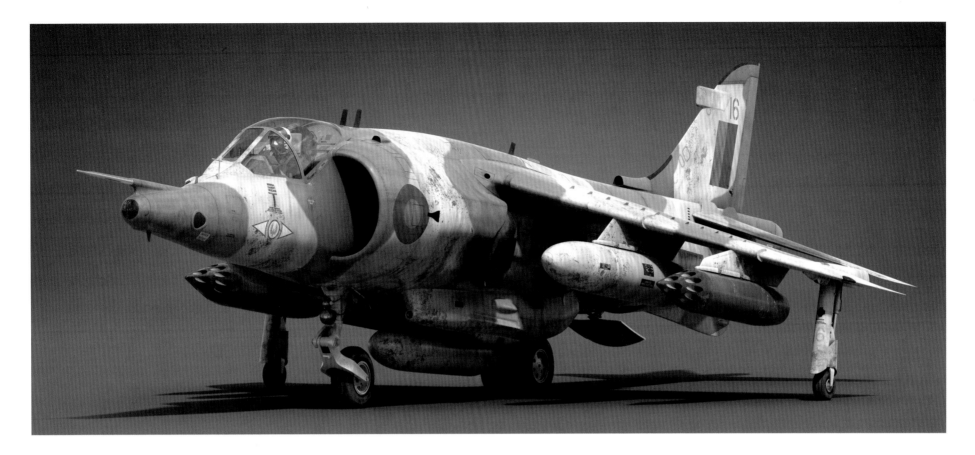

OPPOSITE: **Low and Fast.** A GR.3 in action.

version was the FRS.1 (fighter/recon/strike), which began operational service with the RN in April 1980, forming two squadrons, the 800 and 801 Naval Air Squadron (NAS). In April 1982, both went into action against Argentine forces over the Falkland Islands. Despite difficult conditions – bad weather, salt spray, cramped flight decks, tough wartime flying requirements – mechanics and technicians managed to keep twelve or more of the fifteen 800 NAS aircraft aboard HMS *Hermes* flying every day throughout the conflict.

The aircraft were also rush-fitted with a number of wartime modifications, including chaff and flare dispensers, and twin launchers so that each Shar could carry four Sidewinders instead of two. The Sidewinders themselves were the latest versions, the AIM-9L.

Concerns that the unconventional Shar design might not fare well against the conventional fighters of the Argentine air and naval forces were soon dispelled

when combat was joined on 1 May. Initially flying numerous ground-attack missions alongside their RAF counterparts, the primary mission of the twenty-eight Shars deployed was the CAP (combat air patrol). Hampered by the RN's lack of radar early warning, which proved to be a serious, on occasion near-disastrous weakness, the Sea Harriers still managed to shoot down twenty Argentine aircraft for no losses (although two were lost to ground fire). Such was the Argentine's respect for the Shar they were reluctant to deploy their dedicated Mirage III fighters over the Islands, leaving the strike missions unescorted and, when they could be found, often easy prey for the British fighters.

Despite their much-vaunted success, lessons from the Falklands War made it clear the Sea Harriers needed improving. With the RAF upgrading to the Harrier II, the RN followed suit with an adapted, navalised version entering service in April 1993.

Fear of sea-skimming missiles launched from maritime aircraft, such as the infamous Exocet/Super Etendard team, required a longer reach for the new Shar. As such it was fitted with a new version of the FRS.1 and 2's Blue Fox radar, the Blue Vixen. This allowed it to operate the new AIM-120 AMRAAM air-to-air missile. This all-weather, radar-guided, fire-and-forget missile has a range of fifty miles, providing the Shars with a BVR (beyond visual range) capability.

The FA2 saw action during the conflict in Bosnia, following the break up of Yugoslavia, mainly in the ground-attack role, losing an aircraft of 801 NAS to a SAM in April 1994. Shars also flew CAPs from HMS *Invincible* during the 1999 air war over Kosovo.

The Sea Harrier FA2 was retired from RN service in March 2006 – a much criticised decision that leaves the Royal Navy with no organic air cover or close-air-support capability while it waits for the F-35 Lightning II to come into service.

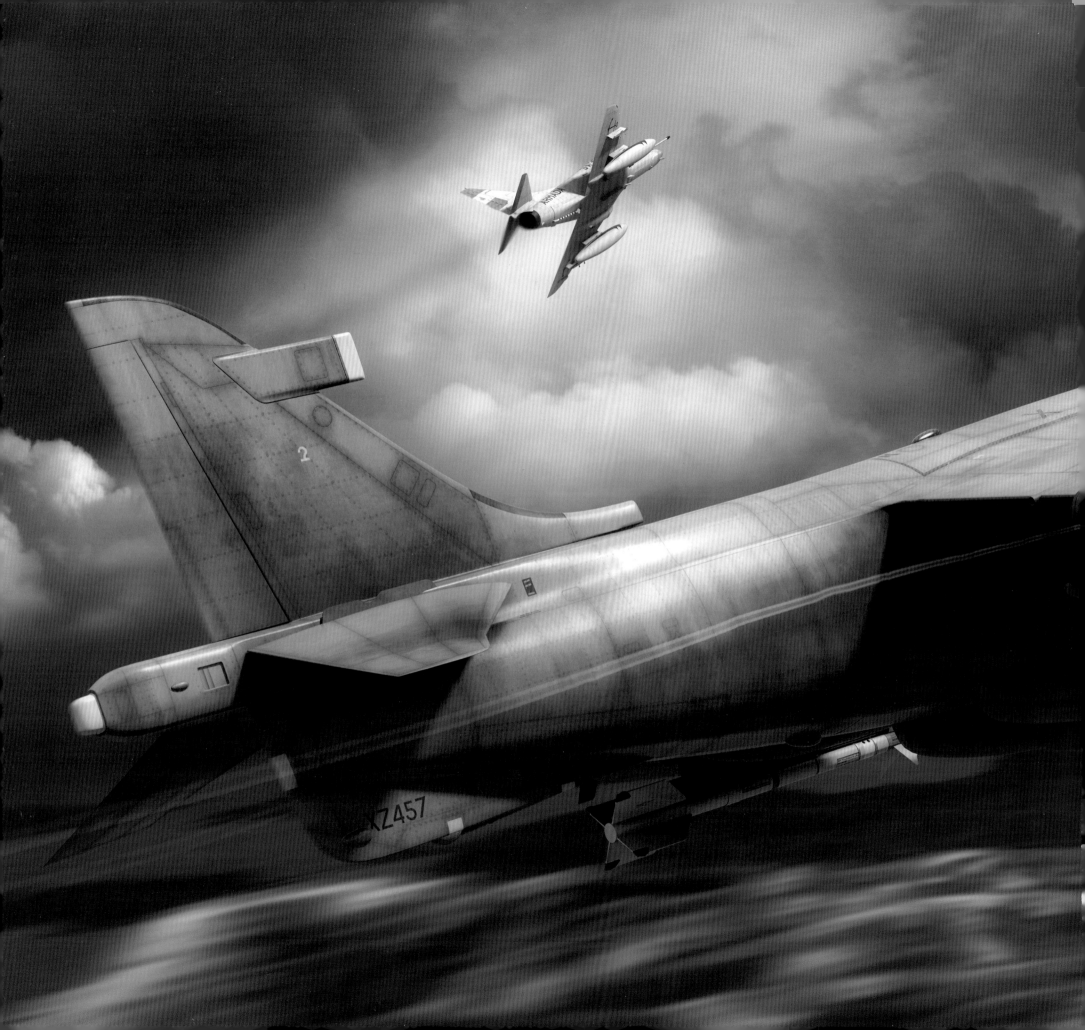